0059121

AFRICAN ART IN MOTION

AFRICAN ART IN MOTION

Icon and Act

By

Robert Farris Thompson

National Gallery of Art
Washington, D.C.

Frederick S. Wight Art Gallery
University of California, Los Angeles

University of California Press
Los Angeles, Berkeley, London

DEDICATION
for Nancy, Peachy, and Clark

Published under the sponsorship
of the UCLA Art Council

The exhibition
AFRICAN ART IN MOTION
was supported by a grant from
the National Endowment for the Arts

University of California Press
Berkeley and Los Angeles, California

University of California Press, Ltd.
London, England

Reissued 1979

ISBN: 0-520-03844-4 (cloth)
0-520-03843-6 (paper)

Library of Congress Catalog Card Number 73-91679
Printed in the United States of America

1 2 3 4 5 6 7 8 9

TABLE OF CONTENTS

An object's measurement is of its greatest dimension: height, width, or diameter and is given in inches.

Objects not referred to directly in the text are assigned alphabetical letters and are interspersed with those mentioned.

LIST OF COLOR PLATES

An Overview of African Dance, an original videotape narrated by Robert Farris Thompson and edited by him from the master tapes recorded in the field and documented for the exhibition *African Art in Motion,* is available from the UCLA Art Council, 405 Hilgard Avenue, University of California, Los Angeles, California 90024. See appendix for illustrations.

FOREWORD

This exhibition is a true collaboration between collector and scholar. We wish to extend our gratitude, first of all, to Katherine White for her generosity in lending her collection for an extended period and for her willingness to participate in the development of a fresh exhibition concept. Thanks are also due Professor Robert Thompson for his wholehearted participation in the exhibition through his field trips, film and TV footage, and the final text and appendices.

The UCLA Art Council, under the direction of Mrs. Franklin D. Murphy, President, has provided financial support for the exhibition which made possible much of the research and field trips. This tradition of support is an ongoing one for the Art Council and extends to the Council's major contribution to the renovation and expansion of the newly renamed Frederick S. Wight Art Galleries of UCLA. University support has taken many forms. Mr. John Neuhart of the Art Department has made the exhibition a matter of particular interest and has designed an informative and effective souvenir which has been published through the good offices of the Ahmanson Foundation. Mr. George Ellis, Mrs. Suzanne Jurmain and Miss Ann Goodwin have provided invaluable services in editing the manuscript and helping with preparations for printing. Professor Jack Carter, Associate Director of the Gallery, designed both the catalog and installation and has given form to many of the ideas generated by all concerned.

We would like also to acknowledge the participation of many members of the National Gallery of Art's various departments, from early meetings in 1973 through to stages of realizing the exhibition. Their involvement has been varied and tireless.

Finally, it is to the artists in Africa that the thanks of all who see this show must go. Their imagination, their skill, and their uncanny sense of art in motion is what this exhibition ultimately celebrates.

J. Carter Brown, Director
National Gallery of Art

Gerald Nordland, Director
Frederick S. Wight Art Gallery
University of California, Los Angeles

AUTHOR'S ACKNOWLEDGMENTS

I express a deep sense of obligation to Katherine Coryton White, whose collection inspired this volume. She made available a copy of her private archive, helped to defray expenses for two field trips to Africa, and extended gracious hospitality during the summer and fall of 1972 when I photographed and studied her collection.

I am also grateful to the UCLA Art Council — currently presided over by Mrs. Franklin D. Murphy — for funding two research trips to Africa and additional research in Los Angeles. Mrs. Herman Weiner, Chairman of the Exhibitions Committee, likewise has been helpful in taking the responsibility for financial matters related to this exhibition.

I am equally indebted to the man whose name is given to the new gallery in which this exhibition opens in early 1974 — Frederick S. Wight, scholar, director, artist, friend and former director of the UCLA Art Galleries, who first conceived of a West Coast exhibition of the Katherine Coryton White Collection. We are equally honored by association with his successor, Gerald Nordland, the present director of the UCLA Frederick S. Wight Gallery, who brings great expertise to the presentation of our project.

Warm thanks to George "Rick" Ellis, curator of the UCLA Museum of Cultural History, for his extraordinary role in actualizing the publication of this volume and the installation of the exhibition. Suzanne Jurmain, also of the Cultural History staff, edited the book with efficiency and located materials from the Human Relations Area File. I am also grateful to the Museum staff for many services.

My debt to UCLA is very deep, and I extend a special thank you to the following persons: Jack Carter, Professor of Art, who designed the catalog and exhibition; his colleagues Dave Paley, Milt Young, Mike Robinson, and Will Reigle, who perfectly complemented his work; Larry Dupont, a first-rate photographer of the arts of Africa, especially chosen for this project; John Neuhart, a prime mover of the installation of the exhibition, who initiated me into the new medium of videotape and who, with Professor Mitsuru Kataoka, allowed me use of an Akai video unit in West Africa.

Much appreciation is owed to former UCLA Chancellor Franklin D. Murphy, trustee of the National Gallery of Art, who proposed the exhibition to his Washington colleagues, for the express purpose of bringing its content to the thousands of Afro-Americans in the greater Washington and Baltimore area. I therefore warmly thank the National Gallery trustees, the Director, J. Carter Brown, the Assistant Director, Charles Parkhurst, and members of the Gallery staff for their assistance and cooperation.

I thank the Foreign Area Training Fellowship Program, which enabled me to study Yoruba sculpture and dance in Nigeria and Dahomey from 1962 to early 1964; the Concilium on Area and Foreign Studies at Yale, which awarded grants for further field study of Yoruba aesthetics in the summer of 1965 and again in the winter of 1967–8; The National Endowment for the Humanities, which generously sponsored fieldwork in Ghana and Cameroon in 1969; Professors Alan P. Merriam and Roy Seiber, authorities in the study of African traditional music and art, who encouraged me to pursue the history of African dance and art and led me to many valuable sources; Neil Allen, who assisted during videotaping sessions in Cameroon and fully participated in the research bearing on the Basinjom cult; and Walter Clark, American consul at Douala, Cameroon.

Pride of place is reserved for Africans, whose friendship and cooperation made this book possible. First and foremost, Ambassador and Mrs. Edward Peal of Liberia personally arranged for the author and his wife to study Dan sculpture in Nimba country, Liberia, in the spring of 1967. Thanks to their most careful attention, a fine interpreter, George Tabmen, was assigned to work with us in the field. All translations from Dan into English are his.

Nigerian research was made pleasurable by Ekpo Eyo, Director of the Nigerian Department of Antiquities, as well as by Ajanaku, Araba Eko, always a rich and incomparable source of the lore of the ancient Yoruba. Chief Defang Tarhmben directly participated in, and made possible, my initiation into the Basinjom cult and shared a rich knowledge of the mystical dimension to Banyang life. Other helpful men of Cameroon were: Tabe of Fotabe, Ako Nsemayu of Mamfe; and the Dahomean chiefs and elders of Otu were equally superb sources. Zaire research was facilitated by the

cooperation of Sukari Kahanga and Kapambu Sefu of Kinshasa; and cordial contact was established with Mwika and Mwabumba Shamakondo of the Kahemba area Chokwe now resident in Ngaba quarter, Kinshasa. I also heartily thank Kabimba Kindanda, Piluka Ladi, and Ilunga of Luebo. They all advanced, in different ways, my thinking.

In the United States, Roger Abrahams, Leonard Doob, Richard Henderson, George Kubler, Sheldon Nodelman, Claude Falisca, Richard Price, John Szwed, and Nancy Gaylord Thompson read portions of the manuscript and made comments and criticisms which clarified the exposition. Paul Gebauer, Baruch Elimelech, and Beatrice Luwefwa Kiyema were kind enough to read and comment on parts of the appendix. Dr. Mildred Mathias of the UCLA Department of Biology was also of assistance. I also thank Charles Davis, Director of the Yale Department of Afro-American Studies and master of Calhoun College, for many favors, many fetes, and much intellectual companionship. In the fall of 1972 I organized a graduate seminar at Yale on African art in motion in which I rehearsed some of the ideas in the present volume. I was rewarded by imaginative response from certain students, most especially Sylvia Boone and Peter Mark. In addition, Charles Cutter, postdoctoral fellow from the University of California, San Diego, and poet Larry Neal, lecturer in Afro-American literature at Yale, honored some of our explorations with their presence.

Finally, I thank my wife, Nancy, and my two children, Peachy and Clark, who tamed the telephone, patiently endured *les déjeuners sur les pages du livre-in-progress*, brightened my heart and mind, and assured the peace in which I could write of African dance as consciousness, art, and aspiration, involving us all in deep and primary vitality.

R.F.T.

1 October 1973
Yale University
New Haven, Connecticut

A NOTE

Africa is a verb to me.
The vitality that comes from the ground is an awakening.
The sunlight is special.
It is huge, so dense it is·like walking through concrete.
An artist, making the most ordinary thing,
sees at high intensity.
The texture of a simple country cloth expands in beauty.
A lovely market stool becomes a moment
of swift, tough abstract form.

The unrelenting sun allows no weakness.
A sculptor glides with it
as shadows and shining surfaces reveal themselves.
When a tool bites, the light decides.

A sculpture in a room sheds the memory of the sun.
It contains a sense of darkness, too—
the revelation of anti-light, as if condensed by enormous pressures.
The flicker of synapse between the sun and anti-light
is the action here.
This is why these objects are alive:
why they pour energy into the air;
why I stay in their fall-out.

KATHERINE CORYTON WHITE

Opposite: Color Plate V Nigeria, Benin, Hip mask

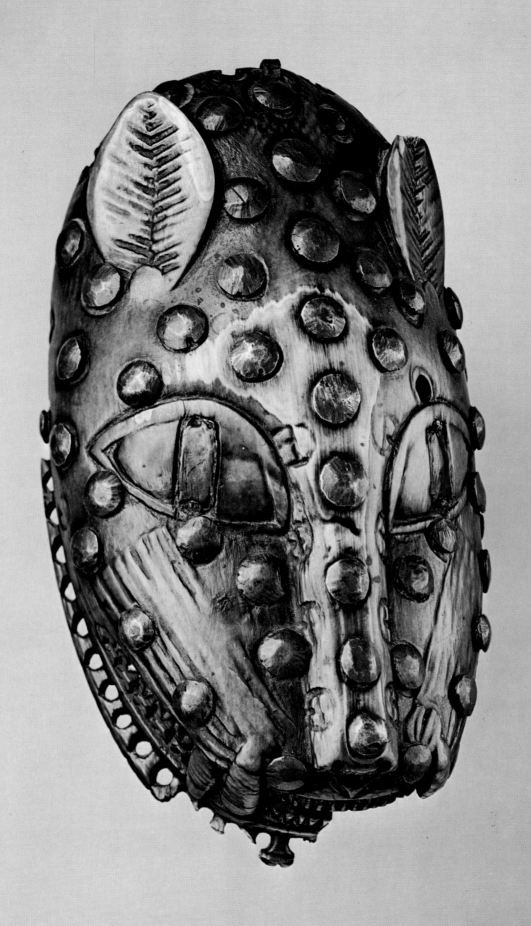

PREFACE

THE TIV PEOPLE OF NIGERIA use a basic verb which means "to dance." This word, *vine,* unites the dance with further worlds of artistic happening. Thus a person can sometimes "dance" a top, setting the toy in motion, or "dance" a cutlass, twirling the blade artistically, causing it to glitter before the metal bites into the wood.[1] This broad conception of the dance is widely shared in subsaharan Africa, *viz.* that dance is not restricted to the moving human body, but can combine in certain contexts with things and objects, granting them autonomy in art, intensifying the aliveness an image must embody to function as a work of art.[2] Motion enlivens stillness with precisely the contrastive logic utilized by an Ngbaka sculptor in the north of Zaire, who carved a portion of a musical instrument in the form of a part of the human frame (Plate 1) in order to add, quite literally, body to beauty in sound.

The spinning top, to return to the Tiv, and the flashing cutlass are objects invested with independent aura and importance. They are things made more impressively themselves by motion. Detachment[3] and sharing of human vitality, involving masks, headdresses, staffs, raiment, and even pottery and furniture, classically unite the inner being of the thing with the inner being of the self. The phenomenon is, fundamentally, poetic. It is a means of gaining access to sacred worlds conjured in artistic shapes.[4]

Africa thus introduces a different art history, a history of *danced* art, defined in the blending of movement and sculpture, textiles, and other forms, bringing into being their own inherent goodness and vitality.[5] Dance can complete the transformation of cryptic object into doctrine; dance redoubles the strength of visual presence; dance spans time and space.

Yet the work of plastic art has a logic and a power of its own. This is especially true in Africa, where the work of art is displayed on domestic altars or within a sacred grove. Thus Basinjom, famous oracle mask of the Ejagham and Banyang people of western Cameroon (Plate 2), remains vital even when at rest, within its private portion of the forest. This is the site where neophytes in the second grade of the cult are taught the lore that makes them effective warriors against witchcraft and, in the process of these lessons, the initiator points to various parts of the gown and mask and explains their meanings.[6] While these lessons in iconography are being given, certain men firmly place two rifles in crossed position over the image, forming an ancient Ejagham sign of arrested motion, for it is believed that unless this is done, the image may move of its own accord and create trouble.[7] The fact that the image of Basinjom must be moored magically, when at rest, is a metaphoric statement of inherent visual aliveness. Precisely this quality of active potentiality of the image is part of the subject matter of this book, in Chapter II, where I consider the motifs of stillness in preparation for their underlining by motion, in Chapter III, in contexts where dance extends the impact of a work of art to make a brilliant image seem more brilliant than could be imagined by ordinary men.

The famed unity of the arts in African performance suggests a sensible approach in which one medium is never absolutely emphasized over others.[8] Sculpture is not the central art, but neither is the dance, for both depend on words and music and even dreams and divination. Music, dance, and visual objects are all important, separate or together; and if motion conveys stature to music and art, sculpture deepens motion by condensation of several actions into one. These unities demand that we start with the shared norms of performance, before considering process or the function of a given object, dress, or dance. In the first chapter, consequently, I am suggesting criteria of fine form which seem to be shared among makers of sculpture, music, and the dance in some parts of Africa. I test this provisional aesthetic by art historical examination in which the documents of the past are sounded in order to see if these structural norms were present before the nineteenth century.

In the second chapter I consider attitude, defined as the position of the body. These attitudes, when assumed, are said to restore ancient modes of self-presentation in contexts of important indication. A traditional man in Dahomey told me that a person who stands well—and by this he explained positioning enlivened with dignity and power—is born with that power.[9] He made this observation while studying a photograph of a standing image of a woman, carved in wood, from northern Nigeria (Plate 3). Other Africans, in other places, have similarly insisted: commanding attitude and presence are ancestral.

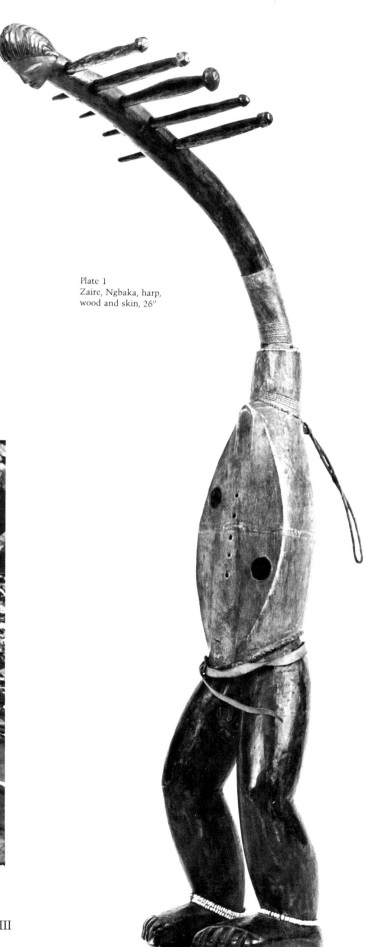

Plate 1
Zaire, Ngbaka, harp,
wood and skin, 26″

Plate 2
Cameroon, Basinjom mask
and costume, wood, fabric, etc., 75″

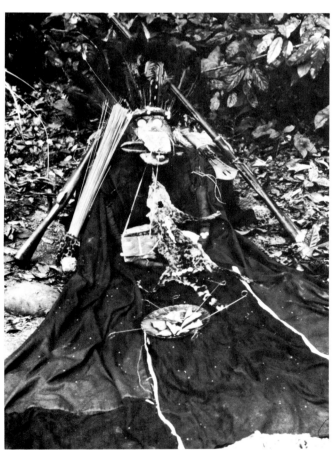

XIII

Received traditions of standing and sitting and other modes of phrasing the body transform the person into art, make his body a metaphor of ethics and aliveness, and, ultimately, relate him to the gods.

The icons of African art are, therefore, frequently attitudes (exceptions will be considered) of the body, arranged in groupings which suggest a grand equation of stability and reconciliation. Thus icons of elevated happening and command, *viz.* standing, sitting, and riding on horseback, seem balanced by icons of service or submission: kneeling, supporting with the hands, and balancing loads on the head. These seem leit-motifs in the history of African plastic art. They coexist, some of them, as early as the dawn of the Nigerian image some several hundred years before the birth of Christ. Theirs is a timeless purity, creating worlds beyond the social turmoil we call experience, alternatives to objective time and, indeed, to the history of art itself. For these icons of perfected stillness and repose have lasted longer than the Roman Empire, longer than the Byzantine. African icons remain *tresors de souplesse,* in the memorable phrase of Jean Rouch, for traditional sculptors in West Africa seem more influenced by the vital body in implied motion, by forms of flexibility, than by realism of anatomy *per se.* Flexibility and balance as modes of iconic phrasing form

a major portion of our interest and, at the risk of anticipation, I should say that I am concerned with social balance in art and dance, with the ability of the performer to move from one unstable setting to the next without a loss of humor (refusal to suffer) or composure (collectedness of mind).

In the third chapter I return to the theme of a history of danced art, combining the icons of standing, sitting, balancing and so forth, with action, and ponder the meaning of their combination. There are many things to consider in these unities, but one thing seems paramount: if spirits challenge gravity by moving on stilts twelve feet in the air to dance rhythms in the forest villages of Liberia; if athletes in Nigeria can carry nearly a hundred pounds of carved wood and shoulder this burden for a quarter of an hour while dancing before their king; if Dahomean initiates into a society honoring the collective ancestral dead can spin and spin and spin and spin and spin (Plate 4) until the very concept of human dizziness begins to lose its force—then anything is possible. I hope that the reader will return to the real world from the brilliance of this realm calm and purified, eager to live, strongly and well.

Robert Farris Thompson

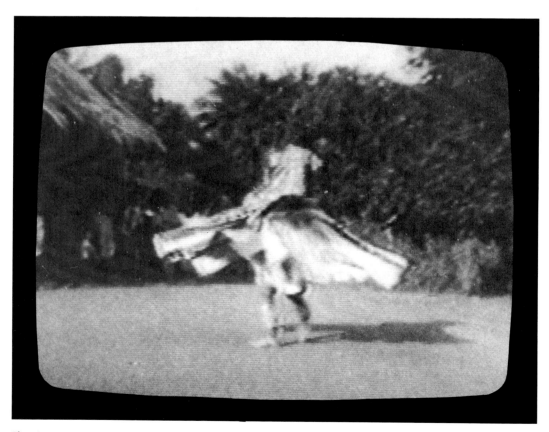

Plate 4
Egungun dancer

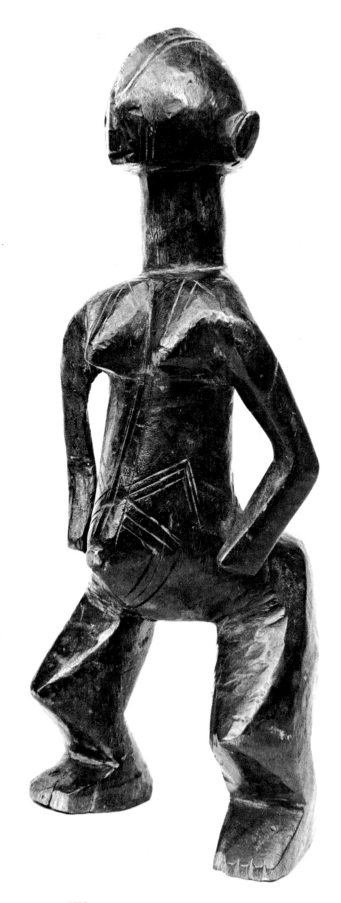

Plate 3
Nigeria, Montol, standing
female, wood, 12″

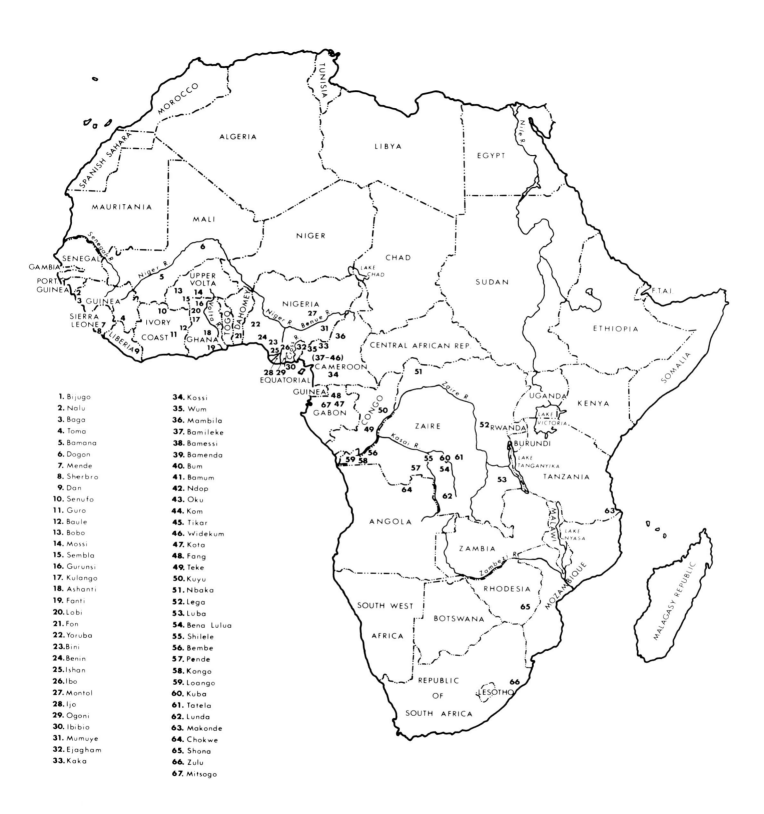

1. Bijugo
2. Nalu
3. Baga
4. Toma
5. Bamana
6. Dogon
7. Mende
8. Sherbro
9. Dan
10. Senufo
11. Guro
12. Baule
13. Bobo
14. Mossi
15. Sembla
16. Gurunsi
17. Kulango
18. Ashanti
19. Fanti
20. Lobi
21. Fon
22. Yoruba
23. Bini
24. Benin
25. Ishan
26. Ibo
27. Montol
28. Ijo
29. Ogoni
30. Ibibio
31. Mumuye
32. Ejagham
33. Kaka

34. Kossi
35. Wum
36. Mambila
37. Bamileke
38. Bamessi
39. Bamenda
40. Bum
41. Bamum
42. Ndop
43. Oku
44. Kom
45. Tikar
46. Widekum
47. Kota
48. Fang
49. Teke
50. Kuyu
51. Nbaka
52. Lega
53. Luba
54. Bena Lulua
55. Shilele
56. Bembe
57. Pende
58. Kongo
59. Loango
60. Kuba
61. Tatela
62. Lunda
63. Makonde
64. Chokwe
65. Shona
66. Zulu
67. Mitsogo

Cultures listed on this map are those represented in the Katherine Coryton White Collection.

When he wanted to show that I was many, he would
say that I have a right and a left side, and a front
and a back, and an upper and a lower half, for I cannot
deny that I partake of multitude.

 —Plato, *Parmenides*

Both space and motion can be manipulated rhyth-
mically. Existence can also be manipulated in like
manner; but we'll deal with that some other time
when we are discussing contests that involve more
than four persons. If we went into that now, we
would have to discuss history, and that bitch is not
the subject of my discussion.

 —Larry Neal, "Uncle Rufus Raps
on the Squared Circle," *Partisan Review*

AFRICAN ART AND MOTION

SHARED EVALUATIONS are vital to the understanding of
African traditional art and dance. I, therefore, start with
the norms of these traditions: the canons of fine form in
art and dance, with occasional reference to music and to
dress, and the persistence in time of some of these themes.

An aesthetic is a mode of intellectual energy that only
exists when in operation, *i.e.,* when standards are applied
to actual cases and are reasoned. Criticism by Africans is
largely verbal, deepened by subjectivity of mind and
expressive of a double admonition: improve your charac-
ter to improve your art. Art and goodness are combined.
The road to social purification and destiny is predicated
upon a process through which the person takes on the
essential attributes of aesthetically defined perfection in
order to live in visible proximity to the divine.[1] The pro-
cess can start in childhood, as when a black mother tells
her child, "the way you walk signals your station in life."

Criticism of visual traditions has been identified in
Africa,[2] but the canons of motion remain to be estab-
lished. The next step is to discover and define artistic
criticism of the dance in Africa in order to complete a
dimension of critical awareness.

Dance Criticism in Africa

In 1912 Robert Schmitz noted artistic evaluation of
dancing among the Baholoholo of Central Africa: "the
spectators commented, one to the other, on the aesthetic
qualities of the dancers, and upon the choreographic ex-
pertise of each person.[3] In 1938 Jomo Kenyatta showed
Kikuyu children in Kenya were subject to close critical

scrutiny by their parents when they danced.[4] Jean Rouch
published in 1950 fragments of dance criticism from Tim-
buktu. He found that, "the slightest errors are criticized
by interminable pleasantry" and that, "where pure fig-
ures, free and abstract, linked in a dazzling series of
variations, are finally finished by the dancer, stopping in
a pirouette phrased close to the surface of the earth, there
mounts from the enchanted gathering that indescribable
murmur by which blacks traditionally applaud."[5]

Margaret Read reported, from what is now Malawi,
Ngoni thoughts about the dance in 1960. Ngoni define
the dance as a force revealing manhood, character, and
birth-right. Ngoni elders praise dancing on the score of
strength and perfect timing. Interest seems to focus on
the beating of the earth by bare male feet. A Ngoni dance
of men is not a dance unless forcefully asserted.[6]

By 1967 evidence had accumulated sufficient to show
dance criticism south of the Sahara existed in its own
right. New sources included research among the Akan of
Ghana, Tiv of Nigeria, and Dan of northeastern Liberia.
As to the Akan, Kwabena Nketia discovered distinct
qualities lauded in dancing, especially creative self-
absorption. The ideal dancer, Akan say, never seeks
applause while dancing, but spontaneously incites enthu-
siasm through total commitment to his footwork and
kinetic flair. It is never to be said, in Akan culture, that a
dancer performed "throwing glances at people" (*n'asa
nhwehwewanimu),* i.e., disgracefully begging support or
praise. Nor will Akan connoisseurs tolerate the one-style
dancer. "He has only one style," a critic might pointedly
remark, "and yet he [has the effrontery to go] round and

round" (n'asa fua, nso na ode reko anwan).[7]

Charles Keil, in a report entitled, *Tiv Dance: A First Assessment* (1966), focused on Tiv adverbs of motion analysis:

> *Girnya*, the traditional warrior's dance, should be danced quickly *(ferefere)*, light on the feet *(gende-gende)* with strength *(tsoghtsogh)*, and vigorously, as a hen scratches *(sagher-sagher)*.

> Some men's and all women's dances should be done smoothly, cool, 'like sleeping on a new mattress' *(lugh-lugh)*, deep, steady, respectfully, as if pressing down the earth, *(kindigh-kindigh)*, slowly, steadily, controlled *(kule-kule)*, and carefully, soothingly, and persuasively *(legh-legh)*.

> Whatever the dance being done, it should be executed perfectly, completely, clearly, without mistake *(tsembele-tsembele)* in an orderly manner *(shanja-shanja)* and in detail *(vighe-vighe)*.[8]

There is much meaningful substance here, sexually distinguishable ideals of strength (men) and coolness (women) and clarity (all dancing), but we will defer discussion and pass on to one further demonstration of the vitality of dance criticism in traditional Africa.

George Tabmen, a Dan from the northeast of Liberia, asserts that Dan people live in a state of constant critical awareness of bodily motion. He gives, as partial evidence, the readiness of Dan to criticize even a good-looking youth if the way he walks is incommensurate with the beauty of his body: "He is fine," a critic might say, "but he bends his head when walking" *(E sa ka a gagban tay gu)*.[9] Artistic criticism is deemed so important in this African civilization that the process of judging music and dance can become a performance in its own right, entertaining and informing the inhabitants of an entire village. Thus the village of Blimiple, near the river dividing Liberia from the Ivory Coast, is said to be famed for its critical code:

> If a band of performers comes to the town of Blimiple, and attempts to perform in the town square, but has no talent whatsoever, the town chief, or the quarter chief, will tell them to go to the house of *Woya* (Bad Singer) and the town will have been informed to ignore these men because of their lack of musical quality.

> If there is a play and they discover that the performers are repeating and repeating, singing and dancing the same phrase over and over again, then a citizen of the town will stop the music, and say, 'let's go before one of our elders' houses,' his name is *Pindòu* (Repetitious).

> Singers whose voices are not smooth will be invited to visit the house of *Zoogbaye* (Harsh Singing).

If the singers begin to sense that their efforts are not appreciated and become belligerent, they are led to *Nyazii* . . . (Frankness) . . . [who will frankly tell them they are] terrible and to pack their things and move on . . .[10]

The young Dan dancer runs a fascinating gauntlet between the peremptory challenges of a master drummer and his peers. He enters the dancing ring in the village square first to salute the master drummer, "to get his motion," *i.e.*, to settle the basic rhythm. He then begins a toe-dragging sequence, kept simple, because the drummer is studying his motion. Slowly he develops his dance; he must keep the drummer active with counter-challenges of percussive footwork. If he is excellent he will win applause, which among Dan takes the form not of handclapping, but symbolic outstretching of both arms, palms open and parallel, "as if to embrace the dancer, you want to embrace him as a sign of deep respect." This gesture may be underscored by the cry, "Yaaa titi!! reserved for something exciting, for the pleasure of the people."[11]

This is the crucial moment of the dancer's entrance; if he rests on his accomplishments, and lets the mark of his pleasure show upon his lips, without returning immediately to the task of discovering fresh patterning, he may suffer a fate identical to that of the Akan one-style dancer. He must search for fresh vision with determination: "When the applause mounts, the smile dies down, and you pay more attention to the footwork."[12]

Consulting the Experts, Traditional and Modern: Remarks on Method

The smile of the writer dies down, too, when he considers the problems of translation of motion, as an aesthetic criterion in the history of African art. It is a sobering experience. There are fortunately a number of sources at my disposal: (1) the traditional expert in Africa, defined as any person who holds a strong and reasoned opinion about dance and who, himself, is a member of a traditional society (2) modern experts on music, dance, and art in Africa (3) the White Collection. Let me discuss and reason these sources.

The aim of this book is an existential definition of African art in motion. Accordingly, the work begins with the opinions of those who live these traditions. They are the existential experts. I identify them as such, citing in the process some of their own terms for expertise, *e.g.*, *amewa* (Yoruba: "knower of beauty"), *edisop* (Efik: "acute in hearing and seeing"), *nganga* (Ki-Kongo: "traditional priest, doctor, savant, expert").[13] Meeting people and hearing their opinions demands discretion. In the spring of 1967 I asked some of the elders of Butuo, a Liberian Dan village, which of several dancers performing were the finest. The answer was immediate: "we know which children are best but they are *our* children.[14] The

situation resembles the Yoruba evaluation of the finest singers of the ballads of the hunters (*ijala*): "usually members of the audience do not speak out, on the spot, their opinions about the relative merits of the performing *ijala* artists. But later on, in private conversation on the subject of who is who in *ijala* chanting in the area, each person speaks out his mind and thus the reputation of the best *ijala* artists are established."[15]

African traditions of artistic criticism, in some important instances at least, tend to favor discretion. I therefore discussed such matters in private, as with my best Dan informant, or in public in the most diplomatic manner, *i.e.*, through positive criticism within the traditions ("why is this dance beautiful?") and positive or negative criticism outside tradition ("describe what I am doing wrong"—where the writer attempted traditional steps and motions—and "what do you think of this dance?" *i.e.*, inviting criticism of foreign modes). The intent was to avoid at all costs seeking criticism of lineage members within the lineages.

The comments of the local observers were never so technical as to destroy the flavor of the motion as a work of art. They spoke in their own voices with a sensible, non-pretentious vocabulary (see Appendix). Characteristically, phrasing was lexically simple but conceptually rich, shared by cultivators and kings alike. This was popular expertise.

Traditional opinion potentially exists everywhere, brought to brilliant focus by men and women of special perceptiveness. I was fortunate to meet several informants who operated on the highest levels of intellectual discourse, notably George Tabmen of Liberia and Sukari Kahanga of Zaire.

Throughout this book when I speak of "Africa" it is shorthand for those West and Central African civilizations I have visited, together with Bantu societies for which the literature yields pertinent material on art and dance. Islamic North Africa, Ethiopia and the Horn, and most of East and South Africa are lamentably omitted from the scope of this study.

I have visited the following cultures: Liberian Dan, Popo, Fon and Yoruba of Dahomey, Yoruba and Abakpa of Nigeria, Banyang and Ejagham of Cameroon, Kongo of Zaire. In addition, in two Cameroon towns (Douala, Kumba) I interviewed migrant workers from rural areas, and did the same in Kinshasa, Zaire. The number of informants in each particular culture varied, *e.g.*, Bariba (1), Kossi (1), Yoruba (31), Banyang (16). The following is a list showing nation, date of work, and number of informants interviewed: Liberia, March-June 1967, 5; Dahomey, August 1972, June 1973, 24; Nigeria, summers 1964, 1965, 1966, 14; Cameroon, March-June 1973, 43; Zaire, March, June 1973, 10. For details, see Appendix. The total sample was, therefore, ninety-six. Most informants were cultivators and often religiously bi-lingual,

that is, they were official Christians who, nevertheless, continued to honor some of the ancient forms of ritual. Lest the impression be given that the sampling was entirely rural, I ought to recall that all Zairois interviewed, though often from savannah villages where traditional flavor still exists, were, nevertheless, now residents of the city of Kinshasa. By contrast, Dahomean, Nigerian, Liberian and Cameroon informants were predominantly rural.

In the villages of the interior informants were identified and gathered by traditional chiefs or headmen after careful prior consultation; these rulers did their best to bring together a representative sampling, but most of the respondents, perforce, were cultivators, leavened with a sprinkling of traditional priests and leaders.

The pace of the research stepped up in June 1973, when I met seventy traditional experts on dance. This last voyage was also distinguished by an experimental usage of the medium of videotape. A portable videotape unit is an instrument with several advantages for aesthetic fieldwork. Unlike photography and film, picture-*taking* media, literally removing the images from the world of the informant (excepting the polaroid process), and transporting them to foreign or locally distant processing stations, videotape is picture-*giving*![16] The image is now. It is immediate. Africans observe the image of their kinsmen performing, on the two-inch monitor screen of the portable (Akai) recorder, while they are performing. They shared in the pleasures of the instant-replay, an expression of the video revolution whose usefulness to the focusing of discussion on the fine points of dance can be well imagined.

I played sequences of traditional African dances, taped during prior voyages, and solicited responses, in the vernacular wherever possible, on form and quality in the motions. I had these comments written down on the spot. I played Zaire dances to Cameroon audiences, Yoruba dances to Dahomeans, and so on, in order to avoid the problems emergent in asking a person to criticize his own tradition.

I also played culturally intra-mural materials (*i.e.*, Ejagham dancing to Ejagham, Yoruba to Yoruba), but never from the same village and always in positive terms, inviting reasons for the beauty of a given dance. By paying careful attention to local protocol I was rewarded by full and interesting discussions in nearly every case, though doubtless the novelty of the medium and the beauty of the dances flashing on the screen also informed immediacy and gusto of response.

Only two persons refused to criticize dances outside their culture, on the score of their formal strangeness: "they dance like devils," one said. All the rest (94 informants) discussed style with saliency, voicing comments about timing, finish, dress, thematic balance, and so forth without hesitation. Foreign dress or exotic iconography

3

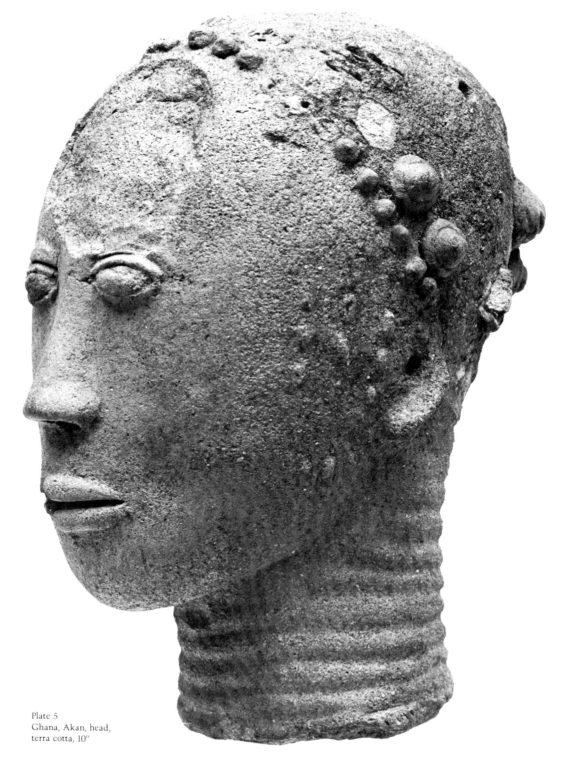

Plate 5
Ghana, Akan, head,
terra cotta, 10″

4

did not distract informants from the basic issues of bodily motion and qualitative phrasing. In fact, I have the distinct impression that the informants were proud of the parallels they spotted between the distant videotaped dances and the dances of their own villages. Without question, among the many winds of change sweeping tropical Africa is a sense of artistic cultural solidarity, and not a few of the respondents talked about the beauty of the dances in terms of their *being African*. Some respondents broke into sympathetic body motions to demonstrate the closeness of their traditional dances to those filmed and visible on the screen. Zaire (Pende) circumcision knitted costumes caused a minor sensation in the Ejagham (Cameroon) village of Otu where a general similarity in weave and striped pattern was immediately remarked and compared to local Ngbe Society traditions.

These experiences suggest that the assumption that Africans cannot, or are unwilling to, evaluate art or dance from outside their immediate cultural universe is untrue.

The words written down were but an abstraction of a larger affective response, including laughter, smiling, brightness of eye, sympathetic bodily response, and gossip of many sorts. The most exciting finding in my opinion was: village after village evaluated dance from areas hundreds of miles away precisely as if the dances stemmed from their own traditions.

Men and women working within Western academic disciplines have also been in touch with the world represented by the field informants. When I reread the researches of Kwabena Nketia, Alan Lomax, *et al.*, upon return from Africa in June 1973, I noted concordance between traditional criteria of fine form and scholarly definition of important musical and dance structure. Field and academic data, therefore, often mesh in an interesting way and reinforce each other.

Agreement between the two worlds forms the basis of this chapter. In every instance, save one, the criteria of fine form in the dance exist as realities, both in the mind of the traditional folk who elaborate them, and of the persons who have studied African aesthetics professionally.

The rationale for the inclusion of a criterion is, therefore, consensus—both intramurally African and extramurally academic. The one exception is the canon of suspending the beat in music and in dance. This trait has been objectively documented by Waterman and Jones in music and dance; its absence in field commentary perhaps reflects the fact that it is so deeply ingrained a habit-of-performance that it is thoroughly taken for granted. It certainly exists. I am attempting to show that the trait of suspending the beat characterizes footwork, bodily phrasing, and, as a promising metaphor, some aspects of rhythmized color patterning in parts of West Africa, notably Akan.

All the other criteria generally represent the writer's synthesis of inside and outside opinion. The intent of marshalling the materials in this way is to suggest a given body of instruments by which to comprehend stylized motion and arrest in the figural sculpture of Black Africa. Attitudes, or positions of the body, as realized in African sculpture, often betray choreographic implications. On close inspection, the relation between the bent knees of the black dance and the identical expression of flexibility in the corpus of black sculpture can immediately be grasped.

I also hope to use these criteria to define, in part, the means by which African icons of repose (sitting, standing, balancing) are reconciled with the fullness of human motion when carried in the dance. Chapters II and III depend on Chapter I, and detail is devoted to this section.

If a private collection of African sculpture is truly representative, points can be made in intellectual argument in terms of the holdings, in spite of the fortuitous manner by which collections ordinarily are assembled. The White Collection, one of the major private gatherings of subsaharan sculpture and textiles in the world, sustains, in most cases, the sort of inquiry we wish to make. In addition, icons of balance and repose which we discuss in Chapter II are so pervasive in African sculpture that, given the breadth of the collection, most are present here. Most felicitously, it was agreed, when I undertook to write this book, that I would be free to omit those objects in the collection which were not germane. It was also agreed that I might add photographs of objects from other collections to illustrate, optimally, a given point and that special accessions would be made. I have thus been able to concentrate on people and ideas in interaction with works of art, instead of, idolatrously, on the statuary alone. The two realms, art and motion, must be brought together. We now come to the canons of fine form.

1. Ephebism: the Stronger Power that Comes from Youth

Beauty blazes out of bodies which are most alive and young. Ephebism, or youthfulness (*cf. ephebe*, "in ancient Greece, a youth between eighteen and twenty years of age"),[17] is universally admired in Africa as an aspect of fine form. A terracotta head (Plate 5) from Akan antiquity, found in the southern region of modern Ghana, represented an important priest or royal person, *i.e.*, a senior person, a person who had attained his rank advanced in years. Yet there is not a single trace of age or stress. The visage is a flawless seal. The lips are discreet. The surface of the skin is smooth and strong. This image is beautiful, in Akan terms, precisely because it makes the subject look both honorable and strong.[18]

Traditional people among the Mende, Baoule, Yoruba,

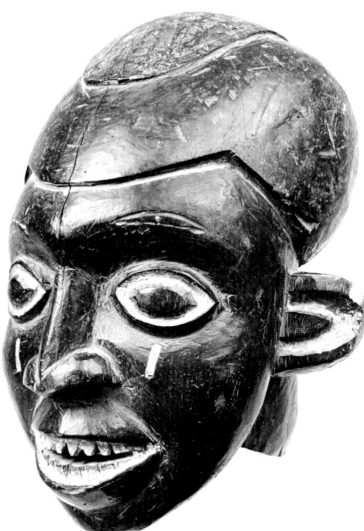

Plate 7
Cameroon, Kom, mask,
wood, 16"

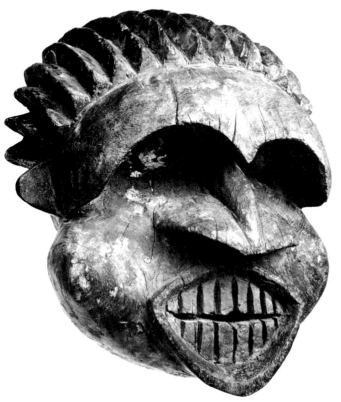

Plate 6
Cameroon, Wum, mask,
wood, 13½"

6

Fang, and Chokwe share the cherishing of newness and youthfulness in artistic expression.[19] Chokwe in Angola, Crowley shows, distinctly prefer new masks over old, because the former have the, "stronger power that comes from youth."[20] Without this, an object cannot shine within its force, and without vital aliveness we are no longer talking about African art.

This point richly applies to the dance. People in Africa, regardless of their actual age, return to strong, youthful patterning whenever they move within the streams of energy which flow from drums or other sources of percussion. They obey the implications of vitality within the music and its speed and drive. Some Western observers fail to see this; they miss the magic act of grace when men and women find their youth in dance (compare Athena's loving restoration of the youthful frame of Odysseus at crucial points within his life). Andre Gide, for example, has written:

the women dance at the entrance of every village. This shameless jigging of elderly matrons is extremely painful to look at. The most aged are the most frenzied . . .[21]

How different is the tone and quality of testimony from the inside. Thus an old member of a Cameroon Ngbe society:

I like him because he uses the conversation with his body. Even an old man can dance conversation, using the whole body; that old man, why he so dance?—to show still get power![22]

The power of youth is suggested by other traits of African art and dance:

(a) "Swing" Every Note and Every Color Strong

Most dancers in Africa (elderly kings are sometimes an exception) step inside rhythms which are young and strong, and to this extent their bodies are generalized by vital rhythmic impulse. This necessitates phrasing every note and step with consummate vitality. This is a uniquely African quality, dubbed "swing" by jazzmen in the United States. "Swing," Gunther Schuller suggests, is a force in music that perfectly maintains an equilibrium between melodic and rhythmic relationships.[23] In the music of the West, in contrast to this history, pitch is considered more important than rhythm. A classical musician is mindful only of vertical accuracy and pays no heed to propulsive flow nor motion; he does not become involved in the horizontal, rhythmic demands of music.

In Africa, pitch is unthinkable without a correspondingly strong impulse in rhythm. Pitch and accent are phrased with equal strength, equal force, creating a youthful buoyancy and drive. Jazzmen call this quality swing, but Schuller rephrases it, "democratization of rhythmic values," and explains what he means:

in jazz so-called weak beats (or weak parts of rhythmic units) are *not* underplayed as in 'classical' music. Instead, they are brought up to the level of strong beats, and very often even emphasized *beyond* the strong beat. The jazz musician does this not only by maintaining an equality of dynamics among 'weak' and 'strong' elements, but also by preserving the full sonority of notes even though they may happen to fall on weak parts of a measure . . . This consciousness of attack and sonority makes the jazz horn player tongue almost all notes, even in the fastest runs, though the effect may be that of slurring. A pure 'legato' is foreign to him because he cannot then control as well the attack impulse.[24]

It is precisely an "attack impulse," in the staccato handling of solid and void, that distinguishes the "Africanness" of a Wum carved head from the north of the Cameroon Grasslands (Plate 6). The hollowed spaces under the brow which suggest the eyes, rich in expressive shadow, become as important, as "strong elements," as the firm cheeks or the bristling fence of teeth. The lines of the hair might have been treated with realistic softness in a Western carving, but nothing here is allowed to project weakly from the surface of the object. Consciousness of fully realized strength of expression, as part of the canon of vitality, caused the carver to make a sharp series of accents to represent coiffure.

Equality of dynamics, in the handling of the masses, characterizes an exquisitely strong piece from the Kom style of the Cameroon Grasslands (Plate 7). The plastic order of the eye, strongly outlined, is matched by the intensity of line which marks the ears; crown and facial surfaces are strongly equalized.

A.M. Jones has observed: "the African normally makes no noticeable physical stress on any note and sings all the notes in a steady outpouring of even tone."[25] The same point applies to the strong use of color in African textiles. There are two ways of preserving the full sonority of colors in textile patterning: either through contrastive colors, hot and cool, of equal strength, or by maintaining equality of dynamics in the phrasing of light and dark colors (the textiles of the Akan of Ghana are excellent examples) (Plate 8). Either way, full sonority and attack in the handling of color means that every line is equally emphasized. For this reason, many or most of the textile traditions of Africa seem "loud" by conventional Western standards, but this is precisely the point. Equal strength of every note parallels equal strength of every color. Yet there are probably differential limits to the amount of intensity in color preferred by different

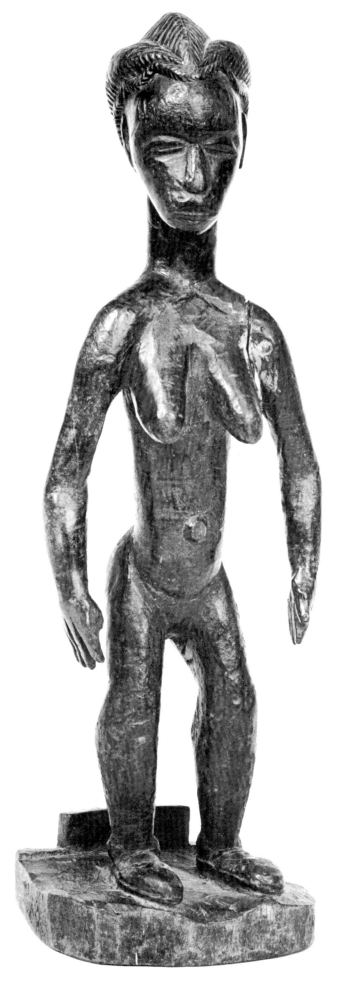

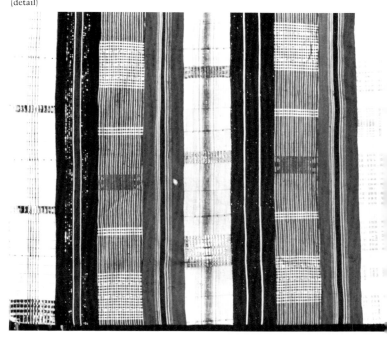

Plate 8
Ghana, Ashanti, Kente cloth
(detail)

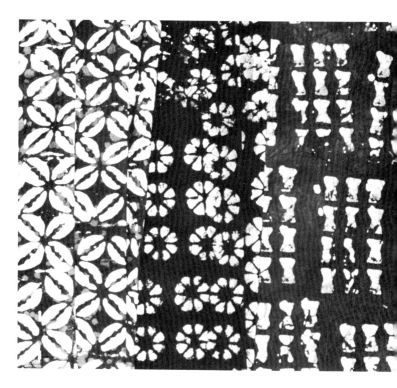

Plate 9
Ivory Coast, textile (detail)

Plate 10
Ivory Coast, Guro, standing
female, wood, 16½"

8

African societies, as suggested by an interlude in Bida, Nigeria on 18 July 1965 when an Eket Ibibio migrant in Nupeland criticized red Nupe cloth on the ground that, "the sun, which is red, makes such cloth brighter than it really is, and the designs on the cloth may disappear. The cloth is too bright."[26] In general, however, the African usage of color in cloth is splendidly vital, as evidenced by textiles from the Ivory Coast (Plate 9).

(b) Vital Aliveness: Playing the Body Parts with Percussive Strength

Intensity in African color is paralleled by percussive attack in African musical and choreographic performance principles. Never is the stronger power that comes from youth more evident than in the canon of vital aliveness. Commentators on the dance in traditional areas are concerned with the quality, which might also be described as full power in response to percussion. Here are some of the voices of the Africans—Yoruba, "[Agbeke] has a great deal of power, more than anyone else"; "dance brings vitality to the body; this dance intensifies the honor and memory of our lord, the God of Iron"; Ejagham, "he turns round, round, round, to show he has power in dancing."[27]

African dance is seen in the eyes of its performers as an instrument of strong expression. The dancer must be strong. He must shake his being with vigor, creating a vision "terrible to watch" in the words of a Bangwa hunter. Vital aliveness, high intensity, speed, drive—these are some of the facets of artful muscularity and depth of feeling that characterize the dances of this continent.

The concept of vital aliveness leads to the interpretation of the parts of the body as independent instruments of percussive force. It is usually not permissible to allow the arms to lapse into an absent-minded swaying while the legs are stamping fiercely. The dancer must impart equal life, equal autonomy, to every dancing portion of his frame. He dances his shoulders strongly; he shakes his hips strongly; he does many strong things besides move his feet. The verbs used by traditional commentators on the dance underscore the transparent value of joyous play that is involved in the remarkable process of infusing, democratically, equal life to different body parts.

Thus one Yoruba talked about *making* the shoulders, with forcefully marked activations; a Banyang mentioned his father *playing* his toes; and an Ejagham remarked on dancing, "with the things where they *make 'em*," i.e., the transformation of upper and lower parts of the body into zones of independently enlivened motion.[28]

The representation of the youthful strength of the body in abstract pulsations is carried forward section by section. The same logic of analysis applies to sculpture criticism. Susan Vogel finds Baoule critics in the interior of the Ivory Coast admire the human body, as represented in traditional sculpture, by examining the parts of the frame, one by one, and commenting on each, separately. She concludes: "the very way the Baoule look at their art reflects one of its cardinal features: segmented quality."[29] The same method of analysis is used by rural, traditional Yoruba. Generalizing for most of Black Africa, Alfons Dauer maintains in fact that there are always points of the body which are most emphasized, rhythmically, in the dance and that these points of percussive emphasis can be identified by clustering of feathers, raffia fringing, bells, and other elements. In sum, I think the segmenting of the strength of the human frame, the playing of the musculature as if it were a series of notes in a melody of youthful stamina and force is one of the cardinal unifying aspects of the presentation of the self in sculpture and the dance in Africa.

The visual side to the dimension was carefully described by Robert Goldwater:

> The African sculptor, whether his forms were rectangular, elliptical, or round in outline, and whether he cut back little or much into the cylinder of fresh wood with which he began, was content to show one aspect of the figure at a time. He achieved his 'instinctive' three-dimensional effect by calculated simplification and separation of parts that allowed the eye to grasp each one as a unified coherent mass.[30]

The image of a standing nubile woman with extended arms (Plate 10), attributed to the Guro, visually corroborates Goldwater's point. But the body parts are not only independently rhythmized and lent strength in African presentation, they are coherently realized within a larger dimension. The dynamic aspects are couched in a flexibly buoyant manner, for youth is also characterized by ability to bend. Thus the Guro woman stands with partially relaxed arms, elegantly bent knees.

(c) Flexibility: "les tresors de souplesse"

Africans refer to a priceless cultural resource, the suppleness of their dancers, by comparing them to beings who have no bones. To say that a person dances as if she or he had no bones is one of the highest compliments a Liberian Dan, Nigerian Tiv, or Zairois Yanzi can bestow (echoed, in a ribald vein, by Lightning Hopkins: "Rock me baby, like your back ain't got no bones"). Dan in Liberia also strongly criticize lack of flexibility in standing; Yoruba do too, and Luba in Zaire simply say, virtually as a matter of choreographic law, that a person must move his hips in as supple a manner as possible. The Luba dancer, a young Luba told me in Kinshasa, must manifest his suppleness with bent knees, bent elbows, and suave oscillations to the music.[31]

The Kongo sense of flexibility in the dance is stark: dance with bended knees, lest you be taken for a

9

corpse.[32] Africans, in short, are very much aware of the import of flexibility as a sign of youth in life, as a demonstration of the bright willingness to respond to change in music and in speech. Such are the African *tresors de souplesse.*

Flexible dancing demands a complicated series of transitions, especially from life to art. Thus Peggy Harper:

> the practice among rural women of carrying loads on the head results in a walk in which the undulations of the ground surface are taken up in the flexibility of the hips and knees whereas the ankles remain relatively rigid and the head remains in a consistently upright position so as not to upset the objects carried. This practice strengthens the muscles of the neck and back, contributes towards the habit of the straight-backed torso with the head and neck carried as an extension of the line of the back, and develops a marked flexibility in the pelvic region.

> These and many other occupation patterns of movement are reflected in the basic body positions which recur in many forms of Nigerian dance. A characteristic body posture in dance consists of a straight-backed torso with the legs used as springs, the knees bending and stretching in fluidly executing the rhythmic action patterns of the dance, and feet placed firmly on the ground.[33]

This fits perfectly the pelvic thrust and spring-like knees under pridefully held straight-backed torso characterizing a minor masterpiece of northern Nigerian sculpture (Plate 3). The point applies, as well, to a figure of a woman attributed to the Kossi (Plate 11), an ethnic group who live in and around the Cameroon town of Kumba, northwest of Douala. This figure, allegedly from a village altar and of undocumented function,[34] extends the straight line of the back through the neck and head, set over buoyant knees and stable feet. The implication of flexible potency at the hips and knees is striking.

2. "Afrikanische Aufheben": Simultaneous Suspending and Preserving of the Beat

Hegel shows that the German verb, *aufheben,* resonates with a double meaning: to cancel and to affirm. "By this suspension and preservation," he writes, "[we gain] an affirmative and indeed richer and more concrete determination."[35] This perfectly describes suspending the beat in art and dance in Africa, *i.e.,* in some African styles art and music forms are enlivened by off-beat phrasing of the accents. Let me begin with a concrete example from the visual arts of Ghana. A state sword from, to judge from the quality of the openwork, the Akwamu area (Plate 12) is constructed in an unusual way, so that the expected continuum of unbroken surface leading from the pommel to the end of the blade is sus-

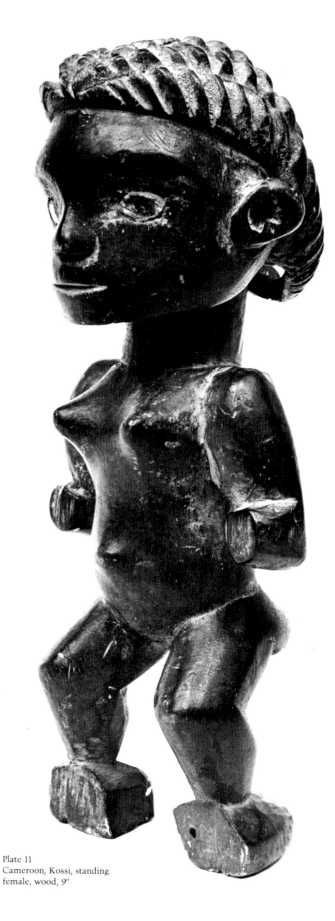

Plate 11
Cameroon, Kossi, standing female, wood, 9"

10

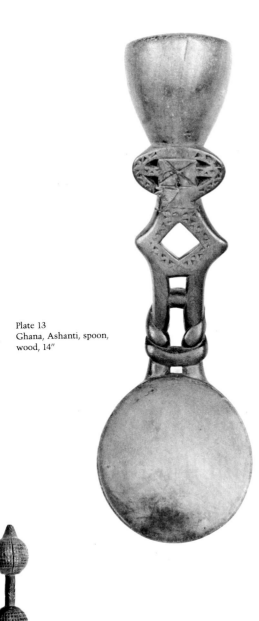

Plate 13
Ghana, Ashanti, spoon,
wood, 14″

Plate 12
Ghana, Ashanti, state sword,
wood and iron, 41″

pended and replaced by three kinds of symbolic chain-work (two representing the royal knot of wisdom and one probably signifying the unifying power of the royal or priestly owner of the sword). Two of these lengths are in openwork, one is not. Suspending the expected continuum of blade surface preserves, at a higher symbolic level, the importance of the owner.

The handle of an Ashanti spoon (Plate 13) is also interrupted by symbolic openwork patterning, suspending utilitarian simplicity of form with complicated and choppy geometric shapes—ellipse, diamond, and rectangle. The base of the handle is also decorated with an apparent representation of the "wisdom knot" (nyansapo), the knot that only the wise leaders know how to unravel.[36] Such special spoons were sometimes placed over a clay pot on the grave of an important person on the fifth day after burial. The impression gained is that of richness of life, surrounding the honorable person in Akan society, here expressed with objects whose ordinary outlines are cancelled with proverbial allusions and other speech-implying units. The mass is modified and perforated with openwork, and thus seems more powerfully sustained and meaningful. It is for this reason that I call the process afrikanische aufheben noting, as I do so, that it takes one of the most brilliant minds of the West, Hegel, to produce a term commensurate with the complexity.

The regularity of striped patterning in Upper Volta weaving is sometimes spectacularly complicated by vibrant suspensions of expected placement of the pattern (Plate 14). Sieber comments, concerning this staggered pattern, that, "careful matching of the ends of the cloth dispels the impression of an uncalculated overall design."[37] Staggered motifs on certain chiefly cloths can be profitably compared with off-beat phrasing in music, dance, and decorative sculpture. In her recent study, *Textilien Aus Westafrika*, Brigitte Menzel illustrates a number of traditional cloths emblazoned with suspensions of symmetrical pattern. The narrow bands which make up these textiles are sewn together so that what is "on beat" at one level of the cloth is immediately "off beat" in terms of another (cf. her illustrations, Vol. II, 523, 529, 535, 688, 765, Hausa and Akan examples). There is an interesting further example of this quality in the White Collection of Akan textiles (Plate 8).

If there is a social meaning to be extracted from this element of West African visual expertise, perhaps the knot of wisdom motif provides a clue. It may be that the chiefly person who wears a cloth with staggered pattern in effect promises to rediscover wholeness in perfecting uneven human relationships, even as he unties the knot of trouble and obstruction. Suspending the beat hints that to dwell at one level is to lose the precious powers of balance inherent in human capability.

Certainly learning to walk with objects balanced on

Plate 14 Upper Volta, textile, 87"

the head, in Africa, depends upon confident absorption of the undulations of the ground, i.e., suspensions of the normal flatness of the earth within the spring-like hips and flexible knees, so that whatever is carried on the head remains safely in repose.

And there is a further dimension to control of off-beat phrasing in African art and life, and that is music. When Western musicians think of cancelled beats or rhythmic elision, they normally think of syncopation, defined as the shift of accent in a passage or composition that occurs when a normally weak beat is stressed. Yet "swing" is prevalent in Africa and musicians characteristically impart equal stress to every note; what is unusual north of the Sahara is a commonplace south. The structuring of the pulse in African music is more complicated than syncopation. Thus Waterman:

> Melodic tones, and particularly accented ones, occur between the sounded or implied beats of the measure with great frequency. The beat is, so to speak, temporarily suspended, i.e., delayed or advanced in melodic execution, sometimes for single notes (syncopation), sometimes for long series of notes. The displacement is by no means a random one, however, for the melodic notes not coinciding with the beat are invariably sounded, with great nicety, precisely on one of the points of either a double or a triple division of the beat.[38]

Waterman thus makes the same observation about off-beat melodic phrasing that Sieber did about patterning, i.e., it is not random, but deliberate. I am not arguing, however, that musical quality is consciously suggested by textile-makers, for there is no evidence to that effect, nor am I suggesting this visual quality is transcendentally African (it seems specially present among the Akan). Nevertheless, it seems to me that it would be irresponsible not to attempt to sharpen awareness of staggered and suspended pattern in some forms of African cloth by reference to off-beat phrasing of melodic accents in music, or in dance, for A.M. Jones shows that foot and hand movements are staggered in the Ewe adzida club dance in Ghana and also in the modern makwaya dancing of Central Africa.[39]

3. The "Get-Down Quality": Descending Direction in Melody, Sculpture, Dance

The nature of tropical African melody has been characterized:

> Broadly speaking, the outline of an African tune is like a succession of the teeth of a rip-saw; a steep rise (not usually exceeding a 5th) followed by a gentle sloping down of the tune; then another sudden rise— then a gentle sloping down and so on. The tendency is for the tune to start high and gradually work down-

wards in this saw-like manner.[40]

Opposition of high and low, gentle and sudden, fits the familiar African taste for high-affect combinations, i.e., hot-against-cool, male-within-female, angles and curves, "loud" colors against "dark." The trend from high to low sets up a basic opposition, inexorably resolved in favor of descent. "Getting down" would seem to be a most important concept, and an ancient one, too, as suggested by the fact that the music of descendants of seventeenth and eighteenth century slaves in Surinam, on the north coast of South America, is characterized precisely by a predominantly descending course in melody.[41]

There are some interesting parallels to this quality in dance. First, waterspirit dancers in southern Yorubaland insist that when the sound of the master drummer ascends in pitch the dancers correspond by dancing "high," i.e., upon their toes, to the maximum vertical extent of their frame.[42] But they bend, gradually, closer to the earth, as they dance until, at one point, they crouch and whirl. In addition, there is a hint of correspondence between rising and falling spears in a certain northeastern Zairois dance of the last century and the rise and fall of the level of the singing,[43] but in the latter instance we cannot be certain in the absence of objective filmed and taped means of documentation.

What is apparently true, however, is that the use of "get-down" sequences in the dance, where a performer or a group of performers assume a deeply inflected, virtually crouching position, thus moving in proximity to the level of the earth, is important in Africa and found in a number of societies of the western and central portions of the continent. Here is field evidence: Anago Yoruba — "step . . . finished at a level superbly low"; Dahomean Yoruba—"if the drum strikes strong, you bend down"; Nigerian Yoruba—"bend down, to complete the dance"; Mbam, Cameroon—"close to the earth, similar to our own ganga dance"; Luba—"dance bending deep."[44] In addition to these sources, Jean Rouch, in contemplating the dance as an art form among the blacks of the region of Timbuktu noted a masterly sequence in which the virtuoso strung a sizzling line of improvisations together and then polished them off with a "pirouette" executed virtually at earth level.

There is more, however, to getting down than sheer proximity to the ground. In a recent study, Ladzekpo and Pantaleoni show that dancing in relation to Takada drumming is characterized by a "flexing torso at one height above the ground *unless the intensity of the movement changes* [my italics] *greater vigor being reserved for more of a crouch.*"[45] This is precisely the situation among the Fon of Ouidah, dancing for the god of smallpox. In the late summer of 1972 I observed this style at a festival in which the finest dancer distinguished herself by the usage of the get-down range. She saved for this level, not only

the high intensity passage of her dance, but also her most inventive shoulder-work, kicks, and whirls (Plate 15).

Compare her posture to an Ibibio sculpture which seems to have been carved with something like the get-down range in mind (Plate 16). The vigor that accompanies the gesture is powerfully conveyed, but the sculptural rendering shows a straight back that indicates a blend of standing and bending low.

In Surinam, the blacks of the interior, notably on the Piki Lio, mark time at a dance with what Richard Price calls a kind of "holding pattern"[46] until they decide that the psychological moment to improvise has come. Then they crouch, bursting into choreographic flames, showing off marvels of footwork and muscular expression. Such displays normally last, in West Africa and Surinam, for two or three seconds. They are subject to what might be termed the aesthetic parsimony of the call-and-response form of dancing, assuring, in the overlapping, that everyone who wants to dance can have his turn at getting down.

Get-down sequences are, therefore, virtuosic. They seem to be frequently correlated in Africa with showing honor and respect, either to a fine drummer, in response to the savor of his phrasing, or to a deity, as in the case of the descent of the Ouidah dancer before the drums. Getting down encloses a dual expression of salutation and devotion. Among the southern Egbado of Yorubaland in Nigeria, when mothers dance with statuettes representing dead twins in their hands, begging the departed spirits for the blessing of continuing fertility, there is a get-down sequence:

Style shifted . . . from group structure to solo, from calm to energy . . . from full posture to low. The mother broke the expected patterns of the dance and bent low, close to the earth, carrying the single image with her in one strong single sweep that brought the image parallel to the ground and then up . . . She had danced an abstract rendering of the lowering of the body of the Yoruba woman on first one elbow and then the other, as special obeisance, when in the presence of a king . . . 'We are begging the twins not to trouble us, we are saying *mo degbe O!*—I prostrate myself—as the royal wives do before the king.'[47]

Thus getting down, structurally, it would seem, correlates with solo dancing, as opposed to choral, with an important part of the dance as opposed to an indifferently selected moment in transition, with vigor and intensity. Iconographically, getting down would seem to correlate with kneeling (Plate 17) or prostration in at least one African society, *i.e.*, as a sign of worship in sacred contexts and salutation in ordinary realms.[48] But in Surinam, Price tells us, getting down is a purely aesthetic phenomenon, the ultimate form of dance virtuosity for a man. When he

whirls down, people concentrate on him. Then he gets back up, then he goes back into it. But the sequence never lasts more than seconds.[49]

By contrast to this Afro-American development, the African form seems, provisionally, more symbolic and honorific. Compare the Tiv phrase, "he bends in dancing" *(a ngurum ishol)* in which the verb can also mean "to bow to a person."[50] Downward descending melody in Africa leads to the same position dancers in Africa assume, to prove openness to talent or authority. Getting down is honoring with virtuosic art and total presence.

4. Multiple Meter: Dancing Many Drums

African music is distinguished from other world traditions by the superimposition of several lines of meter. Thus Ward in 1927: "Broadly speaking, the difference between African and European rhythms is that whereas any piece of European music has at any one moment one rhythm in command, a piece of African music has always two or three, sometimes as many as four."[51] The transfer of this extraordinary complexity to the frame of the human body is implied in the following statement:

An African learns to be conscious mentally of every instrument employed in an African orchestra and this has a tremendous influence on his dance, all the various muscles of the body act differently to the rhythms of the instruments.[52]

Richard Alan Waterman has given us a theoretical account of the interrelationship governing music and the dance in Africa. He talks about response to each metrical thread, within the total percussive whole of the music, without separation from multi-metric context.[53] But he does not tell us how this marvel is achieved. It remained for an anthropologist reconsidering her field experiences in novelistic form, *i.e.*, Laura Bohannan's *Return to Laughter*, to arrive at the existential truth of the matter. The author was directly challenged to dance at a (thinly disguised) Tiv wedding in northern Nigeria in order to demonstrate allegiance to the involved lineages." "'Teach me, then', I retorted. Duly she and the other senior women began my instruction: my hands and my feet were to keep time with the gongs, my hips with the first drum, my back and shoulders with the second." Whenever she lapsed into an absent-minded shuffle, elderly women poked her in the ribs and commanded her to return to what she was supposed to be doing, *i.e., dance.*[54] Charles Keil has later shown that one of the key Tiv musical terms can be variously interpreted to mean "respond," "sing in chorus," or "dance multi-metrically," according to context and to phrasing.[55] This implies, I think, Tiv consciously elaborate multiple meter in the dance as a form of full response to vitality and human

Plate 15
Dahomey, Fon, dancing for
the god of smallpox

Plate 16
Nigeria, Ibibio, female figure,
wood, 19½"

Plate 17
Ivory Coast, Senufo, box
with kneeling figure, wood, 9½"

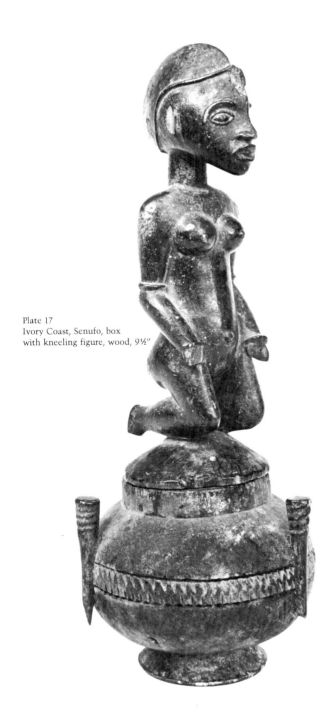

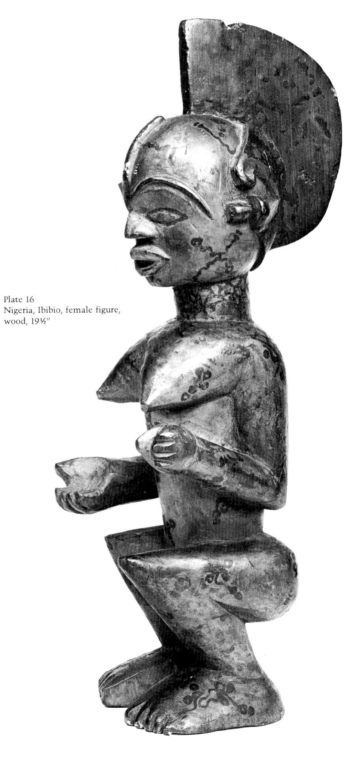

15

presence in the music. Multi-metric dancing seems to refer to shared complexity of response, the giving of the person to more than one musical argument, to more than one musician, to more than one source of musically elaborated form of speech. No wonder the crones poked the anthropologist in the ribs. She was slighting everybody.

Ideally speaking, multiple meter in the dance is a means of articulating the human body more fully than is possible in ordinary discourse; it makes a person blaze as a live entity at the center of understanding. Quite clearly, however, the gift is beyond the reach of the lazy and the distracted. And even among those of talent and imagination there are theoretical limits:

It is common for an individual dancer to combine two rhythms simultaneously in his dance movement; a combination of three distinct rhythms may be used by a highly skilled dancer, and four simultaneous rhythms are rarely observed.[56]

Tiv multi-metric dancing restores music to muscular notation in which "notes" are written in the flesh and can be followed by attention to different body parts. In the following diagram, (Fig. 1), based on the episode in Laura Bohannan's novel, the dancer stands in characteristic posture: whole foot on the ground, knees bent, arms bent, torso forward, buttocks out, face composed. A pattern of four equal diamonds represents a rhythmic motif on gong, answered in the feet and hands; three circles represent another motif, this one simultaneously sounded by first drum and the hips; second drum produces a combined pattern of two and three pulsations, simultaneously embodied in the shoulders and the back; these last pulsations are symbolized by squares.

The contrastive logic of multiple meter in the dance "plays" the parts of the body as virtual instruments of music, so that, as Professor John Szwed has told me in conversation, "shaking that thing" in jazz parlance in the United States can refer, as an element of African influence, either to the tamborine, or to the hips, or to another body part, the point being that all are detached media for the expression of autonomy in vitality.[57]

The phenomenon fills in and actualizes a theoretical statement of potentiality signalized centuries ago by Plato: "when he wanted to show that I was many he would say that I have a right and a left side and a front and a back and an upper and a lower half, for I cannot deny that I partake of multitude."[58]

Africans are very much aware of such potentiality. Their grasp of dancing to various metric lines is sophisticated and clear. Thus Chokwe say, "dance all the drums in your body." They talk about absorbing one tasty "drum bit" after another until all are digested within a strongly moving single frame. People in Africa further suggest that dance is defined as a special intricacy built of superimposed motions. The following are their words: "dance while activating the shoulders, and stamping the feet"; "goes around while shaking the body"; "they dance shaking themselves and breaking at the same moment"; "I like the way he moves because he is always listening to something"; "bending down and hitting."[59]

The inferential leap from complexity in motion to complexity in sculptural rendering must be handled gingerly. Sculpture stops time. This makes impossible the objective determination of multiple meter in the plastic arts even if it were implied. Yet traditional commentary makes us sensitive to simultaneity as an objective criterion in the phrasing of a dance, e.g., combined bending low, circling near, and reaching high in the Sato dance of Dahomey (Plate 18). Accordingly, we note a corresponding complexity in the stopping of various implied acts in some forms of African statuary. To contemplate an image of a Yoruba woman with child (Plate 19) and then paraphrase her impact in the following words—"seated figure, female, Yoruba, 20th century"—destroys the simultaneity of suggested action which makes the image function as poetic act. One young African, looking at a similar object, taught me to recognize an implied combination of five discrete actions in one: sitting nobly, giving generously with both hands, joyously supporting a new-born child upon the back, and supporting fire from heaven upon the head (a pair of thunderstones), while disciplining the face so that pleasure does not reveal itself.[60] If multi-metric dancing is impossible to convey in figural art, nevertheless, in highly sophisticated African civilizations, many acts can be intuited within a single piece of sculpture.

5. Looking Smart: Playing the Patterns with Nature and with Line

The African dancer not only dances many drums. He plays many patterns. In so doing, he is *looking smart*. The phrasing is in African English, based on traditional concern with brilliance of phrasing and vividness of enactment. Thus Yoruba comment: "they put on their costumes, tumbled, and looked smart"; Yoruba again, "whirled like the wind and looked smart."[61] The equivalent construction in the Dan language of northeastern Liberia, is *nyaa ka*, roughly translated as "moving with flair," which means the same thing and which can be provisionally glossed by contextual usage: "This is a quality which must be added to all his actions. With *nyaa ka* I have added something to my dance or walking, to show my beauty to attract the attention of all those around me, even if they should be thinking of something else."[62]

Looking smart, therefore, partially is defined in strikingly attractive use of style, loaded with notions of preening and the making of the person sexually attractive. A.M. Jones simply calls the process "showing off" and adds: "this spirit of emulation should be noted. We

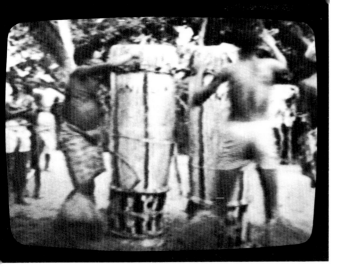

Plate 18 Dahomey, Sato dance

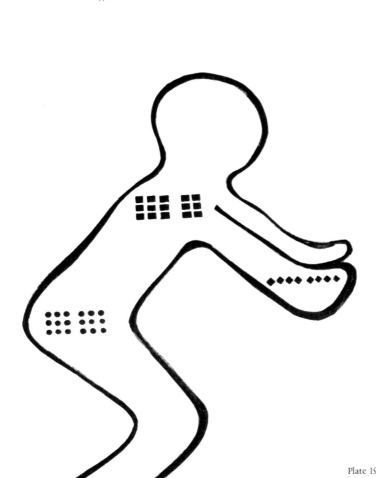

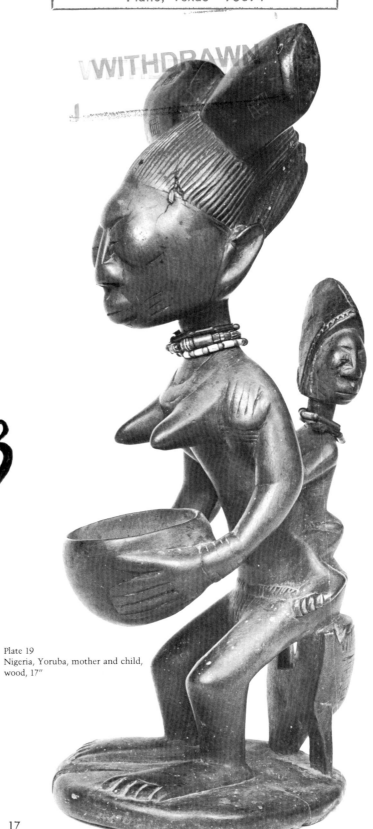

Plate 19
Nigeria, Yoruba, mother and child,
wood, 17″

17

believe it is quite an important element in African dancing as a whole: in fact 'showing off' seems to be one of the vitalizing factors in good dancing."[63]

Continuing with the glossing of the term, another Dan commentator was struck by the beauty of the vibration of the back and chest of two young women dancing and said, "this shows a certain flair; they know how to cut (i.e., properly finish or round off the pattern)."[64] In other words, the vibration looked smart, in part, because it was crisply ended, marked off as a segmentary part of pattern. Looking smart has to do with line in dance. But it also has to do with nature. Thus Bangwa, from the west of the Cameroon Grasslands: good dancing there is compared to the "smart" (strong, graceful, masterly) motion of the leopard in the forest or to the iridescent vibration of the feathers of the Pin-Tailed Whydah, when shaking his plumage during the mating season to display his feathers to full effect.[65] Animal qualities of motion, glitter, and vitality are very much part of the attraction. Ejagham comment adds further dimensions: "their dance looked very attractive because they looked smart and danced very well."[66] To this observer, looking smart meant multiple enactment and variety ("they jump and turn themselves"), multiple usage of color (ita m naring, lit. cap with colors), and embodiment of tradition.

The vibrations of color and muscle in looking smart make human patterning resonate with inner life; it is playing the patterns as if they were autonomous forces of their own, in one instance, part-leopard, in another, bird-like quivering, while at the same time shaped by ordering consideration of limit and of line. The concept involves the idea of nature and line cast in vivid equilibrium. Looking smart carries us within an existential African sense of "art."

The Yoruba word for "art," for example, refers to the shaping of natural elements with craftsmanship: cicatrization of the skin, splitting open and shaping of wood, the cutting and dyeing of animal hide, and even making towns by cutting habitable pattern out of forests.[67] These patterns are all cut from nature by means of line, thus intersecting with the verb, incise (la), which partially qualifies the making. La means to cut, draw line, open up with line.[68] A crucial rendering of natural force with human line defines the artistic process.

Similar modes of thought characterize the Efik of the southeast state of Nigeria. There the word for "art" really refers to decoration and to pattern, viz. painting, textile-making, marking, shaping, impressing, representing.[69] The lined patterning defined by "art" overlaps the Yoruba concept, i.e., splitting wood, marking earth, engraving calabashes, cutting villages out of the forest, in short, "colonizing," making civilization. The aesthetic of the Baoule of the Ivory Coast is summed up in broadly similar terms, as is the aesthetic of the Tiv, the latter society drawing a connection between the verb to sing (gber) and secondary senses, "to cut, to incise," which brings craftsmanship, song, and line into even tighter grouping.[70]

"Art" is, therefore, becoming civilized through the vital patterns drawn on or within objects taken direct from nature, acts so vital in themselves they can be referred back to nature, to the grace of the leopard, to the fluttering of the plumage of a bird. Just as a traditional person in Africa divines or cures by means of objects taken direct from nature, raw herbs, water from the sea, bone and branch, so some informants see pattern in music converted into fleshly terms: "fine on a person . . . like sumptuously patterned cloth."[71] Looking smart is confirmed in making the body glitter with multiple response to multiple meter, with playing the body parts as patterns, with wearing design upon, or deep within the flesh, all elements rhythmized with speed and strength.

Even in the stillness of sculpture this remarkable quality can be partially conveyed, rendering the head or the muscles of the trunk as autonomous units of design. Consider the famous eyima bieri sculptures of the Fang of Gabon and Equatorial Guinea (Plate 20). These images once presided over the bones of the ancestors, stored in receptacles placed beside the image. These guardian images therefore "wore" their stylized muscle as communications of transcendant strength and determination, just as certain parts of the human frame are rhythmized and filled with strength in the sculpture of the Mende of Sierra Leone to portray the power of woman in the Sande Society (Plate 21). Rich feminine curves shape the head and yield below to the strong repeating of the creases in the neck of the represented important woman. The subject "wears" her neck as extraordinary ornament, representing, according to Warren d' Azevedo: "voluptuousness; indulgence; luxury; abundance; fecundity; sexual attraction; wealth; status; and the fattening process within the female secret society." And again, the strength with which the human image in Fang sculpture "wears" his chest, and "wears" his arms, defines his power in deep embodied patterning. The sculptor of style, like the "man of words,"[72] and the dancer of flair, turns his phrases, keeping them brilliant, by making line visible, without destroying natural rhythms.

One final example: in December 1962 in the northern Egbado village of Joga-Orile, in southwestern Nigeria, I saw a group of masked dancers gathered in the market. They postured in honor of departed rulers, making bizarre patterns with their arms and hands, and flashing multi-colored textiles as they turned and jumped and ran. "What do you think?" I asked an English-speaking schoolboy. "They look smart," he replied.

6. Correct Entrance and Exit: "Killing the Song," "Cutting the Dance," "Lining the Face"

Every pattern must have clear boundaries. This is a

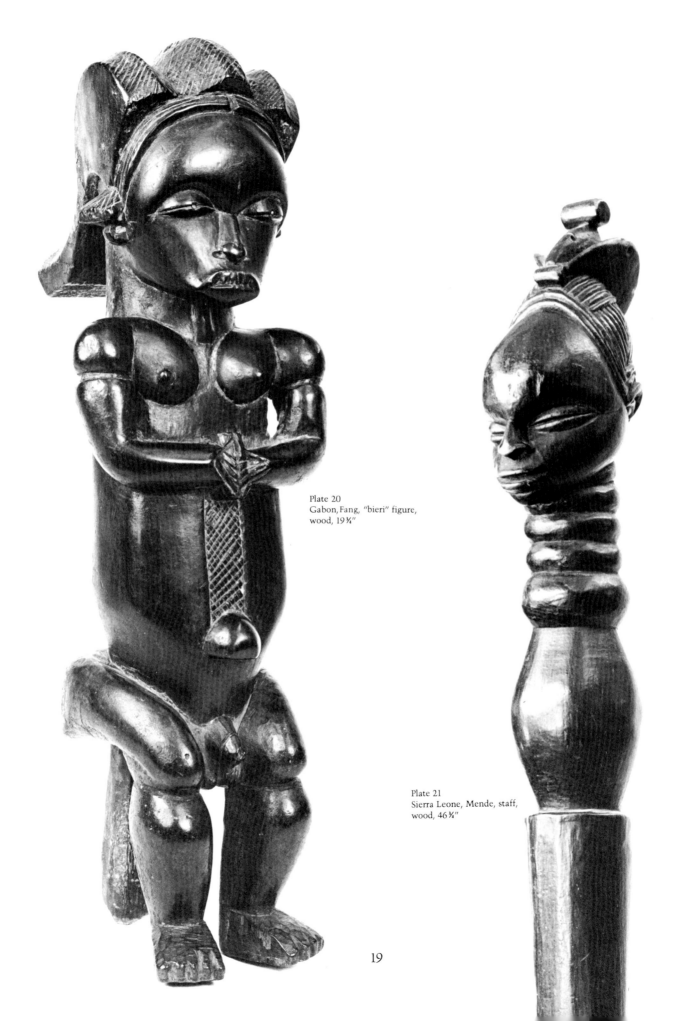

Plate 20
Gabon, Fang, "bieri" figure,
wood, 19¾"

Plate 21
Sierra Leone, Mende, staff,
wood, 46¾"

19

very important rule in Diola-Fogny singing in Senegal. The Diola soloist controls the song and has the right to "kill," or end properly a given phrase. If he does this correctly, i.e., crisply and unambiguously, then the chorus will sing the response in unison and in time. If he does not, he invites confusion.[73]

The importance of "killing" the song parallels the "cutting" of the dance among the Dan of northeastern Liberia. Each dancer must know how to yia, or "cut" his dance. Consider the following Dan testimony: "a good dancer is the dancer who cuts his dance in time to the rhythm of the instrument, i.e., in our tribal dancing, you can be a good dancer with all the requirements I have mentioned in your performance, but if you are dancing and do not yia, end things properly, you are not a good dancer."[74] Cutting the motion is correlated with making sharp pattern. Agreement with this line of thought can be readily found among Dahomean and Yoruba dancers, the latter stating the importance of ending the motion when the phrasing of the master drummer stops.[75]

The Akan of Ghana make this criterion an explicit measure of performance:

When at an appropriate moment the dancer stretches his hands sideways, jumps up and crosses his legs in the landing, the master drummer begins the piece proper . . . for the crossing of the legs is the sign that the dancer is ready to dance vigorously. From this point the dancer must follow the drumming closely for the cue to end the dance in a posture or appropriate gesture carefully timed to the end beats . . . both hands or right hand pointing skywards—I Look to God . . . right forefinger touching the head (other fingers clenched) It is a matter for my head.

The timing of the end gesture is very important, for it is one of the fine points in the collaboration between drummers and dancers to which every spectator looked forward. If a dancer misplaces it, he exposes himself to ridicule and booing. After a dancer has had enough rounds of dancing—each marked by an end gesture—he leaves the ring for another person to step in.[76]

In other words, the end gestures are proverbs. Figurated Akan gold-weights are also enlivened with accurately gestural suggestions of proverbial wisdom. For example, one gold-weight in brass (Plate 22) is said to represent Adu and Amoako, old friends meeting after long absence, recounting their misfortunes.[77] These images are rendered in miniature, with a charming sinuosity of expression far transcending the normal straightforward verticality of African figural sculpture. One figure suggests the act of greeting, the other meditative reaction, hand on chin. Just as end gestures in the Akan dance transform the dancer in fleeting asymmetric

sculpture, so figuration of a proverb in the metal arts enlivens sculptural stance with relative realism of suggested motion. Narrowing the gap between media shows what can happen when two traditions converge on similar function, communication through proverb, within the same cultural universe. The end gesture in the dance and the proverbial stance of the figurated gold-weight also share their stillness, fleeting in the dancing ring, permanent in the metal art. The finishing of these related arts completes iconic communication.

The beginning is also important. Yoruba state that dancers must prepare for the opening beat of the dance before moving—like a boxer, bracing for the punch.[78] The Yoruba dancer is supposed to "come in" correctly, effortlessly, one with the phrasing of the master drummer. The Cameroon Bangwa judge choreography the same way, looking to see if performers make a proper entrance in relation to the beat.[79] Luba demand that a dancer determine the position of his body, as a quasi-sculptural force with bent knees and arms held close to the trunk, before actually dancing.[80] Other societies I have been citing, notably the Tiv, also apply this criterion.

To return to the Dan, ever precise in their phrasing of the criteria of fine dance: the proper dancer initiates his motion from a flexible, knees-bent, arms-bent position. This attitude also characterizes fine standing in Dan culture. The dancer begins to improvise, sometimes crouching, at the end of his phrase. Then he strikes the last gesture of his dance timed to the last syllable of the master drummer's phrase.

It is interesting that correct starting position, from a base of relaxed power, is similar from culture to culture, but that end gestures vary. This might be compared to process in wood carving, where the initial stages of the work, all the masses attacked, seemingly simultaneously, show a rough similarity (indeed provincial styles of wood carving, even when finished, sometimes seem never to transcend the initial stage of blocking-out the masses).[81] But the finished, polished forms vary enormously, from society to society. This observation also applies to dance. Dahomean girls end each phrase of the Aguele Yeye dance with a strong hurling of the arms; Yoruba male dancers for the cult of Gelede at Ketu end each phrase sounded by the master drummer with a kick of the right leg; and Akan strike moralistic poses.

We might compare shaping and finishing in sculpture and the dance in traditional Africa. Beginning, the dancer enters flexed and attentive, body inflected, usually into two or more expressions according to the multi-metric structure of the music, e.g., chest vibrated by one meter, hips by another. This might be compared to the first stage in carving, called among Yoruba Ekiti "hard pattern" (Plate 23), the blocking-out of the initial mass. Then, as he improvises, he further divides his frame. He can get down in a crouch, he can move his head and arms

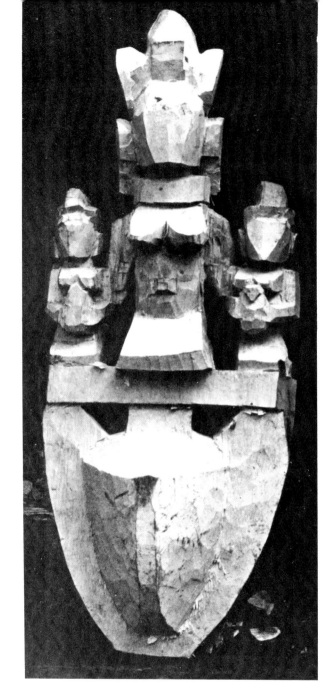

Plate 23
Nigeria, Yoruba

Plate 22
Ghana, Ashanti, goldweight,
brass, 1¼"

21

to staggered patterns, he can, with inimitable hauteur, make his muscles shine with brilliant motions set against his facial calm. This might be compared to second and third stages of carving, where the frozen quality of the face becomes apparent and the main body forms are broken into smaller masses (Plate 24) and smoothed and made more luminous (Plate 25).

It is the last stage where mass contends with line, where the face is "lined"—i.e., when eyelids are cut, lips lined, cicatrized descent markings added, and so forth. The final stage of "lining" (Plate 26) completes the figural shaping of the wood, the civilizing impact of the art of line. Similarly, the end of the dance, sharp, dynamically precise, establishes a clear boundary between one improvisation and the next. The "kill" of the Diola song, the "cut" of the dancer's phrasing in the ring, the "end gesture" among the Akan, and "lining" in the final stages of Ekiti Yoruba carving—each is an instrument by which to realize perfected sequence.

7. Vividness Cast into Equilibrium: Personal and Representational Balance

African design is, quite often, rendered vivid by rhythmized, contrastive, changing elements within the pattern. Compare the wholly predictable alternation of the checkerboard (Plate 27) with the checkerboard-like cloth in Ghana known as *kente* (Plate 28). Balance in the latter case is struck by, first of all, the richness of the oppositions—horizontal sections versus vertical; uncomplicated blue against linear complexity in golds, blacks, greens, and reds; simplicity beside elaboration. One of the master craftsmen of this tradition Nana Ntiamoah Mensah, of Adagomase quarter, Bonwire, northern Ashanti, has concisely summarized the form: "designs combined to show beauty and meaning" (*adwinie ahorow a yaka bonu na ema eye fe efirise ebiara wo ase*).[82]

Ntiamoah further says kente design rests in part on artful phrasing of stripes (*nsensaaye*) whose colors are rendered powerful by the richness of their associated meanings. Kente are thus balanced patterns made doubly brilliant in iconic usage. Our example *(Color Plate I) is superb, a relatively old cloth from perhaps the first quarter of this century. This kente displays, within the gleaming sections dominated by stripes of gold, black, green, and red, a double motif in gold and red called *nkyemfre*.[83] The *nkyemfre* motif is flanked by brilliant stripes and divided from them by pinstripes of white.

Instead of discussing the meaning of these design units and their combination without specific field information, I prefer to repeat Nana Ntiamoah's exegetic commentary apropos of a somewhat similar cloth: "the sections with gold and red thread have kingly meaning. For example, one pattern is called Mixed-Together-From-Left-To-Right (*emotewa*), whose deep meaning is:

*Frontispiece.

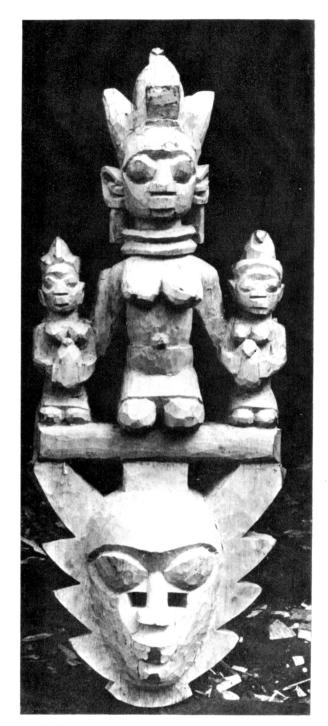

Plate 24
Nigeria, Yoruba

Plate 27
Checkerboard

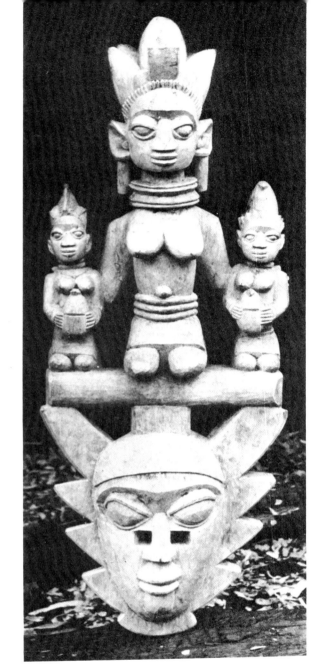

Plate 25
Nigeria, Yoruba

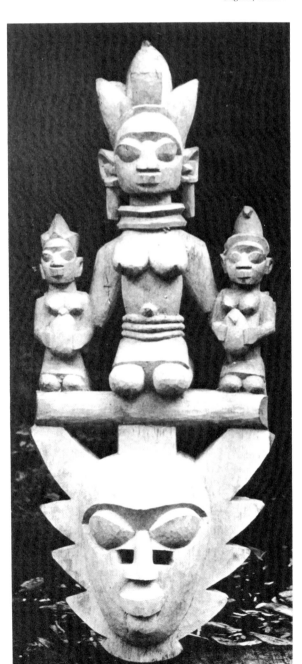

Plate 26
Nigeria, Yoruba

Plate 28, Color Plate I
Ghana, Ashanti, Kente cloth (detail)

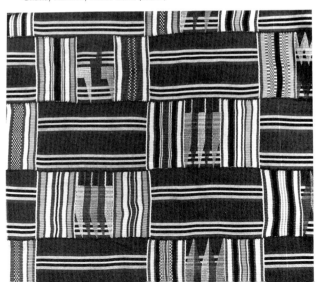

23

wisdom does not stem from a single person. Another pattern [brilliantly stepped, in gold and red, *cf.* Menzel, Vol. II, fig. 942] is called 'cannon' (*apremo*)—the power of the king."[84] The gold-tinged sections of this kente, as in the illustrated example, varied in small or large details, while the blue sections, as again in the color illustration, remained more or less constant. The rectangles dominated by blue, Ntiamoah gives as "playing" (*ahwepan*) or "playful, cheerful people." In sum, the gold sections are filled with references to governmental might; the blue, freshness, humor, and simplicity. Set in suggested alternation, therefore, are: work and play, social heat and social coolness, responsibility and pleasure. It is interesting that Ntiamoah names the entire cloth Everyone-Depends-Upon-Somebody (*obi nkye obi kwan musi*), thus not only rephrasing John Donne, *i.e.*, "no man is an island," but showing the necessity of persons of caprice and humor within the shaping of human viability. We must accept composure and control, but not at the price of humor—the gift of refusal to suffer.

Thus much more than brilliant color is cast into equilibrium by kente design tradition. Nana Ntiamoah has suggested, following the teaching of his ancestors, that the peace which makes possible human interaction is founded on respect for variety and the rights of others. This is one kind of balance memorably struck in African art. Other forms of equipoise are equally rich in nuance and communicative power.

a. Stability or Straightness: Personal Balance

The human image in African art and dance rises, in the main, from feet set flat and firm upon the earth (Plates 29 and 30). The distinctive, continuing Western manner, a preference for asymmetrical posture or stylized instability, remains clear in United States dancing. Bessie Jones and Bess Lomax Hawes have noted the contrast between Sea Island black dancing and mainland white: "all [black] dancing is done flat-footed; this is extremely difficult for [white] Americans, whose first approach to a dancing situation is to go up on their toes."[85]

If Gothic architects sought God through "anagogic"[86] finials, pointed towards heaven, later to be mirrored, in a sense, by the desire of the ballet dancer to soar through the air, West Africans cultivate divinity through richly stabilized traditions of personal balance. Presentation of the self through stability is sometimes phrased as "straightness," as among Ekiti Yoruba where a king viewed an Epa rite in which towering wooden headdresses were moving in the dance and commented, "keep the Epa image *straight*. It's very dangerous to carry those heavy images and they must be kept aright."[87] In a variety of documented verbal instances of artistic criticism in West Africa, the notion of "straightness," in the sense of

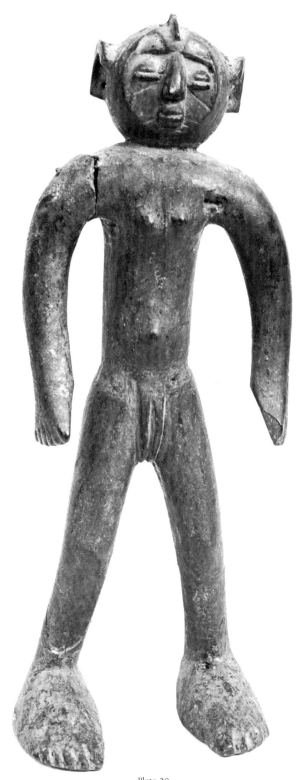

Plate 29
Upper Volta, Mossi, standing
female, wood, 16"

24

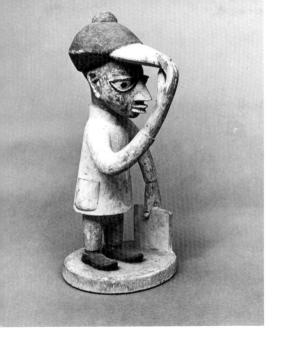

Plate 30
Nigeria, Yoruba, standing male
in western dress, wood, 16"

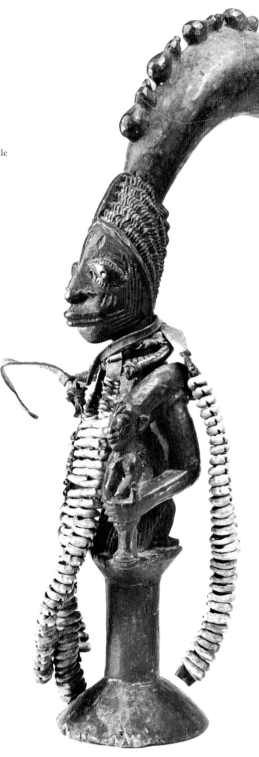

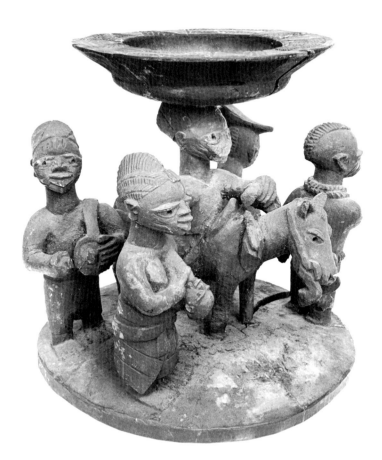

Plate 32
Nigeria, Yoruba, "ifa" bowl,
wood, 10½"

Plate 31
Nigeria, Yoruba, "elegba" staff,
wood, 20

25

the maintaining of the commanding vertical position of the human body, has consistently loomed as an important issue.

However, the convention would doubtless soon wax boring, were it not honored so magnificently in the breach by kicks, spins, and leaps of certain of the men's dances in Africa. In addition, the image of the trickster, defying gravity in every sense, is considered, at least covertly, admirable in some societies. One trickster spirit in Yorubaland is called Eshu Alabada. He dances on one leg (mirrored by his single horn) (Plate 31): when he does so, trouble is supposed to break out.[88] When he returns to dancing on both feet, trouble ceases. In other words, normative stability of stance and balance in art and sculpture, at least in one African society, is correlated with social stability and calm. So pervasive is the richly stabilized tradition of the dance and statuary south of the Sahara that departures can be cultivated and admired. Trickster merely confirms the rule.

b. Mid-Point Mimesis: Representational Balance

The African image stands not only fully upright, but is evocative of balance in another sense—degree of realism. Representational balance is as important as stability *per se*, and can be identified in imagery which is not too real and not too abstract, but somewhere in between. I call this remarkable quality *mid-point mimesis* to convey what Africans have taught me, *i.e.*, that beauty is a mean. Thus Tutuola:

neither too tall and not too short,
not too black and not [too] yellow.[89]

The last citation was Yoruba folk. The Akan of the Ivory Coast similarly believe that the beautiful woman is moderate in height, neither as tall as a giraffe nor as short as a pygmy. The Bete in the same African nation adore eyes that are neither white, the color of death, nor red, the color of cruelty, but shaded and smiling. Bete like noses which are neither too snubby nor too aquiline; and they desire ears neither too large nor too small.[90] Correspondingly, the Kongo find prominent eyes, swollen or staring, distasteful; neither do they like reddened eyes, immediately associated with violence of temper. The perfect eyes are moderate: small, bright, and clear. Kongo skin color is also very carefully judged in terms of moderation: "a very darkly pigmented skin is not considered beautiful, nor is a fair complexion. But a person with a shining brown complexion, like the fish *ngola zanga*, is pleasant to look upon. If the skin is too dark, it is likened to the sooty *mfilu*-trees, where a prairie fire has passed. If a person has too fair a complexion, the mother is considered to have come into contact, for example when bathing, with *nkisi Funza* or *simbi*-spirits."[91] Throughout West Africa, wherever data are available,

moderation seems important.

English-speaking informants in western Nigeria use the word "normal" when remarking such qualities and the word *niiwon* ("expressed in moderation")[92] when speaking in Yoruba and discussing images which are pleasingly phrased at the middle point of representative realism. African connoisseurs savor moderation of resemblance, avoiding puzzling abstractions or glaring realism. The Kalabari Ijaw of the Niger Delta use the criterion of "resemblance" in judging wood sculpture; the canon is mid-way between excessive abstraction ("if an object is so crudely carved as to be virtually unrecognizable, it will certainly be rejected") and undue resemblance ("no cult object should resemble that of any other spirit more than it resembles its own previous versions").[93] Why is this preoccupation with avoiding, on the one hand, photographic or undue likeness, and extreme abstraction, on the other, so important? Bassa tradition, from the interior of Liberia, in effect affords a partial answer to this problem:

Individual likenesses are virtually non-existent in the ritual masks of the Liberian hinterland. Men living in groups tend to identify primarily with clan symbols, rather than with their existence as separate entities. There is the story of a carver who was so fond of his young wife that he took her with him to a secluded place and kept a loving eye on her while he carved a mask. The result was a likeness of the girl so exact that it created a furor when the mask came out for its first public function. 'That's Kwa-za', shouted the people, not knowing whether to rejoice or be frightened. But the elders were not amused; by his lack of self-control, the artist had betrayed the myth of the mask, thus revealing that masks were man-made and subject to the vagaries of human emotion. The mask was 'retired' and the carver punished.[94]

The possibility of photographic likeness does exist in the traditional imagination, but it is not tolerated because it is dangerous, as an absolute, as an extreme. Some Ashanti, for example, are moved to tears by the sight of a photograph of a departed loved member of a lineage: "in fact, such likenesses are often turned face to the wall and only turned around on the occasions when the funeral custom is being revived."[95] Mirrors are subject to cognate cautions. The mirror's glare is often associated with danger and death, and mirrors are carefully covered except when used in some traditional Yoruba and Zulu families in order to avoid the attraction of lightning from the sky during stormy periods in the rainy season. A carved face is much more moderate and its glitter can be carefully controlled.

Preoccupation with moderation applies in the phrasing of the dance, as well. Yoruba say good dancing occurs *olele*, "not too fast and not too slow,"[96] and where

Yoruba refer to moderation of tempo, Luba in Zaire talk about restraint in effort and the cutting-through of space: do not go too far out with gestures of the legs or arms; keep the movement self-contained and moderate.[97] However, regardless of the moderation of speed and dynamics, the speed of most African dancing is remarkable by Western standards because the sliding scale of judgment is weighted in the direction of strength and full-intensity.

Mid-point mimesis or balance in the mode of representing visual reality defines the African aesthetic as a mediating force. The canon also explains, I think, the preference for the generalization of humanity in the dancing ring. Humanity generalized by rhythmic impulse, in sculpture and the dance, is humanity divested momentarily of the heat of personal ambition and individualism, detached from emotion, and shaped within repeated images of ideal vital character. The person of moral perfection is the subject of African art and dance, not the representation of the individual. To find identity through merger with a larger social whole is also important in the formal structure of singing south of the Sahara, the form called call-and-response or leader-and-ensemble.

8. Call-and-Response:
The Politics of Perfection

Evans-Pritchard has observed: "most African songs are antiphonal, that is, they are sung by a soloist and a chorus...If there are several verses then the soloist begins the [solo] while the chorus is still finishing. This overlapping is a common feature of all songs."[98] The characterization extends to most of Black Africa. Thus Waterman: "a peculiarity of the African call-and-response pattern, found but infrequently elsewhere, is that the chorus' phrases regularly commence while the soloist is still singing; the leader, on his part, begins his phrase before the chorus has finished."[99] Alan P. Merriam has noted a clear instance, among Bulu in southern Cameroon, where the song leader initiates his phrase considerably before the chorus completes their own melodic line. Overlapping call-and-response south of the Sahara is linked to a percussive concept of performance:

the entrance of the solo or the chorus part on the proper beat of the measure is the important thing, not the effects attained through antiphony or polyphony. Examples of call-and-response music in which the solo, for one reason or another, drops out for a time, indicate clearly that the chorus part, rhythmical and repetitive, is the mainstay of the song and the one really inexorable component of their rhythmic structure. The leader, receiving solid rhythmic support from the metrically accurate rolling repetition of phrases by the chorus, is free to embroider as he will.[100]

Thus the chorus forms a kind of melodic handclap, testing and supporting the soloist and his ingenuity.

South of the Sahara, solo-and-circle, or solo-and-line, or solo-and-solo forms of dancing mirror melodic call-and-response.[101] Dance and music are very closely interwoven in African cultures, and persons singing the chorus frequently double as the circling group who surround or are led by the master singer.[102] Unsurprisingly, the leader of the dancers is, often, the leader of the song. Often the overlapping danced responses to the calls are enthusiastic and very strong. Rising eloquence can cause the size of the chorus dramatically to swell. But it is not just aesthetic impact that is at issue here, but also the moral condition of the singer or the dancer. Thus a Yoruba refrain:

You are rejected in the town
Yet you continue to sing for them.
If you learn a new song
Who will sing the chorus?[103]

The rights and feelings of others loom very large in African creativity. It does not matter, according to the canon of African call-and-response, how many new steps or verses the person elaborates in his head; if he is of ugly disposition or hatefully lacking in generosity or some other ideal quality, then he may never be given a chance to elaborate his ideas in public. His creativity may be void if the chorus finds him beneath contempt in a social sense. The chorus, as in ancient Attic tragedy, is therefore, a direct expression of public sanction and opinion. Call-and-response goes to the very heart of the notion of good government, of popular response to the actions of the ideal leader.

At this level of discourse it is not difficult to understand in what sense the visual motif of master-and-entourage, highly and memorably developed among certain West African civilizations (e.g., Akan, Fon, Yoruba, and Cameroon Grasslands)[104] seems an analogue in the history of art to the musical and choreographic solo-chorus theme. Master-and-entourage themes in visual art in Africa are usually characterized by a dominant central figure flanked by symbolically small-scale human attendants.

Consider in this vein a Yoruba divination cup (Plate 32) which shows a mounted master accompanied by a portion of his entourage. The spacing of the latter in a semi-circle before his horse is not unlike the circling of handclappers and singers about the master dancer in the ring. This solution brings sculpture close to the structure of call-and-response, closer than the related frontal dispositions of similar themes of leader-follower interaction in the courtly styles of ancient Benin.

I have on several occasions in West Africa observed traditional mounted rulers accompanied by followers who chanted the praises of their master, while the latter,

for his part, led them forward in regal silence. This was a most refined instance of the genre—the ruler who sets the song in motion by sheer force of personality, a tacit "call" that brings out a full and explicit mode of choral response. This poetic refinement of the structure of call-and-response, subtle and unsuspected, is exactly mirrored by the imperatives of gravity, dignity, and composure which mark the face of the mounted ruler who organizes the richly differentiated following (a mother with child, a pressure-drummer, and a soldier and his captive). His silence is confirmed by the visual "noise" of their energetic roles.

There are proverbs galore to warn the ruler, mounted or otherwise, that he can be replaced, should he prove despotic. Herein another telling point of connexion between life and art, between call-and-response and the phenomenon of master-and-entourage in the urban states of traditional West Africa. The arrogant dancer, no matter how gifted or imaginative, may find that he dances to drums and handclaps of decreasing strength and fervor. He may find, and this is damaging to his reputation, that the chorus will crystallize around another person, as in the telling of tales among the Tiv of northern Nigeria. There, we are told by Laura Bohannan, the poor devil who starts a tale without proper preparation or refinement will find the choral answering to his songs becomes progressively weaker until they ultimately reform about a man with stronger themes and better aesthetic organization. He is soon singing to himself. The terror of losing one's grip on the chorus is a real one in some African societies, a poignant dimension of social interaction that for some reason is not mentioned in discourse on singing in African music. Consider the following Azande evidence:

> Sometimes also a man will have a magic whistle and then blows it before going to sing his songs at a dance. When addressing the whistle he says: 'You are a whistle of song. I am going to sing my songs. Men back up my songs very much. Don't let people remain silent during my songs.' [105]

Thus call-and-response and solo-and-circle, far from solely constituting matters of structure, are in actuality levels of perfected social interaction. The canon is a danced judgment of qualities of social integration and cohesion. Call-and-response, essentially hierarchic in aesthetic structure, nevertheless perennially realizes, within the sphere of music and of dance, one of the revolutionary ideals of the last century:

> ...revolutions...criticize themselves constantly, interrupt themselves continually in their own course, come back to the apparently accomplished in order to begin it afresh, deride with unmerciful thoroughness the inadequacies, weaknesses, and paltrinesses of

their first attempts, seem to throw down their adversary only in order that he may draw new strength from the earth and rise again, more gigantic, before them, recoil ever and anon from the indefinite prodigiousness of their own aims, until a situation has been created which makes all turning back impossible. [106]

9. Ancestorism: Ability to Incarnate Destiny

Destiny is achieved where man knows what is good and builds on what is right, what ought to be. [107] The sequence depends upon a supposition: the person of character and the ancestors are one. Ancestorism is the belief that the closest harmony with the ancient way is the highest of experiences, the force that enables a man to rise to his destiny, for, as John S. Mbiti points out, the person in Africa can only say, "I am, because we are; and since we are, therefore I am." [108]

"Our ancestors gave us these dances," a Kongo taxi-driver told me in Kinshasa, "we cannot forget them." [109] In Dahomey a man from Ajashe admired a dance and said, "it is our blood that is dancing." [110] There is further evidence on this point, centered on the notion that the ancestors, in ways varying with every culture, continue their existence within the dancer's body. They created the steps; the dancer moves, in part, to bring alive their name.

Thus African art and dance partially are defined as social acts of filiation, extending human consciousness into the past and the time of the founding fathers. It is essentially a timeless tradition, shaping ultimate values. Evidence of this is found in the widespread belief in reincarnation in West and Central Africa, a belief which dissolves the primacy of time. For a single dramatic example, among the Ga of Ghana when a person is possessed by an ancient spirit she "looks quite young while dancing"; the marks of old age resume when she steps back into real time. [111] Vansina calls this timelessness, this unity with the ancestors and the sources of vitality, Great Time. [112]

Ancestral presence in the dance diminishes the destroying force of time:

> the historic event is thus the descent of Great Time into the passage of time, that is to say, a degradation. But to deny time, or at least to limit its effect, does not mean a rejection of history as such. [113]

On the contrary, traditional people in Africa select those noble persons in actual life who deserve extended life in history and praise-singing. We realize that Africans, moving in their ancient dances, in full command of historical destiny, *are* those noble personages, briefly returned. The more traditional and ancient forms of

dance "transforms one into a noble person among the people of this world."

I can document ancestorism as an empirical fact, as well as mystic assumption, in the sense that many or some of the gross structural traits of African performance have been in existence for at least four hundred years. Let us review the materials.

a. Towards a History of African Dance

I begin with the Middle Ages. Written descriptions of dancing in Africa begin during this period. Before this time there were paleolithic rock paintings, at Tassili and other sites, and there were also certain bas-reliefs in the history of ancient Egyptian art showing black dancers performing. But the latter sources are static and can, of course, have only limited evidential value. A rupestral painting or a bas-relief can communicate posture—assuming that we know for certain that we are looking at a dance which is, in many cases, not at all clear—and details of dress.[114] But they cannot give us motion. And so I have concentrated, as an interim strategy, on writings from the Middle Ages to the beginning of the present century.

One of the first observations of dance in Africa was made by the Arab explorer, Ibn Batuta, at Mali in 1352/3:

> The sultan is preceded by his musicians, who carry gold and silver [two-stringed guitars] and behind him come three hundred armed slaves. He walks in a leisurely fashion, affecting a very slow movement, and even stops, from time to time.[115]

This is an exciting, if sparse, document. It shows creative arrangement in the blending of music and armed display. The ruler sustains a walk punctuated with full stops. There is an interesting modern parallel to this mode, the suspension of the normal beat of walking in the royal processions of Dahomey. Like the ancient kings of Mali, royal persons in Dahomey suspend the flow of their walk with pauses. Rene Bravmann has discussed other aspects of dancing in ancient Mali and masking traditions and their interrelationship with Islam with considerable expertise.[116]

Quattrocento writers, from the period of earliest Portuguese explorations, essentially communicated no more than recognition of artistic difference from modes of motion prevalent in the West. Thus Ca' da Mosto, Venetian explorer in the employ of Portugal in 1455-7, reported from Senegal that the dances of the [black] women were "very different from ours." Vasco da Gama, for his part, noted in his log on 2 December 1497 a meeting with blacks at Mossel Bay in what is now South Africa. The blacks "danced in the styles of Negroes."[117]

After fifty-odd years we are suddenly rewarded with possibly the first written document of a portion of West African call-and-response. In 1556-7 William Towerson was voyaging on the west coast of Africa. He put ashore in a skiff, east of the Cestos River,[118] on the eastern portion of the coast of modern Liberia, "to see the fashions of the country." He was rewarded for his curiosity. Dancing black women greeted him with song and he seems to have caught their refrain:

> sakere, sakere, ho, ho
> sakere, sakere, ho, ho.[119]

We shall never know the calls, nor the motion of the dancers. But those who have worked in Africa know with what inexorable penetration the refrains to call-and-response singing can sometimes lodge themselves in our consciousness, like the sound of the sea, to be heard in the mind hours after the performers have disbanded, allowing, in this instance, Towerson time to write the words down in his log aboard ship. Assuming a rough degree of accuracy, it is just possible that this apparent scrap of sixteenth century call-and-response also shows that delivery in singing (and, by immediate extension, dancing) was as characterized, in those days, by speed and drive as it is today. The intervocalic r in sakere, sakere might possibly have encoded a rapid, eighth or sixteenth-note delivery, as it does today in Ghana and Nigeria.[120] Nketia has shown that an impression of rapidity is conveyed by the presence of r in a series of drum syllables: "the syllable before the rolled consonant is comparatively shorter than the syllable which begins it." Thus:

> kera, kera kera[121]

For a variant of this procedure, compare the drum syllables which command mothers of twins in western Nigeria to perambulate and dance in honor of departed twins:

> kere, kere, yan
> kere, kere, yan[122]

Towerson had heard, probably, a scrap of overlapping African antiphony. He could have heard this form of singing at any point along the known part of the west coast of Africa in his time. I say this with a fair degree of certainty because Iberians had already collected slaves from many parts of the coast by the sixteenth century. In fact the theme of the black man, given the presence of blacks from Africa in several of the major cities of Spain and Portugal, was an important one in the literature of seventeenth century Spain. In the process, the importance of the call-and-response form among blacks had been noted by the Spaniards to judge from at least one of the plays of this century.

The Spanish poets of the seventeenth century—Gongora satirizes Lope de Vega with black dialect ("vimo, Seno Lopa, su epopeya")—had sharp ears for nuance and speech rhythms overheard in the black barrios of the

cities and they reproduced the idiom accurately.[123] The black man was a favored dramatic theme at a time when French dramatists (e.g., Racine) were involved with Mediterranean antiquity. Spaniards recognized and were fascinated by black vitality. The image of the black man on their stage was far from gloomy. In fact the rendering of his cultural universe was spirited. Simon Aguado's *Entremeses de los Negros*, dated 1602, includes a rendering of solo-and-ensemble so palpably black, in phrasing and overlapping, that it might conceivably pass for a *montuno* (call-and-response portion of a tune) in the mambo singing of Spanish Harlem today:

> At the wedding of Gasipar,
> And Dominga, of Timbuktu,
> We'll play all kinds of dancing,
> Play, black man!
> Play, you!
> We'll give it to her, all
> You!
> And stout men will sing
> You!
> Cake and biscuits
> You!
> Radish and cucumber
> You!
> Parsley and cabbage
> You![124]

Indeed, the knowing Puerto Ricans of the Spanish-speaking barrios of America's largest city would hardly need footnotes to understand allusions to radish and cake, cucumber and biscuits in a nuptial context![125]

During the seventeenth century fragmentary reports are suddenly replaced by long and detailed observations, some of which fairly seethe with perceived vitalities of motion. Such was the writing of Pieter de Marees, who probably came from the south of the Netherlands. Nothing is known of his life, however, except that at the end of 1600 he sailed with three Dutch ships on a trading voyage to the Gold Coast. What he saw there, in terms of choreographic splendor, extended by corresponding richness of bodily adornment and dress, greatly impressed him and impresses the reader today, as well. He wrote with a wealth of detail, about Akan or Akan—related aesthetics some one hundred years before the formation of the Ashanti Confederation:

> They dress quite elegantly, especially the women when they wish to go dancing, which they execute with great presumption; they embellish their arms with many bracelets of copper, tin, and ivory. To their legs the women attach rings with bells so that when dancing they will resound; their head is curled and braided on the crown.
>
> They wash their bodies with cold water and then rub

it with palm oil so that it greatly gleams. They also make their teeth quite white and polished, gleaming like ivory, as the result of cleaning them continually with a strong stick of a very hard wood.

> Afterward they put around their body a bolt of white cloth hanging from beneath their breasts to their knees and customarily in the evening they assemble together and they go to the market to dance there.
>
> Others have instruments which are played, one a copper pan struck on the bottom with a wand. Others have drums carved from a hollowed log, covered with the skin of a goat, over which they are seated to drum, the third have round drums, the fourth have cowbells, the fifth have lutes made of trunk with a circle as a kind of harp...they begin to dance there, pair by pair, leaping and stamping their feet on the earth, snapping their fingers in the air, nodding their heads, and from time to time speaking among themselves, having a horsetail in their hands, which they toss, first over one shoulder, and then over the other, harmonizing their play and energetic movement, one with the other, seizing each other, first one way, and then another, together . . .[126]

This is, so far as I know, one of the first references to ritual preparation for the dance in Africa, with detail on the attachment of jewelry and bells. The love of luminosity and personal purity, characterizing many forms of black performance today, was fully rendered. De Marees could not guess the ritual significance, purity of self, of the deliberately gleaming bodies, prepared visages, and white cloth wrappers, but he did document their presence.

And there is more. Pieter de Marees made illustrations for some of the dances which he saw on the Gold Coast at the beginning of the seventeenth century. One of these (Plate 33) is in effect a translation into the visal conventions of seventeenth century European art of "The Manner of Mourning and Funereal Honoring of the Dead." De Marees' description follows:

> In this drawing one can see some ceremonies which they perform to put their dead in the earth. *A* is the sepulchre in which people bury the body with all the things which were used by him. To the right is the funeral procession, *B* . . .[127]

The importance of this account lies in the portrayal, however Westernized in perspectival rendering and facial type, of the dancing of the body of the dead person to his grave. This early introduces the West African tradition of treating the dead man as if he were a sculpture, to be imparted rhythm and power one last splendid moment before interment.

Dancing the dead to the other world is paralleled by dancing the living, silent chief, whose powers in part

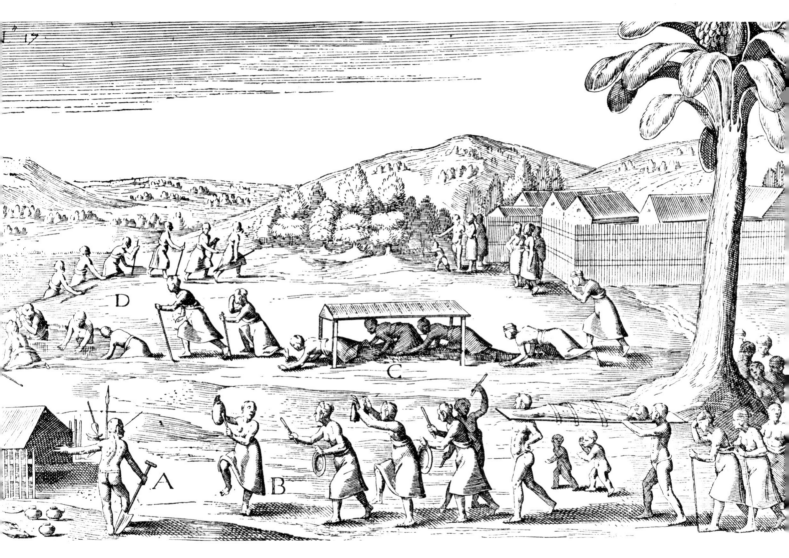

Plate 33 Akan funeral procession

derive from the other world and from the ancestors, on his palanquin in modern Ghanaian durbars. De Marees shows this context, too (Plate 34). An Akan town square is rendered as a never-never tropical piazza.[128] Nevertheless, musicians perambulate, playing side-blown trumpets in front of the noble person, just as is customary today, as documented by Carolyn Bassing at the coronation of the presently (1974) reigning Asantehene (Plate 35). Four hundred and seventy-four years ago a basic structural opposition in Akan ritual life, *i.e.*, carrying the lord to music as if he were ritual sculpture and dancing the dead man to music as if he were in some sense still alive, was a fully-developed phenomenon on the old Gold Coast.

Pieter de Marees, for all the detail, failed to note the composure which probably marked (to judge from modern Akan dancing) the faces of the performers. But this crucial detail did not elude another eyewitness of the customs of seventeenth century Africa, one Ten Rhyne, who saw dancing at the Cape of Good Hope in the autumn of 1673:

> They take the greatest delight in dancing which they perform with astonishing gesticulations. If they have the least feeling for religion, it is in the observation of the dance that they must show it...the males, with their bodies leaning forward, stamp on the ground vigorously with their feet, lustily chanting in unison with rising and falling intensity, and with a fixed expression on their faces.[129]

Control of detail is so good, in fact, that part of the description, *i.e.*, the mention of basic stance or posture, can be swiftly matched to a modern description of Bushmen dancing to the southwest of the Cape in the Kalahari:

> the ceremonial curing dance [is] a religious act, but, although very serious, especially in its final curing aspect, it is not piously solemn or constrained and it provides occasion for pleasure and aesthetic satisfaction...Music and dancing are the arts of the !Kung... the men dance with knees bent and bodies carried with little motion, leaning forward. The steps are very precise. They are minute in size, advancing only two or three inches, but they are strongly stamped, and ten or twenty dancers stamping together produce a loud thud.[130]

The last element mentioned in the late seventeenth century account, facial composure, is not present in the modern account, but this does not mean it does not exist. Nicholas England tells me it is important still in the dances of the Bushmen. The paradox of serious mien over bodily joyousness evidently so struck the seventeenth century Dutchman that he was impelled to write this down. Doubtless the contrastive usage of cold face/ hot body, seriousness and joy, in bittersweet mixture, was

hauntingly different for a person reared in the traditions of the Biblical injunction, "there is a time for mourning and a time for dancing," for the separation of the spirit of the dance, as joy, and as means of healing grief seems to have occurred in the Western world at least as early as the rise of Jewish literacy.[131]

There was, besides de Marees and Ten Rhyne, another seventeenth century source, Richard Jobson, writing in 1620-1, on African customs on the Gambia River. He drew an accurate connection between density of musicianship and the political importance of the music's patron. And he took shrewd measure of the quality of the dancing:

> The most desirous of dancing are the women, who dance without men, and but one alone, with crooked knees and bended bodies they foot it nimbly, while the standers-by seem to grace the dancer, by clapping their hands together after the manner of keeping time.

> And when the men dance they do it with their swords naked in their hand, with which they use some action . . .[132]

Jobson saw the separation of the sexes, solo dancing, posture and flexibility, and interlock of dancer and sympathetic handclapping. Swords were "danced" by men, though in what way we are not told. The description of solo work in relation to handclapping is a very important observation of one form of call-and-response dancing in the seventeenth century. This observation can be added to documentation of call-and-response on the contemporary Spanish stage.

There is another seventeenth century source on dance in Africa, one enlivened with art historical data. Le Sieur Villault made a series of voyages to the Gold Coast in 1666-7 and he published an account of these voyages in 1669 under the title, *Relation of the Coast of Africa Known as Guinea*. At Fredericksburg Castle he noted dancers in traditional costume; small gold ornaments were attached to the arms and legs of the performers. The singing and motion revolved around a large "fetish tree," a detail which matches the modern circum-arboreal groundplan of dancing for the smallpox spirit in the coastal town of Ouidah, farther east in Dahomey.

Villault witnessed, on 26 April 1667, dancing for the King of Ketu:

> His women were dressed in damask and tafetas which they wrapt around themselves from their breasts to their knees, wearing on their hands a large quantity of fetishes, or small works in gold, bracelets . . . around their arms and legs, with manillas of ivory and gold. They dress their hair elegantly in the fashion of the kingdom.[133]

The passion of the seventeenth century Gold Coast

Plate 34 Akan procession

Plate 35 Ashanti procession

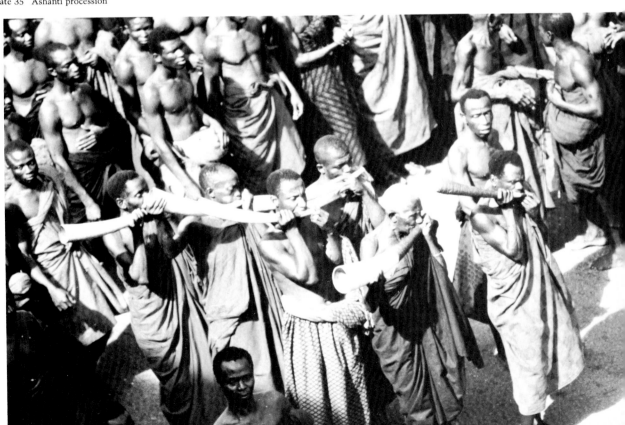

inhabitants for wearing jewelry in the dance is one of the interesting bits of information he brought back:

> the noblemen of the country are extremely burdened with rings, manillas, and fetishes, *above all when they go dancing* . . .[134]

Can these "fetishes," described as small, which they put on their heads, "thin as paper," be related to gold-leaf head ornaments and other forms of figurated small jewelry which Akan kings wear today? I think the fact that we find such forms among Akan whose ancestors migrated from Adansi in the 1700's, bringing these fully-developed arts with them to the southeast of the modern Ivory Coast, lends credence to this possibility. In addition, a few Akan gold-weights portray Europeans in eighteenth century dress and are "certainly very old." The miniature gold decorations Villault noted seem to be important off-shoots of a great stylistic family of miniaturized proverbial decoration. Villault could not have known of the full significance of what he saw, his cupidity, more than art historical curiosity, aroused by the intrinsic value of the objects. The better-known branch, the main branch, in the medium of brass, are the famous Akan gold-weights. That we may be looking at an important lode of art history embedded within the relation of the dance is suggested further by another and immediately subsequent source, Captain Thomas Phillips. On a voyage to the Guinea Coast he met, in January 1694, two canoes from Little Bassam. They approached his ship with a precious cargo:

> The gold we took here was all in fatishes [sic] *which are small pieces wrought in many pretty figures* which the blacks tie to their hair, neck, arms, and legs for ornament are generally very good gold.[135]

We do not have to speculate about the form of some of these "fetishes." Barbot, who traded on the coast about 1680, described some of them: "I have very often admired their ability in casting gold in filigree, so as to represent very exactly the form of large sea periwinkles, and all other species of snail or shell-fish."[135a] And he illustrated others (Plate 36). His drawing strongly suggests that the later gold-weights of the Akan, and these minatures in gold, derive from common sources.

Thus a modern Akan necklace (Plate 37) (richly studded with protective (probably) elements, *i.e.*, miniature shields) together with other images in miniature, such as a scorpion (Plate 38), fish (Plate 39), mudfish (Plate 40), suggest relationships with earlier forms in gold once worn as dance jewelry.

To return to Phillips, although he enjoyed the gold, praising the miniatures as "little pieces of gold exquisitely made in diverse figures," he was not impressed with Gold Coast dance. Nevertheless, he allowed a dance-loving Dutch factor at Axim, one Rawliffon

("boon companion, taking his glass off smartly, and singing and dancing by himself several jiggs") to guide him to an African community near the port where he saw the coastal women dance:

> they went to dance by turns, in a ridiculous manner, making antick gestures with their arms, shoulders, heads, their feet having the least share in the action . .[136]

He had thus seen total bodily motion, in addition to upper body activation played off against moderation of the stepping patterns.

Jean-Baptiste Labat's *Nouvelle Relation de L'Afrique Occidentale* contains a reference to artistic motion based on the field observations of one Andrew Brue. The latter entered Senegal on New Year's Day, 1701 near Fort Louis. He was armed with gifts for praise singers and Muslim clerics. He was allowed to view a procession in a circumcision ceremony:

> The griots were at the head with their drums. They beat out the rhythm of the procession and marched with a grave step, not singing. The marabouts of all the villages came after them, marching two abreast, dressed in white and carrying long spears. In the distance could be discerned those who were about to be circumcised. These men were dressed in quite beautiful, long, flowing robes. . .reaching their feet. . .they marched, one after the other with a long spear in the left hand . . .[137]

This account is illustrated (Plate 41). This is a precious document of patterned walking among the Woloff in the early eighteenth century. The description of the initiates' dress matches both the illustration, more or less, and circumcision apparel still being worn by young men in Segou (in what is now Mali) in the early 1930's.[138] West Sudanic cone-on-cylinder architecture is also illustrated.

John Atkins witnessed aspects of call-and-response dancing and social criticism in Sierra Leone, 1721. Francis Moore on the Gambia in 1738 noted segmental structuring and contrastive flair in dancing, "now and then very regular and at other times in very odd gesturing."[139]

Michel Adanson, moved by the love of natural history and travel, worked in Senegal from 1749 to 1754, as a correspondent of the Royal Academy of Science in Paris.[140] He was in Senegal about six years, learned Woloff and made, as Philip Curtin points out, the first consciously "scientific" effort to conduct ethnographic research in West Africa.[141] Hence the excellence of his account of dancing for the dead:

> All the young people in the village gathered together in a large area, in the middle of which they had lighted a great fire. The spectators formed a long square, at both ends of which the dancers were ranged in two opposite lines, the men on one side the women on the other.

Plate 36 Akan jewelry

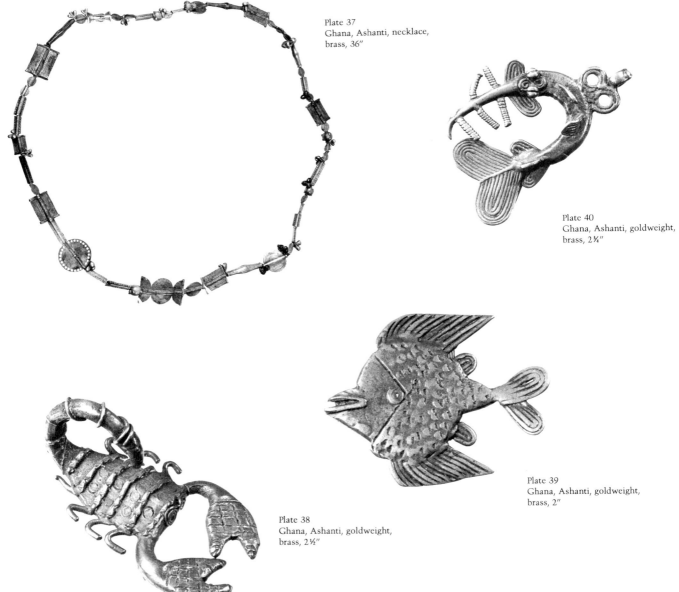

Plate 37
Ghana, Ashanti, necklace,
brass, 36"

Plate 40
Ghana, Ashanti, goldweight,
brass, 2¾"

Plate 39
Ghana, Ashanti, goldweight,
brass, 2"

Plate 38
Ghana, Ashanti, goldweight,
brass, 2½"

35

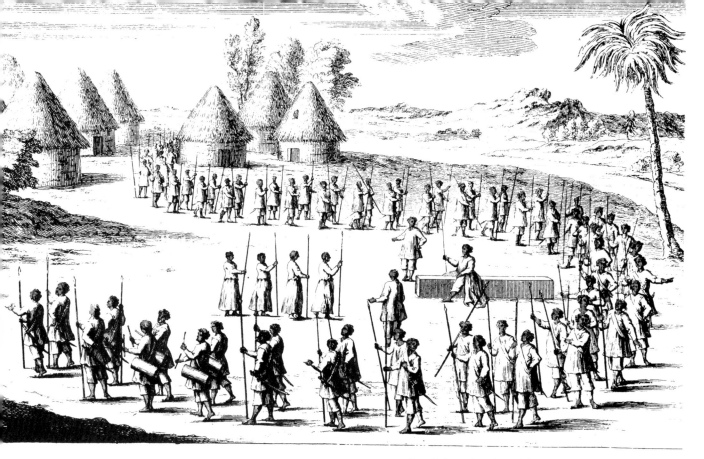

Plate 41 Senegalese circumcision ceremony procession

Plate 42 Fanti dance competition

There were two tabours to regulate the dance; and as soon as they had beat a march, the performers began a song, the burden of which was repeated by all the spectators. At the same time a dancer stepping forth from each line, advanced towards the opposite person that pleased him the most, to the distance of two or three feet, and presently drew back in cadence til the sound of the tabour served as a signal for them to come close, and to strike their thighs against each other, that is, man to woman, and woman to man; this done, they drew back once more and soon after renewed . . . diversifying their movements as often as the tabour directed them . .[142]

Adanson was apparently the first Western man to have remained in one African culture with sufficient length to have noted the fundamental nature of percussive, total bodily dancing:

The Negroes do not dance a step, but every member of their body, every joint, and even the head itself, expresseth a different motion, always keeping time, let it be never so quick. *And it is in the exact proportioning of this infinite number of motions that the Negroes' dexterity in dancing chiefly consists;* none but those that are as supple as they, can possibly imitate their agility.[143]

Adanson rendered the totality of black artistic motion. He witnessed call-and-response. He succeeded in suggesting, with the phrase, "the exact proportion of this infinite number of motions," the sub-facetting of the body by different rhythms. This quality was not to be appreciated in Europe until a hundred and forty years later, when Picasso and his colleagues opened the eyes of the Western world to the special nature of African staccato plastic form. Adanson must be praised for "discovering" the supple qualities of black dance. He was on the verge of discovering multiple meter in subsaharan dance, too, in seeing that there were different motions within a single body, that drums directed these motions, and that the whole was accomplished with exactitude.

Documentation of dance and dance music radically increases, virtually by geometric progression, in the nineteenth century, as a logical consequence of stepped-up colonialism and imperialist intervention.

There are many kinds of competitive dance in traditional Africa. Sir James Alexander documented one form, at Cape Coast, among Fanti in the early 1830's:

A noise of singing and clapping of hands attracted us to a party of women who were enjoying themselves in the cool of the evening with a very strange dance. Standing in a circle, one of them advanced, and

challenged another in performing two or three different steps and motions of the arms, which consisted in bringing the hands from the back of the head to the front, clapping them, jumping up in the air, and striking the ground with the right or left heel, accompanied by the cry of *Osarah*. These motions were performed two or three times; and if the challenged party executed them correctly, the challenger went round to the next, and gave place to one who had made a mistake. This dance is a very favorite one on the Gold Coast.[144]

This game of metronomic timing, in which the woman who misses a beat becomes what is known in North-American games as "it," was illustrated (Plate 42) by an engraving taken from the field sketch of Alexander. The artist has removed half of the dancing ring to let the reader view the work of the soloists with clarity. Support by drums and handclapping is well suggested. Details of dress ring true (simple wrapper, some wearing of necklaces) and the three-pointed Fanti oars held by two bystanders are absolutely correct, ethnographically, and match the form of modern ones collected at Winneba,[145] one hundred or so kilometers farther east. The depiction of basic posture, torso forward, buttocks out, knees and elbows bent, did not suffer in translation, but standing on the toes does seem fanciful. Also truthful, in its own way, is the reaction of the infant to the motion.

Alexander, who wrote perceptively of dancing in South Africa, too, had well seen the flexibility and the sense of timing and his drawing makes us sense the making process of the dance, the division of the body at the waist, the famous two-part body system of black dance.[146]

Alexander's drawing represents an advance in perception: it is a virtual close-up, in comparison to the dreamy perspectival views of earlier illustrations, and there is a stamp of ethnic truth. The West is getting ready for documentary lens-work.

The next notice is a rare fragment of artistic biography, a moment in the life of the great dancer-king, Munza of the Mangbetu, in what is now the northern portion of Zaire:

Dancing there in the midst of all, a wondrous sight, was the king himself. Munza was as conspicuous in his vesture as he was in all his movements... he had now attired his head in the skin of a great black baboon, giving him the appearance of wearing a grenadier's bearskin; the peak of this was dressed up with a plume of waving feathers. Hanging from his arms were the tails of genets, and his wrists were encircled by great bundles of tails of the guinea-hog. A thick apron, composed of the tails of a variety of animals was fastened round his loins and a number of rings rattled upon his naked legs. But the wonder

of the king's dress was as nothing compared to his action. His dancing was furious. His arms dashed themselves in every direction, though always marking the time of the music; whilst his legs exhibited all the contorsions of an acrobat's, being at one moment stretched out horizontally to the ground, at the next pointed upwards and elevated in the air . . .[147]

An engraving (Plate 43) accompanies this description. The king is sited in this illustration under a vault that seems to have more of the Crystal Palace of London in its phrasing than traditional Mangbetu architecture (Junker illustrates a less exaggerated drawing of the same dancer and his wives).[148] However, the flash of the dancer's feathers, fur, and tails shows quite well, and follows what is given in the text.

There is little doubt, using Mangbetu sculpture from the late nineteenth century as basis for the remark, that there is truth to the elongated coiffure of the noble women and their netting-like pattern of body ornamentation.[149] Each noble woman is seated on her own distinctively carved stool, an important detail. Royal persons alone sat on stools in Mangbetu; subjects squatted on the ground. The picture, therefore, depicts a vast honorific seating around the glory of the dancing king.

From the same portion of Africa comes another document of the dance, one that, as Alan Merriam[150] has noted, splendidly conveys the emotional impact of African percussive music. This is an account, given by the famous explorer, Stanley, of the dance of the "Bandussuma at Usiri" in what is now northeastern Zaire. This dance was seen on 29 May 1888:

Half a score of drums, large and small, had been beaten by half a score of accomplished performers, keeping admirable time, and emitting a perfect volume of sound which must have been heard far away for miles, and in the meantime Katto, and his cousin Kalenge. . .were arranging thirty-three lines of thirty-three men each as nearly as possible in the form of a perfect and solid and close square . . .

The phalanx stood still with spears grounded until, at a signal from the drums, Katto's deep voice was heard breaking out into a wild triumphant song or chant. . .and a mighty chorus of voices responded, and the phalanx was seen to move forward, and the earth around my chair, which was at a distance of fifty yards from the foremost line, shook as though there was an earthquake. I looked at the feet of the men and discovered that each man was forcefully stamping the ground, and taking forward steps not more than six inches long, and it was in this manner that the phalanx moved slowly but irresistibly. The voices rose and fell in sweeping waves of vocal sound, the forest of spears rose and subsided with

countless flashes of polished iron blades as they were tossed aloft and lowered again to the hoarse and exciting thunder of the drums. There was accuracy of cadence of voice and roar of drum, there was uniform uplift and action of the bodies, and as they brought the tremendous weight of seventy tons of flesh with one regular stamp of the feet on the ground, the firm and hard earth echoed the sound round about tremulously . . . It was certainly one of the most exciting exhibitions I had seen in Africa.[151]

Concordance between the stamping of the "Bandussuma" dancers and the choreography of modern Bushmen remains to be explained. Here the assertion of bare male strength is shaped in complex military formations, reflecting complexity of social level.

We cannot trust the illustration. Stanley says he saw the dancers from a distance of about fifty yards. The illustrator would have us believe the phalanx was about to bear down upon the explorer (Plate 44). But something of the massing and power and control of the dancing is conveyed, nevertheless. The description of the "dancing" of the spears, their rising and subsiding, which Stanley related to the rising and falling of the voices, might possibly suggest connexion with the overall descent of African melody. But we cannot be sure. Yet the strength and discipline conveyed by the description, and even the drawing, is overwhelming.

Writer-explorers of the last century occasionally witnessed interesting funeral dances. Binger, for example, witnessed a superb procession for a dead man among the Siene-Re,[152] a northern fraction of the Senufo in what is now southern Mali (Plate 45). The illustration is richly detailed. Men fire rifles to announce the burial. A group of women brandish flywhisks and sing of the virtues of the deceased. Strong youths balance the corpse upon their heads, striking one of the supportive poses of West African art and life.

A priest moves at the head of the women, a magnificent horned headdress on his head. This ritual helmet is surmounted by a small figure of a mounted ruler, clearly visible between the horns. The horns have apparently been striped with paint. The headdress resembles, stylistically, a helmet collected in Fenkolo village in the Sikasso District of Mali.[153] The mounted ruler that surmounts the latter helmet is close in form, especially as to heavy stabbing spear, to a Senufo rider in the White Collection from, probably, the Sikasso district (Plate 46). This miniature equestrian sculpture in wood may well have once rested between the horns of a similar helmet, spear raised in the economy of war.[154]

In addition to dances for the dead, there are more references to contests of choreography to be culled from the nineteenth century literature of exploration. East of Lake Chad, the explorers Denham and Clapperton came

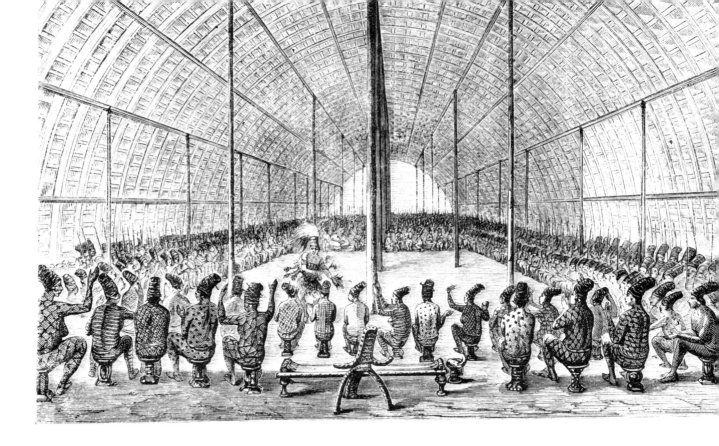

Plate 43 King Munza of the Mangbetu, dancing

Plate 44 Dance of the "Bandussuma at Usiri"

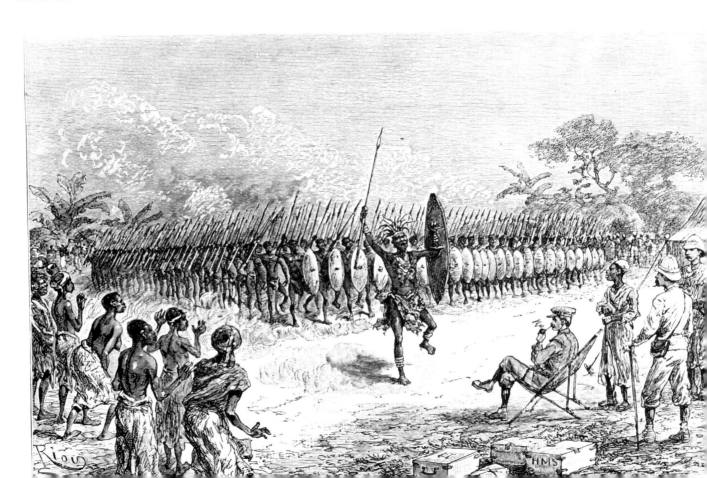

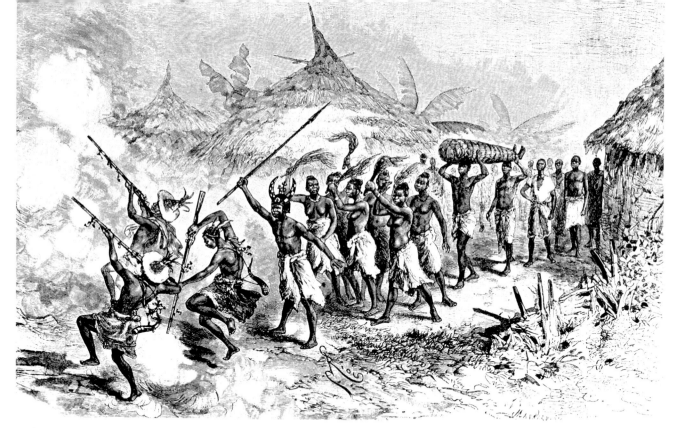

Plate 45 Senufo funeral procession

Plate 46
Mali, Senufo, horse and rider,
wood, 11½"

40

across a Kuka (Lisi) dance in which two contestants met in the ring and, upon metronomic signal, attempted to knock one another down by means of a part of their anatomy described with hilarious prudishness:

The [Lisi women] advance in twos and after advancing, retiring and throwing themselves in various attitudes . . . they suddenly turn their backs to each other and suffer those parts which are doomed to endure the punishment for all offenses of our youth to come together with all the force they can muster, and she who keeps her equilibrium and destroys that of her opponent, is greeted by cheers and shouts, and is led out of the ring by two matrons.[155]

The explorer, Binger, ran full tilt into a similar dance among the Dagomba of northern Ghana (Plate 47). The illustration convincingly suggests an interlock of dancers, handclaps, drummer. But the crowd of observers has, again, been "erased" by the illustrator, in order to make the action readily visible. The drummer follows the motion of the two contestants closely, and may have just given the signal, on his instrument, for the young women to prove that they can end their dance with a well-finished demonstration of their agile balance. Within the humor of the event lies an important determination of personal balance and confidence, a toughening of the self within stability.

Photography begins to replace engravings and other media by the end of the nineteenth century. There is a grainy, blurred, but valuable photograph of a late nineteenth century wrestling match in a village on the Zaire (Plate 48). The river is a glassy mirror behind the center of the action, around which villagers are gathered in disciplined circles.[156] Wrestling is sometimes performed to drums in West Africa and the Zaire basin. In any event, the posture assumed by two of the athletes is very choreographic, so that there is little need to justify their inclusion in a history of the dance.

In this view, the athletes' colleagues stand between them and the camera. At the mention of camera, we note that the photographer has set up his equipment at some remove from the focus of action so that his presence seems forgotten or unnoted and there is an air of purity of concentration.

One of the wrestlers can be discerned, the other is blurred by motion. The former is crouching in a get-down position, knees relaxed and deeply bent, indulging gravity. He has built a base of stability from which, suddenly to lunge, with grappling arms, to destroy his opponent's equilibrium. The form of wrestling rephrases the issue of the Dagomba dance—balance.

There are interesting forms of standing in this photograph. A man stands with spread legs and arms akimbo, hands on hip. He seems relaxed but cocky. He makes a counter-assertion to the inevitable aggressions in the ring. A number of other villagers take this stance, alert, watchful, perfectly keyed to the event.

I close with a "funeral dance" among the Bapoto, an Equatorial Bantu group, of the northern portion of modern Zaire (Plate 49).[157] The photograph was taken c. 1894-7. Men shuffle anti-clockwise in a line. One, perhaps two, solo dancers perform, in the middle background. Faces are blurred. But special necklaces, waist-bands, bracelets, and dance kilts can be discerned; these elements add flash and visibility to the anciently chiseled positions of the body, feet flat upon the ground, knees and elbows bent, torso inflected forward, qualities partially present in some forms of Zaire Basin sculpture.

Dance discovers pleasure in the face of death. While the mourning is presumably going on, the men lean forward, fraternal mirrors of comradeship and solidarity. Person blurs into person. Time and passion stop.

In actuality, these men probably now are dead. Yet their passage through an antique lens documented that they did attain, in submitting to a sculptural mode of vital aliveness, transcendent presence and a kind of immortality.

Small children witnessed this event. They can be seen on the periphery, observing, learning. Some seem impressed by the truth before them, brought to being by shaping for the common good. These children, most of them, probably acquired, in living this tradition, a confidence which burst into full brilliance when they themselves began to dance, a confidence that they could never be utterly annihilated. Even after going from this world, their complex vital patterning was carried forward in the bodies of descendants. And so the process starts anew, in the purity of danced time, Great Time, for "the moon may die but the stars are ever in existence; whatever happens to the person, the noble image will always be."[158]

b. Black Performance in Time Perspective

Certain traits thus have existed for centuries; call-and-response (soloist and handclapping chorus), balance of many kinds, youthful power. To be added to this list are facial serenity, noted in the seventeenth century, descent in melodic and choreographic structure, and a possible medieval notice of suspending the beat. Zero allusion to incarnation of ancestral presence, multiple meter, and rhythmized play with pattern in music and in art ("looking smart") reflects, in all probability, lack of sophistication in observation.

It seems reasonable to suggest that notice of one or more of the traits of African creativity implies the presence of others. These notices were doubtless abstracted from a larger whole of socially aesthetic happening and intelligibility.

Plate 47
Dagomba dance competition

Plate 48
Zaire River wrestling match

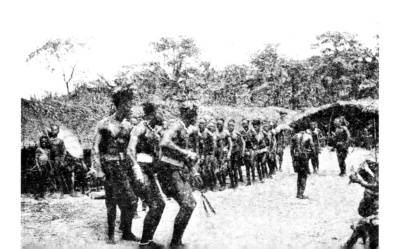

Plate 49
Bapoto funeral dance

The history of the dance in Africa cannot be characterized solely as a phenomenon of individualist will or totally communal effort, but has to recognize the mutual play of both these forces. There were individual masters of form and their accomplishments could and did occur within objective time, *viz.*, the imposition of a tax, a solar eclipse, the visit of a caravel.

But there were also choral dancers, like the women who met Towerson in the sixteenth century and who chanted in his honor, or so he would have us believe. Ensemble expressions of motion on the Gambia circa 1601 and in mid-eighteenth century Senegal belong more to the realm of ontological time—for they were communal events stylized by ideal past perfection, even though they, too, actually happened.

Two kinds of time, the real time of individual variation and the mythic time of choral enactment, seem commingled in the documents of exploration and missionary effort. We guess at their mutual interpenetration each time the call-and-response form seems to appear. This overlap situation combines innovative calls (or innovative steps, of the leader) with tradition (the choral round, by definition blurring individuality). Solo-ensemble work, among the many things it seems to accomplish, is the presentation of the individual as a figure on the ground of custom. It is the very perception of real and mythic time.

The sophistication of all this clearly hints of deeper sources of inspiration, the mediating processes of worldview. A common ground of basic philosophical assumptions, for example, would explain the apparent concordance between observations on the art of certain civilizations in Mali with art among traditional societies in Tanzania and other regions of East Africa. Let us start with art in Mali:

> an antelope head will be carved with the idea of continuing the vital force of the whole species . . . or a human head will be sculptured as a support for the force of some human group or of a certain ancestor.[159]

and continue with East Africa:

> Emotions are expressed by gestures and positions while the faces themselves are generally stereotyped. The reason, in my submission, may be found in the absence of any valuation of the individual within the social structure of a [traditional] society where all are basically equal . . .[160]

The image of a person or an animal in Mali or East Africa therefore is: an expression of aesthetic or spiritual principles. Such principles explain in part the mid-point mimesis which we find virtually everywhere within the African aesthetic universe. The East African art expert continues:

Thus the artists, with few exceptions, correctly express the common faith in the small importance of individual characteristics by the conspicuous absence of individual features. They saw human beings as types and not as individuals. For it is difficult to believe that men who were capable of forming anatomically correct torsos lacked the skill to give expression to the faces.

Generalization by style reflects a cultural preference for ideal substance and spirit, setting aside the possibility of naturalism. It identified another kind of realism, a concern with abiding concepts. This leads us to the most metaphorical, perhaps of the ten suggested canons of African performance, "coolness." It is this trait which grants a person the power to incarnate the destiny of his tradition.

10. Coolness: Truth and Generosity Regained

Cool philosophy is a strong intellectual attitude, affecting incredibly diverse provinces of artistic happening, yet leavened with humor and a sense of play. It is an all-important mediating process, accounting for similarities in art and vision in many tropical African societies. It is a matrix from which stem ideas about being generous, clear, percussively patterned, harmonized with others, balanced, finished, socially perfected, worthy of destiny.[161] In other words, the criterion of coolness seems to unite and animate all the other canons.

This becomes evident when considering the semantic range of the concept, "cool" in thirty-five Niger-Zaire languages, from Woloff of Senegal to the Zulu of South Africa: calm, beauty, tranquility of mind, peace, verdancy, reconciliation, social purification, purification of the self, moderation of strength, gentleness, healing, softness (compared to cushions, silk, even the feel of a brand-new mattress), silence, discretion, wetness, rawness, newness, greenness, freshness, proximity to the gods.[162]

Language in Africa and Europe shares notions of self-control and imperturbability expressed under a metaphoric rubric of coolness, *viz.* notions of cool-headedness and *sang-froid*. But, in traditional Africa it is customary to talk about *cool country* meaning peace, and *cool heart*, meaning collectedness of mind. These expressions would clearly be anomalous in standard English.[163] The metaphor of the cool in tropical African symbolism far exceeds notions of moderation in coldness and degree of self-control and imperturbability. In Africa coolness is an all-embracing positive attribute which combines notions of composure, silence, vitality, healing, and social purification.

43

Composure intersects with silence; vitality intersects with healing in the sense of restoration of shining health; the body politic is "healed" in social reconciliations. Ideas of silence and calm are strongly indicated. Vitality connotes the strength of the young, while discretion, ability to heal, and good government connote the seasoned members of society. Coolness thus emerges as a metaphor of right living, uniting the special strengths of the elder with the warrior, women with men In other studies I have shown the impact of this concept on visual art.[164] Here I illustrate comment on coolness in the dance: "it cools the town when you dance . . . when you finish . . . you are restored to repose . . . and reconciliation with your family. They (the chiefs) keep themselves peaceful when they are dancing—this is reassuring to the townsmen;" "the heads of the dance cult are people who are 'cool,' who like 'to laugh and play' and who do not look for 'cases' (i.e., litigation)."[165]

If coolness is a cardinal tenet, then realization of its facets can transform a person into a purified source of power. But there are a number of canons under its rubric which remain to be explained and identified before we move on to nuance and semantic form in the gestures, attitudes, and motions of African visual art. Three of these are qualified by light.

a. Visibility

A cool person does not hide. The Tiv in Nigeria demand that a person dances clearly.[166] The Yoruba use the arms to make the direction of the dance visible.[167] Bamenda like display, in the sense of making the dancers and their motions fully visible.[168] Diola-Fogny require the voice of the singer to be clear.[169]

Although there are exceptions, such as the king who must work in secrecy to combat the secretive forces of witchcraft in behalf of his people and embody to a certain extent their mystic heart, in general, visibility is an embodiment of the resolving power of the cool, i.e., moderation of force in discovery of the mean between that which is faint and that which is conspicuous. The aliveness of the concept among the Igbo of southeastern Nigeria is apparent in the need, in this society, to be "transparent" or "open" in one's actions.[170] Visibility in the sense of aesthetic clarity governs the thought of artists among the Chokwe of Angola.[171] The Manding of Mali, according to Charles S. Bird, associate the forest with darkness and the unknown.[172] Areas under cultivation and within the town are clear; open to the sky and visible.

The criterion of clarity under the rubric of social coolness (people who have things to hide often generate heat, dissension, and bloodshed) is of importance for the further understanding of the significance of "danced" sculpture, i.e., the sculpture is removed from the secrecy

or relative privacy of the shrine or grove and restored to the public view. Compare the Yoruba proverb: "if the secret is beat upon the drum, that secret will be revealed in dance."[173] Nothing should or can remain unrevealed in viable society. This is also a basic premise among the Ndembu of Central Africa, where it is believed that what is clearly seen can be accepted as valid ground for knowledge.[174]

b. Luminosity

It follows that that which is clear is also brilliant. The Tiv have the strangely beautiful concept of the good dancer "shooting darkness,"[175] i.e., reducing the powers of darkness and social heat by means of his shining athletic grace. Yoruba maintain that some forms of artistic motion positively shine,[176] a belief perhaps continuing, in change, within the Yoruba barrios of Bahia where it is believed that varnished, shining drums produce more brilliant tones than drums without varnish or shining surfaces.[177] In Angola the Chokwe very decidedly prefer bright colors over dull.[178] Onitsha Igbo take the famous ozo title dressed in immaculate white and wear white feathers as essential attributes of shining purity in proximity to the gods.[179]

c. Smoothness

This is again a function of perfected clarity because that which has been properly smoothed and finished will shine and become brilliantly visible. Diola-Fogny laud the smooth-sounding voice, not scratchy or "shrill and hard like unripened fruit."[180] Mbam in Cameroon demand dancing that is smooth and not harsh or brutal and Yoruba compare fine motion with the spinning of the agbaarin seed in a game played by children.[181] Liberian Dan in effect gloss what is meant by this last image when they praise the good dancer by comparison to a spinning top: "because no part of a top will wait; the whole is going."[182] Smoothness is thus identified in unified aesthetic impact; seams do not show, the whole is moving towards generous conclusions based on total givings of the self to music and to society. The analogous smoothing of the surfaces of most forms of African sculpture is so obvious that it will not be belabored.

d. Rebirth and Reincarnation

In another work I have shown how the concept of the cool is often apparent in crisis situations and points of transition. In African ritual, as in ritual in many places in the traditional world, a person "dies" in order to be reborn in new strength and insight. Motion arts in Africa bring pleasure precisely because many people see the founders of the nation or lineage returning in these

styles. The pleasure taken in viewing vitally inflected sculpture or the dance therefore stems, in part, from sensations of participation in an alternative, ancient, far superior universe. Richard Henderson points out that attributes appropriate to descent tend to be defined in Onitsha Igbo culture by emotion: "indeed the affective components of filiation are often symbolically elaborated."[183] African dance and art, we saw in the concept of ancestorism, are vitalized by embodiment of superior mind from the past; conversely, the ancient elders are united again with strong means of realization of their principles, in the bodies of the dancers or sculpted image. It is a remarkable synthesis.

e. Composure of the Face: Mask of the Cool

The mind of an elder within the body of the young is suggested by the striking African custom of dancing "hot" with a "cool" unsmiling face. This quality seems to have haunted Ten Rhyne at the Cape in 1673 and it struck the imagination of an early observer of strongly African-influenced dancing in Lousisana in the early nineteenth century, who noted "thumping ecstasy" and "intense solemnity of mien."[184] The mask of the cool, or facial serenity, has been noted at many points in Afro-American history.

It is interesting that what remains a spiritual principle in some parts of Africa and the rare African-influenced portions of the modern U.S.A., such as tidewater Georgia, becomes in the mainline Afro-American urban culture an element of contemporary street behavior:

> Negro boys . . . have a 'cool' way of walking in which the upper trunk and pelvis rock fore and aft while the head remains stable with the eyes looking straight ahead. The . . . walk is quite slow, and the Negroes take it as a way of 'strutting' or 'showing off' . . .[185]

In the fast-moving urban world of Black America this citation is already dated. The 1974 cool style of male walking in the United States is called *bopping*; but, it is still a mode of asserting strength of self, broadly dovetailing with portions of the African mode of "looking smart." Mystical coolness in Africa has changed in urban Afro-American assertions of independent power. But the functions, to heal and gather strength, partially remain. And the name, *cool*, remains. And the body is still played in two patterns, one stable, the other active, part energy and part mind. This image would seem indelible, as resistant to destruction by Western materialist forces as the similar shaping of the melodies of Africa. Thus A.M. Jones:

> melody in the old folk-music is markedly impersonal; time is not used to express emotion—a very sad subject may well be sung allegro . . .[186]

Time in African music and dance cannot, of course, be contaminated by descent into real time, the sources of petty stress and perturbation. Dance is Great Time, the time in which coolness ideally is realized. Vitality and mind must be made to correspond, like the use of stress in "swinging" music, in order to approach the gods. Coolness, the Songhai of the Niger say, comes in lightning and rain, securing human life within spiritually insured calm.[187] Men are cooled by the flash of the gods' magnificence; and the gods are cooled by promises made and kept. The basis is power, generosity, and truth.

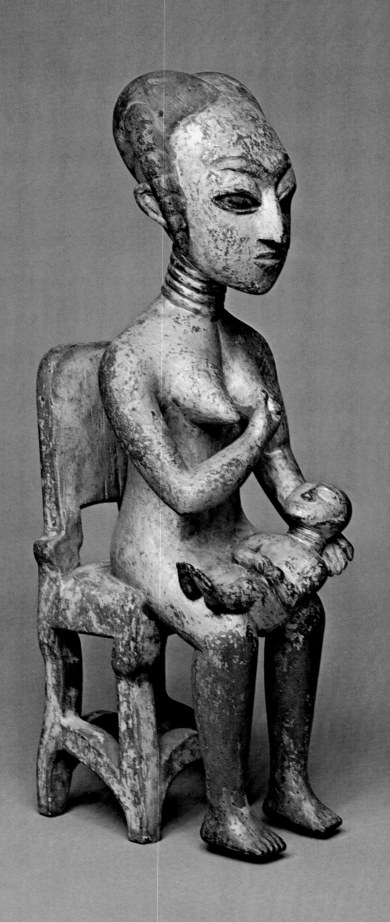

There is in the African a latent lyricism
which tends to express itself in movement,
so that every gesture, every attitude of the body
takes on a special significance which
belongs to a language of which I caught only a few words.

—Richard Wright, *Black Power*

For the Bete, beauty is a visual magnificence.
Even beautiful music is described by the eye
as though beauty could only be conceived by translation
into visual terms.

—Harris Memel-Fote, "The Perception of Beauty
in Negro-African Culture," *Colloquium on Negro Art*

ICON AND ATTITUDE

Introduction

The founders of African civilization, the Yoruba maintain, created the first styles of bodily address and dance.[1] Many traditional people in Africa believe that when they dance or strike an honorific pose they are standing in the image of their ancient divine fathers.[2] Main patterns of black performance, as we have just seen towards the end of the last chapter, can be traced back, historically, for centuries. When dancers enact in the round the ancient motions, the forms of flexibility and communal strength, it is an act of tacit reincarnation.

Ancestorism, the belief that the highest experience pertains to the closest harmony with the ancient way, is also a prevailing force in shaping stance, attitude and gesture. *Stance* refers to standing. *Attitude* refers to the various stylized positions of the body, the manner of carrying the self, indicative of mood and condition. *Gesture* refers to motion, of the body and the limbs, communicating thought or emphasis.[3]

With these definitions in mind, it might be assumed that the positions of the body, as depicted in the corpus of African sculpture, were relatively straightforward, uncomplicated, direct expressions of stability. But close inspection reveals that these points of emphasis, in the main, are concentrated upon a number of modes: standing, sitting, riding, kneeling, supporting, and balancing.

An authority on Dogon art and dance in Mali has written:

> the dance only repeats essential gestures. It is accompanied by a staccato rhythm and a few words . . . alluding to the events which determined the creation of the personage in question. The simplification should teach us to study every detail.[4]

His point about intensification of iconic resonance by simplification of expressive means is extremely well taken. It is an insight which applies, as a matter of fact, to the whole of subsaharan wood and metal sculpture. For example, some traditional Africans consider standing images in sculpture as multi-vocal expressions:

> Dahomean Yoruba: "one who is standing like that is *born* with that stance."
> Banyang: "he stands like a person," *i.e.,* in a principled manner, indicative of anciently realized norms.
> Suku: "I have seen that pose. It reminds me of what I was told: long ago at the feast for our ancestors, they calculated, 'what was the image of our grandfathers?' and they thought about it, and they thought about it, and they remembered their grandfather when he was standing. They began to make standing images for the ancestors."[5]

Traditional beliefs provide the rationale. And tradition selects those bodily positions which come to define lordliness and command in human interaction: standing, sitting, riding on a horse. Tradition also emphasizes postures set at symbolically descended levels of submission and respect. These are: kneeling, supporting, and balancing objects upon the head. The attitudes chorally correspond. Service confirms command. In addition, and it is quite an addition, the human face becomes the focus of each particular attitude, endowing the act with resolving power. The head is sometimes shaped

Opposite: Color Plate II Ghana, Ashanti, Mother and child

47

horizontally, linked in this fashion arbitrarily with animal powers and the forest. Such heads specially discipline the world. These are the attitudes and expressions we shall be considering.

The modes of bodily address represent but a fraction of the available means of human motion. Why they were chosen is an obvious issue. The nuancing of the modes is another issue. For example, sculptural self-presentation in Africa relates to the most dramatic trait of African dance. That trait, as Irmgard Bartenieff and Forrestine Paulay have shown,[6] is the division of the torso in two related parts with a twist at the waist frequently marking the division. In subsaharan Africa, these two scholars report, the upper and lower portions of the body may engage in different motions and directions, not only in hip-swinging dances, but also in some forms of work.

African figural sculpture often relates to this phenomenon: division of the body at the waist in two expressive units, the head and neck erect, the torso forward, the deeply inflected, spring-like knees. The manner by which Africans phrase gesture is deepened within this particular idiom. Gestures of the hands, for example, reflect, quite often, in symmetrical disposition the basic stability of the central body trunk. Facial and gestural detail complicate or confirm communication of repose. As immediate illustration, consider a twentieth century sculpture, attributed to Osei Bonsu of Kumasi,[7] capital of the Ashanti, in Ghana (Color Plate II, Plate 50). The sculpture represents a Queen Mother. I once showed a photograph of this work to a young Suku in Kinshasa, Piluka Ladi. He admired the work. These were his words: "She is purely there. She gives milk to the child. She secures his body with the other hand. She is sitting well, like a person of character." The silent mien was not mentioned, but sensed in appreciation of dignity.

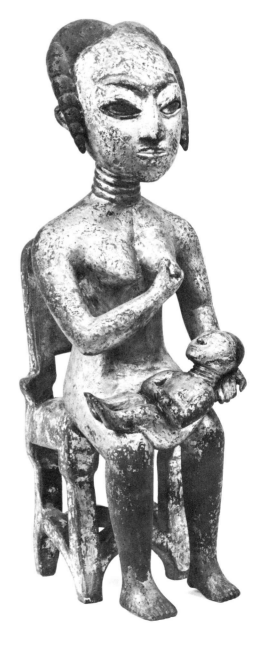

Plate 50: Color Plate II
Ghana, Ashanti, mother and child,
wood, 17 ¹¹/₁₆ "

48

1. STANDING

Standing is a task. Constant muscular adjustment to the pull of gravity is required. To stand is to intervene in a decisive way, attesting the power to compensate for perturbation, to maintain balance. It is a form of strength which engages the whole of the person. It is different from a simple species of immobilization, such as the fixing of an iron bar within the earth.[8] Human standing is a mode of affect and expression. The way a person stands communicates personality and lived relation with the world. Emphasis upon this mode in sculpture introduces an icon of vitalized persistence.[9]

Let us begin with the Akan of Ghana, for whom attention to the communicative aspects of deportment is a function of a philosophy which states that the unexamined life is not worth living. According to Akan notions of time, during the twelve hours dominated by noise and light, from dawn to dusk, mankind is *standing up alive*.[10]

Horizontal positions correlate with darkness and with death. Standing thus embodies light and life; it is the stance of day, the time of morality, as Igbo interpret the hours of standing. Witches and thieves generally travel by night.

It is likely that notions of luminosity and goodness, therefore, cluster about two standing figures attributed to the Kulango (Plates 51 and 52), but carved in an Akanizing manner. The Kulango, numbering some 30,000, live between the Lobi of northern Ghana and the Akan-speaking Baoule, Agni and Brong of the Ivory Coast and Ghana. They are prolific carvers. Kulango sometimes export statuary south to the Akan, hence the Baoule-like flavor to the smooth, segmented emphasis of calves and thighs. George Rodrigues collected the pair in 1967 at Wenchi in the territory of the Brong.[11]

These images not only are "standing up alive" with positive force, but seem to correlate with further virtue in the manner of their gesture. Both indicate with hands the region of the heart. Compare Memel-Fote:

if he wants to refer to the person's goodness . . . the Adjukru [an ethnic group of southern Ivory Coast, affiliated culturally with the Akan] will localize it within two internal and central organs of the body: the stomach and the heart. The heart is a source of

life, in that it is the literal headquarters of respiration or breath, thought, sentiments, will

goodness, because it comes from the heart and the stomach, is an internal realization. . . .[12]

Therefore, the positive associations which cluster about the standing position seem, in this instance, deepened by referral to the heart.

Northwest of the Akan, among the Manding, standing as an act, foretold the very rise of the medieval Mali Empire. The founder of Mali, the famous hunter-king, Sundjata, could not stand or walk when he was a child. He was a cripple. Yet where fear enters into the heart of a man who does not know his destiny, Sundjata remained calm in his affliction. "Tell my father's smith," he said one day, "to make me the heaviest iron rod." This was done. The young boy took this bar, tensed the muscles in his arms, and then, while trembling in his limbs answered the great exertion in his trunk and arms, he slowly felt his limbs begin to fill with magic strength imparted from the bar of iron. Sundjata began to straighten his legs. The bar became curved, like a mighty weapon for archery and for war. In some mystical way the vertical bar of iron had helped infuse stability and straightness into the limbs of the young leader; their former curve had been transferred to the iron.

Standing in the position of a soldier at ease, Sundjata recovered his breath and dropped the bar. He was now fully standing and the crowd stepped to one side. He began to walk, taking giant steps.[13] The future of Mali was assured.

Once a person in traditional Manding society has heard this tale, and it is still being told in rural Mali, it is unlikely that she or he can forget the central importance of standing, through magic and through iron, at the birth of Sundjata's power.

The Bamana of Mali today are a Manding-speaking civilization, and the making of iron objects remains important among them. A standing statuette of a woman (Plate 53) was carved in fact by a Manding-speaking blacksmith. The statuette possibly represents a twin image (*flanitokole*, lit. "double which remains"), according to Pascal James Imperato, one of the ranking author-

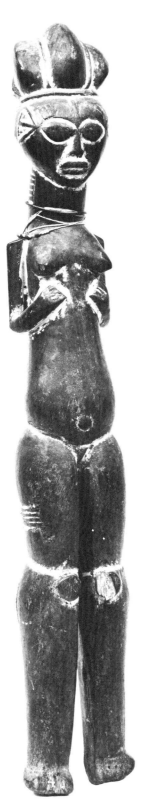

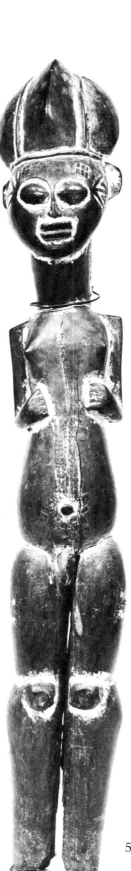

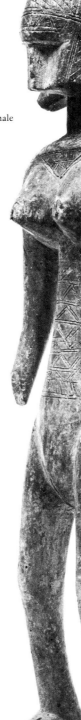

Plate 53
Mali, Bamana, standing female
figure, wood, 19"

Plate 52
Ghana, Kulango, standing
male figure, wood, 38"

Plate 51
Ghana, Kulango, standing female
figure, wood, 32½"

50

ities on the art of the Bamana.

This image stands as a sister of Sundjata must have stood, relaxed but proud, powerfully emphasized breasts telling of her womanly force and ancestrally based fertility. The elegance of her coiffure is a cryptic statement on life lived well, for such an elaborate crest could only be made through the cooperation of others, sympathetic sisters or co-wives or friends. Her manner of beautiful standing places in superb relief readiness to bring good fortune to fruition. She would step forward, as Sundjata did, directly to confront a crisis, lending her ancestral, ordering posture to the situation by mystical means.

We now travel to another historic area of Africa, Yorubaland, the most urban area of traditional Africa. Here thousands of twin statuettes have been carved. The function of these images, called *ere ibeji*, is essentially to appease the spirit or spirits of departed twins so that the continuing fertility of the twins' mother will not be impaired. Twin statuettes are ritually bathed and even offered food and sacrifice. They form a most interesting instance of iconic standing:

> Twins are described as 'standing straight' *(aduro gangan)*. Their position, hands at the sides, arms parallel to the body, is a sign of alertness, being ready to do everything. They are not relaxing. They are standing, either to hear a prayer, or to act.[14]

In fact all the gods of the Yoruba, a leading diviner maintains, are so visualized in the traditional imagination: eyes emphasized and alert, arms at the sides of the body, hands touching hips or the sides of the thighs. God Himself stands in this way. There is a saying: God-Almighty-Standing - Upright - Behind - True - Power - To - Bring - Things-To-Pass *(Olodumare aduro gangan lehim ashe otito)*. Twin spirits stand in readiness to heed the lineage prayers; God stands ready to reshape whole worlds and destinies.[15]

"However the final phase or the initial moment of a movement is characterized," writes F.J.J. Buytendijk, in his study of human motion, "the standing position is always the first phase of a new activity."[16] By the same token, an aura of beginning or potentiality strongly conditions the standing images of the gods in the Yoruba visual tradition.

The latter quality is sometimes strongly communicated by the treatment of the eyes. There are some styles of Yoruba figural art distinguished by the huge diameter of the eyes. An insistent stare is sometimes enhanced by a pupil of iron driven into the wood, a specially conjured "ocular confrontation" that compares with the enormous eyes of figures representing deities from Abu Temple, Tell Asmar c. 2700-2500 B.C. in ancient Sumeria.[17] It is interesting that the Sumerian gods were supposed to reside within these images. In Yorubaland today when certain fiery deities, such as the thundergod or the god of

Plate 54
Yoruba devotee

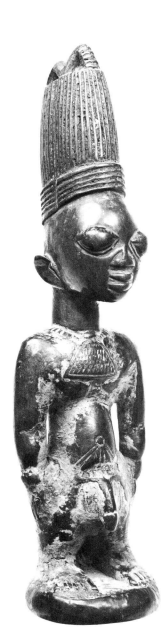

Plate 55
Nigeria, Yoruba, "ibeji,"
wood, 11¾"

51

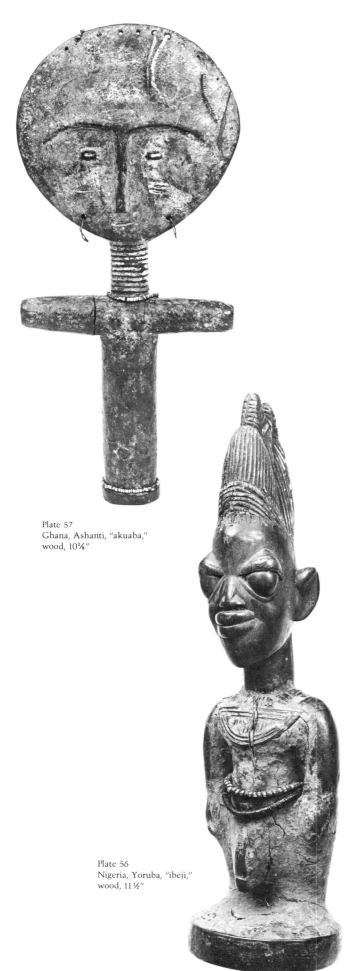

Plate 57
Ghana, Ashanti, "akuaba,"
wood, 10⅛"

Plate 56
Nigeria, Yoruba, "ibeji,"
wood, 11½"

iron, possess their devotee, the eyes bulge and are caused to shine and swell most dramatically (Plate 54). Twins are believed to be the children of the thundergod, in some parts of Yorubaland. It is, therefore, probably meaningful that some twin cult statuary is not only dressed with thundergod possession priest coiffure and cosmetic coloring, *viz.* indigoed hair and camwood-tinted body,[18] but also bears eyes of pronounced curvature and impact (Plates 55 and 56). The neutral hands of twin standing position make the drama of the eyes, a possible intuition of possession, all the more striking. The gods of the Yoruba, Araba of Eko explains, look broadly over the whole of man's world; they "open their eyes abnormally."

Therefore, standing as a twin spirit might be succinctly defined as the stabilizing of bright inquiring eyes of divinity within the upright position of spiritual readiness.

There are further illustrations of standing. An image of a woman from the north of the Ivory Coast (Plate 10), attributed to the Guro, but possibly carved for a Dan patron, exemplifies a combined relaxed and handsomely composed manner of maintaining bodily verticality. Her eyes narrow discreetly, in the scintillating quality of somnolence which is said to wreak erotic havoc on the young men of the Dan, who border on Guro country. This image also fulfills another Dan canon of fine womanly standing: "it is not good for a beautiful person to be stiff in body when standing" *(me sa ba do kpei da sy ka sa)*.[19] The gentle inflection of the arms and legs makes of this carving a most attractively posed exemplar; the forward presentation of her arms suggests something like the Dan gesture of positive reaction, "as if to embrace the dancer,"[20] and perhaps, like the hand-upon-the-heart gesture of Akan and Kulango, deepens the goodness of stability with further references to virtue.

"Among the activities none so engages the whole frame, none permits, in the phrasing of the position of the members and of the head, so many independent variations according to circumstances One could even suggest that, in terms of expressing inner life, the standing position is no less eloquent than mime."[21] The truth of this observation can be illustrated by further reference to the expressive variety of African standing images.

Thus the famous Akan *akuaba* figures, (Plate 57) carved in wood and worn against the back of an expectant mother to foster the beauty of the coming child (as well as other functions), present an unusual mode of abstract standing. Their purpose, I repeat, is to convey, in jewel-like focus, the contemplative beauty of the ideal infant. There are many styles. Ashanti akuaba have splendid disk-like heads; Fanti heads (Plate 58) are rectangular. This contrast is a hint that the head is the most important element of these standing figures. Thus the ruler of the town of Agogo in northern Ashanti in the process of an interview on 19 May 1969:

52

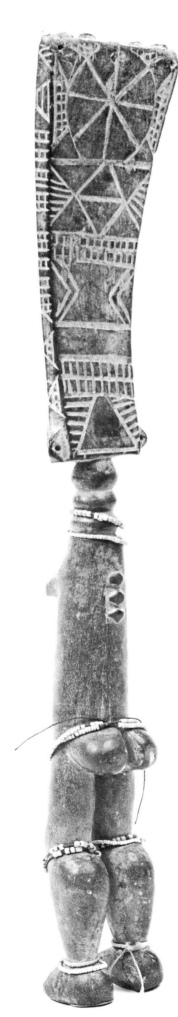

Plate 58
Ghana, Fanti, "akuaba,"
wood, 12¼"

Some Ashanti chiefs own akuaba. The main reason they do is to show them to pregnant royals [royal women of the court] so that they will bring forth a child *with the same head.* These pregnant women keep on gazing, until they give birth to a child with a head like the disk of the akuaba.[22]

Ideal head shape is, therefore, primarily communicated by some forms of akuaba. Yet mothers, according to another informant (Thomas Akyea of Agogo) do not wait on magic; they have a more practical method of realizing aesthetic ambition—upon the birth of the child, soft cloths dipped in hot water are applied to the skull of the infant and an attempt is made to shape its head into the desired sphericity.[23] Some Ashanti akuaba, therefore, stand to communicate not bodily grace as such (foreigners have been puzzled by the abstraction of the trunk and limbs), but roundness of the head.

Such akuaba "stand" in an abstract manner. When attached to the back of the expectant mother, worn as a virtual doll, it could be argued that the occasional lack of feet suggests dependency (Plate 59). Certainly the motif of the rigidly outstretched arms stabilizes the image against the back of the wearer. However, some akuaba images from northern Ashanti and Kumasi show beautifully shaped bodies, standing with arms held neutrally at the sides, like Yoruba twin statuettes.

There are other modes of standing. One suggests an icon of generosity. Dr. Paul Gebauer, the leading authority on the visual arts of the Cameroon, attributes a standing image of a woman (Plate 60) to the Kaka-Ncha group of the Mfumte area, upper Donga River and dates it to this century.[24] Pegged lines outline the milk-distended breasts; they represent a mode of cicatrization. Pointed head suggests coiffure, and grass inserts simulate earplugs and nose-plug. The image stands, in other words, partially to suggest the nature of Kaka-Ncha feminine grace and beauty.

These associations combine with the power of the main gesture of the figure: the woman places hands against the arc of her belly to emphasize her pregnancy. She seems to offer life, an implied gift devoutly to be desired by women who use this image. Women pour libations on this image, hoping to have children. The function fits a remarkable generosity of gesture.

The royal art of Kom, in the Cameroon Grasslands, is, by contrast, urban and monumental. Thus Tamara Northern:

In the panoply of Cameroon art, with its manifold styles of figures and masks in wood, beaded sculptures and its wealth of pottery and brass arts, one encounters a type of figure which amidst the dynamism of forms generally associated with this area may almost be considered an anomaly in the static repose of naturalistic life-size proportions and the

53

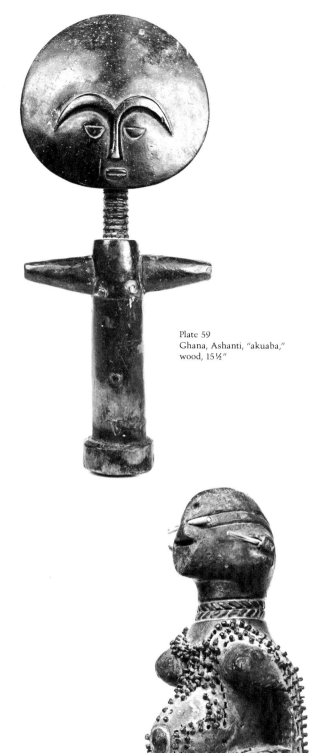

Plate 59
Ghana, Ashanti, "akuaba,"
wood, 15½"

Plate 60
Cameroon, Kaka, standing female
figure, wood, 20"

serenity of facial expression: namely, the throne fig-
ures of the Kingdom of Kom, of which only five are
known to exist outside Africa.[25]

One of the five Kom throne-figures is in the White Collec-
tion (Plate 61). According to Tamara Northern, the tower-
ing figure of a naked woman who presides over the
throne probably represents, albeit generically, the great-
great-grandmother of King Foyn Yu, whose reign is said
to have lasted from about 1865 to 1912. For all the histo-
ricity and magic presence, the figure strikes a calmly
reassuring gesture, because the ancestor in traditional
Africa is an extension of the living elder. Thus a point
made by Jan Vansina apropos of Tio (eastern Teke) cus-
tom also applies to what I have observed of ritual life in
Cameroon, namely, that respect shown to ancestral spir-
its is of the kind accorded to living older persons.[26]

The queen mother is restored to youthful vitality; her
thighs are especially beautiful and well-shaped. Her ges-
ture is reverential, not awesome, something seen in the
normal course of courtly events. She presents kola to the
king, taking care to cover the gift, cupped in her left hand,
with the curve of her right hand. The gesture is also inter-
preted, by members of the present court of Kom, as clap-
ping in salutation of the Foyn. The act of giving, either of
kola or of supportive sound, was monumentalized by a
carver to the King of Kom.[27]

A particular gesture, touching naked breasts with both
hands, specially enlivens the standing position in stat-
uary representing women. Among Yoruba the conven-
tion may symbolize, generally, acceptance of the role of
woman and generousness of presence. It is a promise—"I
shall feed my children from my breasts"—and a meta-
phor, protection of a social grouping by a presiding female
spirit.[28] By contrast, among western Dan the gesture is
involved with serious speech. A mother in Dan culture
swears on her breasts to seal a serious vow.[29]

The convention is powerfully used among the Kongo.
There is an elegant rendering of the theme in the White
Collection (Plate 62). Fu-Kiau Kia Bunseki Lumanisa and
John Janzen, leading authorities on Kongo cosmology,
suggest the meaning of this image:

> She stands to pronounce a blessing. In Kongo culture,
> even today, when there is trouble or crisis, and a
> person is compelled to leave his family on a danger-
> ous or risky mission he seeks, or is sought out, by a
> senior woman of the clan. The person to be blessed
> kneels before her. She receives him in the nude. He
> avoids staring at her breasts and maintains a respect-
> ful direct gaze into her eyes. She holds her breasts in
> her hands. As he kneels, in front of her, she strikes
> her right breast three times on his head, thus associat-
> ing the act, by the use of the number three, with the
> other world. As she does this, she strongly blesses
> him, saying, may there be no accidents, may all go

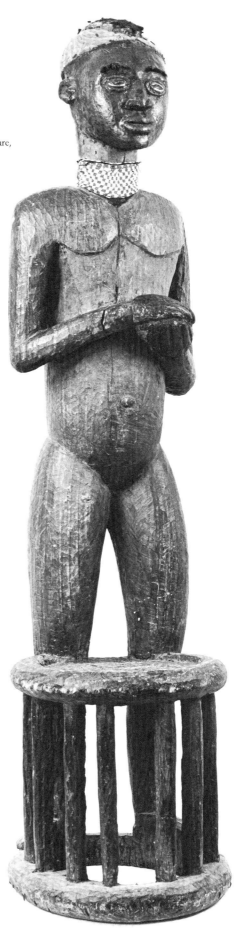

Plate 61
Cameroon, Kom, throne figure,
wood, copper, 69"

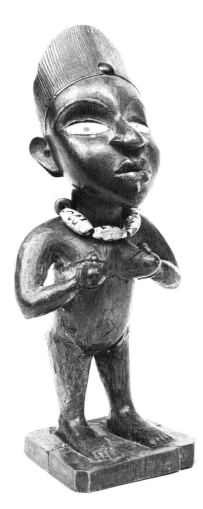

Plate 62
Zaire, Kongo, standing female
figure, wood, glass, 8¼"

55

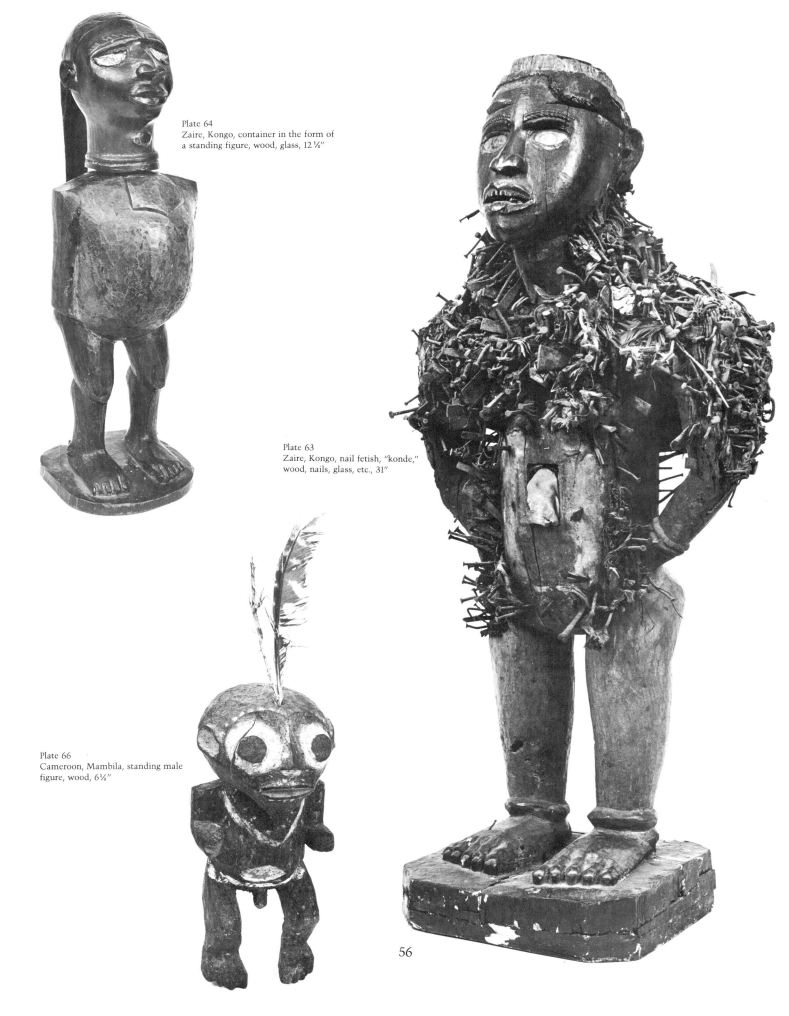

Plate 64
Zaire, Kongo, container in the form of
a standing figure, wood, glass, 12 ¼"

Plate 63
Zaire, Kongo, nail fetish, "konde,"
wood, nails, glass, etc., 31"

Plate 66
Cameroon, Mambila, standing male
figure, wood, 6¼"

56

Plate 68
Cameroon, Mambila, standing figure,
pith, 7½"

Plate 65
Zaire, Bena Lulua, standing figure,
wood, etc., 5¼"

Plate 69
Ivory Coast, Baule, shea butter
container, wood, 8½"

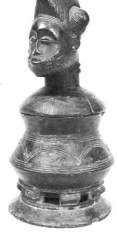

Plate 67
Cameroon, Mambila, standing figure,
pith, 7½"

well with you, may all be reconciled, and so forth. She holds her breasts in both hands before and after the pronouncing of the blessing.[30]

This crisply carved standing image thus conveys one of the most powerful manifestations of womanly force in Kongo culture. The holding of the breasts italicizes the act of benediction. The sanctity of the gesture is extended by her regal standing, her beads, and the richness of her crest or coiffure. As an elder, she is a quasi-ancestor. There is more than a hint of other-worldliness in the glitter of her eyes of glass. The flash of mirrors, painted glass, and the shimmering of the sea are all symbols in Kongo for the world of the dead.[31] She is in touch with that world. Of course, there is no indication that an old woman is standing here. African ephebism has honored her rank by transformation into an attractive youthful frame.

A different kind of transformation, sometimes horrific, qualifies the making of certain magic sculptures in the lower Zaire region (Plates 63 and 64) and includes a Bena Lulua charm from the interior of Zaire (Plate 65). These images seem fully charged with magic purpose; they suggest that the calm of the standing position has been used as a stabilizing base for fiery purposes or secret aggressions.

Magic statuettes by the Cameroon Mambila are extremely interesting. One such figure (Plate 66), according to Paul Gebauer, guarded the point where a palm wine tree was tapped. Only one such figure was needed per tree. Flexed and staring, the figure radiates a posture of readiness. The feather headdress warned passers-by that the statuette was not attached to the palm tree for decoration.

Two raffia-pith figures (Plates 67 and 68) also come from Mambila country. Both served as guardian figures of the village ancestor house.[32] Their power seems to reside in their eyes and mouth; they are essentially flattened, abstract forms, suggesting vigilance and deterrent power. Additional pieces of raffia-pith represent the arms and hands, simultaneously gesturing and blocking the way.

Communication of the idea of standing is sometimes achieved through abstraction in African sculpture. The coordinates of the body are abbreviated and recombined to embellish objects of use and play. Thus a Baoule shea-butter container, carved in wood (Plate 69), is fashioned so that the edge of the lid implies the projection of the breasts; the receptacle below, the protrusion of the belly; and the inflected support, possibly, knees bent to suggest the dance or relaxed forms of standing. This abstract rendering of the fullness of the beauty of woman, therefore, stands to suggest the enclosure of goodness and strength within brilliantly subdivided mass.

Some societies excel in fusing objects of use with realistically carved human legs. Utilitarian objects are

thereby transformed into sources of aesthetic contemplation. This stems from the same compositional rules which generate the playing of the body parts with independent impulse and aliveness in the dance. Thus the reshaping of the body with "made" shoulders and "played" toes, according to the canon of vital aliveness, can be profitably compared to "playing of pattern" in the art of Dan spoon-making (Plate 70). In this tradition the ladle of a rice spoon and the limbs—or head—of a beautiful woman are detached from their respective fields and are recombined to make a comment on one of the highest forms of morality in African terms, being generous.

Such spoons are carved for *wunkirle*, "most hospitable woman,"[33] famed for invitations to her compound where she houses and feeds visitors. Wunkirle and her kinsmen are, by definition, superlative cultivators, hence the surplus food. On certain feast days Wunkirle dances, swinging her special figurated ladle, "dancing" the object, while a chorus of women chant encouragement and back her singing and her dance in call-and-response fashion. Other quarter women follow. These carry bowls of rice. Upon arrival at the village square, Wunkirle dips into the displayed bowls of rice and begins the distribution. The custom can be summarized as a danced demonstration of largesse.

The spoon extends the custom; the generous ladle recalls the giving; and the figurated handle, in this instance, recalls the dance or beautifully inflected standing. The limbs are muscular statements of flexibility and potential. On the back of the ladle (Plate 71) an artist has incised an outline of a reptile. Himmelheber identifies the motif:[34] it is the lizard *(waran)*, a creature of the soil, making contact, within the earth, with the ancestors, hence an important intermediary whenever a woman wishes supernatural aid in having children. The siting of this motif on the swelling curve of the ladle would appear to blend communication of one kind of plenty with another. This strongly suggests the ladle is a cryptic rendering of the swelling curve of a woman come to term, as well as a promise of increase and plenty. In fact, William Fagg has shown that wunkirle spoons terminate in either the head or the legs of a woman. He adds: "it is not clear whether these have the same or an opposite significance."[35] If my hypothesis is correct, *viz.* that the ladle is a suggestion of the belly, then the significance, the giving of life in many senses, would remain the same.

Suspension of the expected contours of the human frame, in order to accommodate the form and embellish the contours of a useful object, characterizes the splendid human-shaped harps of the Ngbaka of the northwestern corner of Zaire (Plates 72 and 1).[36] Strings are missing from our examples. A small human head presides over the long curved neck. The shaping of the torso as a hide-covered resonating chamber, and the addition, to this abstract torso, of legs carved fully in the round, inflected

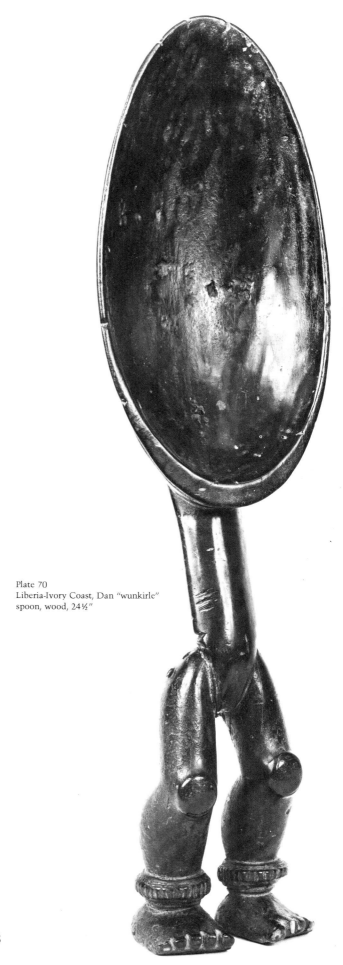

Plate 70
Liberia-Ivory Coast, Dan "wunkirle" spoon, wood, 24½"

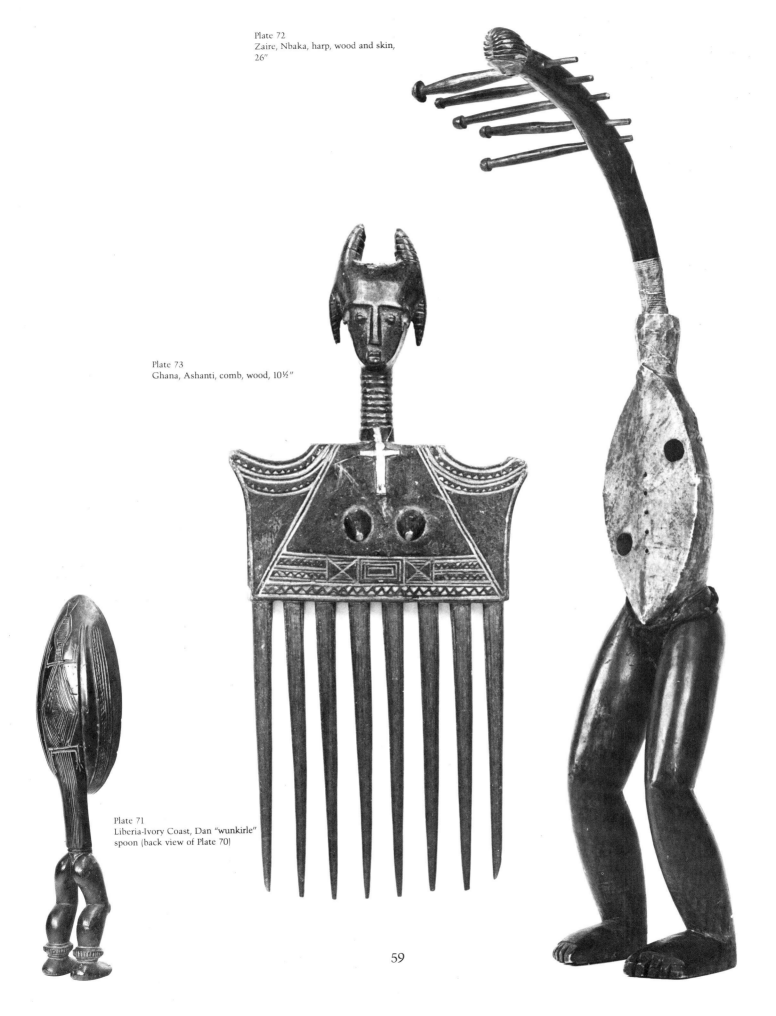

Plate 72
Zaire, Nbaka, harp, wood and skin,
26″

Plate 73
Ghana, Ashanti, comb, wood, 10½″

Plate 71
Liberia-Ivory Coast, Dan "wunkirle"
spoon (back view of Plate 70)

59

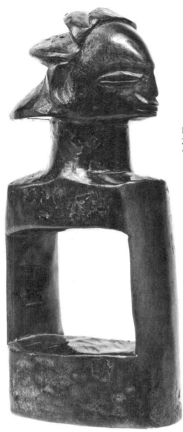

Plate 74
Zaire, Luba, divination implement,
"Katatora," wood, 5"

to show ease or dancing, are impressive details. Expected continuities, within the shaping of the human body, have been suspended and then regained at different levels of visual impact and dimension. The Ngbaka manner of abstractly "standing"[37] a musical instrument seems a further instance of *Afrikanische Aufheben* made visual.

There is another mode of embellishment, incorporating abstracted elements of the human standing position: subtract the legs and leave the head fully in the round. Witness an Akan comb (Plate 73), with akuaba-like arms implied within incised curves below the shoulders. Breasts and head are realized in relief. The ringed neck, sometimes compared to the elegant stem of the adekum calabash, is a mark of luxury and aristocratic status.[38] The rhythmic repetition of the teeth of the comb becomes a pun, in this context, on supporting members, and fuse with their normally intended use in brilliant counterpoint.

Abstractions of the torso and the limbs characterize Luba *katatora* (Plate 74) or divination implements, some forms of African heddle-pulleys (Plate 75) and dolls (Plates 76, 77 and 78). The last-mentioned instance is particularly interesting; in this series of Mossi dolls, the last two attributed to "Luluka," the assertive thrust of breasts is fused with an implication of arms, in a brilliant simplification.

A staff of office is another form of sculptural standing. Trunk and members are fused within a single shaft and, often, only the representation of a head, at summit, suggests the presence of a man or woman. For example, titled women of the Sande Society of Sierra Leone merit the prerogative of staffs (Plate 21). The finial and its embellishments communicate the fullness and meaning of participation in two important aspects of traditional Sierra Leone society. The neck rings communicate luxury and abundance.[39] They are considered sexually attractive in both men and women. Their presence suggests high status, as well as the fattening process, within Sande schools, for initiates. The smooth face and pursed lips are associated with "seriousness" in the minds of Mende informants, according to a field study made by Frank Dubinskas in 1967.[40] The emblematic crown at the summit of the staff communicates "ornateness" and "sacred magnificence," possibly further relating to house top finials, used as protection against fire and theft, and the "mystical heat" of the witches.[41] The staff, then, suggests the disciplined, superb standing of the Sande elder, finished with an emblem of security.

Yoruba iron staffs for the deities of medicine, Osanyin and Erinle, are abstract counters of extraordinary standing. The human head is replaced by an ancient convention which, in a deep sense to be considered here, permits mind to view itself. This convention entails the surmounting of a bar of iron with a representation of a single bird, also in wrought-iron, (although there are hints that

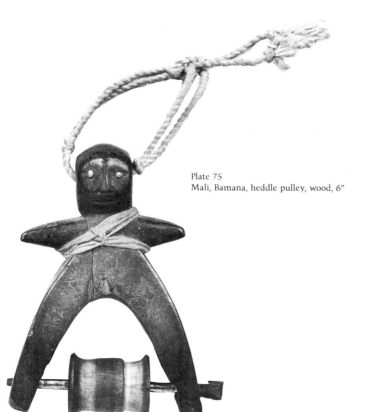

Plate 75
Mali, Bamana, heddle pulley, wood, 6"

60

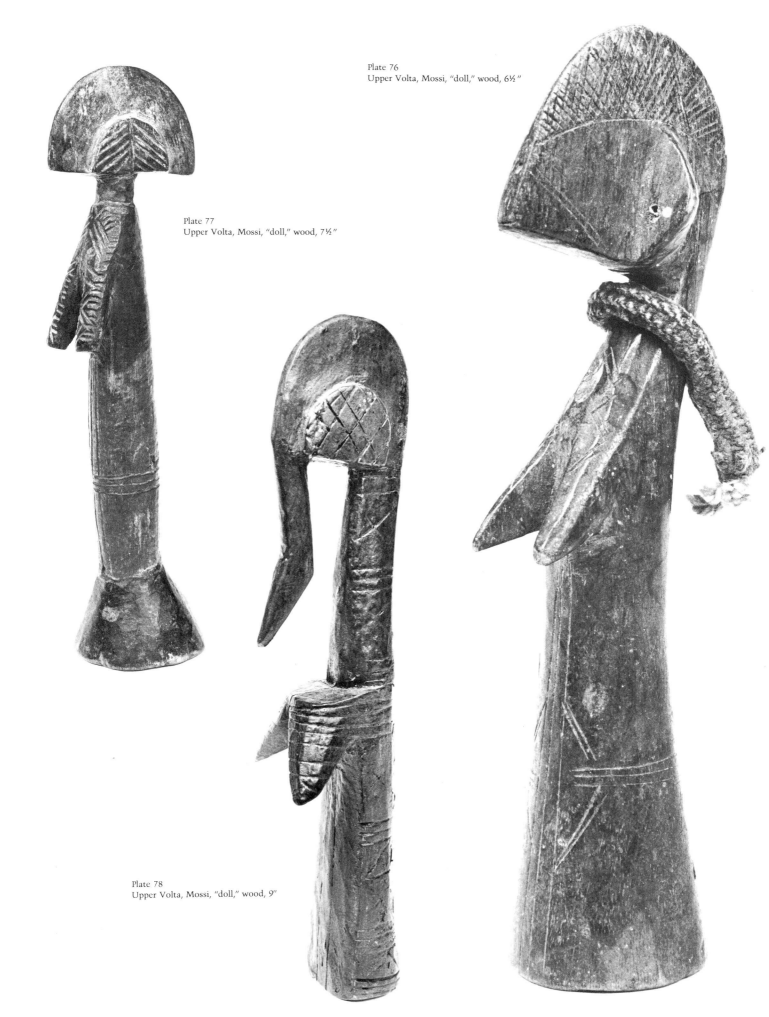

Plate 76
Upper Volta, Mossi, "doll," wood, 6½"

Plate 77
Upper Volta, Mossi, "doll," wood, 7½"

Plate 78
Upper Volta, Mossi, "doll," wood, 9"

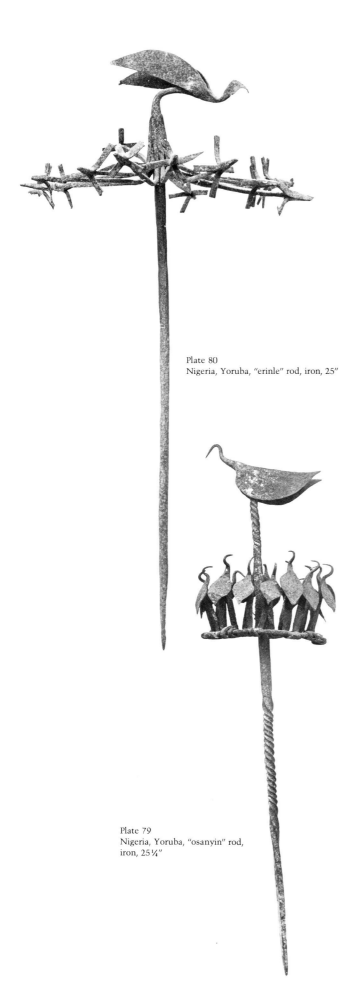

Plate 80
Nigeria, Yoruba, "erinle" rod, iron, 25"

Plate 79
Nigeria, Yoruba, "osanyin" rod,
iron, 25¼"

in antiquity actual heads or skulls of birds were impaled and mounted at the top of iron bars) or a grouping of minor birds under a commanding bird of symbolically larger dimension. It is the latter instance that we consider here (Plates 79 and 80). The first probably came from Oyo, a major collection point for such staffs, characterized by an inward-gazing circle of minor birds, perched on an iron circle, and surmounted by a lordly bird of superior plumage. The second matches staffs for Erinle seen by the writer in the vicinity of the Egba metropolis of Abeokuta, and is characterized by the interesting shaping of the minor birds as dart-like elements which seemingly speed in every direction from the center of the staff below the commanding spirit. In another volume I have already given what seems to me the closest concordance in the verbal arts of the Yoruba with this important visual theme, of which the following is a rapid paraphrase:

> The witches of the Yoruba town of Otta surround the Yoruba god of divination in the form of birds. He, too, becomes a bird, a lordly bird. The birds of the witches surround him and fix upon him their annihilating gaze. But he sits down, thereby emphasizing superiority and ease. He reveals that he has taken the precaution of arming himself with a very hard seed, a featherless chicken, and when they circle around him he says, triumphantly, witch is not fierce, she cannot eat the hard seed, witch cannot kill me at all, featherless fowl lacks wings to fly over the house, witch cannot kill me at all.[42]

God of divination was spared by superiority of mind. Imperturbable, he knew what to do and how to do it. His mind, his bird, neutralized the fiery witches and restored the universe to order. It is in this sense that this powerful image permits mind to view itself, for the ordering of the witches of Otta is a symbol of the power of the alienist and the diviner, men who use such staffs, to restore sanity and social purification through knowledge of appeasing and destroying evil. The sophisticated tales of the trickster in Yoruba lore point out frequently that the "evil" or the "enemy" often lurks within our own insecurities, which are part of our being, part of our mind, and which we must strive to control, even as the witches of Otta were ordered below the confident bird of divination.[43]

Evidence for the deeper interpretation of the birds, as the image of mind itself, comes from testimony shared by one of the leading diviners of the Yoruba world:

> The House of the Head (a cowrie-studded crown), if you look at it closely enough, resembles a sitting bird, a big, white sitting bird, all rounded up in whiteness. This represents *eiye ororo*. The ancient Yoruba believe that the spirit of God is in man's head in the form of a bird. When man was created as mind, God breathed in him. This power is in the brain and in the

head.... There was a time when the god of medicine, Osanyin, was doing magic, first with one head, then with another, and so on until by and by he was working magic with sixteen heads. And each of these heads was a bird.[44]

This powerful symbol, bird as mind, permits the higher power of the brain, to control evil impulses, to become visible. Two-headedness is a classical image of witchcraft in Yorubaland. This suggests the conquest of evil is mind's most important function.

But mind must be supported by a physically strong body. Hence there is a cautionary proverb, linked to the use of bird-surmounted staffs of iron in Yoruba herbalism and divination, especially in the field of divination. Diviners given an iron staff (osun) with a single bird (head) are told: "we always meet the osun staff standing vertically and erect" (aduro gangan ni aba osun).[45] The power of mind depends upon the vertical position. This is the closest symbolic link I know in African tradition between standing as a position and man's rationality.

The bird staffs of the Senufo (Plate 81) are fashioned in another medium, wood, and function on an apparently different plane. Senufo bird staffs are surmounted by a major bird who supports the minor birds upon her back or wings. The birds are disposed in a manner that suggests flying or momentary alighting upon a perch. Such staffs were apparently given as prizes in agricultural contests in which the most skillful tiller of the soil was appropriately lauded.[46]

The staff of office (mvwala, kolokolo) or baton (nkawu) was associated with standing important persons in nineteenth century Kongo culture: "if a chief visits another village, he should walk with short steps and lean somewhat forward, not looking behind him. He holds a staff in his hand."[47] The staff extends dignity in Kongo; it also extends virility, being associated with maleness and vigor in an obvious way, related to similar nuancing of swords and guns in Kongo lore.[48]

In a strict sense, according to Wyatt MacGaffey, the chiefs of Kongo did not have power; only the dead did. Therefore, such strength as the rulers possessed really came from the other world. In the context of this belief, the staff or baton was considered not only a sign of office, but a means of communication with the other world. A chief might place his staff (kolokolo) at the head of his bed whenever important negotiations were thrust upon him, hoping that the ancestors might reveal, in dreams, the true tradition, to teach him what to say on the following day.

A standing Kongo image of a man in Western clothing of the late nineteenth century (Plate 82) holds a cane (mvwala). This staff fits into traditional contexts which are surcharged with mystic beliefs. Even today in the region of the lower Zaire certain high-ranking members

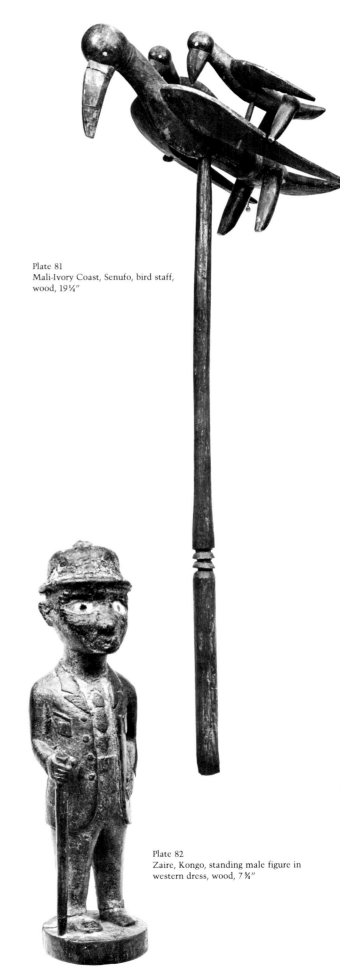

Plate 81
Mali-Ivory Coast, Senufo, bird staff, wood, 19¼"

Plate 82
Zaire, Kongo, standing male figure in western dress, wood, 7¾"

of prophetic religions are believed to be able to speak with their staffs, as if on the telephone, and to shoot down enemies from the sky with their canes.[49]

Tu-Chokwe staffs of office (Plate 83) suggest further powers derived from other worlds. In this instance, the staff is surmounted by four human heads, each bearing the stylized rendering of a chiefly coiffure recalling the image of the culture hero, the great hunter-chief, Tshibinda Ilunga Katele, who is represented in sculpture wearing a flowing version of the same coiffure.[50] Such staffs seem to be abstract counters of ancient standing power.

There are a number of standing images remaining in the White Collection. Two are Mossi (Plates 84 and 85), one is Toma (Plate 86), and another has been attributed by the late R. E. Bradbury to the Ishan village of Amaho, east of Benin City (Plate 87). All show the graceful confidence that makes the standing position in tropical Africa an artistic expression of strength.

I close with two sculptures. The first comes from the territory of the Benue River in northern Nigeria. In the late 'sixties certain figures began to appear on the international art market which were first attributed to the Jukun, then to the Chamba. It remained for Arnold Rubin, the leading authority on the art history of the Benue area, to place them accurately.[51] He identified these pieces as Mumuye, from a group of speakers of an Adamawa-Eastern language, living between the Fan Magna and Iwi rivers, south of the Benue.

In 1970 Philip Fry described the Mumuye style range.[52] He found the tradition characterized by "spiralization," of the whole form about the main vertical axis. He also talked about the repetition of surface planes at the level of the legs. These points apply to our example (Plate 88), which is specially enlivened by an extraordinary rippling of the arms, in counterpoint with the long torso.

Rubin, in his doctoral dissertation, *The Arts of the Jukun-Speaking Peoples of Northern Nigeria*, has shown that northeastern Jukun statuary, roughly bordering on Mumuye territory, was primarily associated with ancestral figures who had the power to bring rain, as well as resolve situations of great crisis.[53] In the light of his findings, it is extremely interesting to return to consideration of the almost electric shimmering of the arms of the Mumuye figure we have been examining. It is also extremely interesting that Philip Fry has discovered bars of iron, made by Mumuye smiths for Mumuye ritual "masters of the rain" that correspond in form with the marked spiralling forms of Mumuye statuary.[54] It is tempting to suggest that what distinguishes the arms of the Mumuye figure in the White Collection is precisely a cryptic reference to the zig-zag of lightning, and, by extension, the power to bring down rain.

The play of surfaces is less accentuated among sculp-

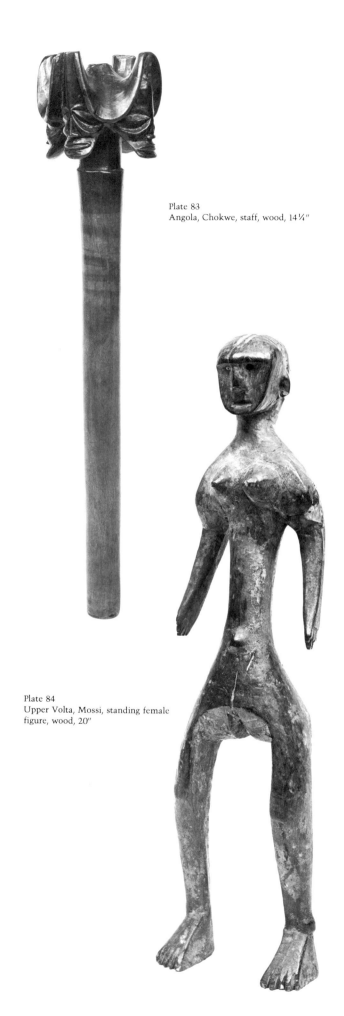

Plate 83
Angola, Chokwe, staff, wood, 14¼"

Plate 84
Upper Volta, Mossi, standing female figure, wood, 20"

64

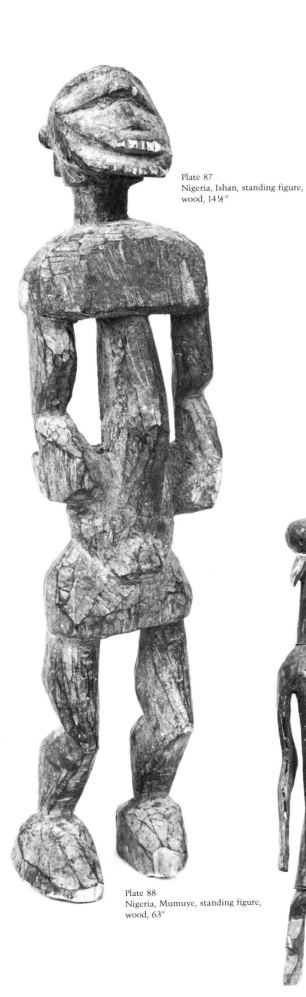

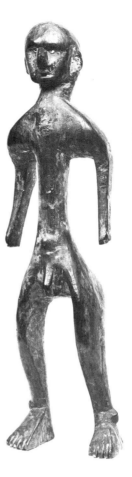

Plate 85
Upper Volta, Mossi, standing male figure, wood, 19½"

Plate 87
Nigeria, Ishan, standing figure, wood, 14½"

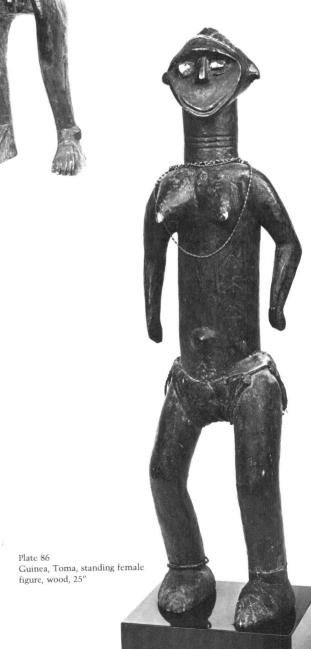

Plate 88
Nigeria, Mumuye, standing figure, wood, 63"

Plate 86
Guinea, Toma, standing female figure, wood, 25"

tures attributed to the Montol and Vere peoples, also of the Benue area. This point is illustrated by a powerful, compact image in wood of a standing woman (Plate 3) which I tentatively attribute, on the basis of concordance with a documented figure in the Musee de l'Homme, and stylistic resonance with Montol figures illustrated in Roy Sieber's *Sculpture of Northern Nigeria*, to the Montol.[55]

This, possibly, Montol figure is powerfully expressed. The light that falls upon her thighs and forearms is brought alive by vigorous facetting of surface planes. The animated quality by which this sculpture reflects the light implies motion. The implication is extended by polished curves and sharp facets. She brings to life *les tresors de souplesse.*

The last object, a figurated throne from the Kingdom of Kom (Plate 89) in the Cameroon Grasslands, has been documented by Gilbert Schneider:

> The throne was kept in the king's treasure house . . . the new king sat and was dressed in it just once, at the beginning of his reign. [Iconographic detail] illustrates a legend of one of the migrations of the Kom. One day a bird flew out of a tree. The bird was followed by a python which, in turn, was followed by a very beautiful woman. She was followed by an entire village. Where the snake, after about three weeks of travel, sank into the earth . . . there the new village was built.[56]

The *dramatis personae* have all been represented (python, bird, beautiful woman), but two have been imaginatively doubled and the woman rendered more impressively herself in sure and confident symmetrical disposition. This founding ancestress, identified as a woman by breasts and almond-form coiffure,[57] communicates, in heraldic standing, the founding of the kingship. At the same time she honors the point at which modern kings receive their raiment on the day of coronation. The unfolding of the legend, as backdrop for polity, suggests, in a particularly rich manner, that within each sphere of endeavor there is a quality of grace of inspiration which eludes our calculations. That quality can only be ascribed to the presence of the ancestors.

In conclusion, as Guido von Kaschnitz-Weinberg points out, the standing position in figural sculpture represents a world that is intelligible.[58] It is intelligible in the sense that powers of mental and physical equilibrium have been established in relation to a vertical axis. Man contests, successfully, laws of mass and gravity, and thus establishes a cosmic principle of action. The quality is inherently heroic and rational, associated with the continuing presence of minds of chiefs and departed rulers. Standing images ideally are distinguished by an immortality-conferring, extra-temporal power that splendidly suggests a sphere of pure achievement.

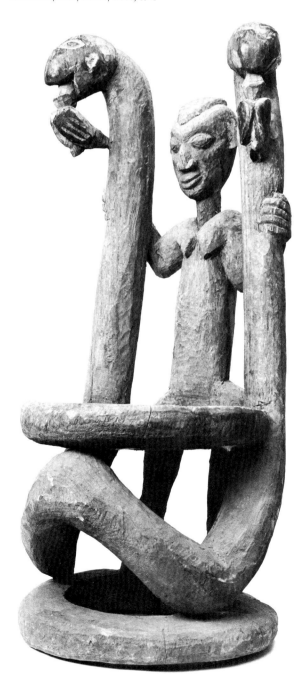

Plate 89
Cameroon, Kom, throne, wood, 39½″

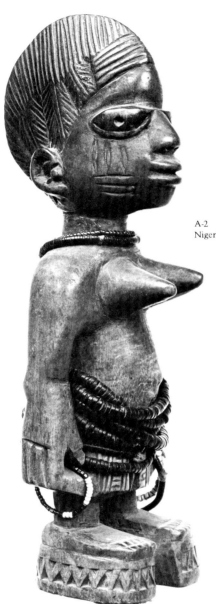

A-2
Nigeria, Yoruba, "ibeji," wood, 9¼"

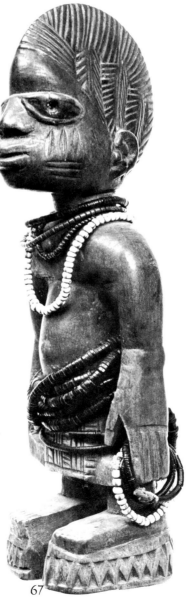

A-3
Gabon, Mitsogo, gong, wood and iron, 13½"

A-1
Nigeria, Yoruba, "ibeji," wood, 9¼"

2. SITTING

The enthroned gesture also communicates permanence, as well as calm, and a sense of character. The calm of the position stems from the easing of the task of standing; the person who rests upon a chair can concentrate upon important social matters, as a member of an assembly, or as an honored guest. He takes his chair as a fundamental right or privilege.

Permanence is suggested in African verbs of sitting. The Yoruba phrase for "place of sitting" is also used to mean "place of residence" *(ibi ijoko),* and restlessness is referred to as lacking a place to sit down.[59] Compare Efik usage, in eastern Nigeria: "that town is seated by the river."[60] Among the members of the Bwami Society of the Lega of eastern Zaire the superbly polished *kisumbi* stool lends a variety of symbolic meanings to the act of sitting and in some areas a special rite is built around the object. There is also a Lega aphorism: "every chair has an open space," meaning that a person in this civilization is a potential notable of "virility and manhood, poise and character, and status; one who is fully human."[61]

In Africa, the seated person, conscious of the privilege of his position, must show awareness of himself as an object of perception. He must present a fitting image to the world. He must teach by manner of composure. To sit well is to savor life on a plane of deliberation and it is possible, at least in one traditional society, to envision this perfect whole from a single isolated part. Thus a woman from Kendem in Banyang country astonished me in June 1973 by looking at a photograph of a calm terracotta visage from Akan antiquity (Plate 5) and remarking, "the way he sits is beautiful" *(achoko erere).*[62] There was, of course, no body and no chair. But the sense of divine order and ease that is associated with perfect sitting in the Banyang imagination intuits, from facial repose, the orderly placement of the entire body. Sitting, in short, is an icon of repose.

It is appropriate to begin a brief survey of seated images in African sculpture with the Akan. Their civilization is especially concerned with the order of seating, which begins with the eldest member and does not end until the youngest person present has been seated. An Akan must rest upon a chair or stool, or, failing this, upon an animal skin, or he must crouch. But he must never sit on naked earth.[63]

The position of the body in Akan sitting is strictly chiseled. The limbs cannot be crossed.[64] The head and torso are maintained erect. Gaze is straightforward; a person does not look down, a sign of sadness, evil, or heavy unwillingness.[65] A person makes of his seated body, in other words, a frontal vision, symmetrically disposed.

The image of the seated person in Akan traditional sculpture suggests the power of the throne to absolve disorder. Such focus is illustrated by a wood sculpture of a seated Baoule ruler from the Ivory Coast (Plate 90). His flesh is naked, strong and hard, highly polished, recalling an ideal vision, "a state of well-being, bathed, shining with pomade."[66] Light defines his virility and his strength, shining in reflection from his noble forehead, the frontal shield of his chest, his membrum, his thighs. The arms are gently bent. Hands are disposed on the thighs, fingers parallel. Two heavy ivory bracelets *(nze)*[67] ornament the left wrist. The canons of sitting are fulfilled: frontal, symmetrical, elevated, powerful, flexible, endowed with matchless imperturbability. This is a portrait of every ideal Baoule ruler, conscious of his impact on the people, of the necessity of maintaining standards. Similar qualities define a seated male nobleman, Baoule, shown with pegged drum (Plate 91).

"The main duties of the queen mother," it has been said, "were giving of life to the clan or state, at its foundation, and then maintaining of this life."[68] The role of this important figure in Akan court life is illustrated by a terracotta in the White Collection (Plate 92). Queen mother and two children, arranged in beautifully heraldic grouping, suggest that the seated position is a form of composure in which noble persons may disclose their character and their goodness. It is as if the power of recollection and the calm, which the sitting attitude can bestow, has involved this grouping in superior influence wherein their virtues become more visible.

For example, the countenance of the main figure is devoid of distracting particularity. She supports each child upon her knee, and secures them both, with an air of consummate impartiality, which is interesting inasmuch as an actual queen mother could be appealed to by women, in cases of minor offenses, the latter rushing to her presence and crying, "Mother, save me!"[69] This fine example of moral heraldry was perhaps made in the

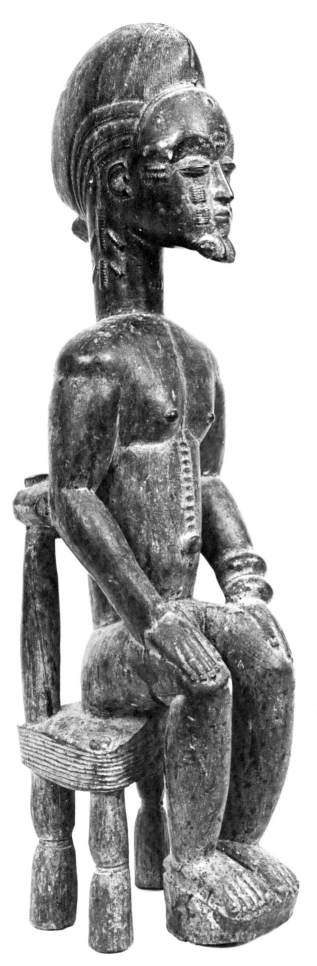

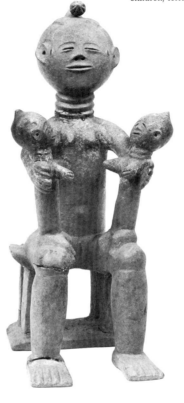

Plate 92
Ghana, Akan, seated female with
children, terra cotta, 19"

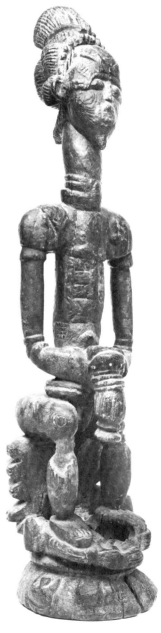

Plate 90
Ivory Coast, Baule, seated male figure,
wood, 30"

Plate 91
Ivory Coast, Baule, seated male
figure with drum, wood, 26"

69

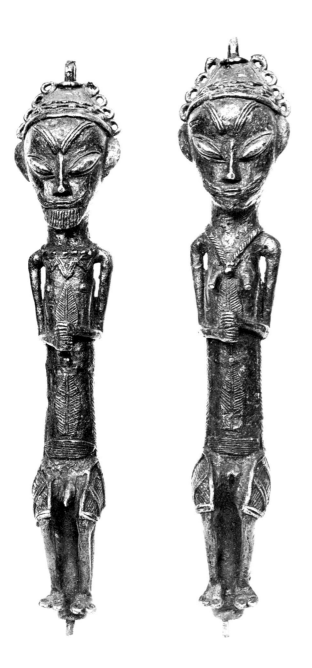

Plate 94
Nigeria, Yoruba, "edan ogboni,"
brass, 15½"

region of Agona Asafu, in southern Ghana, by analogy with a documented terracotta in the National Museum of Ghana.

Yoruba sculptors also situate acts of moral significance within the framework of the seated position, in order to concentrate on the unfolding of generosity. Consider in this regard a figurated container for kola of a kind called *olumeye* ("one who knows honor"),[70] carved in the style range of Efon-Alaiye (Plate 93). A cock is presented by a seated woman, described as a "messenger of the spirits." The cock is actually a lidded container for kola or cakes and, therefore, functions as a double statement of sacrificial giving. "Olumeye" supports one child on her back and guards another, to her right. The keel of her coiffure *(irun agogo)* proclaims her marriage to the gods. She asserts her character in relation to an unseen Other.

When Yoruba seated gestures are made from the summit of an iron staff and are figurated in the precious medium of brass, we know we have entered a realm of special significance. A pair of earth cult brasses *(edan ogboni)* are elegantly elongated and hieratic (Plate 94). Seated brass figures are crowned with impressive heads from which eyes gaze with strangely cutting edges, suggestive of strong possession by the goddess, Earth. The two figures, referring to a foundation myth it is death to reveal to non-initiates, make the ritual salute to Earth by concealing thumbs and fingers in two fists brought before the belly. In actual ceremonies the fists are moved in the direction of the earth three times. Three is the mystic number of the earth. There may be another reference to this number in the fact that the two legs of the seated figures are joined to the undifferentiated cylinder of the staff to make up three sources of support. Three in Ogboni lore is the sign of three stones which support the vessel over the fire, the sign of moral foundation without which civilization topples and falls.[71]

It is reassuring to see these emissaries of the punitive power of Earth, who sit in judgment over everything that men and women do, seated in a relaxed pose. But their gesture refers back to a world of moral vengeance.

The revelation of seated power from the summit of an object also qualifies a brass and iron poker for the Yoruba iron god (Plate 95) and a seated figure of a person surmounting a figurated Loango ivory (Plate 96). The latter figure gazes to the left, a manner of self-presentation that compares with certain Zaire styles, notably Songye (cf. "face to side" figure and "averted face" figure in the Tervuren collection of Songye statuary, 50.42.3; 12258).

In addition, two seated chiefly figures surmount a Baoule linguist staff in an interesting way (Plate 97). They are shown playing *warri*, an African game played with seeds. In all of these latter examples, gesturing or game-playing is conducted from an august summit. Seating lends repose, and elevated seating creates a circumstance in which the nature of the gesture becomes extraordinary.

70

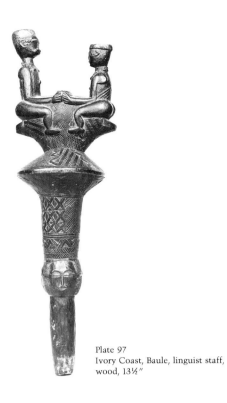

Plate 96
Zaire, Loango, carving, ivory,
5¾"

Plate 97
Ivory Coast, Baule, linguist staff,
wood, 13½"

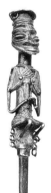

Plate 95
Nigeria, Yoruba, "ogun" staff,
brass, 28½"

Plate 93
Nigeria, Yoruba, figurated
kola container, wood, 14½"

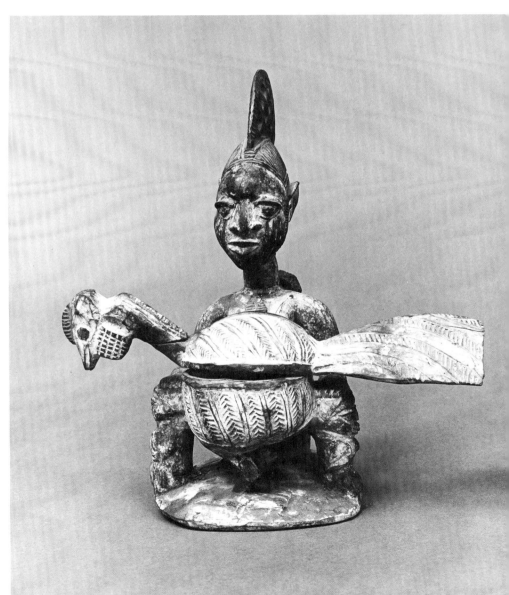

We turn now to the Zaire Basin. There is a complex etiquette involving sitting among Kongo. Thus Laman:

> If a person of the Kongo wants to sit down he should sit sedately with crossed legs and be silent. It is most desirable to sit at the fire; but if several are already sitting there, another spot should be sought out
>
> It is . . . not permissible to sit with legs stretched out towards a person whom one respects. If, after finishing his work, a man wants to sit at home in the village, he should sit with crossed legs, chat with his family At mealtimes a man of the Kongo calls out to his wives to bring out the food; the men-folk sit with crossed legs on their mats. If anyone behaves in another fashion or eats greedily he is admonished.[72]

Kongo etiquette, in fact, compares with the legendary formality of the Japanese:

> After the food, palm-wine is drunk, and the women are generally summoned to join the men-folk in their drinking. When they have finished drinking [the seated guests] may not rise before the one who has served the palm-wine has struck the vessel three times and clapped his hands. All the members of the company should then clap their hands three times simultaneously, and only then is the vessel put away[73]

The formal Kongo sitting pose, legs folded inward and crossed in front of the body, torso and head held erect, resembles the *sila*,[74] or sitting posture, of the Javanese. The trunk is flexibly disposed, however, not ramrod stiff, as in the Indonesian style. Kongo stone images are sometimes carved in this crossed-leg sitting position and one of these, allegedly, arrived in Europe before 1695.[75] The gesture is, therefore, potentially more than two hundred seventy-nine years old in Kongo culture, and may have influenced the royal art of the Kuba, as well, since the seventeenth century.

William Fagg is of the opinion that a human figure in wood from the Sundi region of the lower Zaire represents a seated figure (Plate 98). I quite agree. The artist has evidently represented the legs as a continuously encircling ring, from the back to the front. Frontal enlacement of the legs is merely implied. Crest, head, and patterned cicatrization confer participation in Sundi (Bembe) culture. These are the important elements, emphasized by staccato treatment of mass and linear embellishments. One other point might be made about sitting in Kongo art. The crossing of the legs, conjuring diagonals and angular design, fits very appropriately a sculpture tradition noted for asymmetry of gesture and hard-edged pattern in textile-derived decorations.

In the Zaire Basin the act of sitting sometimes is combined with an important meditative gesture. Thus among

72

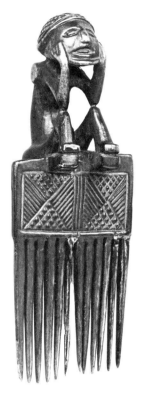

Plate 99
Zaire, Lunda, figurated comb, wood, 6¾₆"

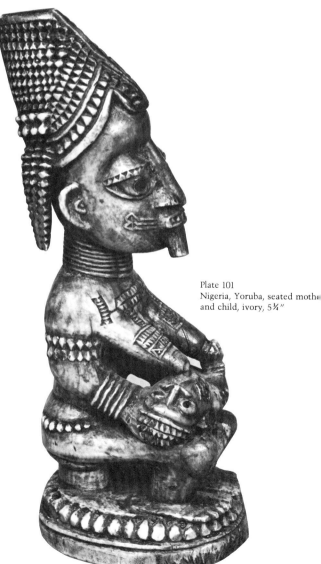

Plate 101
Nigeria, Yoruba, seated mother and child, ivory, 5¾"

Plate 98
Zaire, Bembe, seated
figure, wood, 8½"

Kongo:

Many different movements have each their special significance. If one clasps one's hands together above the nape of the neck *(taka ntaala)* this is a sign of sorrow, weariness, or hunger. Sometimes a person may go and weep thus. If the hands are clasped together above the crown of the head, this signifies a very great grief. To cup the chin in one's hand is a sign that one is pondering.[76]

And among Luba:

The Baluba say explicitly: You may have riches, prosperity, a large number of descendants, and yet on certain days be seized by a *kulanga* (yearning) or *bulanda* (nostalgia) and find yourself *kuboko pa lubanga* (with hand upon your chin) without knowing why, beyond the fact that the human heart is never satisfied.[77]

And, finally, the Zigua, of the hinterland of the northern Tanzanian coast, in the vicinity of the town of Pangani, fashion a figure in clay with hands on cheeks. This figure represents the orphan, "unhappy all her life."[78] The moral precept, to be specially kind to orphans to help alleviate their loss, is reinforced by the display of this image during the teaching of young people.

The correlation of hands-upon-the-cheeks with sadness would appear to be pervasive among many Bantu African cultures. "Why are you sad?" an American anthropologist was once asked by a Kongo, when he placed his hand upon his chin.[79] Thus the seated male figure which surmounts a Lunda comb (Plate 99), made in territory to the southeast of Kongo, probably symbolizes the pondering of a heavy, extreme situation. Bastin illustrates combs decorated with this same theme, from the Tu-Chokwe of Angola, who border on the Lunda. One of these comb figures, striking an identical pose, is given as a representation of "an attitude of lamentation."[80]

There are rare sculptures from the lower Zaire region showing dogs resting, with hindquarters lowered (Plate 100). In this example, ears are alert and teeth are bared. The honoring of the dog with an attitude of repose suggests the special status the animal enjoys among the Kongo. Dogs were cherished, not only as hunting animals, but also for their role in religion, for, "it is a general rule that [such] animal figures symbolize the speed and strength of an *nkisi* (charm)."[81]

I close the survey of seated statuary with an image from Yoruba, a seated figure of a woman, who in this instance both nourishes and secures her child (Plate 101). A gesture of emphatic generousness shows that Africans ideally exist in vividness and sharing.[82]

Plate 100
Zaire, Kongo, seated dog,
wood, 14"

3. RIDING

To ride upon the back of a horse represents an arrogant form of sitting, for in it speed and elevation combine with ruling power. The reaction of a Banyang priest to a photograph of a carved African image of a mounted ruler was immediate: "you see a man on horse, you think—war!"[83] The man on horseback, an image of martial order in the history of Western art, "so much so that in Rome during the reign of Marcus Aurelius equestrian figures were the prerogative of the emperor,"[84] acquires in Africa special resonance because the horse is rare, very expensively imported, and, sometimes, mystically associated with the ruler.

The horse is not indigenous to Africa. The Hyksos invasion of Egypt, about the middle of the second millennium B.C., introduced the species to the continent.[85] Thereafter its use spread to Black Africa, fully developed there by the rise of the Mali Empire[86] in the Middle Ages. Yet horsemanship has always remained problematic in tropical Africa because of climate, areas of bush, and the bite of the tsetse fly. In northern Ghana, for example, most horses have to be imported:

> In Gonja I could find no record of any mare that had successfully foaled. All had to be purchased from traders or received as gifts. The acquisition of horses must have been on a large scale since their life-span was short. In 1957 the chief of Kusawgu told me that he had possessed 20 horses during his reign of some 20 years; if true, this total represents a very considerable investment in these prestigious and expensive animals, all brought down by horse-copers from the north.[87]

Regardless of difficulties, horsemen in Africa have exerted power out of proportion to their numbers. It has been said that states arose in West Africa on the backs of horses:[88] Mali, Bornu, Songhai, Hausa, Bariba, Gurma, Gonja, Mossi-Dagomba.

In Africa south of the Sahara the horse was never used for agricultural labor, but was reserved for the transport of important persons.[89] In addition, horsemanship is also charged with mystical beliefs. I showed a photograph of an equestrian figure in wood (Plate 102) to a priest of a traditional cult near Ouidah, Dahomey and these were

his words: "that rider sits with force (joko pelu agbara), the force of the horse (agbara esin). He has the speed and power of the horse within his body."[90] In his mind, horse and rider were one.

This can be compared with the annual Damba ceremony, in the divisional capitals of Gonja, in which members of the ruling state perform movements which mime the motion of horseback riding, as "both horse and rider." Moreover, in eastern Gonja every horse belonging to a chief had assigned to it one of the chief's wives, who offered the animal water three times a day, kneeling as she did so, as if in the presence of her lord.[91]

When we pass in review a number of horse and rider figures in African sculptural traditions, we therefore note occasional suggestions of incarnation and mystical union, a quality which can be sharply distinguished from the straightforward realism of the equestrian theme in the West.

Our first mounted figure comes from northern Senufo[92] territory, in the south of Mali (Plate 46). The rider is shown holding a stabbing spear in his right hand. His left is poised on the flank of the animal. The powerful curve of his pectorals flows into his arm, narrows, then expands into the enormous hand that grips the weapon. The vertical assertion of the rider, in profile, is brilliantly interrupted by the horizontal line of the body of the horse. The warrior, instead of suggesting travel across space on the back of the beast, seems to move within its mass. The exactitude of separation, of rider from animal, in Western art does not seem to apply. The warrior seems to receive a part of his vitality from the beast. For example, the horse's legs, made human by reduction into two columns, combine with the vertical of the body of the rider to suggest a union of forces. Man is clearly at the center of this power: subtract the head and tail of the horse, and the seated man seems restored to standing; subtract the rider, and the legs seem ludicrous. There is a sensuous uprush of vitality, brought to focus by interplay of diagonal and curve.

There are literal magical qualities to admire in certain Kongo "riding figures." However, the identity of the animal in this instance is ambiguous (Plate 103). It is probably not a horse. I think it is sensible simply to say that

75

Plate 103
Zaire, Kongo, sorcerer's whistle,
wood and horn, 8½″

Plate 102
Nigeria, Yoruba, horse and rider,
wood, 26¼″

the figure is mounted on "an animal form." The "rider," on the other hand, appears human, head turned to one side, a gesture we have already met in Zaire statuary. The mounted figure is pitched forward in an extraordinary posture of motion and flight. He seems almost "cantering" and the raking angle of his body makes him have more motion than his mount. In this instance the "rider" seems involved with mobility as an expression of magic speed and intensity, rather than military power or realism. This certainly fits the function. We know that animal figures in the visual tradition of the lower Zaire can symbolize the strength and speed of certain charms (nkisi). We know that this figurated antelope horn whistle comes from Kongo and that it was probably used in connection with the ritual exposing of a sorcerer (bandoki), or during the healing of a sick person, or as a hunting charm.[93] Regardless of which function applies, the figure, "cantering" and dominating, seems to direct a splendidly decisive and swift attack on witchcraft, illness, or forest beasts. He was perhaps urged on, in some secret way, by the sound of the duiker horn whistle. This is a remarkable instance of the theme of "riding" in African art. It cannot be placed in the same category with most Sudanic representations. The points of reference are not the same.

We return to the western Sudan to consider a Dogon horseman from Mali (Plate 104). The position of the rider's legs is highly ornamental. Relaxed flexion of the leg and the looseness of the means by which it is brought out from the horse, in the round, suggests the lightness of the seating of the rider on his mount. The nonchalance of this attitude implies the rider rides the horse virtually as a sylph, that he cannot possibly fall from his position, because his journey is mystically ordained and certain. Now let us consider information from the field. Griaule and Dieterlen in Le Renard Pale[94] suggest that mounted figures in Dogon art can symbolize the god, Amma, and that in such cases the animal symbolizes a nommo, one of the original eight genii of the Dogon, an extraordinary group of water spirits.[95] These scholars allege that the horse in Dogon lore is associated with descent from the sky. They further assert that certain wooden ritual objects, belonging to a society of "ritual thieves" (Yona) represent the head, neck, and mane of a horse. In this instance, openwork chevrons which form the mane represent the descent of the ark of creation from the sky. The zig-zag, I might add, is recognized in other West African civilizations, notably Fon and Yoruba, as marking a line of communication, an avenue binding heaven and earth, in the form of lightning.

The head and torso of the rider are tilted back. This, too, seems appropriate to an extraordinary journey, for the backward positioning of the head is often correlated with ecstasy and heaven in the possession cults of West Africa.

Riding has been prominent in Nigerian art history since the ancient culture of Igbo-Ukwu, dated by radiocarbon to around the ninth century A.D.[96] Today, in the corpus of Yoruba traditional sculpture the image of the mounted ruler has lavished upon its representation considerable detail. The ruler usually is shown carrying the reins high in his left hand, while holding a spear, sword, or staff in his right. Carved wooden figures of horsemen abound in Yorubaland and usually honor, according to Robert Smith, an actual warrior.[97] Such images were kept in the house of a commander of veteran warriors, or of other military leaders, in the last century. These were kept together with his divination tray.

One of the great Ketu carvers of the last century seems to have combined the themes of divination and military horsemanship with a series of important commissions. Each of these is characterized by the centering of a mounted figure under a divination cup, for which it serves as support, and the disposition, in a frontal semicircle before and around the horse and rider, of figures in a procession or entourage (Plate 32). Each of these figurated divination cups is a minor masterpiece of nineteenth century Yoruba art. One of the famous examples belonged to the commander-in-chief of the forces of Ibadan in the Ijaye War of the last century.[98] It is said this most important warrior used to take the cup whenever he consulted divination in council of war and when he wanted to make other crucial decisions. Another work is in the collection of the King of Ibara.[99] Another is in Ibarapa. Two are in the Nigerian Museum, Lagos. Dalton illustrated a further example in 1901.[100] And the seventh is in the White Collection.

The bowl for divination equipment shades the head of the mounted warrior like an umbrella. Its balanced position, on his head, may refer to powers of equilibrium. This would fit the function of divination to reduce diversity to unity and restore matters to balance. The military commander, or ruler, holds his reins in the left hand, in the traditional manner, while, probably symbolically, supporting his right hand on a wife, who in turn sustains a child with nursing. Behind the woman stands a pressure-drummer in a nineteenth century fez sometimes called fila tajia.[101] To the left of the leader stands a soldier with a captive. The latter is tied up in a manner described by Bowen in 1858: he is tied with an ajae[102] (compare a detail from the divination cup by the same hand in the collection of the King of Ibara—Plate 105), a strong cord with which his right hand is bound to his neck. This style of tying-up captives was also used in the Sudan in the last century. There are further traces of this sculptural mode in the hills far to the west of Ibadan—all attributed to an itinerant "Ketu carver" of the last century. He was certainly a master of the theme of master-and-entourage, a visual pendant to the musical theme of call-and-response. The parallel is lent peculiar strength in this instance, because the entire scene is animated, by implication,

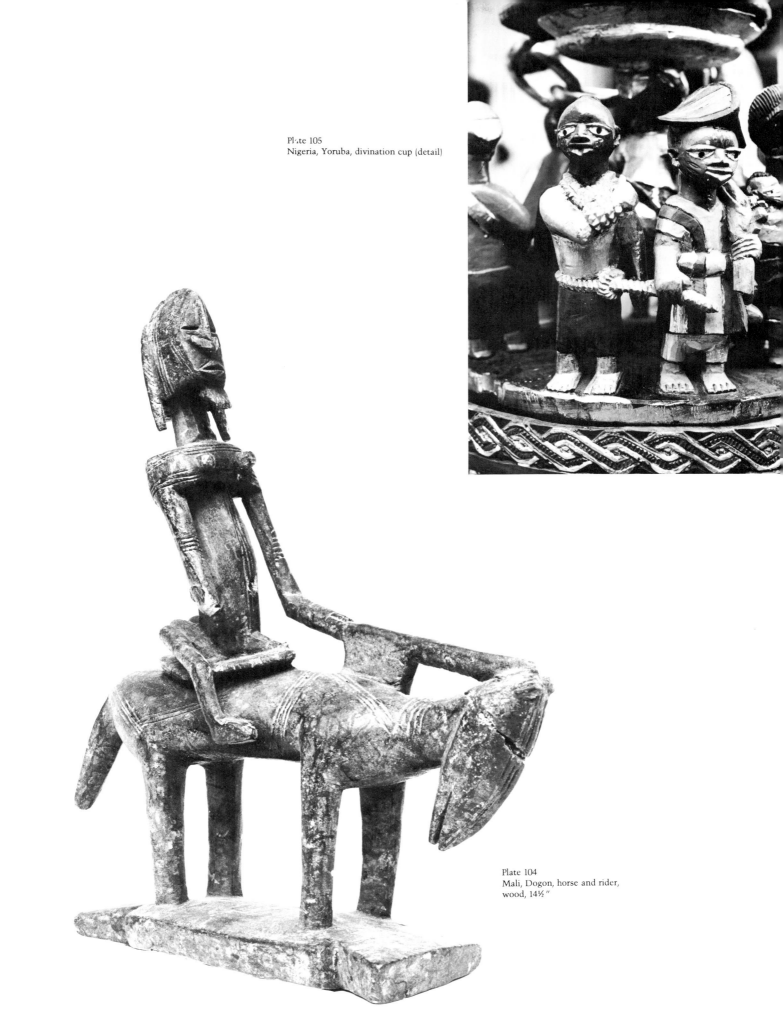

Plate 105
Nigeria, Yoruba, divination cup (detail)

Plate 104
Mali, Dogon, horse and rider,
wood, 14½″

through the pressure-drummer's presence, at the right of the mounted dignitary.

The association of some forms of Yoruba equestrian statuary with actual warriors of the last century might explain the degree of relative realism that is devoted to the genre in which the careful eye can pick out representations of reins *(inu)*, saddle *(gari)*, saddle cloth *(iteyin)*, bridle *(ijanu)* and stirrups *(lekafa)*, the latter broad and flat, with decorated sides, resembling the stirrups of Bornu.[103] Some of these details are visible in a series of mounted Yoruba figures from Oyo country (Plate 102), Odo-owa in northern Ekiti (Plate 106), and the style range of Osi-Ilorin (Plate 107). The latter object, a sumptuously decorated divination bowl, also shows the bicycle (Plate 108), which emerged in the iconography of northern Ekiti in the 1880's and forms a modern pendant to the more stately form of journeying. Ekiti cultivators, with whom I have talked about this iconic theme, refer to the rider and caparisoned horse as *"ara Ilorin,"* a person from the city of Ilorin. In the last century horsemen from Ilorin swept over the villages of northern Ekiti.

In Yoruba equestrian sculpture the animal is frequently reduced to a subsidiary element. Man is the master. Yet there can be a kind of interaction between the rider and the beast. A Dahomean informant studied the photograph of the mounted figure in an Oyo Yoruba style (Plate 102) and commented: "the rider has eyes like the horse." He went on to say, and he has been cited already to this effect, that the rider incarnates the horse's strength.

The disposition of the human frame upon a horse varies in the examples we have surveyed. Senufo and Yoruba riders are vertical and firmly sited; the Kongo figure "canters;" the Dogon image is elegantly seated, with a remarkable air of detachment and sacred calm. It is clear that riding is a richly differentiated expression in the sculpture of Africa. It is an activity which demands gestural asymmetry, sharply angled positioning of the arms and hands, as a function of its essential arrogance.

Plate 107
Nigeria, Yoruba, divination bowl,
wood, 21½"

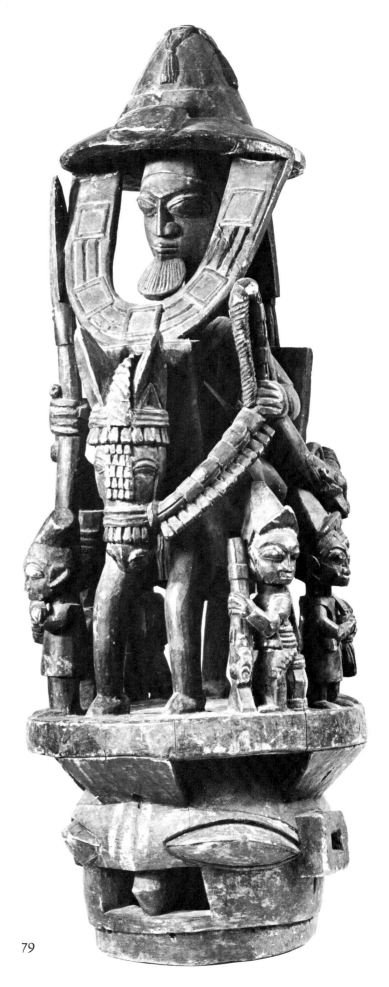

Plate 106
Nigeria, Yoruba, "epa" mask,
wood, 46½"

Plate 108
Nigeria, Yoruba, divination bowl
(alternate view of Plate 107)

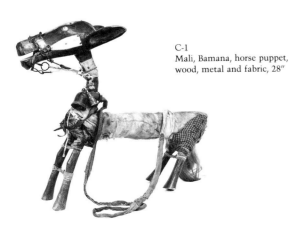

C-1
Mali, Bamana, horse puppet,
wood, metal and fabric, 28"

79

4. KNEELING

To kneel suggests relation to higher force. Celine Baduel-Mathon identifies some of the contexts of the position in West Africa:[104] fiance in the presence of the father, plaintiff in the court, son before father, youths before elders, subjects before the king, members of the court before the king, person praying [in the invisible presence of the ancestors or the gods]. These are public manifestations of salutation or respect. By contrast, the king kneels in private. In every instance kneeling indicates dependent relationship. The position suggests a person only fully exists when set in relation to a governing source of nobility, otherwise mind becomes lost within the endless mirrors of its own subjectivity.

The contexts of the attitude merit more detail. Among Bamana, when a man ate tabooed food, the woman who had served that food in error had to ask forgiveness on her knees. She held her hands at the back. The latter gesture in Bamana country signifies humiliation. She knelt to mend a ruined situation.[105] Young men in Mossi country during circumcision ceremonies were supposed to walk in a bent-over manner that communicated willingness to take orders and listen to admonitions.[106] Kneeling and kneeling-related gestures had other meanings and functions among Mossi, as well. Young girls entering the market place might bend the knee, place both hands on their breasts, and then initiate a friendly conversation with their comrades.[107] They repeated this formula upon conclusion of the conversation. The gesture neatly opened and finished social discourse with a declaration of salutation. Women also knelt when addressing respected male relatives. In addition, kneeling-related posture was associated with child-birth: "for the delivery itself, the Mossi woman goes down on hands and knees, her arms stretched out upon the ground, her body inclined slightly from head to hips, in the posture ordinarily used to salute or to remain before a chief."[108]

Southwest of Mossiland, among the Agni of the Ivory Coast, a young man, during a formal occasion involving drinking, untied his cloth, knelt before his father, and drank from the goblet that the latter held carefully in the hollow of his hand.[109] A member of the traditional religion of the Ga of the region of Accra, farther east along the coast, knelt to offer to the spirits sacrificial fowls, offered carefully in twos, and with both hands. Among the Ga the

act of kneeling was made more powerful by the act of giving with both hands, so-called "double prestations."[110] Continuing east, Nigerian Yoruba, when in the presence of an important elder, knelt to offer food or drink and remained in the kneeling position while the gift or offering was being given and received.[111]

Among Egba Yoruba every morning each member of a compound had to pay his or her respects to the head of the extended family and his senior wife. If the person were male, he would prostrate himself *(dobale)* before the leader. If she were a woman, she would kneel *(kunle)* or lie upon her right side *(yinrinka)*.[112] But even the king must kneel in the presence of the gods or their emissaries upon the earth. Thus the King of the Oyo was expected to kneel before the titled woman known as Iyamode:

> The King looks upon her as his father, and addresses her as such, being the worshipper of the spirits of his ancestors. He kneels in saluting her, and she also returns the salutation kneeling, never reclining on her elbow as is the custom of the women in saluting their superiors. The king kneels for no one else but her, and prostrates before the god Sango, and before those possessed with the deity, calling them father.[113]

One very special use of kneeling involved the ceremony known among Yoruba as *ikunle*[114] (lit. "the kneeling") a vigil during which members of a recently deceased person's family, allegedly, spent the entire evening on their knees. The position in this rite is sustained, apparently, in proportion to the extraordinary seniority of the dead.

In the sculpture of Africa the representation of the attitude of kneeling is idealized. The face is impassive and the limbs are strong and absolutely calm. There are few representations of men shown actually prostrating full-length upon the ground. I think the reason is fundamentally aesthetic: the horizontal position would vitiate canons of straightness and stability and would, in any event, trigger associations of night and dark forces. To carve a man in an horizontal position would seem too startlingly real an image for persons conditioned by a visual culture of heroic calm and upstanding vigor. Thus the head and trunk of a kneeling person in African art are normally held erect, as in strong forms of dance and

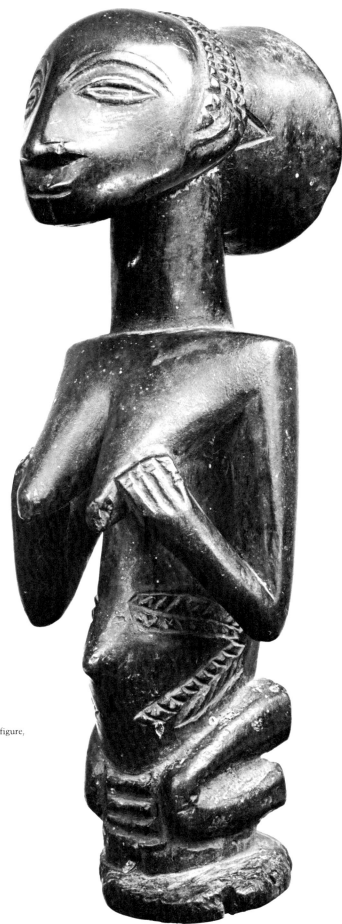

Plate 109
Zaire, Luba, kneeling female figure,
wood, 12½"

81

proper standing, as opposed to the deeply inclined actual forms of the position. Again, it is the *idea* of kneeling, the attempt to saturate an environment with an aura of respect, that governs the depiction.

We turn now to the Zaire Basin. Kneeling before the King of Kongo was a complicated act.[115] The subordinate fell to his knees, rubbed his hands upon the earth, stroked his ear, and clapped his hands. The king, for his part, responded *Yes!* The person repeated this sequence three times [a number symbolizing, as we have already seen, transition and supernatural presence] in overlapping call-and-response with the king. When he left the monarch, he did so on bended knee, backing out, never losing direct facial contact, for it was a serious offense indeed to turn the back upon the king, a law recalling the court procedure of nineteenth century England.

The motif of the kneeling woman in Luba sculpture, Jack Flam shows, expresses moral rightness tinged with timeless certainty, with further associative values, the support of the ancestors and their purity of vigilance, suggested as well.[116] For example, a Luba woman kneels while also offering, with both hands, her breasts (Plate 109). In this case the accentuation of the power of woman would seem more important than the act of kneeling *per se* because the lower limbs are in very small scale in relation to the body. Presentation of the coiffure, head, and breasts adds hauteur to a deferential act, carefully expressed within superb physique.

There is a Loango ivory crowned with the representation of a kneeling woman (Plate 110). Her hands are disposed differently; one is placed upon the breast, the other upon the vagina. Possibly she bestows a powerful blessing, swearing on her total role as sustainer and creator of life, but this particular piece of sculpture is an example of "seaport art," designed for export, and her pose in this case may be purely ornamental, albeit possibly derived from sacred archetypes.

There is a very thoughtfully rendered image of a kneeling woman from Dogon country in Mali (Plate 111). The calm of the face might suggest patient resignation to the role of woman in Dogon culture, essentially conceived of in terms of giving birth and rearing children.[117] Marking the center of the body is the "obstetric line," the inevitable arc seen on pregnant women. She seems to have come to term. The quiet placement of her hands upon her thighs lends focus and stability to her condition. It is just possible that her position is a graceful euphemism for the obstetric attitude; we recall the Mossi position of delivery. The Mossi border directly on Dogon country.

This sub-section ends with a representation, from Senufo country, in Ivory Coast, of a kneeling woman (Plate 17). The figure dramatically surmounts a shea-butter container. It is said the object once contained shea butter, compounded with camwood, palm oil, gum rice starch, blood, and millet juice.[118] This splendid mixture was used to annoint the hair as pomade, thus serving to make a person beautiful for the pleasure of a lover or a spouse. The shining youthfulness of the crowning figure is like a paradigm of the sort of beauty which Senufo say inspires a man to work as skillfully as he can in the fields.

Anita Glaze suspects the bowl might be connected with the Sandogo society.[119] Sandogo are Senufo women diviners. Note that horns stud the outer perimeter of the bowl. Such horns are symbols of women's divination in Senufoland. By this hypothesis, the kneeling figure conceivably represents a person kneeling before a person of the society. The woman kneeling, in real life old and prestigious, is restored here to flawless strength according to the canons of the black aesthetic. Interestingly enough, as we shall see at the conclusion to this chapter, women of Sandogo perform, in funeral contexts, dramatic elaborations of "getting-down" and kneeling.

In sum, then, kneeling is both icon of respect and canon of performance. To rest on bended knee conveys belief that life demands the beautiful giving of the self to persons of honor. To kneel is to confirm that every perfect gift is from above.

Plate 111
Mali, Dogon, kneeling female figure,
wood, 23½"

Plate 110
Zaire, Loango, carving, ivory,
6"

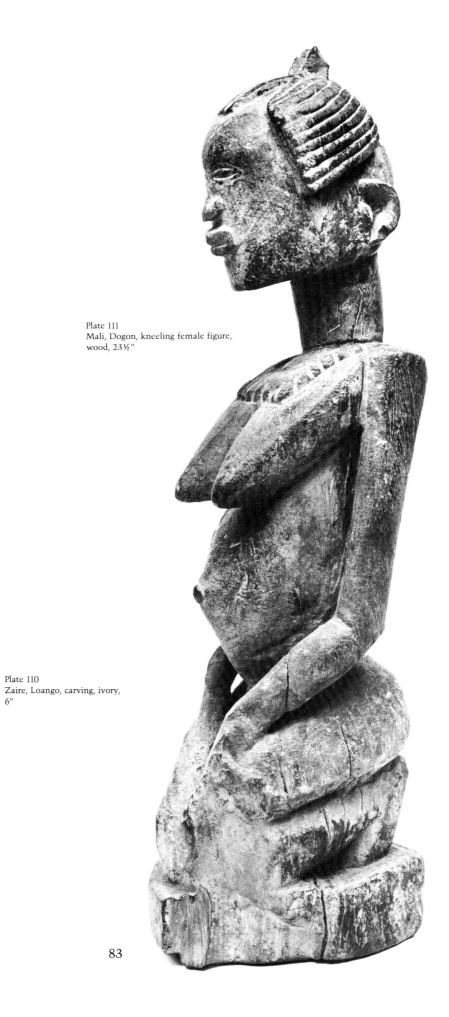

83

5. SUPPORTING

Supporting refers to the carrying of an object on the head, steadied by both hands. The term also applies to the carrying of a person on the shoulders or upon the back. In furniture the term is more broadly applied to objects supporting the human body. Balancing is a phenomenon of superior poise, wherein the object is maintained in a state of equilibrium on the head of a person by itself. The twin modes extend the notion of stability. Where figurated, they demand the cold impassive stare of the supporting image, when the weight is borne, as the seal of noble nonchalance. They are spectacular manifestations of aesthetic coolness.

The forms of figural sculpture assembled under this double rubric do not convey a single and exclusive meaning. Evocative cases force the conclusion that the canon is multi-valent, *i.e.*, charged with simultaneous meanings, depending on social and aesthetic context. The point can be swiftly illustrated by reference to the reaction of three Africans to a single photograph (Color Plate III, Plate 112) of a sculpture depicting two persons, one male, the other female, supporting a Luba-Songye chiefly stool from the southeast portion of Zaire:

Ejagham: "they seem to carry something for an important person. The way they carry it is beautiful. They hold it with both hands. The load can never fall."

Banyang: "this is a heavy load which cannot be carried without supporting with both hands, to reduce the weight of it"

Suku: "our ancestors carried things like that. This pleases me because I have seen my own mother carry things like that, with both hands, taking care that the water in the vessel did not spill"[120]

The informants interpreted the canon in terms of duty to a lord, practical reduction of weight, beauty, and ancestral embodiment. They were agreed, however, in interpretation of the image as an arrest of a particular kind of motion: portage. This overlaps with the ancient Greek interpretation of the caryatid figures of the Erechtheum in Athens. These figures, Jerome J. Pollitt tells me, probably represented processioneers, maidens who carried sacred objects in the Panathenaic procession.[121]

Supporting as motif communicates, not only arrest of motion, but also idealized flexibility. African women absorb the undulations of the earth in their spring-like hips and knees to preserve the stillness of their heads.[122] Compare the meaningful inflection of the knees of a pair of African caryatid figures (Plate 112). In addition, ability to rise with a heavy load upon the head is a direct expression of the stronger power that comes from youth:

Let us bend down to work
Only once are we young
Old age arrives
And then we place a burden on our heads
And find that we cannot manage.
It is fleshy vigor that marks the youth.[123]

Supporting is also a metaphor of intellectual vitality. The Lega of Zaire, for example, interpret objects of art as precious "burdens" to be shouldered by the high and responsible persons of the world. Thus Daniel Biebuyck:

The ivory statues do not depict [the norms of Lega society] they *are* the values. They—the statues, the values—sustain the *bwami* association and the Lega society at large and symbolize the cohesion and endurance of both institutions. Perhaps coincidentally, the generic term *iginga*, which is used to refer to all the human figurines, is paralleled by the Lega with the verb *kuginga*, 'to sustain, to protect from falling or collapsing.'[124]

This recalls the Yoruba image of three stones. This was the sign of the mystic support of the Earth, preventing the crashing down of fragile human life.[125] Several meanings attach to the image of the supporting figure in African art, including advocacy, witnessing of the truth, and the acting out of roles in subordination. Let us examine the evidence.

First there is furniture. A Zulu head-rest (Plate 113) rests on sturdy legs which express the nature of support in a concrete way. This compares with documented examples in the Amherst College Art Museum, dating from the middle of the nineteenth century.[126] A back-rest for a Pende chief, from Zaire, (Plate 114) is most interesting. Torso and legs take the weight; arms stabilize the position of the user. Brilliant copper studs activate surfaces and emphasize, through extension into the arms, the presentation of stability.[127]

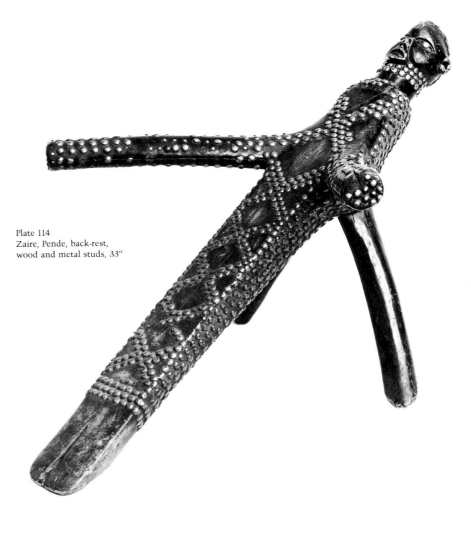

Plate 114
Zaire, Pende, back-rest,
wood and metal studs, 33″

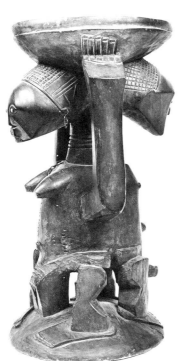

Plate 112, Color Plate III
Zaire, Luba, chiefs stool,
wood, 20″

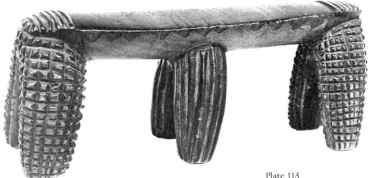

Plate 113
South Africa, Zulu, head-rest,
wood, 12″

85

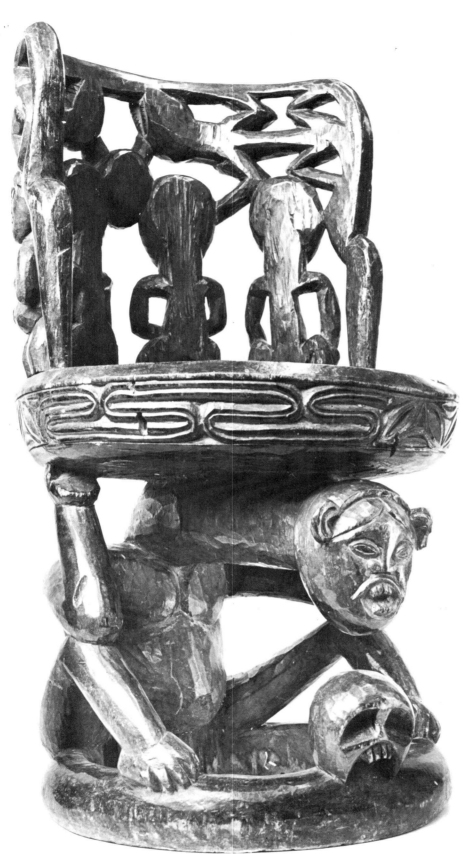

Plate 116
Cameroon, throne,
wood, 36"

Allegorical support is made most virile by the next example, a Lobi stool. This object comes from the north of Ghana (Plate 115). Each Lobi initiate is said to have had such a stool. He struck the ground with it when elders appeared. The seat was involved in honorific percussion. It was also carried on the left shoulder. The form of the stool sometimes suggests the figure of a man, and sometimes suggests the body of an antelope. All such stools include, however, a strikingly emphasized leg which curves at the bottom, like the phallic poker of the Yoruba iron god (Plate 95). Stools in similar styles are found among Birifor, east of the Lobi, as well as among Bamana, Senufo, and Baoule. In the latter culture, according to Elsy Leuzinger,[128] such stools were used ritually on the wedding night. This might confirm the special significance of the phallic element.

In the Cameroon Grasslands the seat of the king was decorated with the sign of the leopard. This was the sign of remarkable force (Plates 116 and 117). In some instances—for example an elaborate throne attributed to the Kom-Tikar area (Plates 118a and b)–the leopard motif becomes luxuriant. A brief examination of this interesting symbol is in order. Among the chiefs of one western Grasslands culture, it is alleged that every leader of consequence is backed by a secret leopard. When such a person is seen dancing with particular strength and grace people may comment, "Oho! He takes his leopard out to dance!" This is a Bangwa allegation. West of the Bangwa, the Banyang believe that there are "were-animals of destruction" which can be magically associated with strong rulers:[129] "the leopard, which can chase or attack other animals in the bush or may carry off goats from a settlement is associated with physical strength in litheness, in fighting, running, or dancing." This throne thus suggests the invincibility of the king, moving beautifully, like the leopards in the forest. The riding of the leopard by the king, identified by his horn, makes the communication of incarnate speed and ferocity doubly impressive. King and leopard are one. The king supports himself.

It is instructive to contrast the textural roughness and figural complexity of the Grasslands throne with the Ashanti stool. The smooth surfaces and abstract contours of the latter object (Plate 119) compare to Ashanti akuaba. This virtual "jump-cut," from Cameroon to Ashanti, is like moving from turbulence to noise. This particular example, probably collected c. 1900–1920 according to Roy Sieber, illustrates the rainbow motif in Ashanti stool-making. The motif refers to a proverb: "rainbow is around the neck of every land."[130] In other words, just as the curve of the rainbow, doubled, flanks the central supporting shaft of the throne, so the head of the king and the head of common man are surrounded by higher forces, in the presence of whom awe and humility are demanded. This sleek throne, therefore, "supports" on several levels, of which the most interesting is moral admonition.

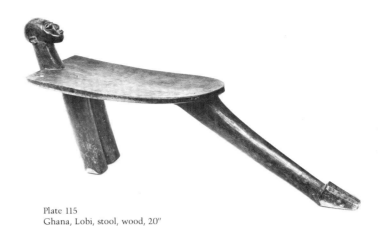

Plate 115
Ghana, Lobi, stool, wood, 20″

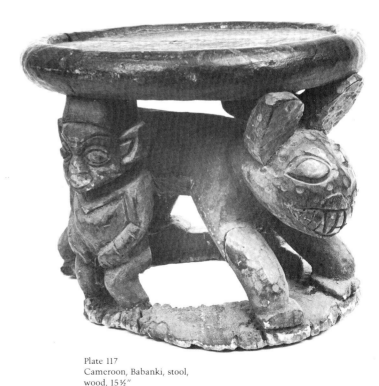

Plate 117
Cameroon, Babanki, stool,
wood, 15½″

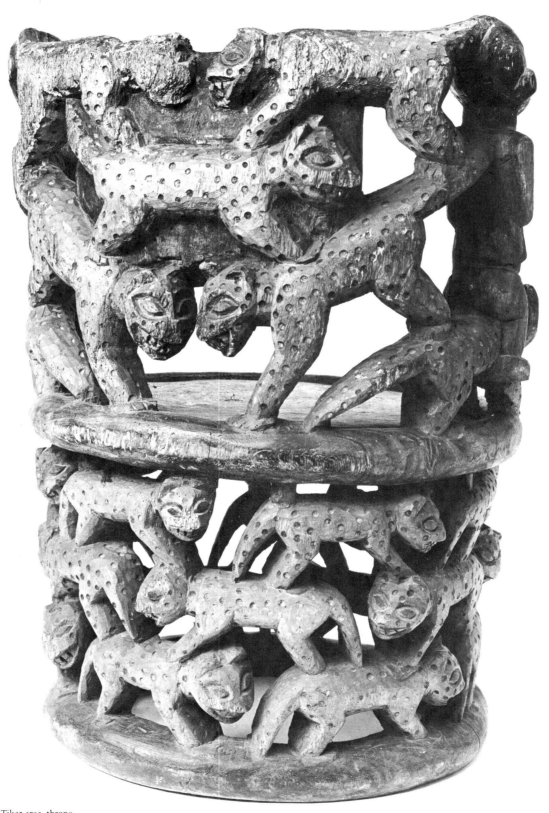

Plate 118a
Cameroon, Kom-Tikar area, throne,
wood, 32½″

88

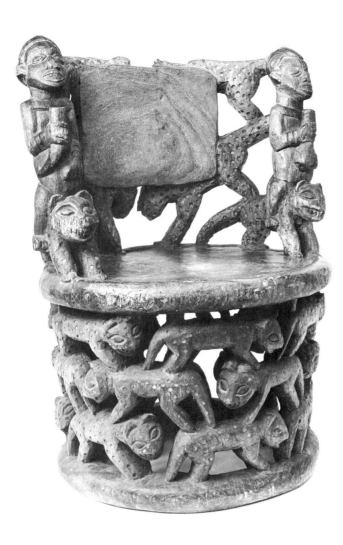

Plate 118b
Cameroon, Kom-Tikar area, throne
(alternate view of Plate 118a)

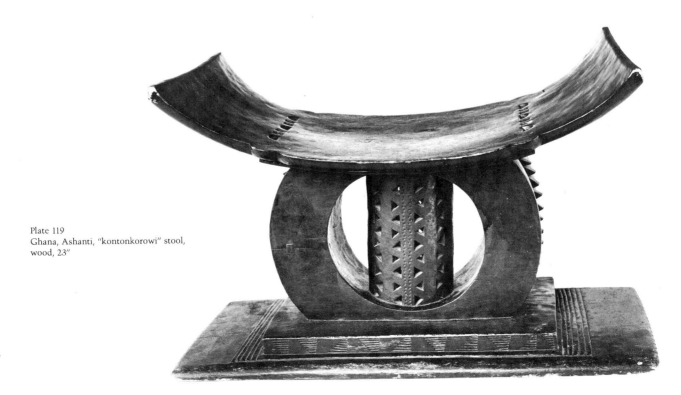

Plate 119
Ghana, Ashanti, "kontonkorowi" stool,
wood, 23"

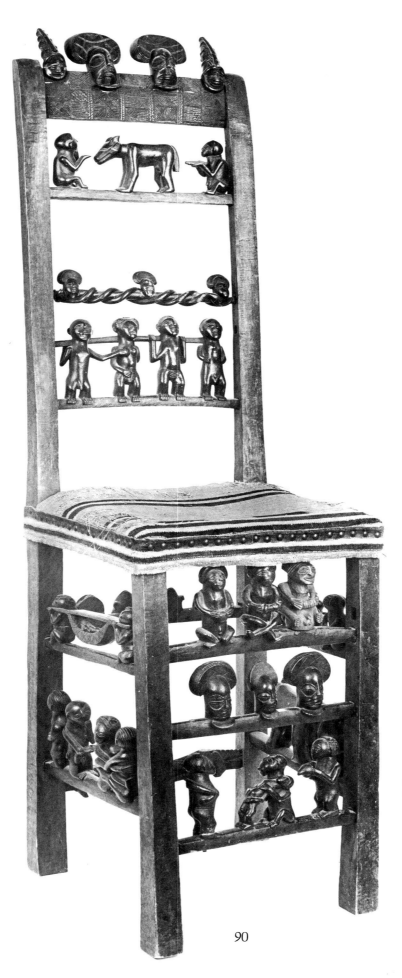

Plate 121
Angola, Chokwe, chair, wood, 52½"

90

Ashanti ingeniously elaborate the expression of metaphoric support. For example, after alluding to the well-known function of his state sword (Plate 12) in oath-taking and swearing of allegiance, the Agogohene of Agogo in northern Ashanti then added the following novel piece of information:

This is the oldest state sword. Wherever I sleep, it is always under my pillow. This means my head is always on the stool. And when I dream I will thus be told what I am supposed to do[131]

Gilbert Schneider collected in the village of Mbanga, the center of Mambila art-making in the Cameroon, a strong figurated stool (Plates 120 a and b). The stool belonged to a Mambila patriarch. When women experienced difficulty in child-birth they were brought to this impressive sculpture and seated upon it and told to confess.[132] Release of tension, in admission of repressed guilt and other sources of anxiety, doubtless favored ease of delivery. The lozenge-like stylization of the torsos of human figures on one side of the throne might be compared to the lozenge motif, concentrically represented to suggest people gathered in prosperity, in the ngam divination writing of the Kaka who border directly upon the territory of the Mambila.[133] When the woman in labor confesses, and tells exactly what she has done, these figurations support, by witness to her action, the saving efficacy of the truth.

With the next object we move from a context of maternity to political leadership. Thrones, according to Daniel Crowley, are the spectacular form of Angolan Chokwe art (Plate 121).[134] They represent, in the opinion of the present writer, an African intensification, by rhythmic handling of solid and void, of the late seventeenth century Portuguese *cadeira de sola* (leather chair). The latter is characterized by a large front stretcher, carved in the rich form of a Baroque scroll, and a high back of leather.[135] The high back remains in the African form, but the leather surface of the back and the frontal scroll have been eliminated in favor of a strong play of solid figuration and negative space that imparts visual "swing" to an old Iberian form. Back splats become miniature stages on which stand key figures in Chokwe traditional civilization.[136] These sculptures are sharp when pressed against the back and Crowley explains that Chokwe, accustomed to stools before the coming of the Portuguese to Angola, undoubtedly rested their weight on the front edge of the seat and avoided leaning back.[137]

The high back of this splendidly Africanized chair is surmounted by the image of Cihongo, spirit of wealth, and Cikunza, lord of initiation, he who leads the boy to manhood. Cihongo is identified by a fan-like chin, faithfully reproducing the resin-made mask of the circumcision schools; Cikunza, by his horn.[138] Such images, Marie Louise Bastin suggests, are not to be taken as literal sup-

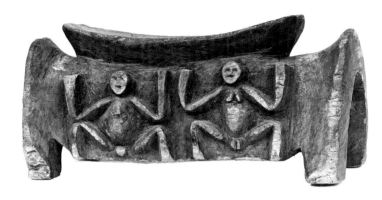

Plate 120b
Cameroon, Mambila, stool (alternate view of plate 120a)

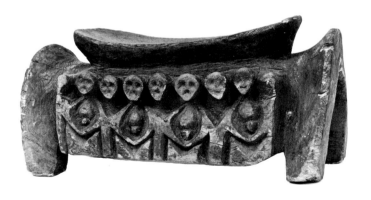

Plate 120a
Cameroon, Mambila, stool, wood, 19½"

port manifestations. They rather form part of a comprehensive vision of advocacy. The seated ruler functions in the midst of his ancestors and the vitality of the land.

A standing image of a mother with a child upon her back (Plate 122a), attributed to a Luba-Songye "style of transition,"[139] would appear to restore to straightforward representation the theme of bodily support. But the representation is inventive and bears close examination. On the back, the child (Plate 122b) is not dependent, but grasps the shoulders of the parent and extends the legs across the buttocks of the mother. The implied athleticism of the positioning of the child matches the strength of the stance of the mother. Luba judge vitality through personal carriage.[140] I should think there would be little doubt in the minds of Luba connoisseurs about this image. She communicates the idea of the strong mother who produces the strong child who can support himself.

The antelope headdresses of the Bamana, *tji wara* (Plate 123), are normally carved in pairs, one male, the other female. They allude to spiritual instruction. The male of the pair is usually identified by the representation of a mane and represents, according to Dominique Zahan, the sun.[141] He sometimes combines with the stylized or abstract representation of an aardvark, a beast also linked to solar symbolism.[142] The female of the pair is represented here, identified by the supporting of a child upon her back. Support in this case is pure convention. The smaller antelope stands upon the larger with quintessential calm. Our example comes from the Segou District of Mali.

A chief carried on the shoulders of a retainer surmounts a linguist staff from Baoule country in Ivory Coast (Plate 124). Here, bearing the weight of another person probably refers to a proverb appropriate to the protocol of the court of an Akan king. The image of a person who bears a load upon his head, and the image of the person carrying a royal stool, are linked to proverbs warning against insubordination and insolence in the presence of superiors.[143] A similar communication seems likely here, furthered by the larger head of the ruler. The formal gesture of the ruler, face frozen and hands indicating belly and heart, refers to the sources of noble accomplishment.[144]

Genre pieces are sometimes founded on the important motif of supporting weight, including an attractive little cup from Fon country in Dahomey (Plate 125), a lower Zaire head-rest (Plate 126) and a superb terracotta food bowl from the Ndop pottery center of Bamessi (Plate 127). The support of the latter vessel is nicely rendered by inflected and heraldic elements.

I close with three sculptures. One comes from Cameroon. It is attributed, by the original owner, the Fon of Nso, to the Oku people who live east of the Kom and northwest of the Nso. The rounded legs of the supporting figure (Plate 128) artfully mirror the round surface of a stand for a calabash of palm wine which she steadies on her head with both hands. She concentrates, within the

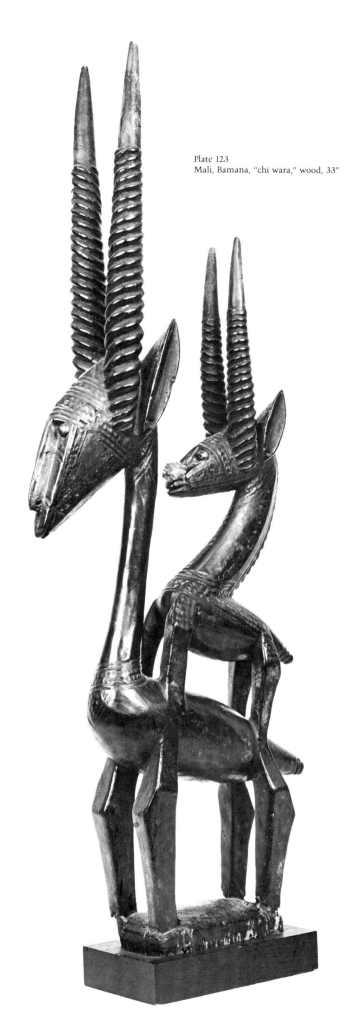

Plate 123
Mali, Bamana, "chi wara," wood, 33"

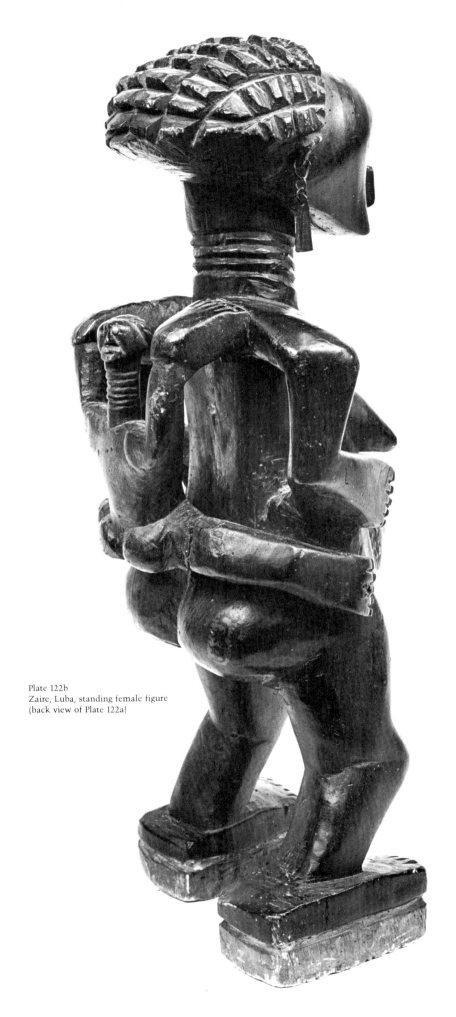

Plate 122b
Zaire, Luba, standing female figure
(back view of Plate 122a)

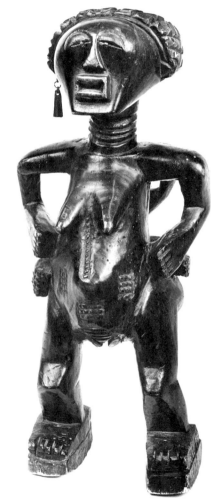

Plate 122a
Zaire, Luba, standing female figure,
wood, 19¾"

calm of the seated position, upon the act of giving, to take on the character of an unmovable perfect goodness.

The Luba of the southeast of Zaire have created styles of figural sculpture which are beautifully suited to the theme of allegorical support. According to J. Cornet, Luba art bears comparison with Baoule sculpture of the Ivory Coast, in its nobility and calm: "no exaggerated attitudes or awkward gestures break the inner serenity of the faces of the ancestor statues."[145] It is precisely the quality of ancestral composure and certitude which lends to the Luba caryatid bowl (Plate 129) or caryatid stool (Plate 112) an air of timeless purity.

An engraving from the end of the last century shows the King of the Luba seated on a large and handsomely carved caryatid stool. The ruler at the same time rests his feet upon the knee and thigh of his wife, as if sustained by actual and ancient presences.[146] An earlier illustration shows Queen Djinga Bandi, received by the Portuguese governor of Angola. The queen rests upon the body of a retainer who forms a living caryatid. The latter illustration was published in 1687.[147] There is thus depth in time for the concept of the caryatid gesture in courtly life in Central Africa. The summation of the visual significance of the tradition in Luba art has been nicely rendered by Jack Flam:

> the effortless grace with which they carry their burden, the serenity of their countenance (so close to other Baluba ancestor figures) and the hierarchy of importance in their body parts, all infer that the caryatid image is meant to be interpreted as a spiritual representation.[148]

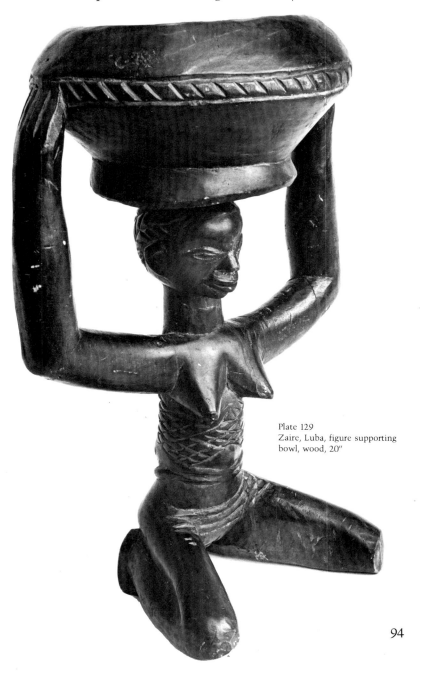

Plate 129
Zaire, Luba, figure supporting bowl, wood, 20″

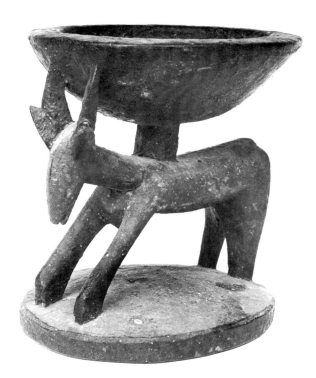

Plate 125
Dahomey, Fon, cup, wood, 5½″

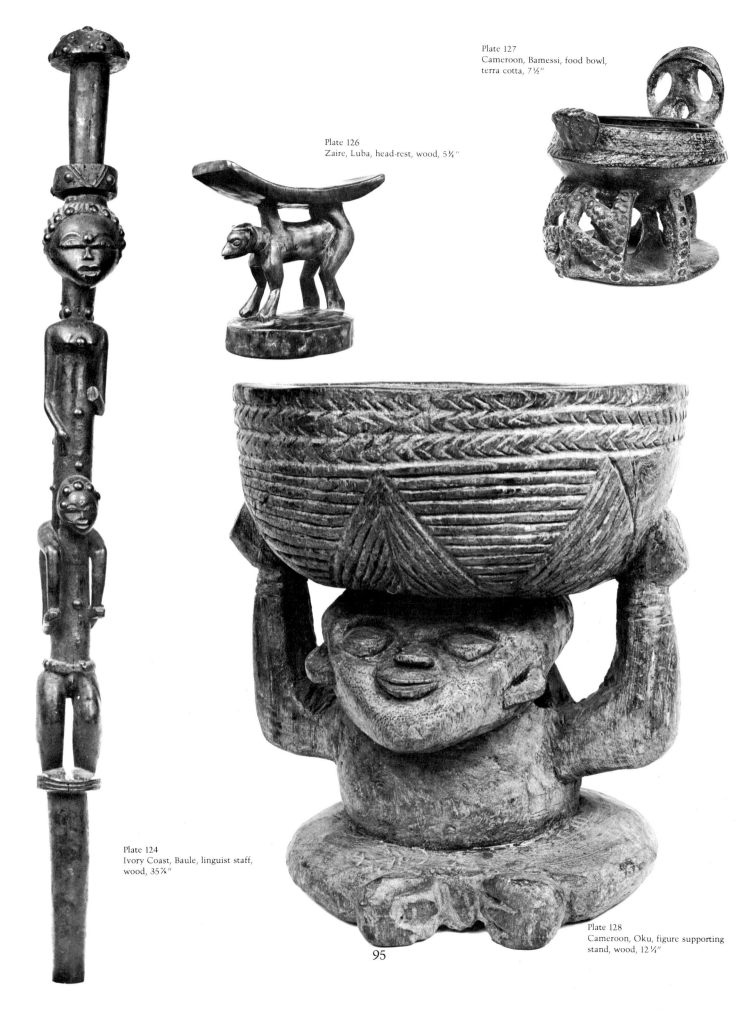

Plate 127
Cameroon, Bamessi, food bowl,
terra cotta, 7½″

Plate 126
Zaire, Luba, head-rest, wood, 5¼″

Plate 124
Ivory Coast, Baule, linguist staff,
wood, 35⅞″

Plate 128
Cameroon, Oku, figure supporting
stand, wood, 12¼″

95

6. BALANCING

To move in perfect confidence with an object balanced on the head is one of the accomplishments of traditional life in Africa (Plate 130). It is a gift cultivated from the earliest years of a person's life. Children in Dahomey, for instance, must have mastered this skill before they can play certain games. Thus Charles Beart:

> *adigba*, 'woman with the burden,' is a game played by all small Dahomeans. The children fix twelve wooden sticks in a pile of sand. Then each child, by turns, carries on his knees, with his hands tied behind his back, a cushion balanced on his head, from a distance of about twelve meters. At the same time, his companions sing . . . as he approaches the area where the sticks are standing he is supposed to pick them up with his lips, never allowing the pillow on his head to fall. It is a very difficult game, ventured only by children experienced in carrying things on their heads.[149]

This is one level of the skill. A higher level in adulthood is defined in attainment of transcendental equilibrium, of the initiate and the elder and the king, enabling a person to communicate mind itself by the quality of his composure and the nature of the object balanced on his head. The theme of head portage occurs with formalized repetition in the arts of Africa; there is every reason to suggest iconic content.

Dominique Zahan reports the importance of the human face, in Bamana iconology, reflects its symbolization of the forces which make men whole: "those senses, by means of which man receives impressions from his surroundings and so communicates back to these same surroundings, are all contained in this part of the body. It is for this reason that initiation society masks are worn either on the top of the head or on the face itself."[150] Stable facial expression is the ground of objects-on-head masking traditions. Conversely, awkwardness can suggest disorder and even witchcraft (compare the attribution of sinister qualities to bodily distortion in many cultures of the world). Akan women, at funerals, sometimes dance with a vessel filled with water on their heads. If it falls, spilling symbolic coolness, it is tantamount to proof of guilt, *i.e.*, that they have willed by witchcraft the death of the deceased.[151] A sense of balance is a mandatory skill

in a world sensitive to performance and presentation of the self.

Akan priests dance with a shrine, a vessel filled with magic substances and water, poised on their heads. They suggest by this reception of superior mind from the gods and gloss the contents of their shrine by incantation: "O tree . . . we are calling upon you that we place in this shrine the thoughts that are in our head."[152] In other words, heroic displays of balance, in head portage, form metaphors of superior intelligence, the power to surmount the natural head with the head which comes from the gods.

Equally dramatic is iconic load-carrying among Yoruba. Oyo Yoruba thundergod devotees must dance upon initiation with a living flame balanced in a vessel on their heads.[153] This proves the depth of their possession, the command of the magic strengths imparted by worship of the thundergod. The importance of this test of the mystic coolness of the novitiate is suggested by the prevalence of its representation in art. Thundergod axes, for example, are often carved in the shape of a devotee or deity upon whose head are poised twin thunderstones, meteoric fire hurled down from heaven, restored to meaningful repose at the summit of the head. That stones, even in artistic representation, recall a form of fire was brought out by the remarks of a thundergod devotee in the town of Efon-Alaiye:

> actual thundergod stones are *hot*, things picked up only by possession priests, with a pair of tongs, and placed within a vessel filled with red palm oil. Immersion of the stones causes the oil to bubble. . . .[154]

Powerful associations cluster, perhaps, about a thundergod axe from Efon-Alaiye (Plate 131). The staff carries a Janus image surmounted by the fiery burden, carved like incandescent horns. The Janus motif in Efon represents the presence of a god; *e.g.*, the double-headed caryatid column in the Osanyin courtyard of the palace is commonly said to represent the god of medicine.[155] The thundergod is represented by this axe, balancing fire, staring a double all-seeing stare.

When a person kneels (Plate 132) proximity to fire is obtained through different means. Support of the stones becomes an all-encompassing symbol of the power of humility to cool the gods.[156] The retiring position com-

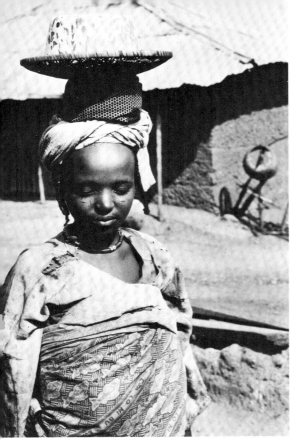

Plate 130
Young girl balancing bowls on her head

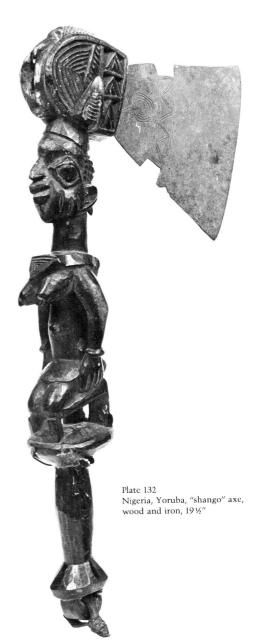

Plate 132
Nigeria, Yoruba, "shango" axe,
wood and iron, 19½"

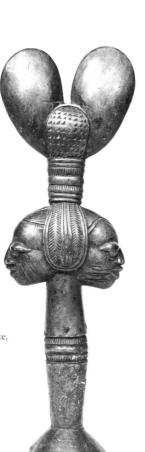
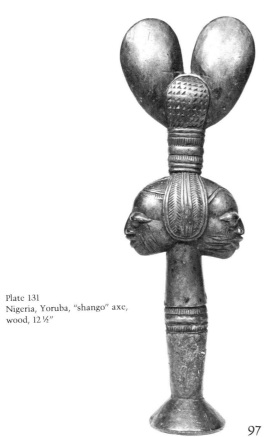

Plate 131
Nigeria, Yoruba, "shango" axe,
wood, 12½"

97

bines with balancing of objects, at the end, to seem the more authoritative posture.

The goal of another cult complex, Efe-Gelede, is broadly the same: to master the fiery world of the witches, "our mothers," real anti-social forces who can sometimes be detected in elders who have been slighted and who harbor, thereby, dangerous grudges. Efe is a performance of the night; Gelede follows the next afternoon. The point of the night performance is social criticism and moral enlightenment. The afternoon ceremonies focus on honor to the witches through outpourings of paired masks, each pair danced in beautifully chiseled dance sequences called *eka*. Two such mask types (Plates 133a and b), possibly a rare preservation of an original field pair, illustrate the crocodile. This reptile is sometimes held to be a witch's familiar, although nocturnal birds with long red beaks are much more usual. The fiery thundergod himself is a witch. He is very dangerous. He is associated with the crocodile. In northern Yorubaland some compounds keep a crocodile in a sunken pit as a guard against lightning.[157] In this case, the reptile has been balanced on the head-tie of a robust maiden with strong cheeks and perfect features. The late Duga of Meko carved these masks, perhaps ten to fifteen years before his death in 1960. He restored ferocity to balance.

In recent years carvers for Gelede allude with frequency to aspects of modern technology. One example shows a young type, with goggles, balancing what appears to be a wine-keg from the West upon his head (Plate 134). The old-fashioned reaction to such sculpture is to make noises about "acculturation" and the impact of the Western world. But a richer and deeper process is at work, and this has come out in an excellent study of Gelede by Henry Drewal:

> The technology of the white man is attributed by traditional Yoruba to the white man's witchcraft. By representation of machines, buses, airplanes, and so forth, the Gelede devotee hopes to encourage the use of similar powers, of speed and potential destructiveness, for the good of human society.
>
> There is constant reference, in villages, to the witchcraft of the white man. 'The mothers' (*i.e.* witches) are capable of the same powers; some have x-ray vision; others can talk long distances without the use of the telephone. By referring to these powers, in modern technology, the Gelede member hopes to turn the comparable prowess of 'the mothers' to socially useful goals, so that everyone can benefit.[158]

In the context of these findings, the image with goggles must be considered with seriousness and analytic care. I know from my own field research that goggles and dark glasses are associated, in some traditional villages, with witchcraft, crime, hemp-smoking, and prostitution. At Ajilete in Egbado Yorubaland there is a Gelede mask type

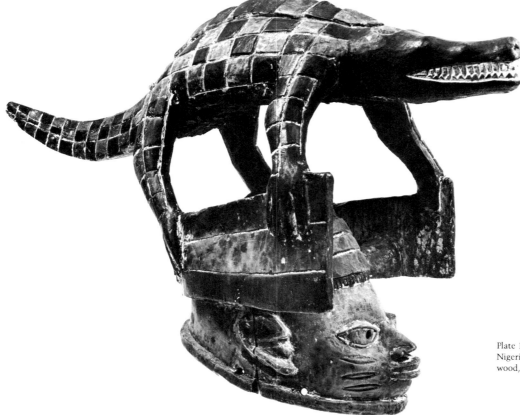

Plate 133a
Nigeria, Yoruba, "gelede" mask,
wood, 30⅛"

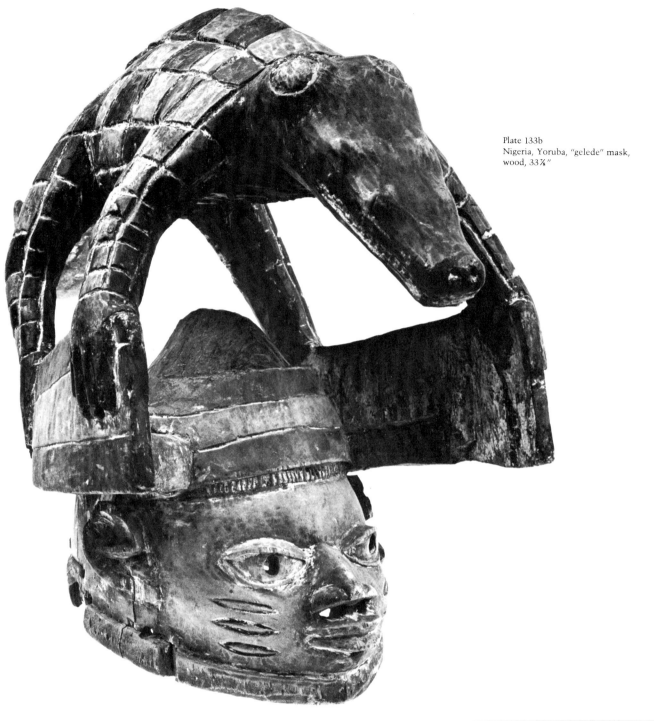

Plate 133b
Nigeria, Yoruba, "gelede" mask,
wood, 33⅞"

Plate 134
Nigeria, Yoruba, "gelede" mask,
wood, 10"

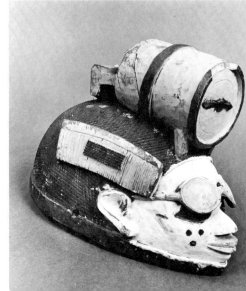

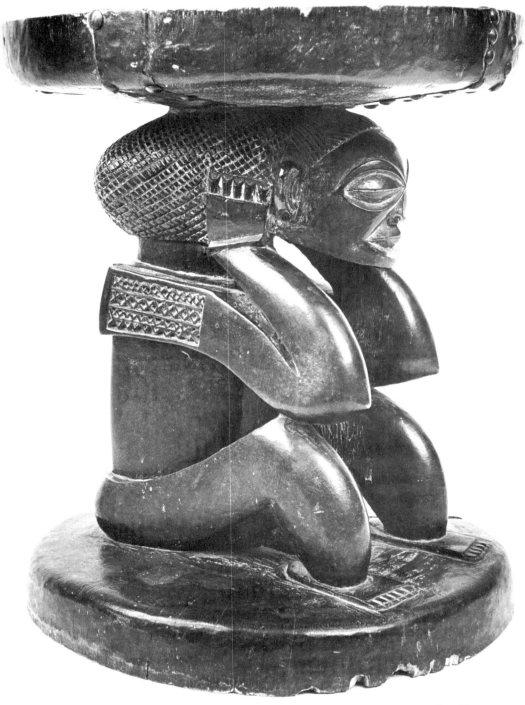

Plate 137
Angola, Chokwe, stool, wood, 13¼"

with dark glasses called *ashewo koforun* (lit. "we-do-it-for-money;" "we-don't-like-to-stare-into-the-sky"). An informant, Adisa Fagbemi, explained,[159] "when a prostitute goes about the town, she puts on dark glasses to prevent the sun from falling on her eyes; the style of wearing them is always the same; they always put them on in a peculiar way." The modish wearing of glasses above the eyes is very strange to villages conditioned by a visual culture of purposeful moderation. Moreover, goggles hide the eyes and this violation of visibility is highly suspect in life and art. Hence the "wine keg" might fit an allusion to excess or some other form of indulgence introduced by the white man to the coast. The carving, however, by idealized repose and beauty, attempts to deflect or re-orient these powers, whatever they may be conceived to be, for the good of the community. The conceptual framework of Gelede remains the same. Exotica are woven into balance by means of familiar superimposition. Head portage is a pretext for statements about the continuity of sacred transactions within ancient systems of relation.

The modern devotee wages magic war against the machines of the West. The traditional devotee wages magic war, via transformation into horsemen and warrior-leopards. The latter are icons balanced on the head of important sacred objects of the Yoruba (Plate 135) and (Plate 136, Color Plate IV).

The first is a "house of the head" *(ile ori)* made in honor of the head of the person as source of his character and destiny. The second object is an elaborate appliqued gown for a moral inquisitor come from the dead to judge the conduct of the living. The house of the head is made of vertical leather panels which have been decorated with cowrie shells, the ancient currency of this portion of the Guinea Coast. The costume of the inquisitor is also fashioned with vertical panels, embellished with sequins, and rich appliqued patterns of heraldic nature. The structural linking of the two forms of art suggests a common rooting in celebration of heroic minds.

The nature of the elaboration is communicated by the finials. The house of the head carries an equestrian figure. The ancestor spirit carries a brass image of a leopard. Both stabbing spear and tooth of leopard are equivalent expressions of bravery, balanced over images of nobility and character. The nature of balance rises to a richer level of communication.

Equilibrium develops from both physical vitality and mental calm. This seems evident in certain Chokwe sculptures from Angola. A smoothly finished stool (Plate 137) rides the head of a figure who strikes the classic meditative pose, the hand upon the head, indicating thought or sadness. The next image (Plate 138) balances a mortar for snuff upon the head and suggests increase by placement of the hands upon the abdomen. Many African figures in wood deepen the meaning of their load-bearing

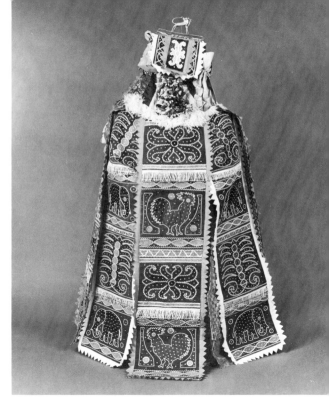

Plate 136, Color Plate IV
Dahomey, Yoruba, egungun costume,
cloth, sequins, etc., 72"

Plate 135
Nigeria, Yoruba, house of the head,
leather, cloth, shell, etc., 22"

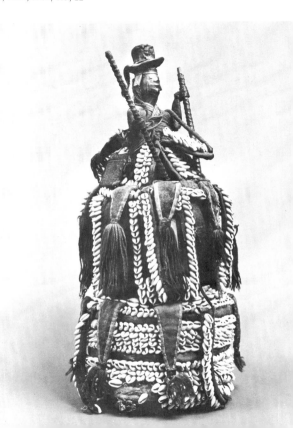

101

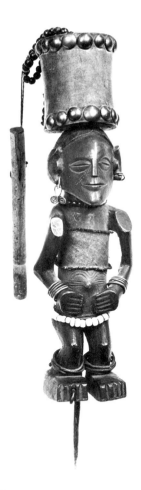

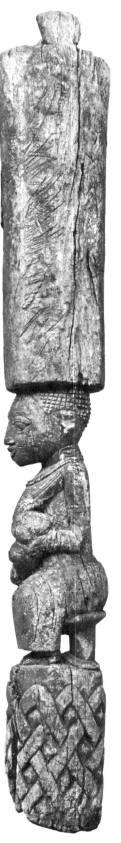

by gestural references. Caryatids make signs of thought (hand on head), creative goodness (hands on belly), discipline and respect (kneeling), and order (sitting).

Let us pursue this universe, considering further references to spiritualized equilibrium, levels of suggestiveness wherein whole worlds seem balanced upon the head.

First, there is a carved housepost (Plate 139) from Efon-Alaiye in Yorubaland. The bottom portion of the shaft is richly textured with a motif of royalty that is ancient in Nigeria. The communication of royalty is confirmed in the jewelry of the seated nursing mother image—she wears a double strand of beads about her neck which identifies her as an *iyawo oloye*, wife of an important man, perhaps of a ward chief, whom William Fagg plausibly suggests was the original owner of this post. In a sense, this woman supports the compound with her inherent goodness.

The next illustration (Plate 140) belongs to the section devoted to supporting, but the weight borne is so heroic I arbitrarily include it here. A woman is shown supporting the motif of the mounted warrior-chief. The post was carved in Efon-Alaiye, and I can suggest its possible meaning by analogy with vernacular interpretation of a similar column in the palace of the Alaiye:

> the mounted figure represents a warrior who fought and destroyed the enemies of Efon-Alaiye at the time of the Kiriji War [*i.e.* in 1880]. Under him is his wife. This woman was brave, too. When her husband went to war, she would be somewhere else, working magic to save her husband and to bring him back alive.[160]

The infinite coolness of this full-breasted woman already expresses a portion of her insight and a portion of her power. She endures with dignity her husband's absence and keeps his world intact for his return. We recall that the King of Agogo sleeps over his sword, that his head be always supported by the throne. The legitimacy provided by the sword is here provided by the woman.

We come now to another kind of balance. I refer to the art of Epa, a dance cult of the northern Ekiti in Yorubaland. Epa tradition is characterized by massive headdresses in wood, consisting of a grotesque helmet over which is balanced, on a tray of wood, figural expressions of commemoration and honor. The figures usually stand fully in the round. The style of the figures is vividly representational, while the style of the helmet mask below is palpably more abstract and monstrous (Plate 141). The contrastive quality of the tradition embodies, I think, a fusion of a tradition of awesome icons with a trend towards relative realism of commemoration.

Evidence with which to appreciate these differences and their resolution lies embedded in the testimony of Michael Ayoola Arowolo, King of Iloro-Ekiti. He distinguishes between the energy of Elefon, a cult of ancestral spirits, and Epa, a cult of culture heroes in splendid com-

Plate 140
Nigeria, Yoruba, fragment of a
housepost, wood, 22½"

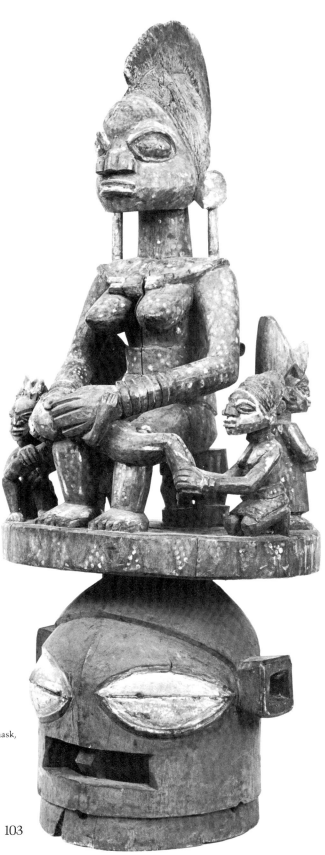

Plate 141
Nigeria, Yoruba, "epa" mask,
wood, 39¼"

103

memoration. He believes Elefon is older. He says Elefon are spirits; Epa, ancient men. He says choreography marks the difference:

> Elefon means fast, agile dancing. Epa is slow, stately, ponderous, because of the heavy loads on the heads of the dancers. Elefon is strong, a manly festival. Epa is not as strong; it goes with slow and patient things. Epa does not lash people, like Egigun [an ancestral masquerade]. Epa does not dart about. It is a woman's kind of juju.[161]

Womanly cool surmounts demonic form, enormous eyes and mouth (Plate 142). This is an Elefon mask with an Epa-like standing figure. The tension between the two parts is admirably suggested; the woman is relaxed and giving, the mask is compressed and menacing. The speed and drive of the Elefon dance is in the curve of the bulging eyes; the stateliness of the Epa procession lies in the elegant standing of the woman. This piece, in other words, is a hybrid and we will be well advised not to try to divide sharply the traditions. The interconnections of the forms will be discussed in the next chapter. Here it suffices to point out that the sense of unity between the mask and figures (Plates 141 and 142) is so adroitly developed that the observer has the feeling that if "beast" were removed, "beauty" would fall. This anticipates the argument, *viz.* that Epa and Elefon derive from common roots, crown-making traditions, and that both express the same insight: a person can defend life only if he combines the understanding of evil with an essential goodness.

West Sudanic masking traditions also combine relative realism over relative abstraction. This applies to a Senufo headdress attributed to the *kwonro*,[162] or intermediate grade of the Lo Society (Plate 143). The composition is complex. From an abstract wooden helmet rises the head of an antelope, surmounted by a figure of a young woman who gestures to her thighs while balancing on her head a closed calabash container upon which rests a bird. An openwork screen, rising like a fugitive Senufo door, serves as a perch for three more birds. And at the rear a cowhead projects from the helmet and supports a bird. This is an extraordinary complication of the theme of balance. Lacking precise field information, I pass on to Mossi art, in Upper Volta.

Here we meet a mask type for which fresh information has been documented by Rene Bravmann, a leading authority on the art styles of Upper Volta. According to Bravmann:

> There is a specific mask type, generally known as *karan-weba.* Karan-weba are distinguished by the mounting of the figure of a woman over an antelope mask. The arms of the woman are flexed, with hands more or less parallel to the hips. The figure is powerfully breasted and has a very long neck. She

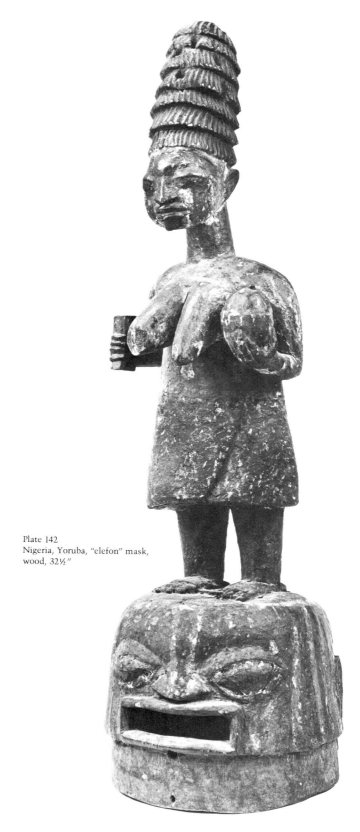

Plate 142
Nigeria, Yoruba, "elefon" mask, wood, 32½"

104

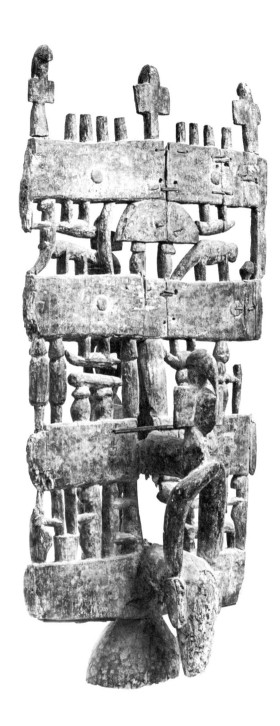

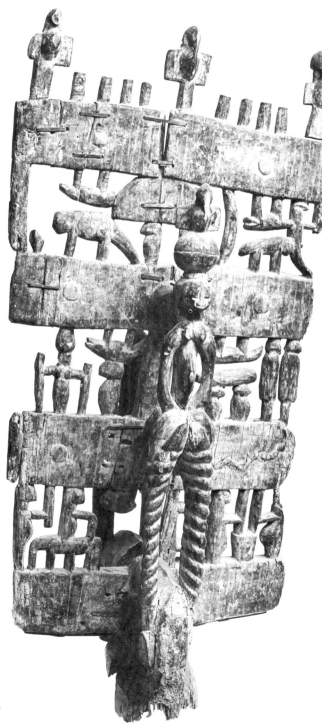

Plate 143
Mali-Ivory Coast, Senufo, "kwonro"
headdre'ss, wood, 50"

surmounts an abstract mask with diamond-form recessed area in which are sited deeply cut eyes, sometimes in the form of a circle, sometimes not. The context of this mask is always funerary.[163]

There are two karan-weba in the White Collection, plus a possibly related mask type (Plate 144). The first (Plate 145), Bravmann says, represents a generalized ancestress, come from her special region in the sky. She comes to earth during the funerals of the dry season. The second (Plate 146) karan-weba is a masterpiece: the transition from mask, through figure, to high panel (embellished with openwork) is handled with the economy and sophistication of stylistic means of a highly developed craft tradition. The meaning of the panel is unknown. I would guess that it might refer to the descent of the figure from the sky, for similar motifs of sky origin exist in the art of the Dogon.[164]

What is certain is that a Mossi sculptor has reconciled images of beast and woman at a single point of ultimate balance. Yeats could almost be describing the woman on the mask:

Her eyes
Gazed upon all things known, all things unknown
In triumph of intellect
With motionless head held erect.[165]

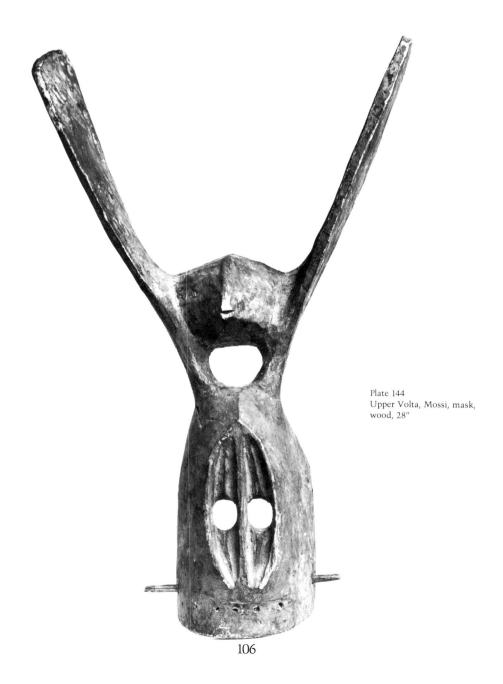

Plate 144
Upper Volta, Mossi, mask, wood, 28″

106

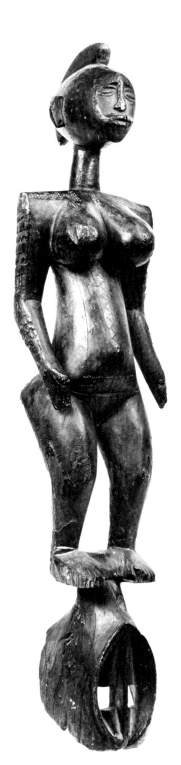

Plate 145
Upper Volta, Mossi, "karan-weba"
mask, wood, 39"

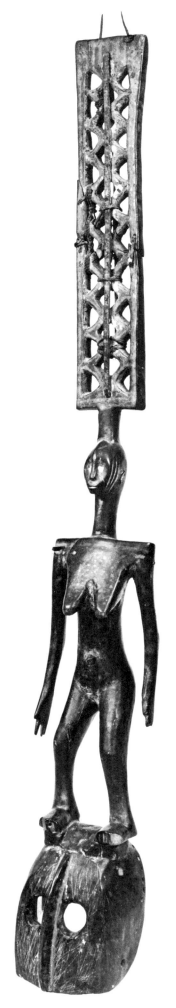

Plate 146
Upper Volta, Mossi, "karan-weba"
mask, wood, 54½"

107

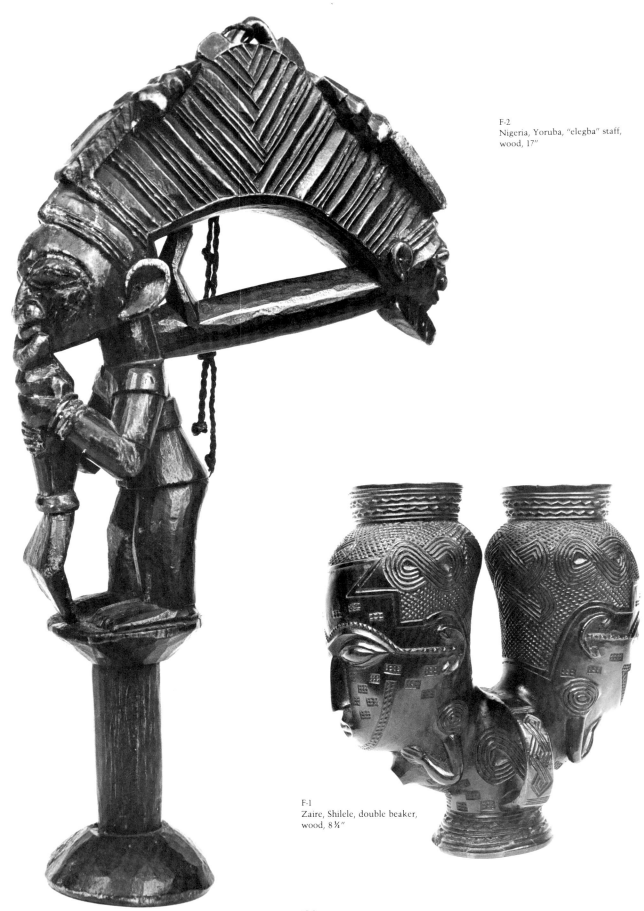

F-2
Nigeria, Yoruba, "elegba" staff,
wood, 17"

F-1
Zaire, Shilele, double beaker,
wood, 8¾"

108

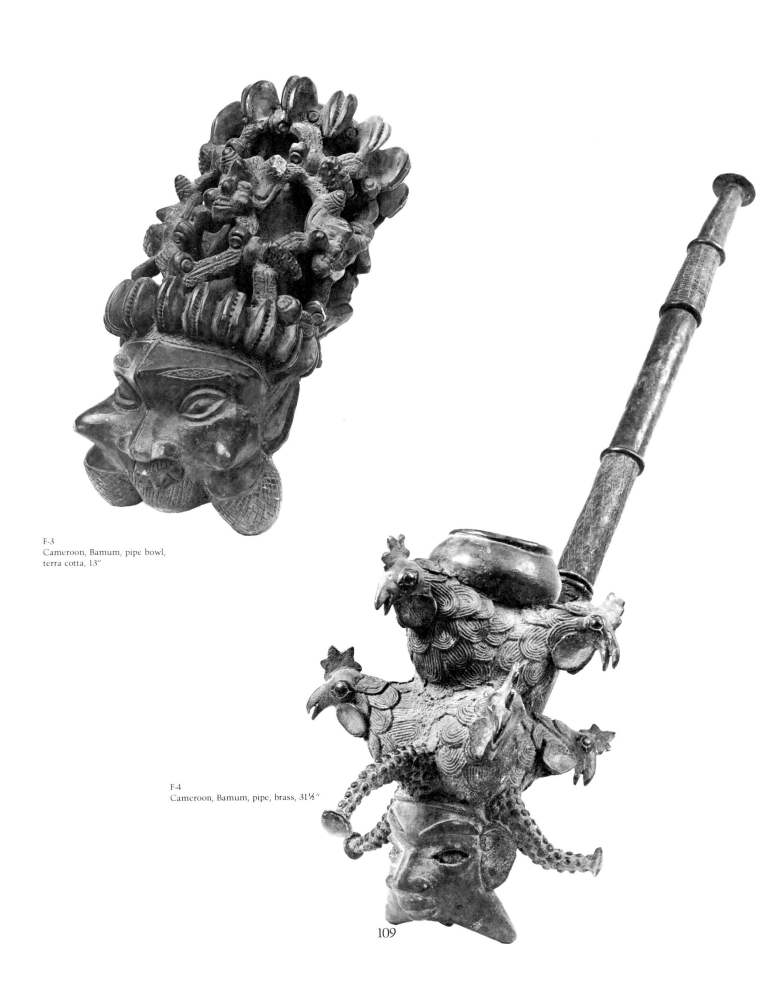

F-3
Cameroon, Bamum, pipe bowl,
terra cotta, 13″

F-4
Cameroon, Bamum, pipe, brass, 31½″

109

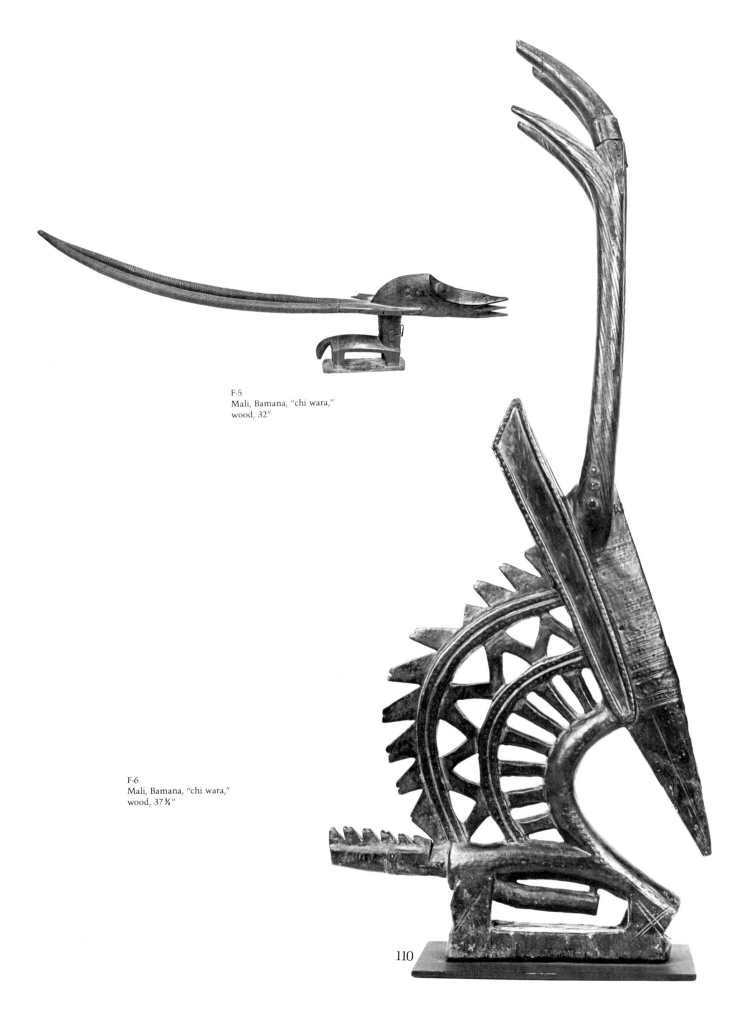

F-5
Mali, Bamana, "chi wara,"
wood, 32"

F-6
Mali, Bamana, "chi wara,"
wood, 37¾"

110

CONCLUSION

Africans stand to perform or initiate important matters. They seat themselves to deliberate. They arrive upon the back of a horse to impose military or ritual order. They serve and submit by kneeling. They achieve spectacular forms of balance.

These icons are conceptual designations of idealized repose. Thus to recall, the standing or crouching human figurations on the sides of a Mambila delivery-stool (Plate 120a) witness the confession of the mother in labor, thus to support, in a most dramatic way, the saving power of the truth.

Stance and attitude in African art must not yield to uncritical naturalistic assumptions. Twin images, for instance, are not figurines simply representing dead children; they are semi-divine beings who communicate by positioning of arms and hands the readiness to act on behalf of human prayers for more children. Similarly, a walking-stick when maintained in the vertical is more than a walking-stick. Among Yoruba, when the king of the city of Ijebu-Ode cannot attend an important function in person, he sends his staff instead, to manifest concern and lend his presence to the gathering. This is standing-in, in a marvelous sense.

Neither do iconographically similar objects within attitude categories necessarily mean the same thing. Consider bird-mounted standing staffs. Yoruba birds are of iron; Senufo, of wood. Yoruba birds are witches, overcome by the bird of divination. Senufo birds are babies, riding on their mother's back. Anita Glaze, in a personal communication (October 23, 1973) informs me that the latter staffs are connected with champion cultivator ceremonies, "really a whole philosophy and a very important part of the life-cycle," a much richer context than could be imagined from the literature. A person follows behind the hoeing men in the fields and, at the end, inserts the metal tip, frequently found at the bottom of such staffs, in the yam heaps.

There is an orchestra and singing to stimulate the contestants. A girl oils the bird-staff, leaving it red and gleaming, words in Senufo, which Glaze reveals, are associated with the sky. Sometimes there is spectacular dancing with the staff, either by the recent champion cultivator or by a champion of long standing. These champion cultivator staffs are often surmounted by the figure of a handsome young woman, for the essential Senufo concept is that beauty, for cultivators, is a great and overpowering reward, strongly associated with the well-built woman and her image on the staff or, most interestingly, high-flying birds in the sky, "birds which never come down to earth, birds which perch on mighty trees." We are light-years from the Yoruba altar of divination. In a sense the champions' staff stands within a world of call-and-response, the men calling with their labor and their sweat, the staff silently answering, behind them, as they work, with handsomeness and repose. It is, as Anita Glaze says, a most beautiful phenomenon, one of the dramatic instances which whet a scholar's appetite for the day when, ideally, as many forms of African art as possible have been restored to motion contexts.

Such insights and elaborations lend authority to African society. The role of the object becomes as beautiful as the making. In addition, sculpture via its very permanence anchors the person in moral certainty. Figural sculpture suggests action where it is appropriate or stimulates its enactment. Sculpture also suggests submission where this virtue is essential. Objects evoke the psychological and moral commitments of the black nations. We saw, for example, in the images of supporting and balancing, a reflection of a far wider universe of indicated truths.

Among the many lessons suggested by stance and gesture in African art is the suggestion that men, for all their heat and muscular glory, must, at crucial points, emulate the cool of women, lest they be destroyed. No matter how powerful, their morality is corrupt when they come to believe there is no one before whom they need to kneel. Recall the testing of the young men of Mossi, who bent to assure their elders that they could take commands and submit to discipline.

Icons serve to communicate that men and women in Africa recognize that certain balances must be sustained. Assertion and collectivity, "riding tall" and "getting down," being beautiful and being productive—these are some of the essential balances which are struck in life and art. Above all, supplication cools the ancestors in demonstration or receptivity. And receptivity becomes the medium through which the dead and the gods return their blessings to the world. The balance is far-reaching. It eludes the mind of the outsider who is not prepared to

accept the truth that the center of African artistic happening is often mystical and can absorb all practical concerns in a deeper manifestation of the divine.

It is generally assumed, for example, that formal social relations require controlled disposition of the body. Informal relations, the notion goes, are identified by relaxed posture. Moreover, recent studies indicate that stiffness of body suggests the subject finds himself before a person he does not know or trust. Such stiffness is surely not the happiest of body communications when men are meeting to safeguard the continuity of life. However, Africans, in characteristic multiple expression, mix these modes. The head is immobile. The body moves. The communication of the blend is very strongly rendered in sculpture where the formality of the face (even other-worldliness) is relieved by inflected limbs.

An important correlative of the face, in sculpture, which has not been discussed in this book, is the positioning of the fingers. They are always parallel and strictly aligned. There are a few exceptions, such as proverb-sculpture among the Akan, which shows the two fingers of congratulation pointing skyward; but, in general, fingers are rarely separated or displayed in contrasting positions. There is no equivalent, so far as I can determine, to the opening of the hand of the subject and the disposition, in the lap, of the fingers arranged along contrasting axes, as happens sometimes in Western portraiture. Cold head and cold hands are logical mirror images. They develop within the ideal coolness of the subsaharan mode.

In addition, the combining of formal hands and formal head with informal flexion suggests that African icons address the truth in the deepest sense: we are blends or patchworks. The mask of the ancestors may have descended, but we cannot escape our body. Nor would we wish to escape our body, for vitality of muscle and motion restores vitality to the past and to the gods.

These values continue to shape life and polity in areas where African sculpture has long since vanished or is in the process of disappearance. People are art in Africa. Icon and act stem from common roots. These roots, we recall, include getting down, looking smart, being vital, and keeping cool. The canons do not depend upon material objectification. The only imperative is human existence and respect for the transcendent.

Among the Bamana, Pascal James Imperato reports, standing remains important as the mode of meaningful speech and action: "Anyone engaged in an activity which is very important will do so in the standing position. Private gatherings may be conducted seated. But an important public pronouncement must be made standing. An important visitor to a village, for instance, will announce a new procedure and this will be translated by a standing blacksmith." The association of the posture with consequence remains strong in the land of Sundjata and the

use of the standing blacksmith as "translator" adds a most interesting possibility of ritual evocation. Nevertheless, we are also touching upon what anthropologists call a universal, for a person the world over rises to make a formal address.

If standing appears everywhere in contexts of initiative and oratory, there are some areas of Africa where rhythmized lowerings of the body seem unique in point of intensity and elaboration. Thus among Senufo, according to Anita Glaze, the leading authority on the artistic culture of this important traditional civilization poised in northern Ivory Coast and southern Mali, women of the Sandogo divinatory society honor a dead member by extraordinary motions. They kneel—in a manner very close to the attitude of the "maiden" surmounting the shea-butter container—but they also roll on the earth and even crawl under the carved death-bed (Plate 147). They make numerous stylized descents in honor of the person who has passed into that other level of energy we call death. Glaze says the key word is *suffering*, that the situation is another kind of call-and-response, written in stylized agony. The Sandogo women say the dead individual suffered in her time on our behalf—now we shall suffer for her. And they roll and kneel and crawl.

Perhaps the heat of death specially inspires the cooling of a situation through appropriate submission in body posture. Wyatt MacGaffey has documented important continuities at the Kongo funeral (Plate 148). The photograph documents a person greeting a mourning dignitary with a forward inclination of his body, cognate with kneeling in Kongo statuary. The seated person, for his part, responds to this by cupping cheek in palm, reminiscent of the seated figure on the Lunda comb (Plate 99). He communicates both his sadness and the fact that he is thinking, with dignity, about the greetings given by his brother.

Embedded in the myriad themes of command and submission lies African moral continuity. These themes stem from very ancient roots. The icons of repose come into pure profile no later than the first millennium B.C., when the terracottas of the so-called Nok Culture, sited in northern Nigeria, begin to emerge in history. There are several standing figures from Nok Culture sites, a fine kneeling figurine, and a magnificent fragment of a seated figure from Katsina Ala. The latter shows parallel legs, feet flat, frontal formalism of phrasing, and tastefully asymmetric arms. In some respects this ancient image suggests an antecedent for the seated Baoule king in the White Collection, just as the kneeling Nok figure found at Bwari, in its hierarchy of body parts, is in many ways ancestral to Luba caryatid sculpture.

The White Collection includes excellent examples of ancient postural icons. One is a Sherbro-Portuguese ivory salt-cellar (Plate 149). Such works date, at least, from the period of Portuguese exploration, *i.e.*, the sixteenth cen-

Plate 147
Sandogo divinatory society funeral
ceremony

Plate 148
Kongo funeral

tury. Their making was established on the coast by 1506–10, at which point Valentim Fernandes wrote: "in Sierra Leone men are quite ingenious. They make truly marvelous works in ivory of all the objects which one asks them to make; some make spoons, salt-cellars, handles for daggers, and any other subtlety." Human figures at the bottom of the illustrated salt-cellar suggest support of an orb over which presides a Janus. Two kinds of balance seem embodied here, one phrased in terms of support and sited low, the other, phrased in terms of metaphysical equilibrium and sited high.

The other document comes from the period 1550–1650, William Fagg's "plaque period," *i.e.*, in the history of Benin art (Plate 150). This brass plaque from Benin illustrates the august standing of the king in the midst of reverential servants and kneeling sword-carrier. High and low aspects are then subtly restated in the king's gesturing. He holds his staff vertical, as a kingly surrogate. This is balanced by the slashing horizontal of his sword. Order and destructiveness are therefore held in harmony by the king. He arms himself with forces vertical and horizontal. We shall learn in the next chapter how these deep and ancient themes, the verticals of mind and government, and the horizontals of night and witchcraft are explored and reconciled in art and motion.

Plate 149
Sierra Leone, Sherbro, saltcellar, ivory, 12"

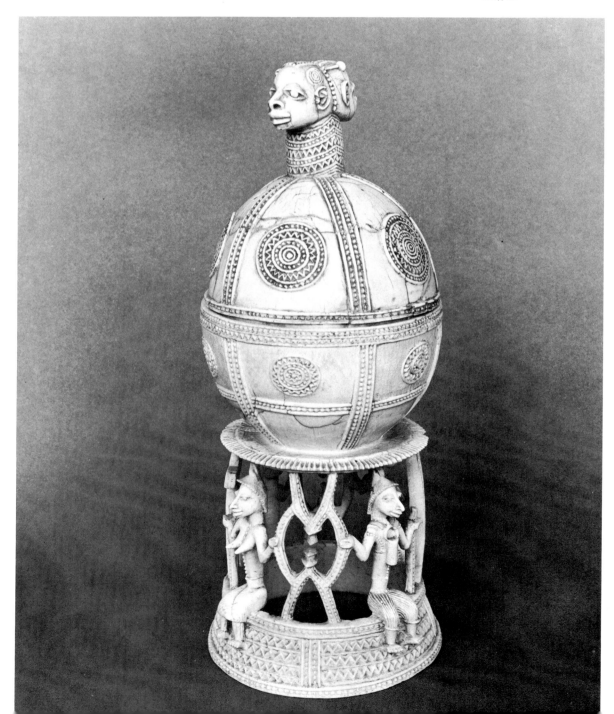

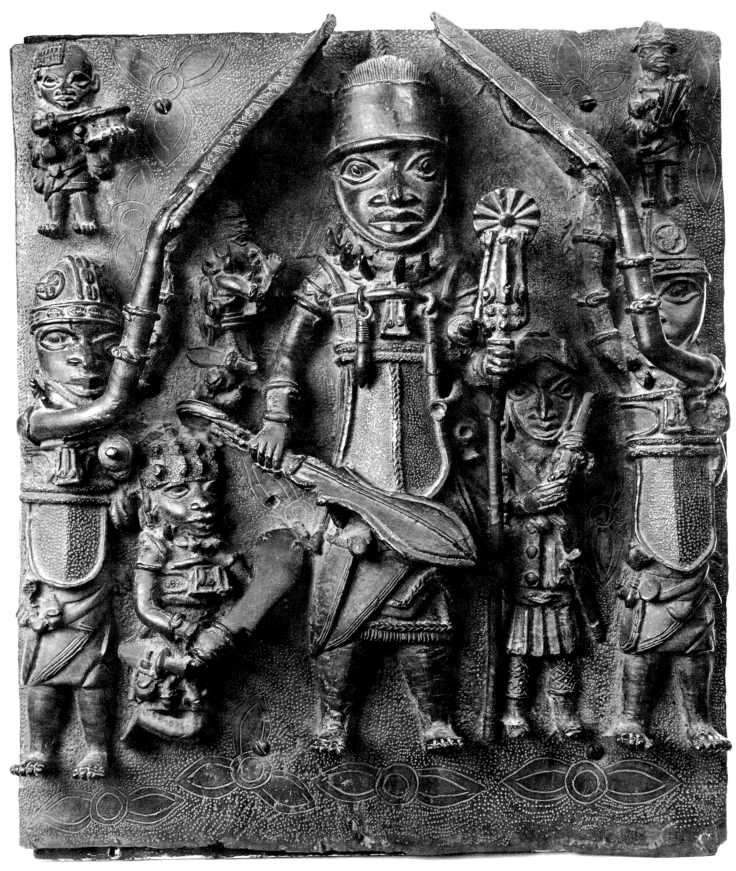

Plate 150
Nigeria, Benin, plaque,
brass, 17"

115

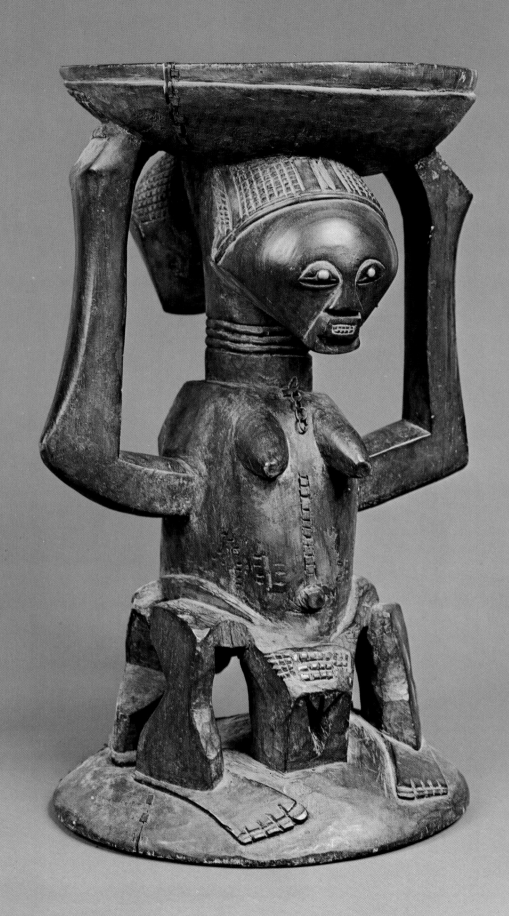

Instead of the swift and imperceptible
flowing of time, you are aware of its
nodes, those points where time stands
still or from which it leaps ahead.

 Ralph Ellison, *Invisible Man*

Overcome by the spirit, he danced on his
knees, moving backward and forward in a
kind of body-swing while he also 'danced'
the candle and the glass with flowers.

 Melville J. and Frances Herskovits, *Trinidad Village*

ICON AND ACT

Introduction

Icon defines itself in act south of the Sahara. Things done, sculpture and dress, combine with things happening, music and dance. A fundamental principle is made manifest: action is a superior mode of thought. Movement serves long-term knowledge with sensuous uprush and spontaneity, answering to the imperatives of life. There is no turning back. The artist transcends particularity to illustrate, with authority, vital grace.

Dance sweeps over image and audience with a blast of super-individuality that tears down ordinary distinctions. The process begins with the fusing of disciplined facial expression, connoting seriousness and detachment, and rhythmic vibration of the torso and the hips, connoting life and sensual energy. Brilliant dress extends the synthesis, providing in intensity of color and patterned accents, a kind of visual sound to set beneath the silence of the mask or the silence of the dancer's lips. The inherent language of made stuff is therefore charged with ephebic intensity, with strong allusions that honor the dead, in funeral contexts, wrapping life about spirit, vitality about remembrance.

Revitalization through rhythmic pattern compares with the enlivening of a musical instrument by the hand of a player or the dancing of aphoristic sculpture to supplement the telling of the truth.

The interplay of sculpture, costume, and dance is fascinating to follow where the intent of the performance is to illustrate the "person" (of ideal character and spiritual bearing) or the "bush spirit" (the mirror of dissension, war and death). There are, however, balanced presentations of the two tendencies, as in the suggestion, in mask-wearing, of possession by powerful spirits, or the relation of leaders to heroic beasts with horns. This leads, also, to a brief discussion of horizontal forms of masking in Africa and referral to witchcraft and mystic heat.

The review of these categories helps us to define and enjoy the more salient aspects of African danced feasts, where artistic media are commingled in a high state of mutual definition. These dance contexts have the force of a divine illustration, of idealized human flexibility in the face of dramatized situations where valor and aplomb are ruthlessly tested. At the end many modes of adaptive response have been elaborated. Seasoned performers emerge triumphant in their coolness.

This coolness is a philosophic ground for orderly human existence. With its understanding we gain fresh insight into the sources for black accomplishments in history.

The Two-Part Body System

The findings of Alan Lomax, Irmgard Bartenieff, and Forrestine Paulay, conveniently assembled in the volume, *Folk Song Style and Culture*, provide a basis for the philosophic interpretation of movement in tropical Africa:

The most dramatic and outstanding feature . . . of much Negro African dance south of the Sahara, is the two-unit system. The torso is divided into two units, and sharp twists at the waist set up an opposition between the pelvis and the thorax or between the upper and lower parts of the body.[1]

117

Color Plate III Zaire, Luba, Stool

These scholars confirmed the existence of a distinctive human motion in Africa:

> The . . . profile is notable for the number of types of transition employed in movement. Curving and looping transitions are frequent, but simple reversal cyclic and angular are just as frequent . . . because of contrastive use of a variety of transition, shaping and effort qualities, dancing gives the impression of extreme liveliness and high excitability. . . .
>
> Speed and power flow through all African movement. Dancing displays an orchestral use of the body where the upper and lower halves develop different supporting but complementary rhythms. It is with this polyrhythmic handling of the body, combined with dramatic bursts of strength and speed, that the African dancer produces an effect of orgiastic excitement. All is change here. . . . [2]

Norms emphasized by traditional African experts, youthful drive and intensity, the rapid playing of the patterns, the importance of dancing to many drums, and so forth, converge upon these findings. A tradition that emphasizes variety of transition is obviously a perfect school for self-transformation at higher and higher levels of metaphoric suggestability.

Mbira-Playing: Variations on a Visual Theme

The shifting strategies of African expression apply to the making and playing of certain musical instruments. One of the unique contributions of Africa to world instrumentation, the *mbira,* is a case in point. The mbira is a traditional instrument, consisting of metal keys mounted over a bridge on a hardwood sound board, played with the thumbs or thumbs and both index fingers (in lower Zaire sometimes three fingers on each hand).[3] Laman describes the Kongo mbira:

> The instrument may have eight or more bars. The first from the left is called mbadiki (beginning), the two following bars and the two to the far right binkele or nseki za nkunga (the leaders of the song with the highest tones). The other bars are called mintabudi (that answer). The largest bar is called ngudi (mother), the ones next to it balanda ngudi (they follow the mother). In other cases some of the bars are designated as minkumata (used to modulate the tone) kya ngudi (mother) and kya mbangudi (that explain). Alternatively, the scaling of the bars follows the vocal register, while two of them are denoted mbangi (witnesses). [4]

The poetic names given to the keys imply instrumental internalization of call-and-response, the left hand answering the right.

Plate 151
Rhodesia, Shona, "mbira", wood and metal, 9¼"

Plate 152
Angola, Chokwe, "mbira", wood and metal, 5½"

Plate 153
Angola, Chokwe, "mbira", wood and metal, 10½"

118

Plate 155
Central Africa, "mbira", wood and metal, 7½"

The mbira can be elaborated as a work of art (Plates 151–155). Examples include instruments from the area of the Shona of Rhodesia [5] (Plate 151), the Chokwe [6] or Chokwe-related portions of Angola (Plates 152 and 153), Tanzania (Plate 154), and Central Africa (Plate 155). Pitch is communicated by length; high-pitched keys are short, low are long. All are plucked with staccato timing, set against the continuous buzz, in three instances, resulting from the vibration of tiny iron beads attached to a bar on the instrument. A similar effect occurs on the Shona mbira by means of rattled bottle-caps.

The resolution of sizzle and off-beat accenting is delicious to African ears. In addition, the keys of mbiras are often sited in flanking symmetry about a central set of keys and this reaffirms heraldry in sound and structure. Yet another sort of balance is established in the playing. Thus John Blacking:

> The most significant common factor of the kalimba tunes are not their melodic structure but the recurrent patterns of 'fingering' which, combined with different patterns of polyrhythm between the two thumbs, produce a variety of melodies. Tunes are variations on a theme but the theme is physical. . . .[7]

Action of the hands is converted into auditory terms. Finally, mbira music is normally "cool" in that a brisk tune will, interchangeably, accompany songs of happiness as well as songs of sadness and abuse.[8]

Bwami: Moral Philosophy in Motion

The publications of Daniel Biebuyck on the Lega of Zaire [9] have advanced our thinking about the dancing of important objects in Africa. First, the elders of the Bwami Society, for whom Lega art is made, must not allow their legendary moderation to lead them into asceticism nor self-punishment. They must cultivate pleasure.[10] They must enjoy the dance. They must delight in the display of beautiful objects. In particular, they savor the use of sculpture and art as means of aphoristic enlightenment.

Thus the hornbill knife [11] (Plate 156) is a miniature of the large hornbill implement used to clear forest undergrowth, and communicates the concept that the initiation of the person cannot be promptly accomplished without the help of many persons. There is another instance of communicated ethical insight, a staff with three heads (Plate 157). This is an allusion to a proverb referring to powers of exceptional discernment, "Father Big-Head has seen elephant on the other side of the large river." [12] The same meaning is suggested by a similar, multi-headed staff (Plate 158).

Lega objects attain a fuller meaning in motion contexts. They are commonly made to gleam with oil, then displayed and danced, category by category, while the meanings and the aphorisms connected with the objects

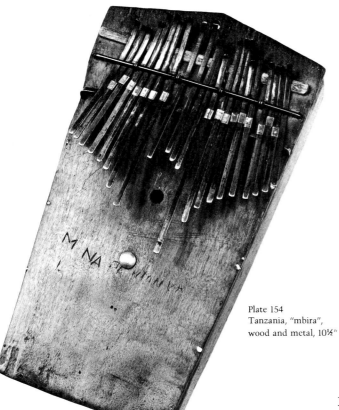

Plate 154
Tanzania, "mbira",
wood and metal, 10½"

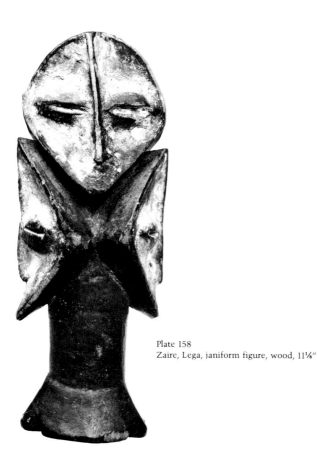

Plate 158
Zaire, Lega, janiform figure, wood, 11¼"

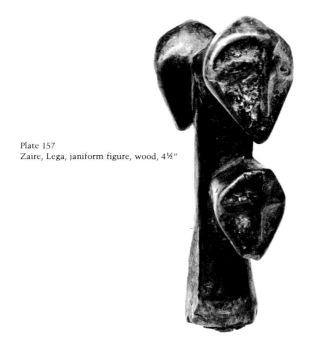

Plate 157
Zaire, Lega, janiform figure, wood, 4½"

Plate 156
Zaire, Lega, bill hook, ivory, 11⅝"

are given. These icon-laden dances can be strik-ing.[13]

Biebuyck has documented the dancing of a Bwami member with a carved image of "the adulterous pregnant woman,"[14] belly swollen with deliberate distortion, meant to emphasize ritual pollution of the family. While he dances with this striking image, he distorts the sides of his cheeks and the shape of his mouth in order to express the "pains of the adulteress during child-birth."

The Mask and the Person

Susan Vogel discovered in Baoule villages (Ivory Coast) that traditional commentators distinguished between fine sculptures representing "the person," "controllable, productive, civilized," and less fine statuary associated with "the bush spirit," "arbitrary, uncontrolled, not civilized."[15] Biomorphic precision prompted the first judgment, monstrous lapse of quality or expression, the second. A badly polished skin or marred surface, she found, could even be compared to leprosy.

It is interesting that some Yoruba commentators also distinguish between fine statuary compared to "the person" (enia), and less fine, compared to pathology, or dismissed, as in one instance, with the phrase, "it is just an image."[16] Moreover, during a series of informal "seminars" with an Ejagham woman at Mamfe, Cameroon, in January 1972, I learned that fine skin-covered sculpture was praised for resemblance to a "person," whereas careless or horrific-looking sculpture was criticized with the phrase "looks like a mask" (ochi na okum).[17] The modal praise in Ejagham-speaking territory was: ochi na binne —"face resembling a person." Downriver at Calabar, the Ejagham of Big Qua Town used the same terms. Good figural art resembled the person (nje efona ne); bad or evil-looking art, the mask (nje efona esi okum).[18]

The sources, and I could supply more, indicate that the ideal image of man or woman resembles "the person," of high moral character and equanimity of mind and body; whereas, bad or evil-looking art disturbs the purity of idealized communication by introduction of particularity, signs of excess or disease, heat, self-expression, danger, and ugliness.

Compare Luba philosophy:

The word 'muntu' [person] inherently includes an idea of excellence or plenitude. And thus the Baluba will speak of 'ke muntu po', 'this is not a muntu', of a man who behaves unworthily. They will use the phrase of a newly-born who has been begotten outside the normal ontological, moral, and juridical conditions of clan life.[19]

Accordingly, in many arts of Africa there is meaningful concentration on moral representation. However, there is more to the "person" than facial calm; not only must

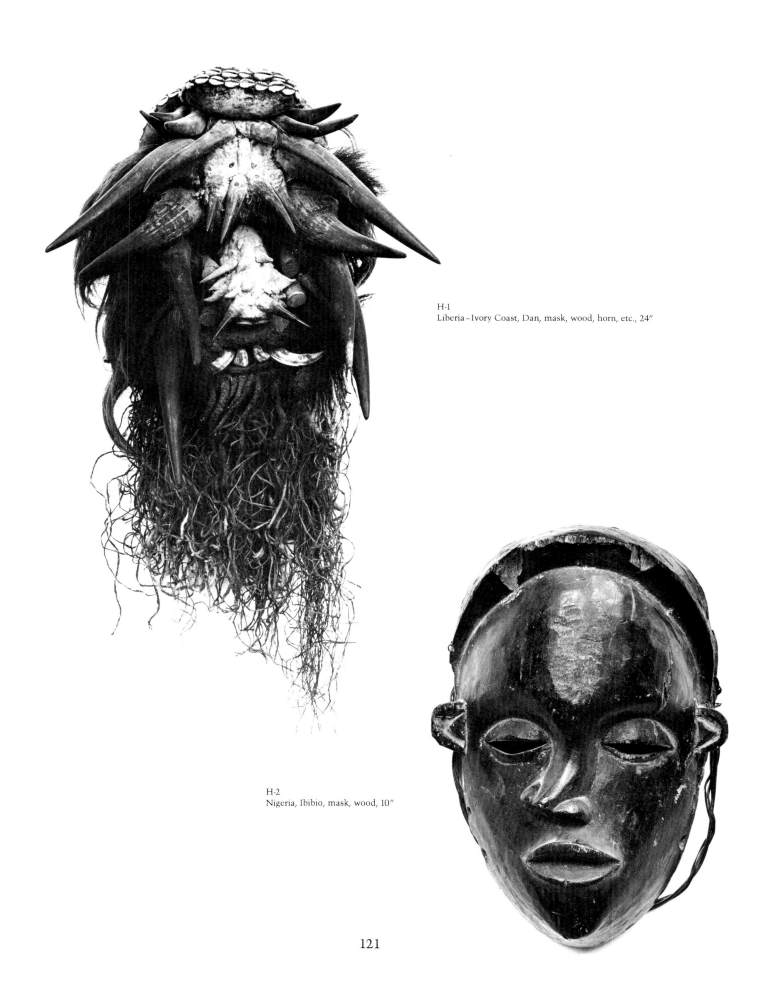

H-1
Liberia – Ivory Coast, Dan, mask, wood, horn, etc., 24"

H-2
Nigeria, Ibibio, mask, wood, 10"

121

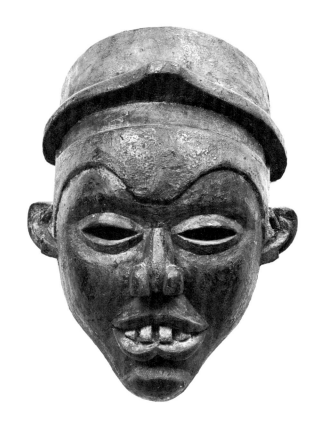

H-4
Nigeria, Ibibio, mask, wood, 13″

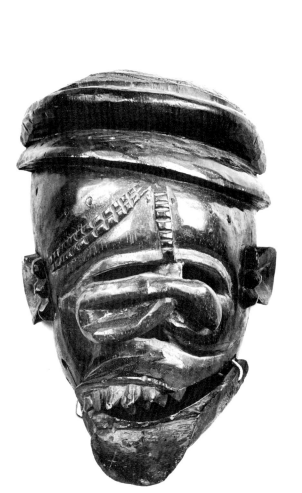

H-5
Nigeria, Ogoni, mask, wood, 7″

H-3
Nigeria, Ibibio, mask, wood, 11½″

122

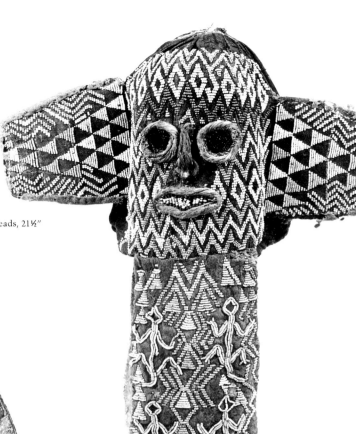

H-8
Cameroon, Bamileke, cloth and beads, 21½″

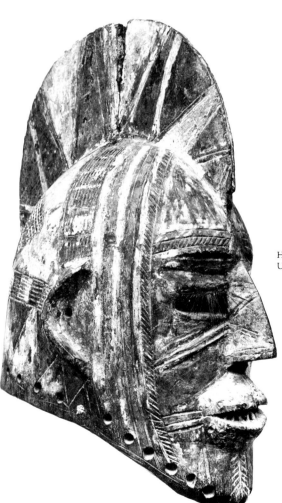

H-7
Upper Volta, Bobo, mask, wood, 18″

H-6
Nigeria, Ibo, mask, wood, 8½″

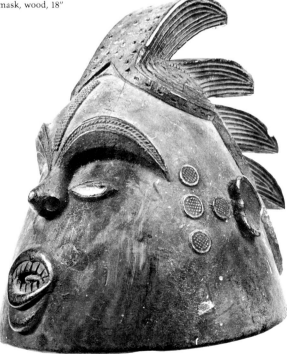

123

H-10
Mali – Ivory Coast, Senufo, mask, wood, 14½"

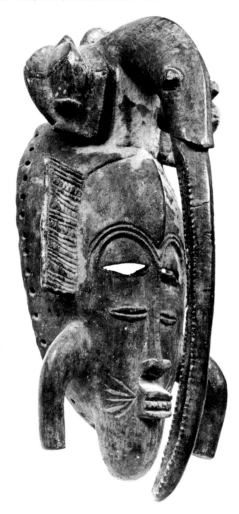

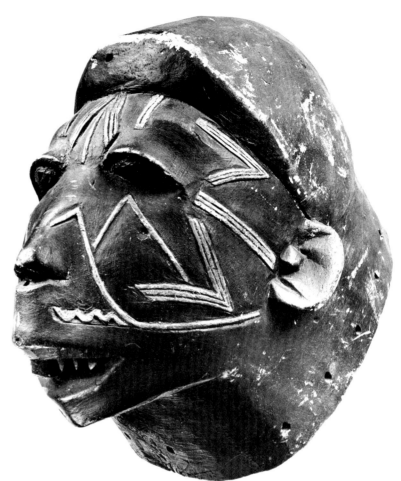

H-11
Tanzánia, Makonde, mask, wood, 11½"

H-9
Nigeria, Ibibio, mask, wood, 7½"

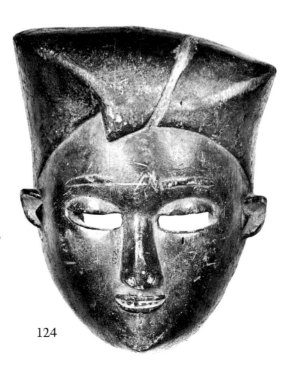

124

he or she be physically strong, and dance and dress with energetic flair, but the person must also show, ideally, metaphysical powers of insight or revelation, a sense of humility and concern before unseen sources of vitality: "after recent investigations made in various Negro societies, it appears that one of the fundamental ideas of their religion is that of 'the person.' It crops up constantly, as much in everyday activities as on feast days. . . ."[20] Being a person is also being mystical, being endowed with a rightful thirst for transcendence of human limitations. The point is liberation. Self-realization in a transcendent mode immediately identifies the proper elder or the proper chief. Thus the Luba:

> It never takes one long to observe the transformation on becoming chief of a man whom one has formerly known as an ordinary member of the community. The qualitative change is made evident by an awakening of his being, by an immanent inspiration or even, sometimes, by a kind of 'possession'. The 'muntu', in fact, becomes aware of and is informed by his whole conception of the world around, through all his modes of knowledge. [21]

Thus on very close inspection we discover the spiritualization of the facial icon, just as we found that postural modes, in the last chapter were simultaneously of this world and the next. I think that when African connoisseurs praise the person and condemn the mask that they are not saying figurative realism is art. I think, on the contrary, that they are objecting to a break-down, through improper realization, in the balance between the real and the transcendent.

Mask as Spiritualized Person

Deliberate imperfection can illustrate moral preoccupation in exact comprehension. Thus among the Maravi of Malawi the *Nkhokomba* mask[22] (Plate 159), used to "instill discipline during initiations and beer-drinking," has a narrow nose, said to be typical of Maravi male masks, and a projecting domed forehead. The abstract mouth is splashed with paint. Shredded cloth surrounds the mask. Certain of the elements correlate with the Maravi image of old age (extreme features, lack of teeth, and so forth). Yet this image is culturally supportive: "old age is associated in Malawi with wisdom . . . because the oldest men preserve the tribal history and traditions."[23] A fusion of authority and force is suggested by the associated motion: "the dancer who becomes this figure conducts himself with an air of aggressiveness and authority, and this assertiveness is reflected in the sure, strong planes of the mask as they protrude, recede, and meet in sharply defined edges."[24]

Balance between worlds is rendered in a different, ascendingly scaled manner by the carvers to the famous

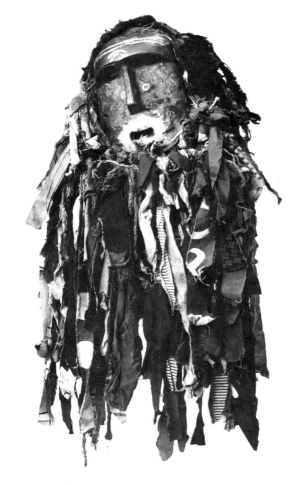

Plate 159
Malawi, Maravi, "nkho komba" mask, wood, fabric, etc., 8½"'

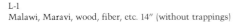

L-1
Malawi, Maravi, wood, fiber, etc. 14" (without trappings)

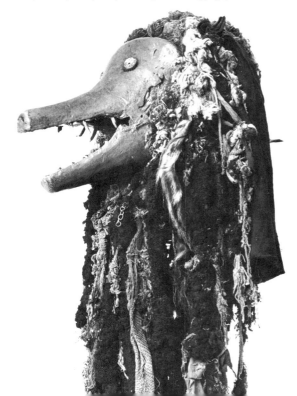

125

Sande Society of Sierra Leone and Liberia. Sande dedicates women to the learning of beauty, social usefulness, and moral self-realization. By convention, masks for Sande are called *Bundu*. One mask (Plate 160) illustrates, in shaping, what girls in Sande are taught in words, *i.e.*, to maintain youthful gracefulness, tempered by seriousness and embodiment of ancient spirit attributes. Fleshy cheeks and luminous rising brow fuse with serious mouth and closed, spiritualized eyes.[25] But there are many modes of phrasing within Sande, for another mask (Plate 161) with exposed teeth and staring metal eyes, seems awakened and might reflect another function.

The road to understanding, as always, lies within the commentary of indigenous connoisseurs. These laud the eyes of the Bundu, large or closed but "knowing," the shining black forehead that is "broad, wise, unmarred," and the rhythmic neck-rings which communicate opulence tinged with mystic associations, *viz.* the rise of the head of a spirit from concentric rings within the water.[26] These delicately blended transitions, from one world to the next, are mirrored in the qualities of the Bundu dance:

> smooth perfection of their delicate movements, the
> precise rhythmic timing, the graceful complete execution of each step, the one mingling with the next,
> so that they cannot be separated by the eye. . . .[27]

The Person, Spirit Possession, and Art

In a world of multiple meter and constant change in dance possession by a spirit (the formal goal of many Niger-Zaire traditional religions), seems a logical, consistent characteristic. A person, when the spirit comes upon him, changes in personality, attitude, and stance. He moves in the image of the deity. If the god is strong and fiery, he becomes strong and fiery. This ultimate act of transcendence brings prestige. The servitor may make prophecies or miraculously heal while in the state of possession. The otherworldliness of this condition can be transferred to sculptural representation.

Thus the closing of the eyes and the freezing of the face in one form of Akan possession in Ghana[28] can be compared to the closed eyes and cold features of a Baoule mask (Plate 162). Even more to the point, the backward-tilt of the head in Akan possession and statuary is sometimes compared to the proverb, "face looking down shows sorrow, face looking up shows ecstasy and trust in God."[29] The proper time to cite this proverb is at a funeral. It is important to add that some Akan terracotta heads represent priests or priestesses, specialists in possession, and many of these show the ecstatic angle of the head.[30] Hence it is reasonable to suggest that the honorific function of the terracotta head, funereal commemoration, combines with the funereal citation of the

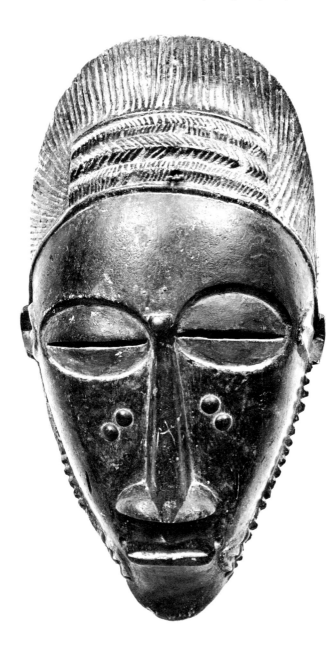

Plate 162
Ivory Coast, Baule, mask, wood, 13"

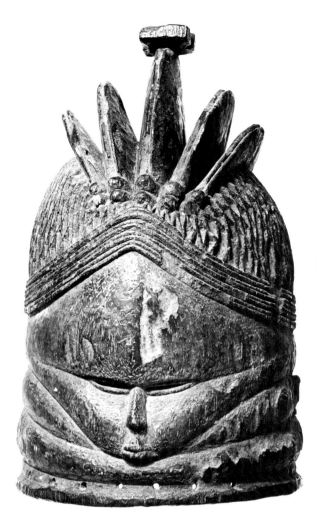

Plate 160
Sierra Leone, Mende, "bundu" mask, wood, 14½"

Plate 161
Sierra Leone, Mende, "Bundu" mask, wood, 14"

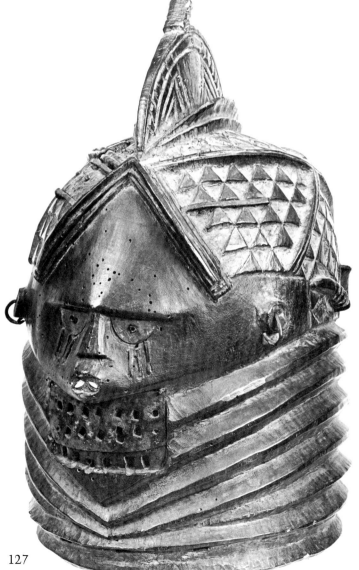

127

Plate 163
Nigeria, Benin, belt mask, ivory, 9¼"

128

proverb, on the backward-tilted head as sign of joy, to cool the searing fact of death. According to Nketia, the Akan phrase the pain in a certain way: "Death hews down trees that give shade and coolness."[31] Ecstasy, nobility of mien, and closed eyes are a way of transcending the pathos of mortality.

If closed eyes and an ecstatic angle of the head suggest one form of possession in Akan art, eyes of huge diameter and frontal disposition identify another form of possession in Yoruba culture.

It is believed that the gods of the Yoruba were a race of giants who once looked broadly over the world with enormous eyes.[32] Thus when a Yoruba person becomes possessed (Plate 54), and his eyes open abnormally wide and shine with an almost uncanny glitter while his lips freeze in a particular way, it is held that he has returned, in a fundamental sense, to the beginning. He mimes the age when the gods were giants and looked broadly over the world.

There are possible allusions to this phenomenon in Benin art. Two superb heads, one ivory, the other terracotta (Plates 163 and 164) are impeccably cool, with a controlled gaze that is the very antithesis of the shifty-eyed look of the ritually impure. Yet the diameter of their eyes and the intensity of their gaze is heightened to suggest ancestral embodiment or possession. The subtlety of this suggestion becomes blatant in some forms of Yoruba sculpture. Thus the "bursting-out" of the huge eyes of a night mask (ere efe) for the Gelede society in the Yoruba southwest (Plate 165) intuits awesome interiorization of heat and energy. Such force would presumably come from "the mothers" (witches) to lend force to the songs of moral allusion the Efe singer must perform at Ketu, with undiminished stamina and accuracy, from midnight until dawn.[33] Ritual energy is written in his eyes.

Royal persons in Yoruba cities embody ancestral power to protect the people against enemies of the community. Such persons, especially in Ijebu province, can own brass face-bells (omo)[34] which are said to represent noble ancestors (Plate 166). Omo bells are often emblazoned with eyes like those of a possessed person and the present example, given as originating from the Forcados River in Benin territory, dating perhaps from the seventeenth/eighteenth centuries, is no exception. In fact not only the bursting quality of the eyes, but the freezing of the lips and face with a particular strong rictus is close to the stylized face of an actual Yoruba devotee (Plate 54). The bell itself, therefore, seems possessed.

The opening of the eyes to reveal enormous orbs, as if to give birth to a new kind of vision, also characterizes certain forms of soapstone statuary (nomoli) from Sierra Leone (Plate 167). Such figures are at least as old as the earliest period of Portuguese exploration.[35] This stone head may well represent a western extension of a mode of spiritualized presence that was widely diffused in the

129

Plate 165
Nigeria, Yoruba, "gelede" mask, wood, 15"

Plate 164
Nigeria, Benin, head, terra cotta, 5½"

Plate 167
Sierra Leone, Sherbro, "nomoli" head, soapstone, 4½"

J-1
Nigeria, Ogoni, mask, wood, 12¼"

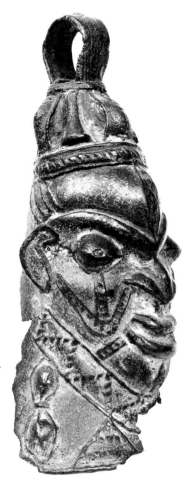

Plate 166
Nigeria, Yoruba, bell, brass, 5¾"

130

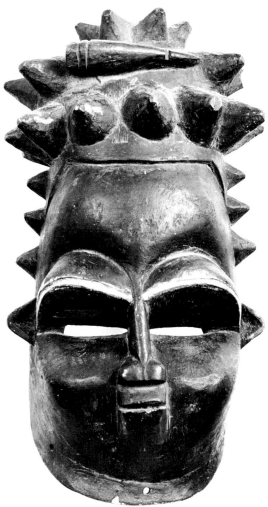

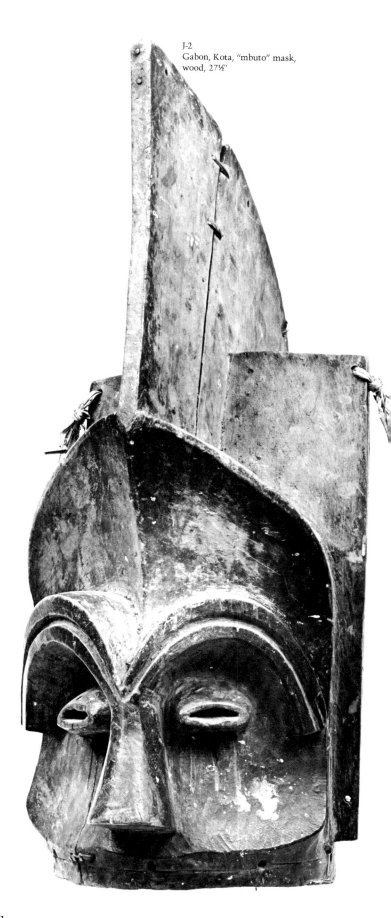

J-2
Gabon, Kota, "mbuto" mask,
wood, 27½"

J-4
Nigeria, Bini, mask, wood, 13"

J-3
Cameroon, Grasslands, pipe bowl,
terra cotta, 6¼"

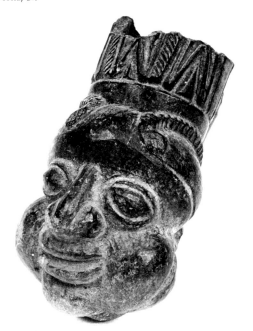

131

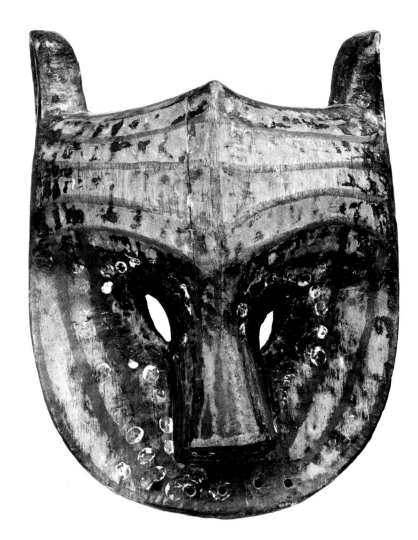

Plate 169
Mali, Bamana, "kore" mask, wood, 17"

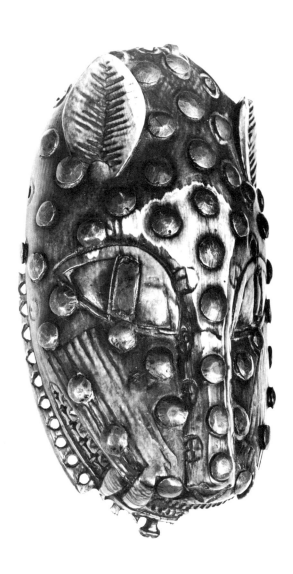

Plate 168 – Color Plate V
Nigeria, Benin, belt mask, ivory and metal studs, 7"

132

art of West African antiquity. At a later point in this chapter we shall come to a cult in which enormous eyes, ancestral commemoration, and dance are all combined—the Epa fetes of northern Ekiti.

The Person as Feline

There are many ways of suggesting extraordinary embodiment in African art. The powers of control and grace which ideally identify the ruler are compared to the leopard or the lion. The former symbolism is strongly marked among Onitsha Igbo:

> His capacity to kill points to a final major aspect of the king, namely his position as the greatest of all 'killers' (ndi-ogbu) or 'warriors' (ndi-ikenga). The Onitsha king is identified with the leopard (agu), regarded as the animal most dangerous to man and called king (eze) of the forest. Only a king can sit on leopard skin and most of the artistic emblems of his palace are covered with leopard spots . . . the hunter who kills a leopard or a warrior who kills a man thus dangerously identifies himself with the king, and for this reason the latter must legitimize the act. [36]

A Benin ivory belt-mask in the form of a leopard head (Color Plate V, Plate 168), dated to around the sixteenth century, is a splendid example of the feline motif in African leadership. The sign of the leopard in association with kings can be established at least as early as the ninth century, for metal representations of this feline have been found at the Nigerian Igbo-Ukwu [37] site dated to around this period. Moreover, Valentim Fernandes noted in Sierra Leone in the early sixteenth century: "if a black man kills a leopard he must give to the king the teeth and pelt as testament of his submission." [38]

The ears of the Benin leopard mask (Plate 168) are rendered like sensitive leaves, set above the head. Strong iron studs, embedded within the warmly patinated ivory, suggest the spots of the animal as well as possible further allusions to elements of fire in the making of the iron, dovetailed into the communication of danger and power. The wide open eyes relate this mask to spirit possession.

When we shift from an image of a leopard to a leonine mask for the Kore Society in Bamana country, Mali (Plate 169), we switch from ivory to wood, from wide humanizing eyes to discreet slits, from glitter to softer forms of expression. This mask was carved for a class of initiates within a society which, according to Dominique Zahan, aims at the moral and intellectual shaping of men. [39] The smallness of the eyes and the relatively "quiet" treatment of surface prepares us for a corresponding dignity in dancing. Kore lion dancers begin their motion on staffs, which represent their front paws; they leap in place; they walk on stylized paws with fixed and frontal gaze:

> The 'lions' remain imperturbable during the whole of their dance. The 'hyenas' come and tease them but without successfully importuning them. The lions continue their motion with calm . . . [they] are, in fact, the symbol of calm and serene knowledge, the bases of education and development. The 'lion' is a form of divine knowledge proposed as a model for mankind. [40]

The Benin mask is an intuition of heat within purity. The Kore mask shows coolness, "nothing that the lion does has not been thought-out, meditated—all his motions seem reflected-upon and reasoned." Appropriately, I think, Kore masks and their meanings in motion are associated with water. [41]

Person as Horned Embodiment of Power

Alexander the Great wore the horns of divinity on an ancient coin. Similarly, the extraordinary person in West Africa is sometimes spectacularly associated with horns. In Senegambia, where Manding influence has pushed down to the sea, there are bovine themes in masking, as in the case of a Bijugos ox head (Plate 170). [42] Bijugos ox head masks, according to Fernando Galhano, frequently appeared at festivals, the wearer imitating with great realism the motions of the animals. [43]

The theme of the horned mask is strongly marked in Manding country and Manding-influenced territory. I suggest one key to the antiquity of the tradition is the Sundjata myth: a famous Manding hunter meets a witch and is kind to her. She is cooled by this and tells the hunter she will help him kill a buffalo he is seeking: "your heart is generous and you will be the buffalo's vanquisher . . . I am the buffalo you are looking for." And so the hunter vanquishes the buffalo with the "menacing horns." There is an implication that the horns of the buffalo pass down the line of Sundjata as a special emblem of magic force and accomplishment, for one of the praise names of the great hunter-king is "son of the buffalo, son of the lion," combining both bovine and feline themes. Possibly the buffalo and its horns were a *tana*, [44] or hereditary taboo of certain important families in Manding. A taboo, so long as it was honored, allowed a person to concentrate within his body the strength of his ancestors. The area where the wild buffalo once ravaged the countryside, according to the Sundjata epic, was the land of Do, the present day Segou region in Mali.

It may be a coincidence, but it so happens there is a Manding masking tradition in central eastern Ivory Coast and the name of the tradition is Do. The White Collection includes two Do masks (Plates 171 and 172), the latter a metal version of the image in wood. There are several stock mask types within the Do "play" and the illustrated examples are Do bush-cow masks, which the Ligbe call *siginkuru-ayna*. [45] This mask combines lidded

133

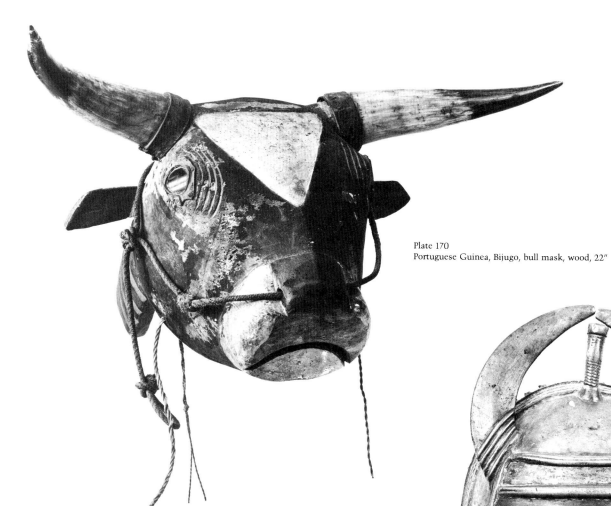

Plate 170
Portuguese Guinea, Bijugo, bull mask, wood, 22″

Plate 172
Ivory Coast, Senufo, "do" mask, metal, 10″

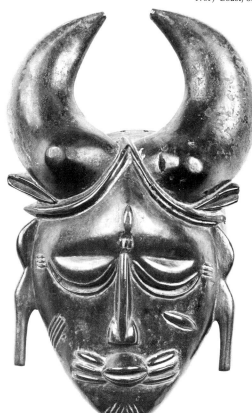

Plate 171
Ivory Coast, Senufo, "do" mask, wood, 13″

134

eyes, recalling the face of an Akan priest in a state of possession, and the geometric flanges of the Senufo kpelie mask. The face is intense, but focussed. The power of nature is honored in great horns, upraised. Three horizontal marks at either end of the mouth represent the scarification marks of the adult Manding male.[46] The two masks also share an asymmetric pattern of cicatrization on the cheeks.

Siginkuru-ayna masks, like Yoruba Gelede, must appear in twos and the pairing is significant. Rene Bravmann shows that at Bondo-Dyoula the siginkuru-ayna will appear with the mask of the Muslim elder, "for the former is regarded as an important sacrificial animal and the latter the cornerstone of the Muslim faith."[47] If horned masks in Manding and Manding-influenced areas perpetuate themes fully blown in the days of the Mali Empire, then a Muslim twist has been added to tradition. The old adversary, the bush-cow, familiar of the witch, becomes another of Allah's victories over evil. The curve of the horns communicates great energy. Bravmann notes that the men who dance these masks are athletes. They dance the Do so vigorously that, from time to time, they must stop, to be cooled by the fanning of attendants.

Bravmann attributes another horned mask to the Bwa group of Upper Volta (Plate 173) and identifies a Bobo antelope headdress (Plate 174) as a *yanga* mask, the "last to come out at a festival."[48] In the last instance the dancer carries two canes to simulate front legs, not unlike Bamana kore. The forward-pointing curves identify this mask as deriving from the region of Bobo-Dioulasso. In the panoply of horned themes in West African art, including art from the Moshi, Bobo, and the "circumcision mask" of the Sembla (Plate 175) (a Senufo-related group living in the Sindou region of southwestern Upper Volta)[49] themes of transition, ancestral embodiment, darting motion and witchcraft are variously accented or combined.

The Kifwebe and Motion

Among the many modes of Zaire Basin masking (Plates 176–180), the rounded "kifwebe" mask (Plate 179) remains enigmatic. The term, "kifwebe," appears to mean, simply, "mask" and sheds little light upon the problem. Our example, of striking stylistic purity, was published in Olbrechts' pioneering text on the artistic geography of the Zaire Basin.[50] The object was given therein as, "mask, carried by the leaders of initiation ceremonies; Baluba."

The meaning of this mask, a sphere sectioned by concentric lines of light and dark, remains an important issue in the iconography of Zaire. Without pretending to final information, I think, nevertheless, that the fact that (1) the mask was associated with initiatory leadership (2) ini-

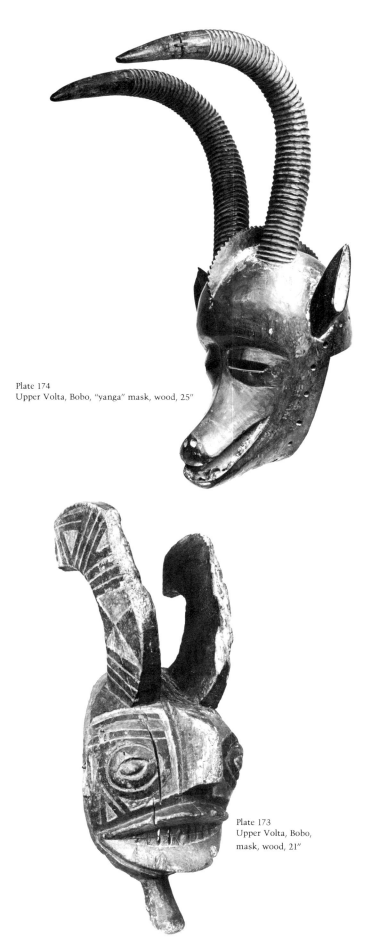

Plate 174
Upper Volta, Bobo, "yanga" mask, wood, 25"

Plate 173
Upper Volta, Bobo,
mask, wood, 21"

G-2
Nigeria, Ibo, mask, wood, 21"

G-1
Nigeria, Ogoni, mask, wood, 26½"

Plate 175
Upper Volta, Sembla, mask, wood, 25¼"

136

G-9
Upper Volta, Mossi, mask, wood, 21"

G-7
Zaire, Pende, mask, wood, 12½"

137

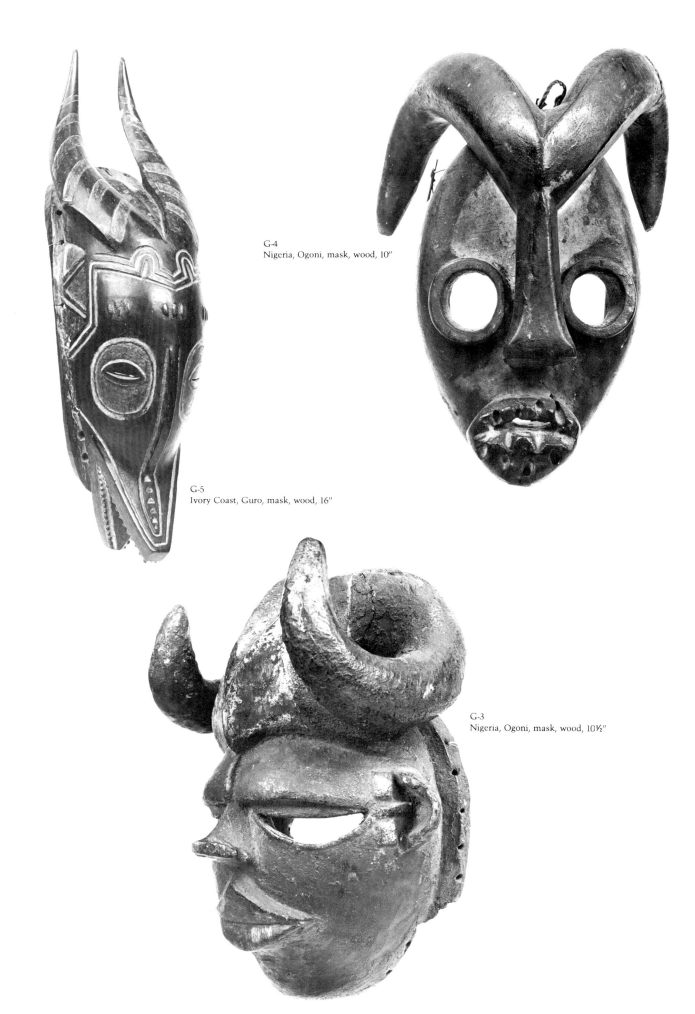

G-4
Nigeria, Ogoni, mask, wood, 10″

G-5
Ivory Coast, Guro, mask, wood, 16″

G-3
Nigeria, Ogoni, mask, wood, 10½″

G-6
Ivory Coast, Guro, mask, wood, 11"

G-8
Nigeria, Ibibio, mask, wood, 17"

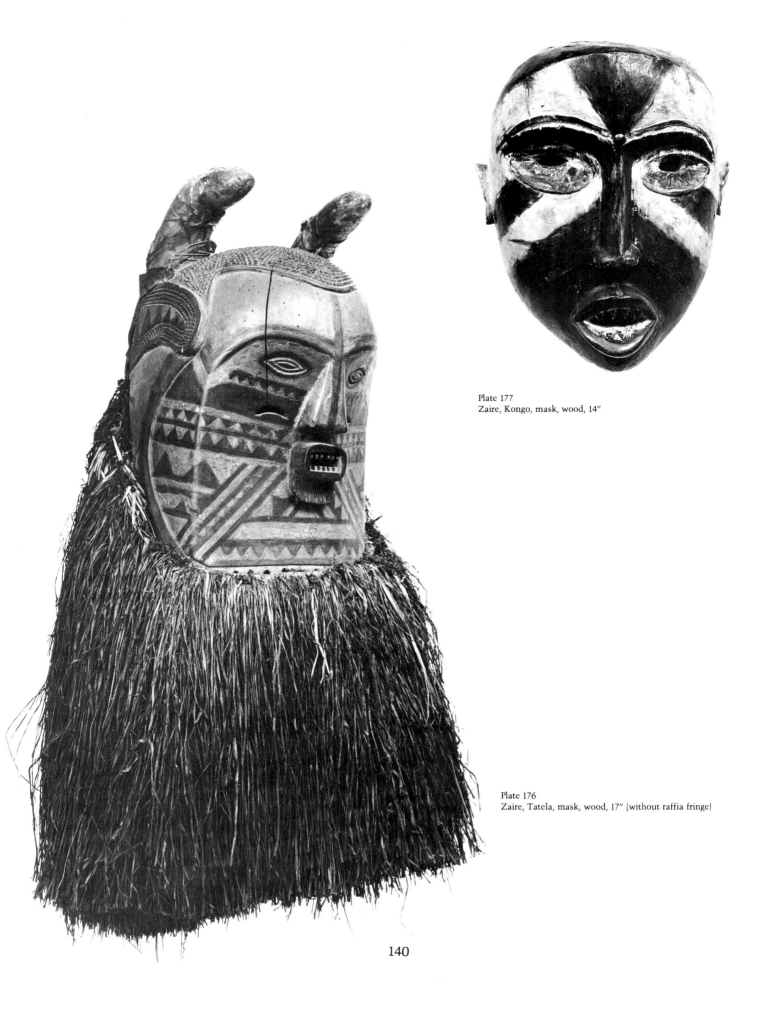

Plate 177
Zaire, Kongo, mask, wood, 14"

Plate 176
Zaire, Tatela, mask, wood, 17" (without raffia fringe)

140

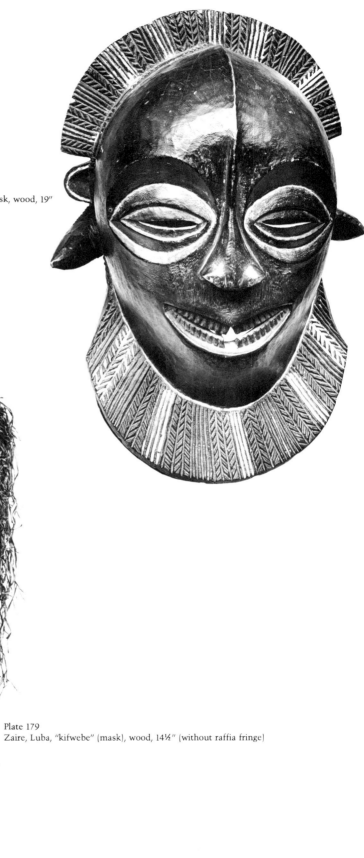

Plate 178
Zaire, Luba, mask, wood, 19″

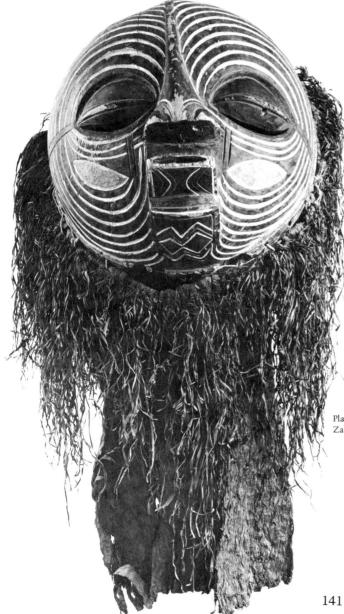

Plate 179
Zaire, Luba, "kifwebe" (mask), wood, 14½″ (without raffia fringe)

141

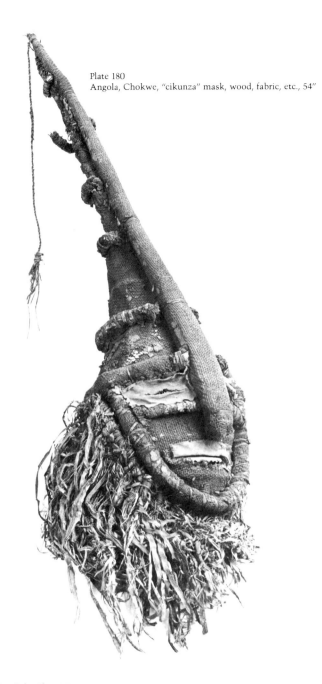

Plate 180
Angola, Chokwe, "cikunza" mask, wood, fabric, etc., 54"

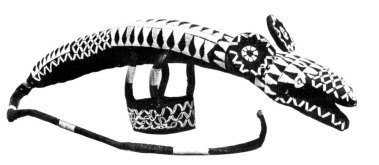

Plate 181–Color Plate VI
Cameroon, Bamileke, python headdress, cloth and beads, 46" (without tail)

tiation societies (mukanda) are found among Yaka, Suku, Chokwe, and Luba as virtually a single structural entity,[51] with similar functions and similar masks, permits us to open the inquiry in a special way.

Young Yaka initiates are said to carry a mask which is surmounted by a pagoda-like stem, rhythmically interrupted by intersecting disks of diminishing size as the summit is reached. This mask seems broadly cognate with another mukanda type, the Chokwe *Cikunza* mask type. The latter (Plate 180) are distinguished by a horn which "rises like a tower ... pointed and representing the horn of the *tengu* antelope, with its ribbing suggested by tiered rings."[52] The tiered rings compare with the tiered disks of the Yaka mask. The upward prolongation of the nose is paralleled by a similar extension in the Luba kifwebe. The enigmatic lines of the latter mask may possibly represent a sophisticated simplification of the staccato tiering of Yaka and Chokwe forms, a kind of compacting of stylistic elements within a single sphere. The fact that both the Luba kifwebe and Chokwe Cikunza are associated with leadership within the initiation society provides an important link in function. Alternatively, the Yaka and Chokwe forms are developments of a form remaining relatively uncomplicated in Luba country and all three styles derive from an undetermined common source.

In any event, the motion context of the Luba mask is an urgent problem, assuming choreographic reconstruction from the memory of aging informants is still a possibility. If there is an extant account of the accompanying motion—and research by Siroto in the Ivindo River area in Gabon proved how important remembered information can be—or even dancers who still recall the accompanying motion of the Luba kifwebe, the discovery of choreographic similarity with existing Yaka and Chokwe dance modes for Cikunza and Cikunza-related types might confirm the spread of a masking theme.

Horizontal Masks and Witchcraft

The path of the animal, moving horizontally across the surface of the earth, has always fascinated the African. I begin with a beaded python headdress (Color Plate VI, Plate 181). The object is Bamileke, according to Paul Gebauer, but also used by the Tikar. The cover photograph of the summer 1971 issue of *African Arts* documented a beaded python headdress in motion context at Santa, south of Bamenda, at a dance of the local regulatory association in honor of a visit by Prime Minister Ahidjo. The dancer wore a painted resist dye cloth from the Bamun. The dancers were of the Menndangkwe group and the photograph documents a feature of Grasslands dance that is fairly consistent—there is space between performers and audience, for masks and headdresses in Cameroon highlands art are, it seems to me,

142

signs, carried over auxiliary writing emblazoned upon the gown. The masks are signs which project, with huge eyes and outlined features, the special nature of the force represented by the dancer. As "signs" they project their meaning across the compounds and dancing arenas.[53]

In this case, the body of the reptile is brilliantly sectioned by shifting decorative rhythms and suspensions of the expected flow of pattern until the climactic eyes are reached. The eyes are separate flaps which compare, stylistically, to the treatment of the eye in *Suah Buah* masks of the Mambila, north of the Bamileke (Plates 182, 183).

The connotations of extending an object along a horizontal plane are stark and dramatic in the African imagination. To return to the Bamileke python, the headdress is used in a python cult which is widespread in the Cross River and Grasslands area. The python leads people, so it is believed in certain Grasslands cultures, from flooded territory to dry land, from water to the mountains.[54] In addition, among the Banyang,[55] to the west of the Grasslands, it is believed that witchcraft is most notoriously embodied in owls, closely seconded by pythons. The python is thought, typically, to work in league with the owl. The owl takes the "shadow" or "spirit" of a child and gives it to the python who then "sits with it" while the child, at home, sickens and eventually perishes. Our masterpiece of Cameroon bead-work resonates with an honorific rendering of a reptile of dark capabilities.

Extending horizontally mimes not only the sinuous journey of the python in the forest, but also the fiery power of the word of the ruler, as suggested by the spitting of the cutting edge of a ceremonial blade from the mouth of a human figure attributed to the Teke (Plate 184).[56] Horizontality mimes not only the release of heat-forged weapons and magical instruments of aggression, the blades of war and death, but also the darting of bush-cow and leopard, who carry their "blades" upon their head or retracted within their paws. If the vertical position belongs to stability, rationality, and coolness, horizontal design often, but not always, correlates with darkness, mystical heat, witchcraft.

The Suku of Zaire, for example, believe traditionally in witch familiars who all trace more or less horizontal paths through space:

> It is that witches can become invisible, fly through the air, and while going about their nefarious business disguise themselves as leopards, jackals, mosquitoes, and owls.[57]

Yet there is a remedy:

> One important point must be kept in mind: a witch is not a being living and operating in some nether world separated from everyday life. Witches are, above all, living people and witchcraft is simply an attribute of persons who simultaneously play normal

Plate 182
Cameroon, Mambila, "suah buah" mask, wood, 18"

Plate 183
Cameroon, Mambila, "suah buah" mask, wood, 19½"

143

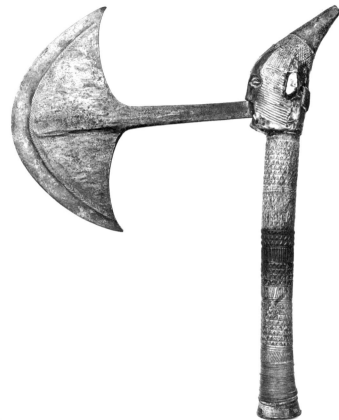

Plate 184
Congo–Brazzaville, Teke, ceremonial axe, wood and copper, 16"

Plate 185
Nigeria, Ijaw, mask, headdress, wood, 39"

social roles and have their own unique personalities. Although witchcraft is itself by definition evil, a person who has it is not necessarily and entirely so. To a Suku, a witch may also be a friend, a father, a sister, or a respected and liked head of the lineage who has fulfilled well his obligations to it and has worked hard for its interests.[58]

In other words, witches are embedded in human society, anti-social beings who must be identified and, hopefully, reshaped through manifestations of concern and generosity, lest under cover of darkness, along unspeakable horizontal pathways, they wreak their destruction. Ignored, or incited out-of-hand, they have the power to destroy society.

With leadership, therefore, goes a certain amount of witchcraft for, as the Suku say, "since the world of the witches exists, this means that it is best to have someone who can operate in it, and that someone must, of necessity, be a witch himself."[59] Similarly, in the horizontal anti-witchcraft masking tradition of the Ivory Coast known as *gbon*, the carrier of the horizontal mask dances an athletic dance "including prodigious leaps, crouching and kneeling movements, and rapid turns, and it last[s] for nearly an hour. Having finished his performance, the gbon carrier, accompanied by a member of the cult, [goes] through the town in search of witches."[60] In other words, just as political leadership must embody knowledge of witchcraft, to combat evil, so the horizontal mask carrier must render the lightning-fast transformations and speed that identify both the master dancer among humans and the speed of the witch among supernatural beings. Political and artistic leadership are both connected with the neutralization of witchcraft. Sometimes, under the rubric of horizontal masking, they are combined.

Thus the horizontal waterspirit headdresses of the Ijebu Yoruba, which apparently derive from western Ijaw creek styles (*cf.* Plate 185) are conceived of as crowns[61] and are associated with an underwater kingship; they are also attributed spectacular powers of metamorphosis and witchcraft. Their powers of sorcery and justice are extended by choreography; the central masquerader of three masks is sometimes supported on the shoulders of his helpers, in the image of the Benin divine king, and sometimes wheels and activates his shoulder blades with extreme heat, with an almost fugitive sense of patterning, and this is "hot" and sorcerous.

Finally, in an important paper, "The Legendary Ancestor Tradition," Douglas Fraser talks about similarity in form and function in West African horizontal masking.[62] He shows that in the Manding areas and their cultural satellites, horizontally worn masks are strongly animalistic in nature and are sometimes associated with devouring. Among these are the *elek* images of the Baga, the *Banda* headdresses (Plate 186) of the Nalu and the *dandai*

144

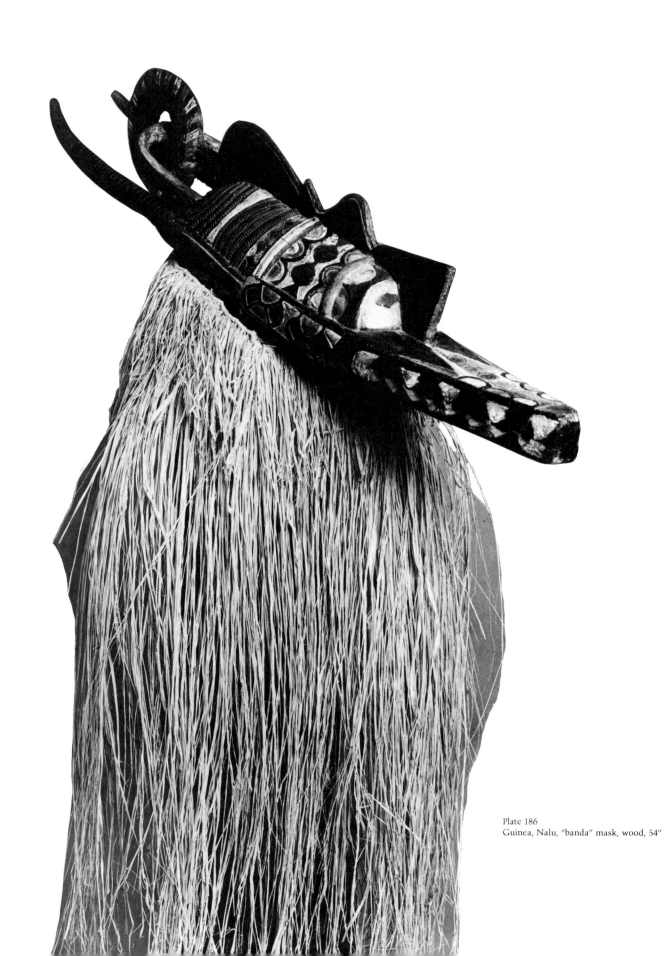

Plate 186
Guinea, Nalu, "banda" mask, wood, 54"

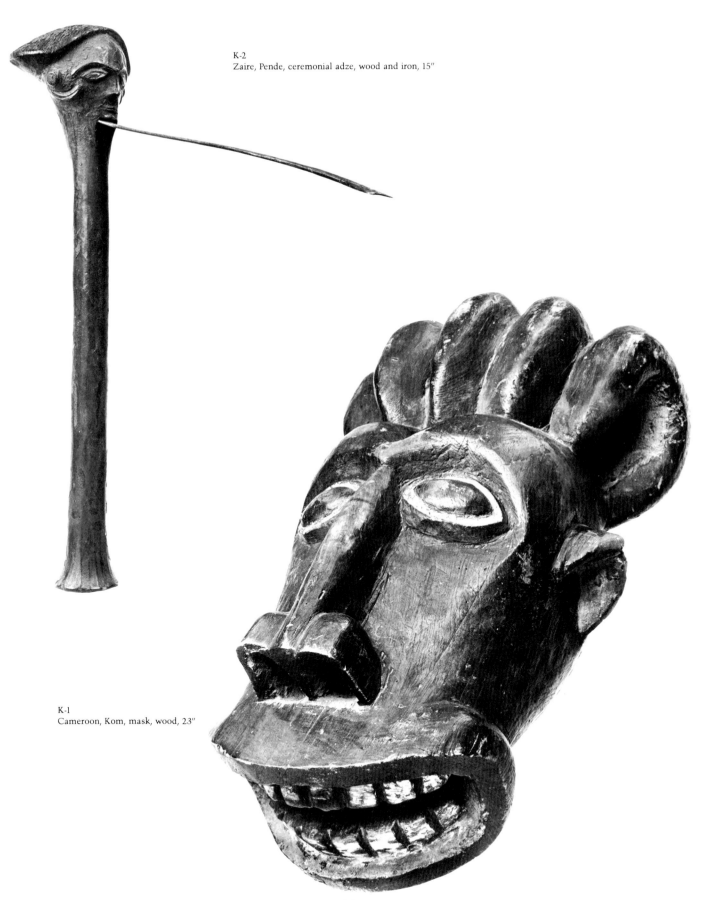

K-2
Zaire, Pende, ceremonial adze, wood and iron, 15″

K-1
Cameroon, Kom, mask, wood, 23″

146

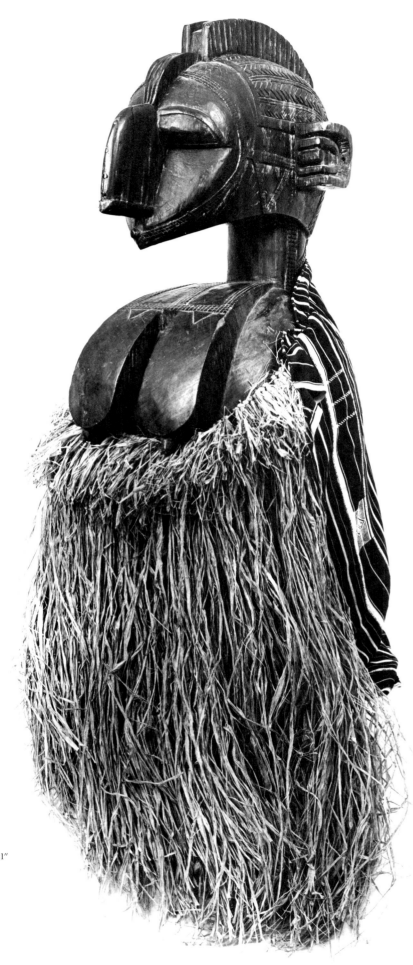

K-3
Guinea, Baga, "nimba" mask, wood, 51"

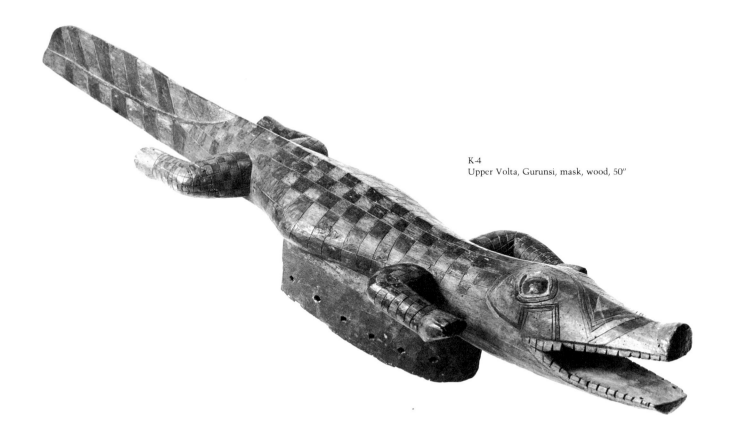

K-4
Upper Volta, Gurunsi, mask, wood, 50″

K-5
Ivory Coast, Guro, elephant mask, wood, 26½″

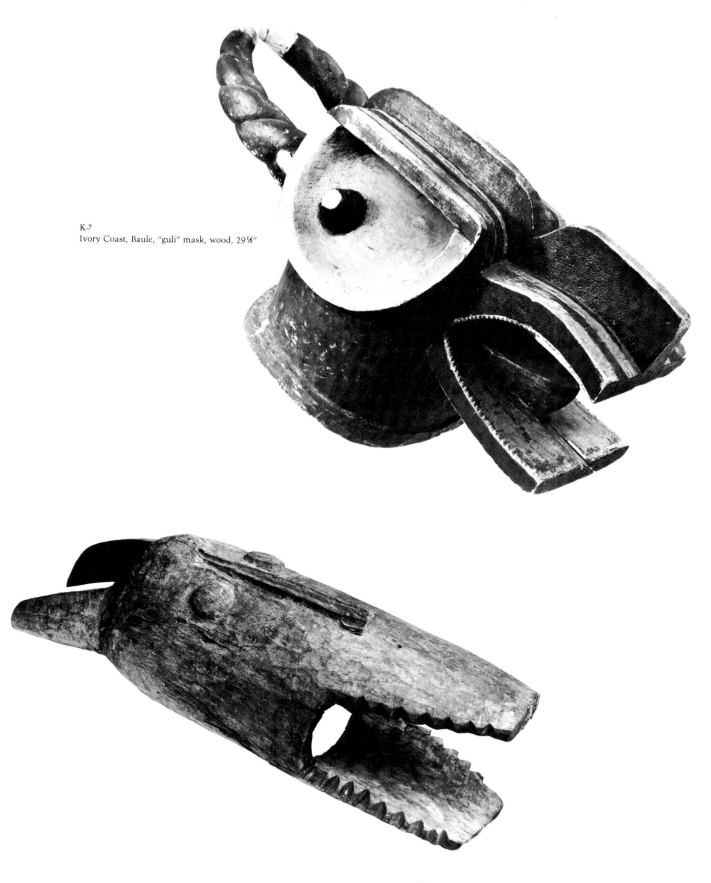

K-7
Ivory Coast, Baule, "guli" mask, wood, 29½"

K-6
Ghana, Kulango, "aban" mask, wood, 34½"

149

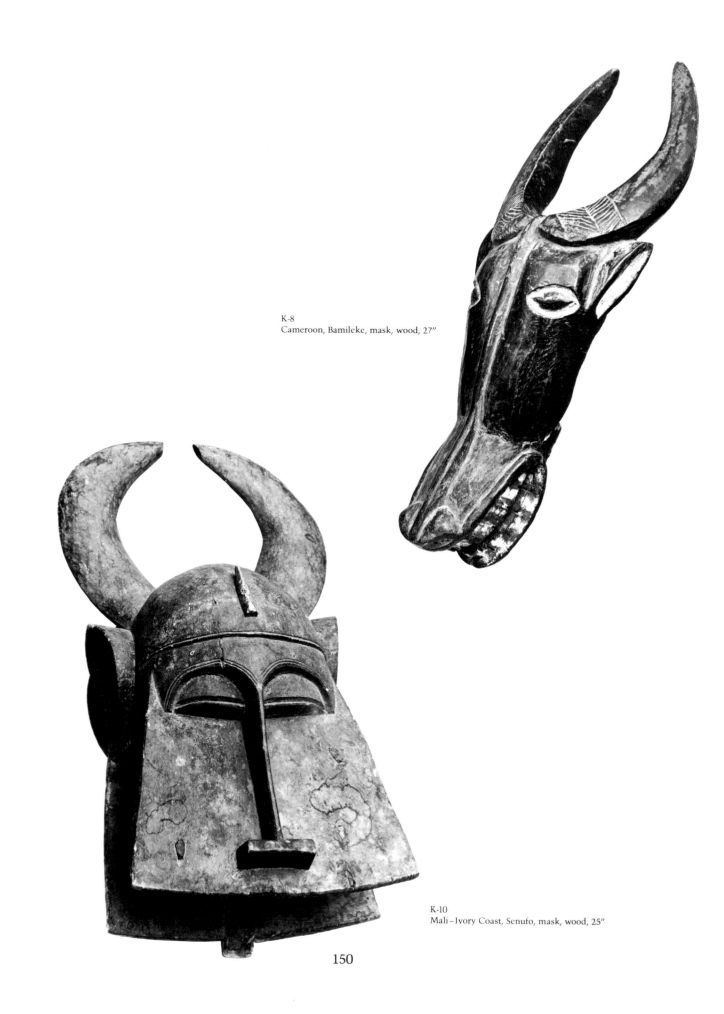

K-8
Cameroon, Bamileke, mask, wood, 27"

K-10
Mali–Ivory Coast, Senufo, mask, wood, 25"

150

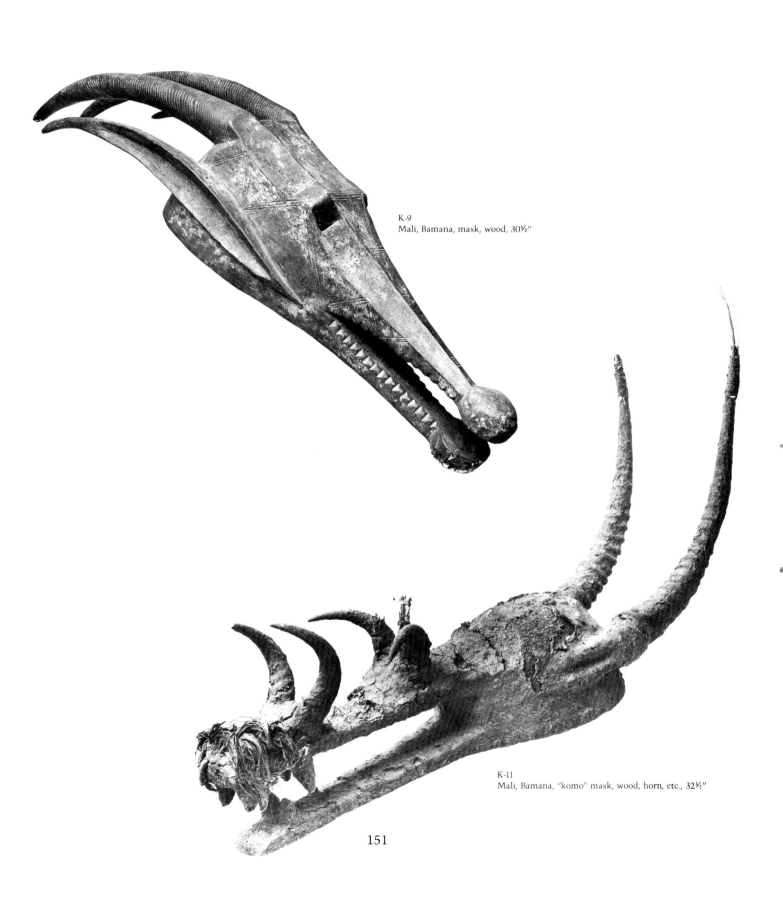

K-9
Mali, Bamana, mask, wood, 30½"

K-11
Mali, Bamana, "komo" mask, wood, horn, etc., 32½"

151

masks of the Gbande, Toma, eastern Mende, and certain Kissi groups, all linguistically related to Manding, but for the Kissi. Fraser elaborates:

> Perhaps the clearest expression . . . is to be seen in masks known as *dandai, landa,* or *landai* found among the Gbande, Toma, eastern Mende and certain Kissi groups of the highlands where Guinea, Liberia, and Sierra Leone meet Considerably over life-size, a typical *dandai* mask has a massive forehead and flat face with close-set eyes and a large nose that juts sharply downward from the overhanging brow [*cf.* the *Banda* mask, Plate 187]. Bunches of hair spring from the head, browline, nostrils and chin. A mouth of the human type is usually lacking but beneath the beard, on the sides of the jaws, are carved huge crocodilian teeth. *Dandai* carries a whip with which he lashes out at the spectators; moving the lower jaw of his mask up and down, he mouths a strange language in guttural tones and pretends to devour gifts and initiates The wearer is completely covered with a voluminous costume of raffia and country clothes.[63]

The rationale behind the form is similar to the iconography of the *Nkhalamba* masks in Malawi, *i.e.,* authority rests with the elder and hence the "legendary ancestor" is given the attributes of old age, thick beard, and hair growing from the nostrils. But the gigantic size, crocodilian teeth and horrendous gaze derive from its personification of a bush-spirit. Dandai inducts young boys into manhood and pretends to devour them, only to deliver them reborn as though from the womb. He is, therefore, the ritual actor par excellence, one who "kills" at one level only to "save" at another. The Banda mask of the Nalu is a continuation of this special logic, combining horns symbolizing the land, according to Denise Paulme, and crocodile teeth emblematic of the water. The bush spirit dimensions,[64] Fraser says, suggesting violence and witchcraft, reflect recognition of the irrational divisive forces of the world, but there are counterbalancing valences of authority, "a form of divine power which God has partially delegated to man."

The harsh transitions and abruptly contrasted blunt planes of the "Legendary Ancestor Image" convey, admirably, the arbitrariness and relentless power of the first founder, as Fraser points out. They also obey monstrous laws of physical embodiment because, I suggest, they perhaps refer back to the days of the hunters on the Manding plains of Do. In this remote era of heroes and founders, the "menace of the horns," and the "evil of the owls,"[65] (*i.e.,* witch-birds roosting on the roofs) were won over to the cause of the hero because of his essential nobility of bearing and generosity. Thus evil attributes identify the founder not only because he is, by necessity, morally intimidating, but also because his goodness is of such transcendent force and impartiality that even the

evil are won to his side. In the process, evil forever complicates the image of the hero with a certain combination of terror and decorum.

In the section on the Basinjom masks of the upper Cross River we shall explore in detail how motion clarifies and deepens the themes of the horizontal mask.

Towards the History of Danced Art

Each time I return to the West from the complexity of this choreographed universe, I am amused by the old-fashioned definitions of the dance in Europe and North America: social grace or theatrical spectacle. In addition, Western couple dances are an inappropriate basis upon which to begin to understand communal African dancing, to say nothing of the interlock of sculpture, words, and motion. Some Europeanized Africans have told their wives and grandparents to give up their "out-moded" styles of dance, but the latter have refused to be intimidated:

> . . . the dances of foreigners
> . . . I do not like it.
> Holding each other
> Tightly, tightly
> In public,
> I cannot.
> I am ashamed.
> Dancing without a song
> Dancing silently like wizards,
> Without respect, drunk[66]

For a Western person to comprehend the moral power of danced art in Africa, he must divest his mind of various prejudicial junk and start from the beginning.

Understanding can begin with so simple a phenomenon as the wearing of a ring. On 1 January 1972 the king of Agogo, Ghana, during a ceremonial, slowly extended his right arm, and turned his hand slowly, slowly, so that a ring in the form of a fish could be clearly seen. The motif of the fish cited a proverb, "fish out of water dies; king without followers ceases to exist"[67] and the style compared with other forms of classic Akan jewelry and miniaturization (*cf.* Plate 187 and 188). The ring carried a cutting edge, a warning to the king, a sanction against indifference.

The "dancing" of a ring in Ghana can be compared with a moment in the history of Afro-American piano. Larry Neal has brought to my attention a comment by the great Afro-American pianist, James P. Johnson:

> All of us used to be proud of our dancing—Louis Armstrong, for instance, was considered the finest dancer among the musicians. It made for attitude and stance when you walked into a place and it made you strong with the gals. When Willie Smith walked into a place,

152

Plate 187
Ghana, Ashanti, ring, gold, 1½"

Plate 188
Ghana, Ashanti, "soul" disk, gold, 3⅛"

153

his every move was a picture . . . every move we made was studied, practiced, and developed just like it was a complicated piano piece[68]

The Ashanti king displayed his power yet kept his face impassive; the Afro-American pianist set the brilliance of his playing against another kind of nonchalance:

Some ticklers would sit sideways to the piano, cross their legs and go on chatting with friends nearby. It took a lot of practice to play this way, while talking and with your head and body turned.[69]

Most interesting was the fact that some jazz pianists were famous for wearing a sparkling diamond on the little finger of their right hand, "which would flash in the treble passages."[70] The twirling of a jewel to extend the brilliance of a phrase compares not only to the behavior of an Ashanti king but also recalls, in a sense, the physical dimension defined in playing mbira. The reader can well imagine the special flourishes that may have accompanied the playing of a Kuba bow lute from Zaire (Plate 189) or a Senufo harp from Ivory Coast (Plate 190). The photographs of musicians holding such instruments fail to communicate that instrument and player are co-presences, involved in a muscular relationship as visual as it is musical.

During the past fourteen years form and elaboration in African danced art have become more apparent. Daniel Crowley discovered that Chokwe art, contrary to Western notions of fixed installation upon altars, is, largely, theatrical paraphernalia meant to be rendered in the dance.[72] Leon Siroto studied commemorative carved faces in wood, covered with elegant thin strips of brass, in Gabon.[73] A number of Kele and Kota-speaking peoples, of the eastern tributaries of the Ivindo River, used to make these images (cf. Plate 191) for use in a cult called Bwiiti. The "face of the Bwiiti" was placed on a container which held skeletal relics of important family members, not only chiefs and political leaders but men of special

accomplishments, religious specialists, powerful judges, artists, exceptionally fecund women. The polished face in brass thus celebrated, in a sense, the talented and the creative, but the deep function was apotropaic, i.e., to repel supernatural interference with the power of the relics.

Informants spoke of their fathers dancing with these images; thus Siroto: "whoever spoke of this clenched his hand and made passes back and forth with his arm as if to show how the image was handled."[74] Siroto had discovered an unsuspected aspect of danced sculpture in Africa. He relates this account to the activation, in the Kebekebe dance, of carved heads in wood among the Kuyu (Plate 192). The latter were carried at arms-length above the head of the masked dancer. The passes of the face of the bwiiti above the head of the dancer, his fingers perhaps tightly clenched about the aperture below the neck of the image, would have added sparkle and excitement to the object, not unlike the motion of the diamond on the hand of the jazzman.

The present writer discovered in 1965 that Yoruba figurated pottery-lids (Plate 193) for the cult of the riverain spirit, Erinle, were sometimes danced on the heads of devotees, before shrines, at Ajilete, or during processions to the river, at Abeokuta.[75] He also learned that devotees danced in relation to works of art displayed upon the earth. Each year in the Aworri village of Iyessi, for example, followers of the god of divination celebrate the name of this deity by dancing while facing divination paraphernalia, including a carved tray (cf. Plate 194), carefully polished and laid in a neat line on a mat.[76] There is a nice intuition, in this dignified motion, to and from static objects, of the power of divination to restore things to calm in a world of disorder and transition.

There are new worlds to discover, in the completion of iconic communication through dance, and we come now to seven examples, starting with the masks of the western Dan.

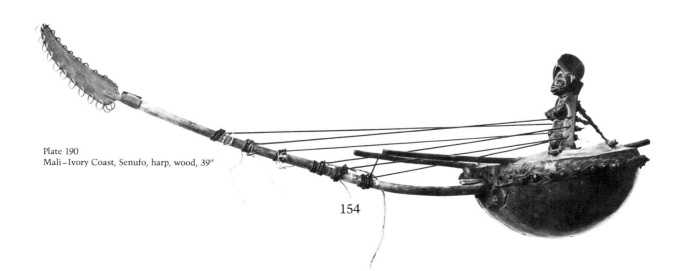

Plate 190
Mali – Ivory Coast, Senufo, harp, wood, 39"

154

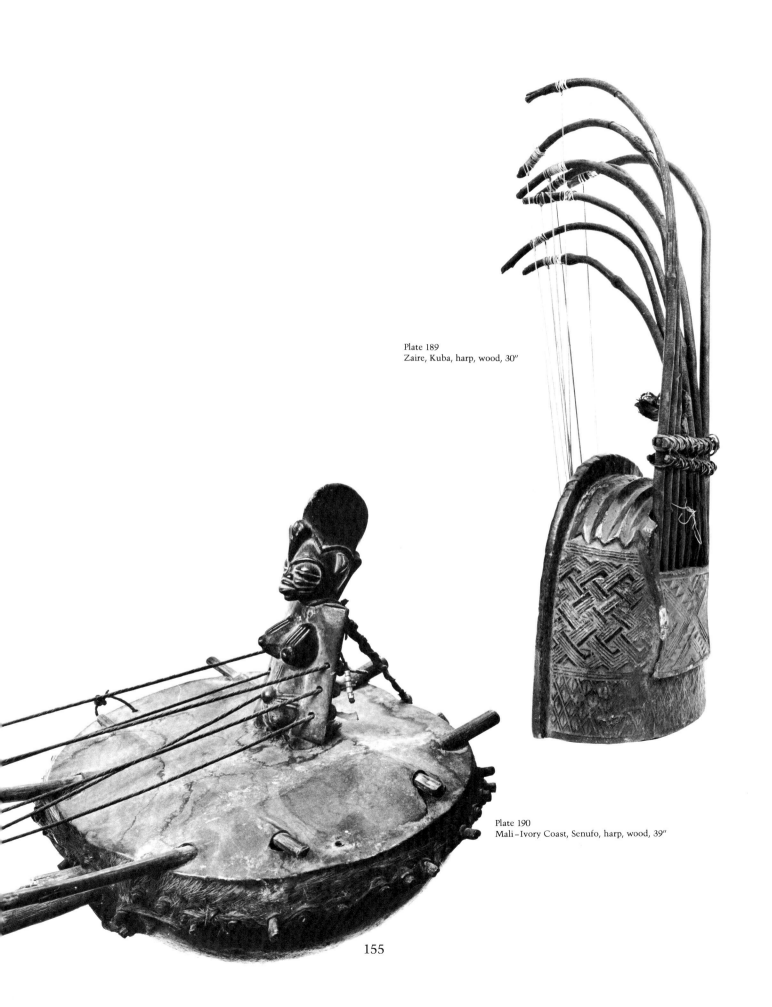

Plate 189
Zaire, Kuba, harp, wood, 30"

Plate 190
Mali–Ivory Coast, Senufo, harp, wood, 39"

155

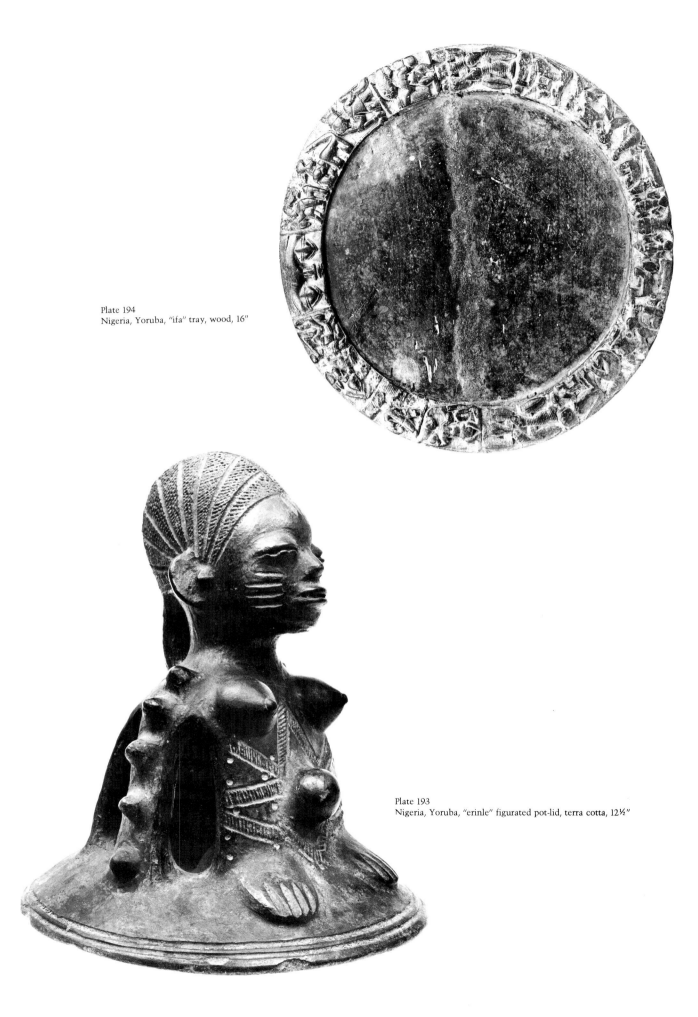

Plate 194
Nigeria, Yoruba, "ifa" tray, wood, 16"

Plate 193
Nigeria, Yoruba, "erinle" figurated pot-lid, terra cotta, 12½"

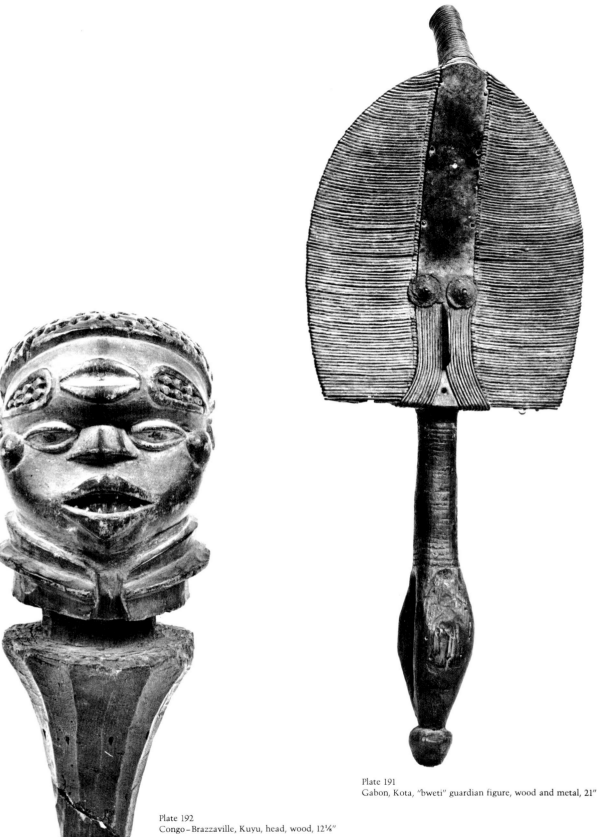

Plate 191
Gabon, Kota, "bweti" guardian figure, wood and metal, 21"

Plate 192
Congo–Brazzaville, Kuyu, head, wood, 12⅛"

157

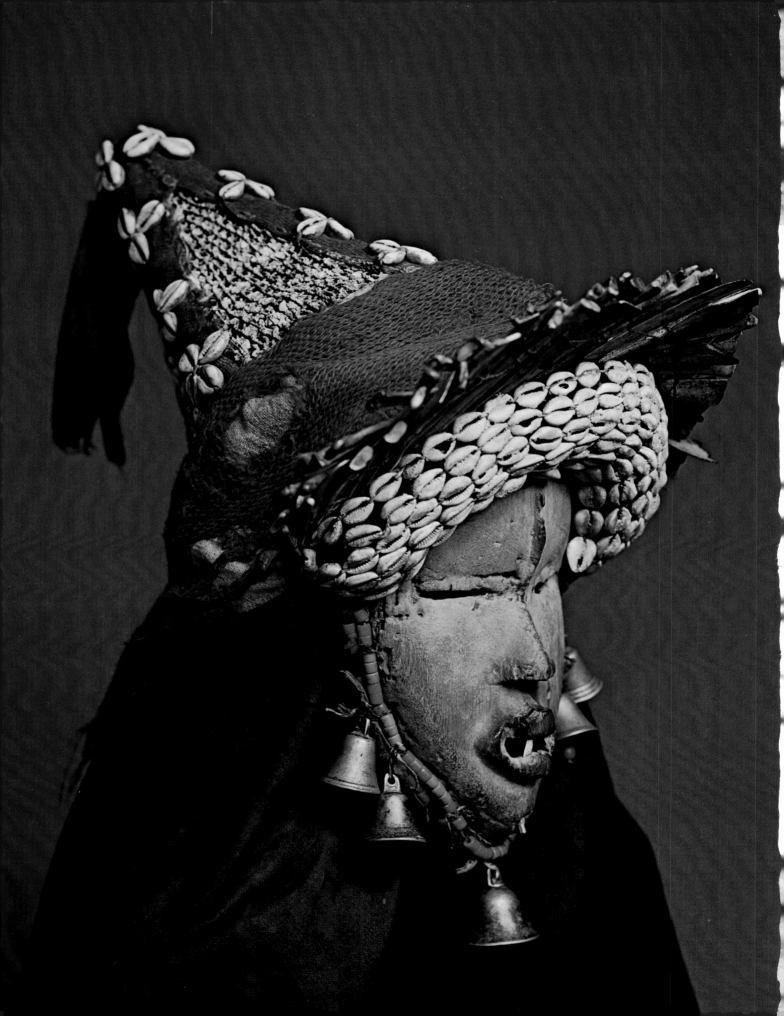

1. DAN MASKS AND THE FORCES OF BALANCE

In the character of its content the art of the Dan people of West Africa brings together, in a culturally distinctive manner, the ancient antagonists: the forces of cool, standing authority, and the forces of discord and disorder.

Order can of course be imposed by brute authority. But traditional Dan seek social control through artistic and philosophic means, through a cult of masks. A guiding principle is inner calm—"cool heart." Thus a fragment from a myth:

> That night it rained. On the next morning Samunga took a hoe and said to the spirit: 'I am taking the hoe.' And the spirit said: 'Start working.' That night it had rained upon the burned earth. The soil had become soft. The spirit sat down in the field and began to play the slit-gong. Samunga took his hoe and his rice for sowing. While he was bent over the spirit played the slit-gong. Sweat trickled down the body of the cultivator. He sowed the rice. He worked his way towards the spirit. When he reached him and stood in front of him he said: 'Spirit!' 'Yes?' 'I have done my work and I am still strong, but what can I do to earn a wife?' And the spirit said: 'cool your heart, you'll win a woman soon enough.'[77]

Dan highly value self-control and personal purity. They protect these virtues with their cult of masks. We shall consider three examples. The first is connected with jurisprudence and beauty, the second, with shock and disorder, the third, with transcendental balance. The first mask is worn by one of the most important judges; the second, by an irascible monster; the third, by a stilt-dancer. Before we examine their attitudes and movements, let us consider the culture in further detail.

Dan speak a Mande language. They live in northwestern Ivory Coast and adjacent portions of Liberia. Ivory Coast Dan are known as "Yacuba" and number over 200,000. Their Liberian kinsmen, called "Gio," probably exceed 100,000 in number. Our attention concentrates upon the Butuo village area, in Liberia, among the Niqua clan. In former days, the chieftains of this area, known as "fathers of war," presided over villages. Musicians symbolized their power; they clustered about the leader to extol his greatness and vitalize his appearances.[78]

Descendants of warriors, Dan define their music as that force which imparts vitality to a man.[79] They like, consequently, music that gives energy and direction to dangerous or heavy tasks: sowing and harvesting rice, clearing the forest, wrestling, hunting, fighting. They especially love, in other words, vital aliveness in music. The criterion is interestingly cultivated in those forms of their singing distinguished by hocketing. This technique refers to an interlocking mode of singing, whereby each person sings one or a few notes at the correct time to form the melodic contour.[80] The interlocking quality of Dan choral music is especially apparent in certain songs where two soloists alternate while the chorus maintains a steady *ostinato.*

The mask is the main sculptural form of the Dan. Just as singers recombine melodic fragments to make a song, Dan artists fragment and recombine the coordinates of the human face to make their masks. The eyes are a main point of emphasis. The face of the mask divides along their horizontal axis. The line of the eyes continues across the face to divide the form in two. In some instances the eyes of the mask are implied within this shadowed groove.

Beautiful Dan masks are correlated with slitted eyes, because of their feminine associations: "whenever you see a mask with slitted eyes, you think of a beautiful woman."[81] Shocking masks have long tubular, projecting eyes—"so the image will look dangerous"[82]–or they show the ocular region cast in shadow underneath an overhanging brow. Manner of representation is, however, no absolute clue to function. Masks can change function when different magic substances are applied.[83]

According to Harley, who devoted his life to the study of Liberian art and traditional culture, a bewildering number of masks once complicated the cultural landscape of the Dan and their neighbors.[84] These masks included types connected with the commemoration of victory in war (ram horns on forehead, beautiful slitted eyes, plaited beard), judgment in cases of adultery (tubular, dangerous eyes, kaolin-splashed brow, horrific open mouth with inserted, exposed teeth), and the execution of capitally convicted felons (beautiful brow and slitted eyes counterset by horrific projecting snout sprouting monkey fur). The last-mentioned type, called *To la ge,* which carried felons into the forest to their

death, matches (minus the fur) the style of a mask in the White Collection (Plate 195). [85]

In addition to large masks, often charged with awesome functions, maskettes were also used. These were called "raffia dress heads" *(maa go)*. Five from Dan and Dan-related areas are illustrated (Plate 196). Tabmen explains their nomenclature and their use:

> They are called 'raffia dress heads' because while the human head rests upon the body, these 'heads' rest upon raffia, the dress of the mask-wearer.
>
> They are used for sacrifice, to honor the spirit of a large mask, if one has violated a mask law. For example, a priest *(zo)* who wears a mask cannot eat food cooked with wood from trees out of which the mask is carved. If he does, he will become seriously ill. If he does so by accident and the cause is identified by divination, sacrifice is made to the maa go; droplets of blood from chickens are sprinkled on the image.
>
> Maa go are also carved for identification. Every masked zo will be recognized by the maa go he carries on his person. He conceals the maskette in a woven bag called *m boo*. Male children of the masked priest may also keep maa go. In the sacred groves of the mask a person may be challenged, as to his right to handle or discuss mask matters, and, if he cannot produce a maskette showing he has a right to be where he is, he can be confined and seized by mask authorities and not set at liberty until he pays a heavy fine.[86]

These functions, sacrificial focus and cultic validation, differ from the notion that miniatures serve as "passports." It is true they are used for answering peremptory challenges within mask groves, but they are not, to my knowledge, shown at the entrance, like a visa at a pass-kontrol.

The fact that maskettes are related to raffia, emblematic of forest origins, is extremely interesting and suggests that even in miniaturization it is improper to think of the mask in isolation. Large masks are believed to originate in the forest, hence their associated raffia garments, their animal names, their animal voices. All Dan masks seen in this section have raffia gowns. Dan believe masks represent the materialization of a forest spirit who appears to a carver in a dream whenever it wishes to take a concrete form.[87]

Himmelheber divides the world of Dan masking into three main groups, identified by headdress:[88] (1) *masks crowned with large plumes;* these are frightening or imposing masks of social authority, charged with peace-keeping duties, and the fighting of fires; (2) *masks surmounted by a conical headdress;* these are "beautiful masks," connected with circumcision, and the teaching of initiates, with their beauty rationalized: "without the

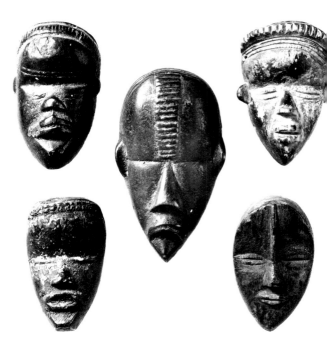

Plate 196
Liberia–Ivory Coast, Dan, maskettes, wood, 2" (average)

Plate 195
Liberia–Ivory Coast, Dan,
"To-la-ge" mask, wood, 13"

160

help of women men will not suceed, so the initiation masks must be carved with the *beautiful* appearance of a woman in order to be able to transact business between the school and the women; also, beautiful masks keep children from being frightened, for through these masks they will learn tradition";[89] (3) *masks with cotton wigs* generally correlate with entertainment and fault-finding, sometimes achieved through deliberate provocation, as when members of the audience are duped into punishable behavior by laughing at the deformities of the mask.

Let us compare these broad categories with hierarchic ranking defined by a priest *(zo)* of the Butuo area: (1) *go gle,* priestly masks, given full power by God *(Xlan),* serve within the cult of the leopard as the highest seat of the Dan; *go gle* literally means "leopard spirit"; (2) *wopo gle,* masked judges who impose the law and hear cases; (3) *dian* or *boda gle,* entertainers and peace-makers.

At Butuo I found elements of one mask mixed with elements of another. Thus the great judge, *Gaa Wree-Wre,* compounded aspects of the beautiful mask of conical headdress with signs of the leopard.

(a) Gaa Wree-Wre: Ideal Perfect Justice

Even before I left the capital of Liberia, Monrovia, for the interior, in late March 1967, I began to hear rumors of a splendid mask, called Gaa Wree-Wre.[90] The mask was described as a perfect face with hairpin embellishments, rich beads and bells, with kaolin across the eyes as a mark of purity and beauty. This mask was also said to speak, as one of the leading traditional judges of the Dan, with a strong and superbly rolling voice, disguised but clear. I was given to understand Gaa Wree-Wre never danced, that it appeared without musicians and with a single speaker, every six years, "for cow feasts or most important matters." Impeccable behavior was demanded by this mask, "which could stop a war":

> people watch their lips when Gaa Wree-Wre is about, that nothing is done against tradition. There are certain motions of the body, for example, which are not done by men in the presence of women and we carefully avoid them before Gaa Wree-Wre. In this modern age, when people are more or less careless, we fear whenever go gle masks are coming[91]

By luck my visit to Butuo in April 1967 coincided with the visitation of this mask, come to proclaim a new tribal law and to hear an important dispute between Gio and Yacuba. The mask was accompanied by its speaker, Laame (Plate 197), who wore kaolin about his eyes, matching the effect of the mask itself (Plate 198), and another speaker. The first-mentioned speaker claimed that the mask of Gaa Wree-Wre had been carved "in the late nineteenth century" by Wehi Tiakangbaye, of the village of Yaogortu, among the Yacuba.

161

Plate 197
Laame of Butuo, Liberia

Plate 198
"Gaa – Wree – Wre" masker

The mask was surmounted by a towering conical head-dress *(comoo)*, emblazoned with patterning in indigo blue, red, and cowrie embroidery (Plate 199). The shape of the headdress, emblematic of great beauty, was accompanied by feminine calm of countenance, emphasized by vertical marks on forehead, "indeed a wonder of beauty among Dan women." The eyes were slits, veritable *yeux en coulisse*, emphasized by sharply stylized kaolin-daubed decoration. Above the generous brow was an ornamental band of cowries, centered with a device in blue and red beads, all symbols of power and prestige. This ornament was surmounted by a striking fan-like headdress of metal hairpins. It was said that some of these pins had been "forcibly removed from aged women." This was the story: when Gaa Wree-Wre is out, no one is allowed to wear dress that resembles its costume in any detail; careless old women had stood with hair-pins in their hair in his presence, whereupon he swept into their midst, seized their pins, and carried them away as permanent forfeits to his power.[92]

Lappets of red with embroidered cowrie shell motifs decorate the sides of the wearer's head. Red is the color of the Go society. The mask is a go gle mask. As such, it is only to be addressed as "my lord" *(m de)*. Red refers to the leopard, to killing, to spilled blood.[93]

Brass bells and the teeth of a leopard hang from strands of blue beads at the jaws of the mask. These elements refer to the extraordinary final powers of the Go society. Gaa Wree-Wre wears a striped shawl of cloth in indigo about his shoulders, over another cloth, in alternating brown, blue, and white stripes, and an enormous flowing skirt of raffia fibre. The latter element refers to wild growth and forest origins. The relationship of details of headdress, pins, beads, and bells to a mask in the White Collection (Plate 200, Color Plate VII) leads me to suspect that the latter may derive from one of the villages where the go gle masks exist.

The mask incarnates forest fierceness (leopard teeth, redness, raffia) and human elegance (slitted eyes, kaolin, conical headdress, hairpins, textiles). It is an awesome go gle, tempered by feminine grace. The profound authority of its example is furthered by the dignity and strangeness of its motions, which also stir wonderment in the villages where it has appeared.

Go gle are normally seated when they hear a case. The raffia gown spreads across the surface of the earth (Plate 201). The mask does not dance. He walks and sits. Immersed in the voluminous fibre folds, he cannot swiftly rise or descend, as ordinary men. He is locked into great weight, suggestive of his transcendental character, of the gravity of his function.

I observed the seating of this mask within a forest glen near the banks of the river dividing Liberian Dan from Ivory Coast Dan. With the speaker responding, *"a we, a we"* (I answer, I answer) to the first and last phrases,

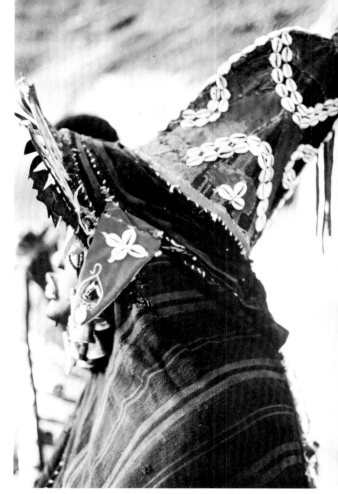

Plate 199
Side view of "gaa-wree-wre" masker

Plate 200, Color Plate VII
Liberia–Ivory Coast, Dan, "Gaa-Wree-Wre" mask, wood, metal, etc., 23"

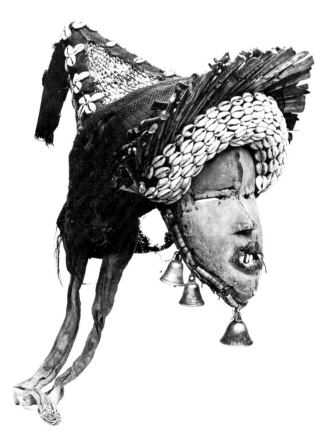

162

the judge chanted in a growling voice the following words:

Who passes far?
Who passes?
You may say: Krua!,
Final-Decision-Giver!
You must act: with the consent of the highest mask.
Rumors!
Person-Gave-Person-up: indictment!
Attention!
You must act: with the consent of the highest mask.
Rumors!
Black Mask!
Heeeeeeeeeeey! Heeeeeeeeeeeeeeeeeeeeeeeeeeeeey!
Behold the mask.
Who passes far?
Who passes? [94]

He demanded to know who was before him, from what village, and for what purpose. He revealed his appellations, Krua, Final-Decision-Giver, Dense Forest, though no one had the right to use them. He broke his chant with syncopic shouts and admonitions, ending, as he began, with the cry, "who passes far, who passes?"

Suddenly the mask rose and began to walk, a bell at the hip clanging in time to his motion. The walk was strange—short steps, tilting gown, pronounced sway, reminiscent of the walk of a heavily feathered aquatic fowl.

The mask re-seated itself upon the earth, immediately immersed in an aura of otherworldly deliberation. This Final-Decision-Giver, sifting truth from rumor, promises, in the resolution of fierceness and calm, the ability to weave justice from a total understanding.

(b) Wuti: the Hook Spirit

Go gle infrequently are in session. Lesser masks attend to lesser problems. One of these teaches etiquette by contrast, i.e., by doing the wrong thing dramatically. [95] This is the *kao gle* category. Kao gle literally means "hook spirits" and refers to a sharp metal or wooden hook which they almost always carry (Plate 202). Kao gle hurl hooks. They hurl them at their accompanying band of athlete-musicians, trained to leap above the flying missile with practiced calm. [96]

The hook is the key to the masking form. Hurling and rending space compares with the harsh jutting protrusions of the kao gle mask form (Plate 203). Pyramidal cheek-bones and crisply facetted nose, shadowed abstract eyes, and projecting savage teeth, give a constructivist excitement to the mask. [97] Kao gle masks are sinister and cruel. They bite into space, like hook into air, and they more or less match the thrusting diagonals of kao gle dance motions, especially when the dancer moves

163

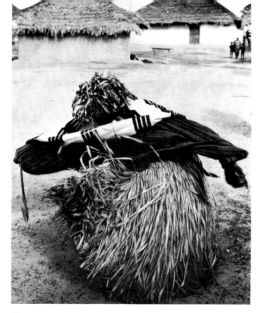

Plate 202
"Kao Gle" dancer

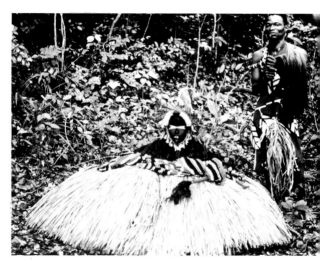

Plate 201
"Gaa-Wree-Wre", seated

Plate 203
"Kao Gle" mask

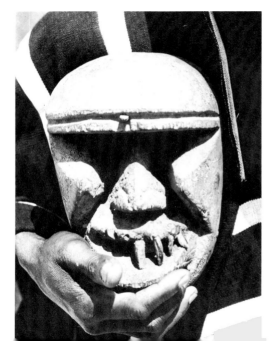

with one shoulder up, the other shoulder down (Plate 204). The kao gle observed in action at Butuo was called Wuti.

The rationale for his amazing face follows:

There is a monkey in the forest known as Klang. The face of Klang looks exactly like Wuti. The Klang is a mischievous monkey. When you watch the kao gle in action, you see that it likes to touch and destroy. That which it sees, it abuses, that which it touches, it touches to destroy.[98]

With the go gle in residence, Wuti appeared at dawn, "to drive the witches away, for Gaa Wree-Wre and the town." Dan believe witches can leave evil, web-like traces between houses, dangerous to brush against or pick up on the body. The darting, aggressive motions of the kao gle admirably serve to clear the way, cutting through the webs, purifying the passage-ways.[99] This is an unsuspected element of goodness, concealed within outrage.

Another positive quality is revealed by Chief Tomah of Butuo:

Our forebears were warriors. Every chief was endowed with the power of war. In the old days a chief tested the men to see who were for him and who were against. Proof that a man loves you is when that man is injured by a relative of yours and does not press a claim for damages. For that reason kao gle are connected with the chiefs, to do deliberate damage to people, to test their loyalty. And if a person does not criticize the chief, this proves they love him.[100]

Significantly, Chief Tomah of Butuo and two Butuo officials insisted on having their photograph taken (Plate 205) with the mask. The same informant alleged that in the old days if a person lost his temper and struck back against the kao gle the penalty could be extreme:

The chief would enforce the penalty of masks: four domestic animals. If the guilty party could or would not pay this fine, the case was given to the go gle and the chief had no more participation in the matter. The offender, if he remained in his arrogance, might be sold by the go gle to the Mano or the Kpelle, never to be seen again.[101]

The specialness of the kao gle, the cryptic affection which attends them, is implied in the eager following of their athlete-musicians. These young men dance behind the mask bare-chested; kao gle are notorious for their propensity to shred the shirt of any man they encounter in their immediate presence.[102]

The kao gle orchestra at Butuo included a side-blown buffalo horn (goo sotluu), an iron gong (lao), a gourd rattle with exterior bead strikers (gee), two bamboo slit-gongs

(yelli bao), and one major slit-gong in wood (li bao).[103] A master percussionist played the latter instrument. The combination of horn, gong, rattle, slit-gongs, and hocketing melody provided a high level of excitability and speed.

But the player on the li bao gong orchestrated quick stops and thrusting pulsations, shaping the asymmetric, explosive gestures of the mask. The canon of correctly ending a choreographic-musical phrase was crucial to the effect. Each asymmetric parry, thrust, and lunge was timed to coincide with the last syllable of a given phrase on senior gong.

The choreography of the kao gle was therefore divisible by pattern, each stylistic fragment determined by a dominating force within the total constellation of excitements. That fundamental force was explosive angularity, played off against brilliant blurring whirls, rotations on the self, circular running patterns, disequilibrations of the head, shaking the rags on the top of the mask with an almost insane side-to-side jerking. The rapid shifts of style demanded great control, for each motion became a correction of another motion, directing the mask towards aggressive goals and missions of destruction.

Most impressive was the entrance of the kao gle and his band at the village square. The mask approached the center of the village shooting up and down behind a moving shield of followers.[104] As they stood up, he darted down; as he loomed up, they shot down. The kao gle coming up was most impressive, its hook thrust, like a grasping claw, into the sky.

There were "stop time" passages wherein the musicians maintained musical momentum, but the mask no longer responded to the beats of the master percussionist. Instead, he wheeled into acts of pure destruction. He pulled material from a thatched roof and hurled it with demonic force. He fell to the ground and crawled. He danced over the freshly laundered clothing of a woman and left the textiles filthy. He discovered a pile of garbage and hurled the offal into every direction. Then he returned to his customary artistic disequilibrations.

At this point he concentrated upon testing the nerve and athletic skill of his followers. Again and again he attempted to impale them with his hook. One of the followers carried at all times a supply of hooks. Guided by a final syllable on gong, the mask hurls the hook. The dancers hear this signal, too, and are already leaping as the hook leaves the hand of the mask. They soar coolly in the air.[105] The missile sails harmlessly beneath them. The musician hands the mask another hook. He hurls it. But the men again are well above its path. He receives another hook. He hurls; the men avoid it. He hurls; they jump. He hurls; they jump. He hurls; they jump.

There is a splendid internal "rhyme" between the opening interlude of kneel-loom interactions and the concluding hurl-jump passages. Both situations express a fundamental truth—village order is not assured unless

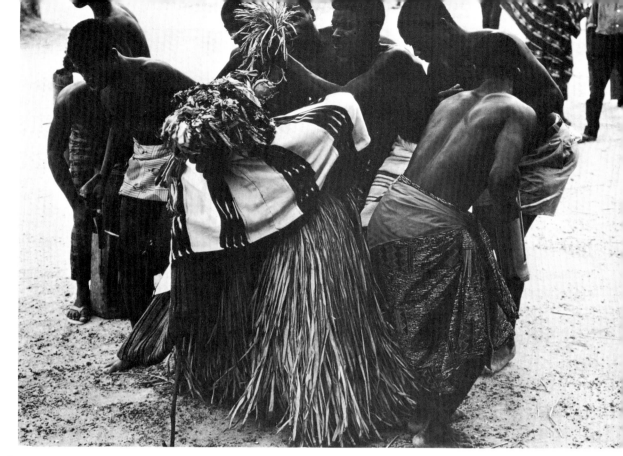

Plate 204
"Kao Gle" dancer

Plate 205
Chief Tomah of Butuo, with two officials and "Kao Gle" dancer

armed with the tough ability to compensate immediately for disturbing influences.

Poised on the outskirts of propriety, the kao gle teaches the world to recapture awkwardness. His motions free us, forcing us to move from one position of instability to another. [106]

(c) Gle Gbee: Stilt-Dancing and Transcendental Balance

In a world of tested balance and inner calm the stilt-dancer is exquisitely appreciated. Dan love stilt-dancers. The tradition is apparently not indigenous. All sources agree the origin is Kono, to the north of the Dan. Chief Tomah of Butuo maintains the first stilt-dancers from the Kono began to penetrate the Niqua Clan during the presidency of Daniel E. Howard. [107]

Dan call stilt-dancers "long spirits" *(gle gbee)*. They are said to have no religious significance, but Hugo Zemp finds that some stilt-dancers are believed to have emerged, as spirits, from the water. One stilt-dancer told Zemp that: "when the gle gbee are in town there is no witchcraft, for the witches are afraid—gle gbee sometimes kill them." [108] We, therefore, consider their costume and the drama of their act as allusions not purely secular in character.

Stilt-dancer dress (Plate 206) shows amazing consistency—tall conical headdress trimmed with leather strips, cowrie shells, and animal fur; featureless mask, long tail of fibre falling from its center; arms and legs enclosed in brilliantly striped blue and white cloth, with a belt of bells suspended about the waist. [109] A short skirt of raffia covers the hips. The cloth normally draped over the shoulder of the go and kao gle masks is missing and the raffia skirting is minimal, reflecting necessity for free use of the limbs, as balancing instruments.

The dancer stands on supports mounted on the side of the stilts. The stilts themselves reach his knees and are tightly bound to his shins, but the knee remains free, granting the possibility of agile, wheeling movement, a technical refinement. [110]

The dancing of gle gbee at Butuo was characterized by amazing forms of balance. He danced using his arms and whole body as compensating gestures, enabling him to work against gravity with figures bold, rapid, and precise. It was clear that the technical stratagem of tying the stilts to the shins afforded the dancer a lower center of balance than if he had been poised on top of the stilts. From a close analysis of his work on film, Peter Mark derived the observation that the entire body of the performer was normally involved before each step or jump: "his technique boils down to divesting himself of weight, before each jump or step, by going through a sequence involving going down, coming up, and jumping or stepping. The basic sequence seems to be: down-up-*jump*, down-up-*jump* and so on." [111] Stilt-dancing dramatizes total bodily dancing in Africa. It is a manner of saying, with total vital aliveness, that the person can transcend his human limitations, switching from style to style, under extraordinary conditions of instability.

The dancer crosses his stilts before his body. He relaxes his elbows, waist, and knees and sits down on thin air, posterior brought perilously below the level of his knees. He rises and walks with giant steps. He stands, staring down, at the admiring populace ten feet below. He jumps backwards seven times. He twists his body at the waist and swings his enormous legs, literally dancing. [112]

Kao gle pause in dancing to wreak destruction. Gle gbee step out of choreography into further dimensions of equilibration. Where Wuti hurls, the choir leaping, gle gbee deliberately begins to fall, to be saved by young followers who artfully prevent his body from dashing against the ground (Plate 207). There are screams from women in the audience at this point. And when the stilt-dancer tires, he sits upon the roof of a house, in preparation for further dramatic explorations of transcendental balance, climaxed by reaching the summit, still on stilts, and sliding down the sloping thatch (Plate 208).

In conclusion, masks of the Dan are motion essays on the nature of equilibrium and perfectability. The judge moves in gravity and splendor, everything centering on the mask as source of wisdom. The motion of the kao gle is syncopic, violent, whirling, spinning off energy, hurling the hook, probing the strength of the social fabric, the balance, the judge has woven or repaired. Finally, the stilt-dancer, incarnating directional strengths transcending conventional stability, furthers the lessons of composure under fire. He works against the pull of the earth and the play of the witches. Moving within the richness of his heroism, his motions take on the irreversibility of a sacred act.

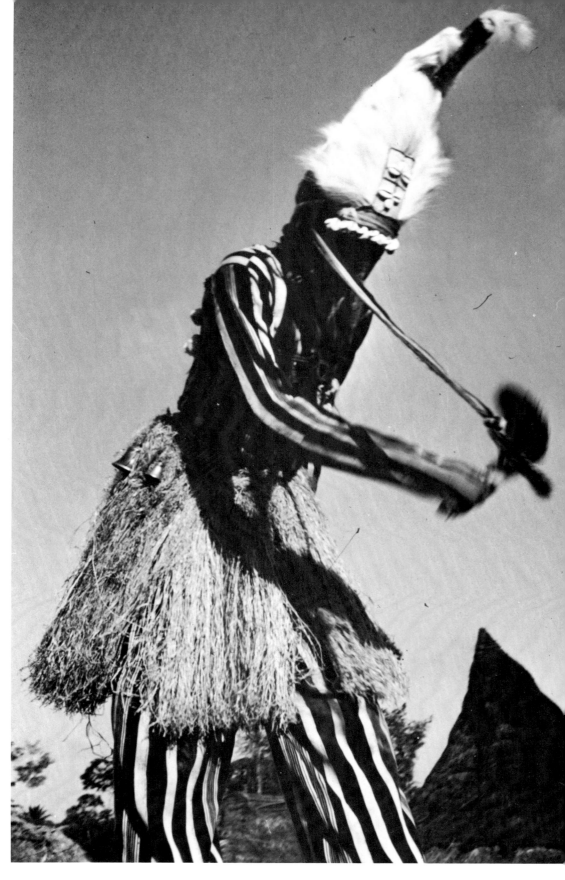

Plate 206
"Gle Gbee" dancer

167

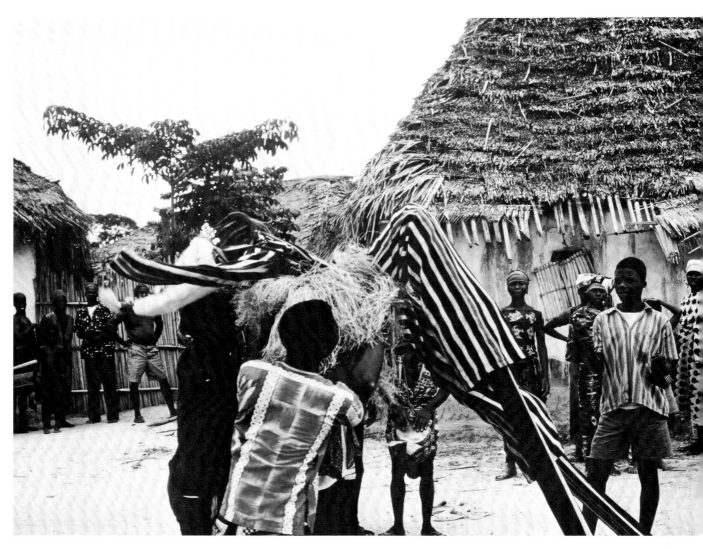

Plate 207
"Gle Gbee" dancer supported by followers

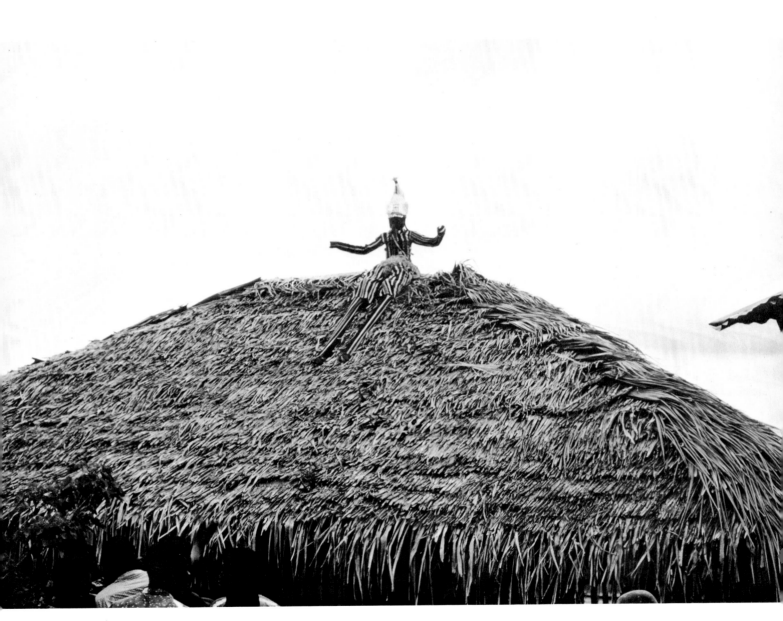

Plate 208
"Gle Gbee" dancer on roof

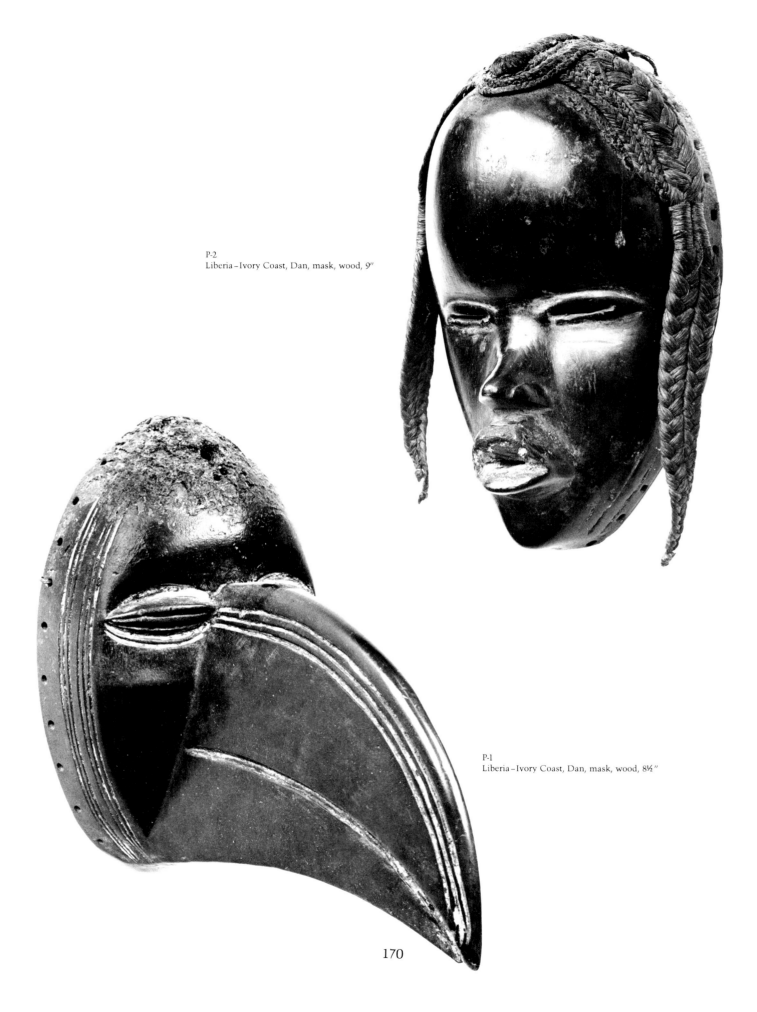

P-2
Liberia – Ivory Coast, Dan, mask, wood, 9″

P-1
Liberia – Ivory Coast, Dan, mask, wood, 8½″

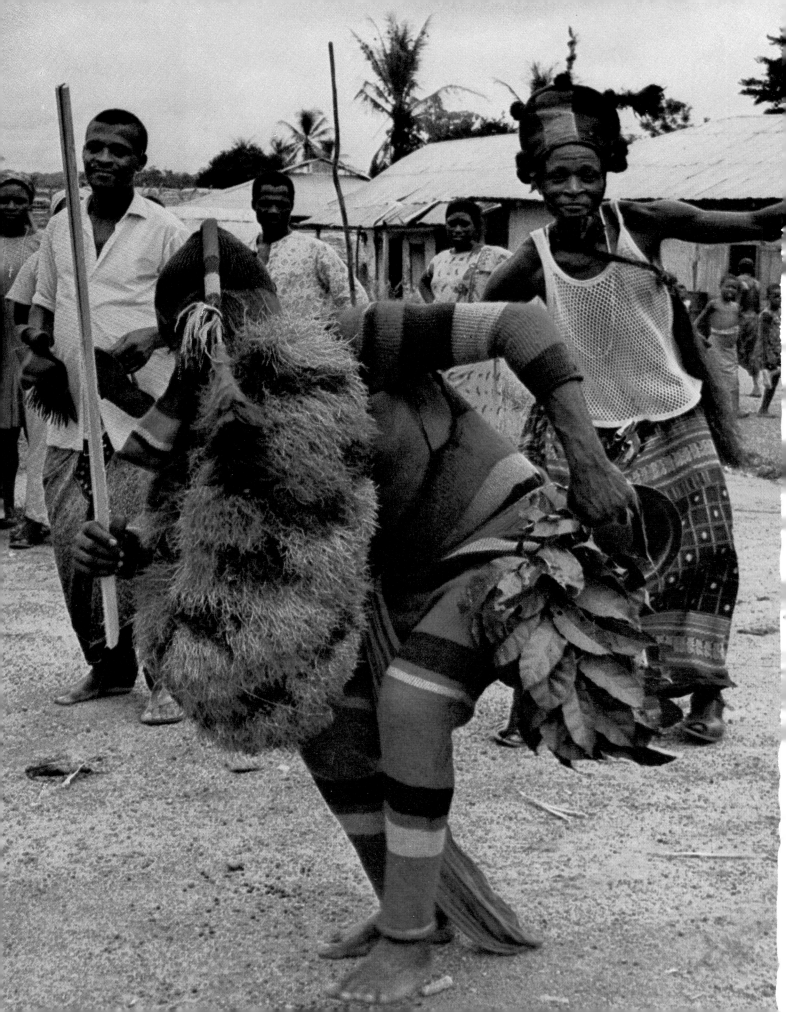

2. EJAGHAM LEOPARD MIMES AND THE SIGN OF GREATNESS

The Ejagham people, often called by an Efik term, Ekoi, [113] live in southeastern Nigeria and western Cameroon. They have elaborated incomparable art. Their contribution includes sculpture covered with gleaming duiker skin and raffia-fringed costumes for the miming of important leopard spirits. Their art communicates a calligraphic sense of line, sensuous and superb.

Ejagham artistically dominate the Cross River valley, from its origin at the confluence of the Mainyu and Bali in Cameroon, to its junction with the sea near Calabar. The members of this civilization are famed for powers of ritual expression. The Mbembe of the lower Cross River esteem them for their ritual prowess, with "new cults repeatedly disseminated from their region." [114] The neighboring Yako are, likewise, proud of their Nkpe cult: "the [Ejagham] origin of the cult lends great credence to its power, for the [Ejagham] peoples are credited with remarkable magic powers and the control of most powerful spirits." [115]

The admiration of their neighbors is explained in part by the quality of Ejagham aesthetic elaborations. Even an early twentieth century British colonial officer was impressed:

The belief has gradually grown upon me that among the [Ejagham] there exists a love of beauty almost Greek in character. That pure beauty appeals to them is shown by their knowledge of flowers, and their delight in the form and color of these, and even in the texture of leaves. [116]

The same author was struck by the Ejagham use of physical beauty as a means of special communication: "leaves or blossoms are only worn as signs, to express a definite message, such as the scarlet *akpanebesin* worn as a challenge behind the ear of a wrestler or the little *ishut* flower or leaf of the *ekuri* fern, which, worn in the hair or cap, announces a death in the house." [117]

With the exception of forest-clearing, Ejagham farm labor traditionally was done by women. [118] This meant that men were free to concentrate on heroic privileges, hunting and the arts of war. It also meant that men had leisure for the elaboration of art. Like their spiritual colleagues, the ancient Greeks, the men of Ejagham did not abuse this privilege, but combined a love of physical combat and physical self-realization in hunting with a love of intellectual and artistic fulfillment. Both women and men wove raffia cloth on upright looms; both women and men devoted loving care to the elaboration of coiffure, body paint, and dress; the sense of line, as already pointed out, in the latter manifestations was superb. [119]

The Ejagham aesthetic can be traced, in part, to a repertory of decorative themes, applied to the embellishment of two hundred sixteen ancient basalt monuments, each raised in the memory of an Ejagham chief. These monoliths, found along the middle Cross River, are called *akwanshi*. [120] They are sometimes embellished with concentric circles, spirals, squares, triangles, or circled crosses. The last motif, for example, appears on a particularly strong specimen, an akwanshi from Ekulogom among the Nnam Ejagham (Plate 209). Such signs remain, some of them, within the continuing secret scripts of the Ejagham. The ancient signs probably referred to, or confirmed, political and spiritual power.

The chiefs of Ejagham were ceremonial figures, yet they presided, each one, over several thousand people as final authority. They were strongly associated with the leopard. Ejagham transformed athletic energies into artistic embodiments in which they could proudly display vitality of body and of mind. They concentrated upon the leopard as a hieroglyph of ruling grace. [121]

The special energy of the Ejagham image is remarkable. Ejagham quicken spiritual presence by placing leopard signs on cloth (Plate 210) about the source of the leopard voice in certain shrines, by placing similar leopard signs about the skin of a dancer, and, finally, in a structurally related solution, wrapping the gleaming skin of another animal, the duiker, polished and smoothed virtually to the consistency of majolica, about the carved wooden image of a human head. Let us survey these forms.

(a) Ejagham Skin-Covered Sculpture

Covering carved wooden sculpture with shaped, sized duiker skin is a unique Ejagham contribution to the history of art. There seems no reason to quarrel with the traditional attribution of invention of this form to the Ejagham. As Marcilene Wittmer points out, the styles of nuclear Ejagham skin-covered art are the purest manifes-

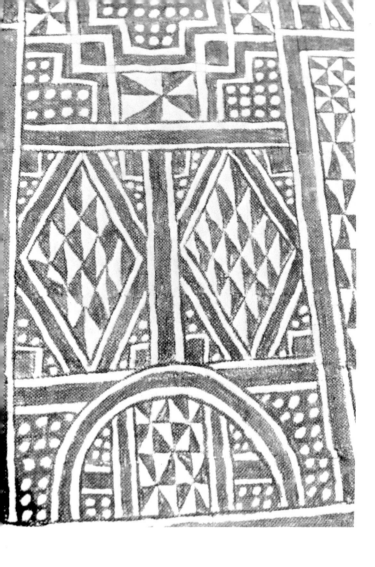

Plate 210
Cameroon, Bamun, textile (detail)

Plate 209
An Akwanshi from Ekulogom

tation of the mode, showing less variation, less susceptibility to comparisons with neighboring civilizations, such as the Nigerian Igbo or the cultures of the Grasslands. [122]

Let us examine a few of the main Ejagham modes and contrast them with the style range of the Widekum area, the latter forming a transition between the former art styles and the Grasslands. There are, according to Keith Nicklin, who has recently completed an excellent field documentation, two major kinds of Ejagham skin-covered headdress: caps and helmets. [123] The former are secured to a circular basketry base which fits over the crown of the head of the wearer and is secured, by a cord, to his chin (Plate 211). Skin-covered cap headdresses often represent women. Some are crowned with spectacular horned coiffures, in vogue among Cross River women at the beginning of this century (Plate 212). The dancer who dons this headdress is normally covered by a long gown extending from the summit of his head to his ankles.

Nicklin reports that skin-covered helmets, as opposed to caps, cover the entire head of the dancer and rest on the shoulders. They are often Janus-faced, sometimes even tri-facial (cf. Plate 213). A dark face represents a male, a gleaming yellow-brown face, a female. Helmet headdresses are strongly conceived forms, crowned with emblems of power, the feathers of an eagle or the quills of a porcupine. Quills among Abakpa Ejagham suggest the control of animal power by the ruler; it is a "sign of valor." [124] The helmets are worn with a dark jacket and a kind of hoop-skirt built about a frame of cane. In the Ekwe Ejagham settlement of Otu, on 3 June 1969, the chief of the town explained the meaning of a Janus-helmet, in choreographic context:

> This mask represents Tata Agbo, a man born in war, and his wife. All his brothers and sisters had been killed in combat. Only he and his wife remained. Whenever he went to battle, his wife went behind. When he shoots, she loads, till he wins. That is why when Tata Agbo died they made that [skin-covered helmet] as remembrance, the man was facing the battlefield, the wife was in back, loading. It is a double remembrance. [125]

The dancing of Tata Agbo was accompanied by "rifle music," i.e., the rhythmic, occasional firing of guns, and a band of followers mimed the attack and slaughter of an enemy. The helmet-wearer himself, took aim with his rifle, from time to time, to complete the martial image. The combination of male and female valences within this martial mask was extremely interesting. The commemoration of famous men, almost by definition, aggressive warriors in the traditional culture of the Ejagham, may well explain the bared teeth of much Ejagham skin-covered sculpture, so different from the closed lips prevalent in the Yoruba visual aesthetic.

There are interesting stylistic variations within the

Plate 211
Ejagham headdress. The sign of "love" and "marriage" appears on the right cheek.

Plate 212
Nigeria, Ejagham, headdress, wood and skin, 11¼"

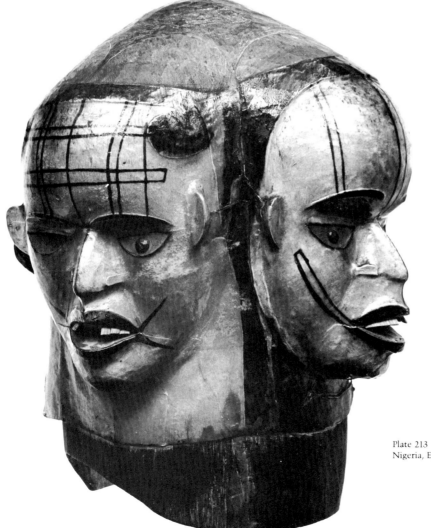

Plate 213
Nigeria, Ejagham, Akparabong Area, helmet mask, wood and skin, 16"

176

world of skin-covered sculpture. The Calabar style range (Plate 214) is elegant: oval head set on neck of answering length, with flat metal eyes and painted dotted pupil. [126] In this mode the nose is hooked, and the mouth encloses evenly spaced teeth of cane, creating an effect of startling realism. The Akparabong style range (Plate 213) is close enough to Calabar to suggest trade ties and/or the traveling of masters from one workshop to the other, possibly via the pre-1900 overland route from Okuni, on the middle Cross River, to Calabar. [127] Akparabong area sculptures represent a kind of intensification of Calabar detail in the following sense: foreheads are high, very curved, and bulging; eyebrows are narrow and curved on female faces, heavy and horizontal on males; iron marks the center of the eyes; the nose is strongly hooked; the mouth is conceived in sweeping, projecting contours; the lower row of teeth is omitted altogether.

The contrasting mode of Widekum (Plate 215), at the gateway to the Grasslands, suggests a geometrization and heavier massing of Ejagham realism. Eyes and mouth are arbitrary rectangles. A taut expression governs the whole conception. According to a Widekum informant, quoted by Marcilene Wittmer, this mask was used in a dance called Nkwem, worn with the "hoop-skirt" associated with the Ejagham helmet masks. [128]

Widekum figurations lead to the Grasslands. In these Cameroon highland areas, the rounded shapes of the Grasslands helmet masks share a sign-like directness with Widekum form (Plates 217, 218, and 7), even when miniaturized, as in the case of a flywhisk with maskette handle (Plate 216). It is significant that Grasslands helmet masks may be worn with gowns of Bamum painted-resist-dyed cloth; it is significant because Bamum cloth bears signs which relate to Ejagham ideographs, hence a sign-like mask is balanced by a dress of signs. The connections linking Ejagham writing with Grasslands decoration are clear, as can be evidenced by a comparison of published Ejagham nsibidi signs with Grasslands motifs in bead-working, divination, and wood-carving. The concordance is not absolute, and a good deal of Grasslands creativity has enriched the original fund of forms, but it is, nevertheless, substantial. To sum up, the calligraphic influence of the Ejagham may well have included the Grasslands, materially transformed in the famous cheek-bulging sculptures of the latter area. The openwork forms which crown certain Kom-Tikar masks take on pictographic qualities which refer back to nsibidi-like Bamum textile patterns.

(b) Nsibidi: The Ancient Script of the Ejagham

The traditional writing system of the Ejagham, at least as old as the basalt monoliths of the Nnam and neighboring Ejagham groups—*i.e.*, predating Western penetration

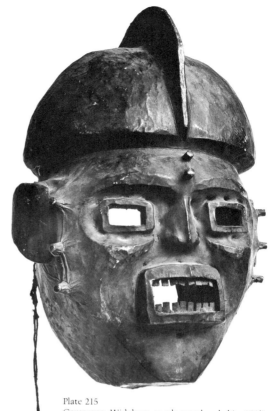

Plate 215
Cameroon, Widekum, mask, wood and skin, 16½"

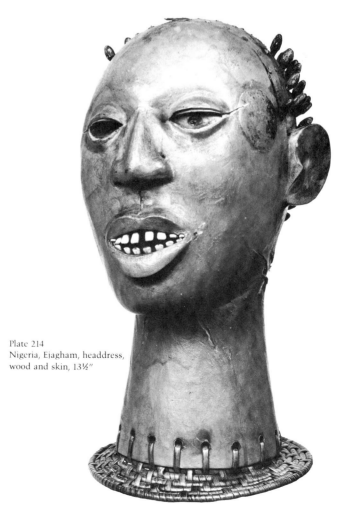

Plate 214
Nigeria, Ejagham, headdress, wood and skin, 13½"

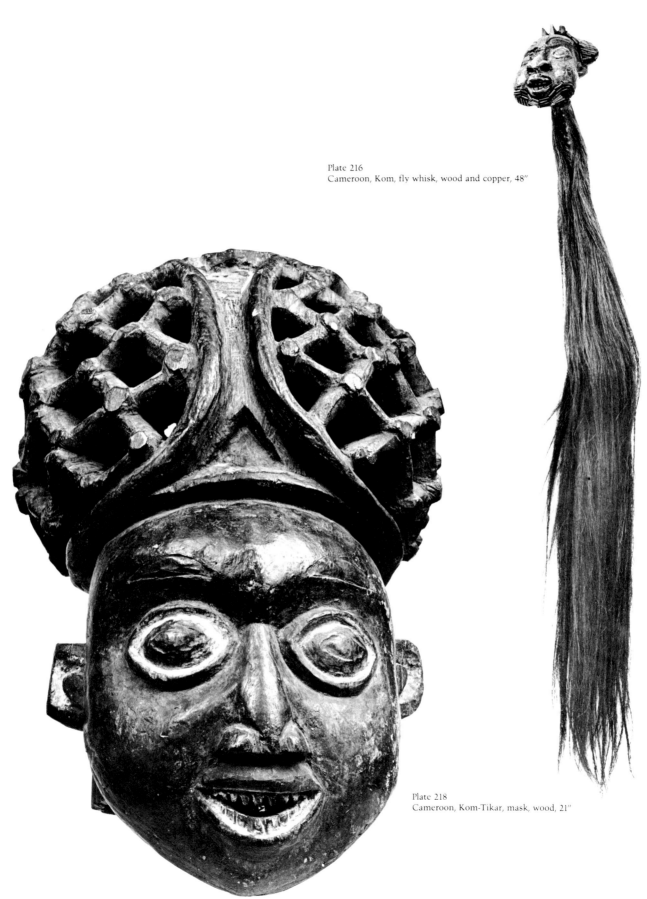

Plate 216
Cameroon, Kom, fly whisk, wood and copper, 48″

Plate 218
Cameroon, Kom-Tikar, mask, wood, 21″

178

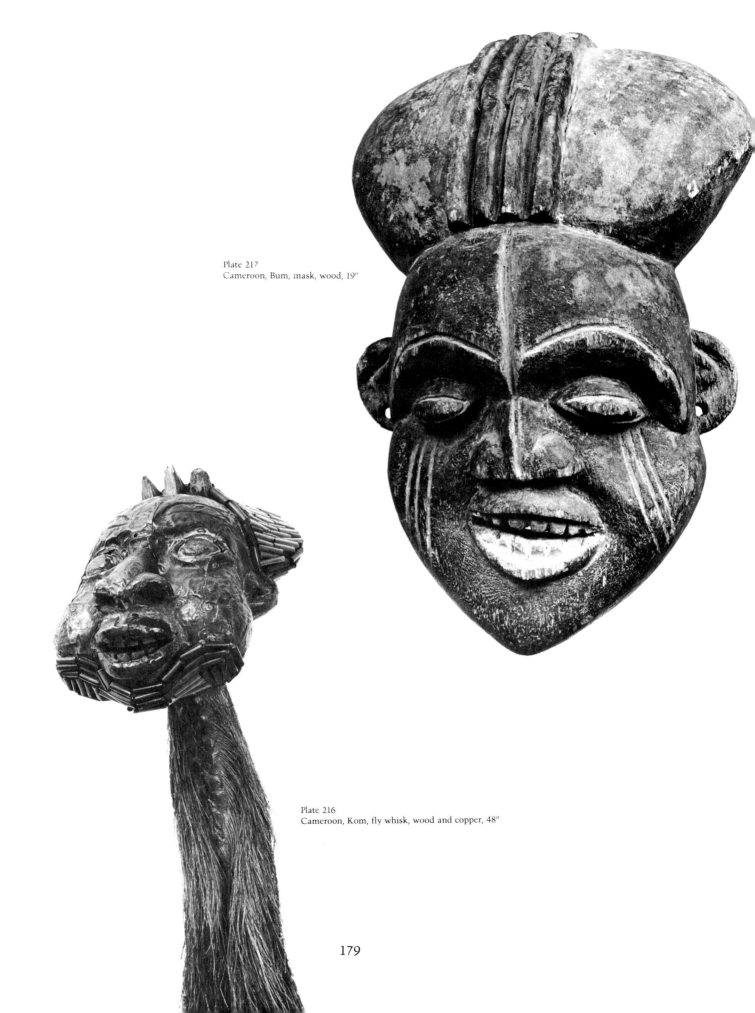

Plate 217
Cameroon, Bum, mask, wood, 19″

Plate 216
Cameroon, Kom, fly whisk, wood and copper, 48″

179

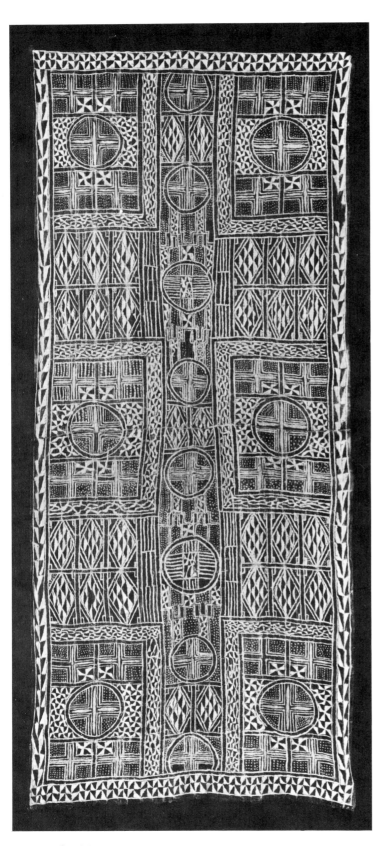

Plate 219
Cameroon, Bamun, textile, 11' 6"

of the area by several centuries,[129] essentially functioned on two communicative levels, sacred and profane. The latter focussed on love and reconciliation, leading to birth and rebirth. Sacred signs were documents of death and initiation, matters of most important transition. Much of the former and a little of the latter can be rapidly illustrated by a sampling of recurrent motifs, which once were chalked on walls, embroidered or appliqued on cloth, painted and resist-dyed on cloth (Plate 219), incised on calabashes, hammered (at Duke Town) on brass containers, cut in divinatory leaves, painted on toy swords, and tattooed on human skin.

The forms today are fugitive, such as fading tattoos (Plate 220) on the faces of elderly Ejagham and other Cross River peoples. The more recondite symbols survive within the Ngbe lodge, seen only by highly-initiated members at the moment of their swearing-in and at the death of their most important members. A sampling (Fig. 2) of the signs includes: (1) the sign of love, a pair of interlaced curves; (2) the sign of hatred or discord, opposed curves, a line drawn between them; (3) the curved line of falsehood over the straight line of truth; (4) the crossed lines of speech, meaning a Ngbe command has stopped or blocked an action; (5) the intersection of equal lines within a circle, a sign of important discussion within an assembly hall; (6) the checkerboard, representing, in stylized form, the multiplication of the spots of the leopard's pelt; (7) the same motif rendered as a field of shaded or solid diamonds; (8) the Janus, a quartered circle, with one small circle within each quadrant, suggesting the meeting of the earth with the sky, or female with male, as in Janus-helmets; the four small circles standing for the four eyes of clairvoyance.[130]

(c) The Ngbe Society and "Action Writing"

The Ejagham Ngbe Society (*Ngbe* means leopard) is an all-male brotherhood devoted to the making and keeping of law, the maintaining of village peace, the hearing of disputes, and, above all, the pleasurable dancing in public of secret signs of magic prowess.[131]

Knowledge and depth of membership is remorselessly tested by battles of sign language between two members. Each sign is, in a sense, a mimed nsibidi, and for this reason I designate the tradition "action writing."

This secret idiom, called *egbe*,[132] is a gesture language referring, in the main, to symbols and ideas which bind men together and lend them strength or inspiration for the hearing and resolution of discordant social situations. The positive character of nsibidi, their ability to notate fundamentals of social viability, love, trust, truth, and political efficacy, is given parallel substance by this tradition. The nsibidi mime is performed by two members (Plate 221), in prolonged intellectual and artistic combat.

Mime and calligraphic sign correspond. This can be demonstrated by the following gestures. For instance, the sign of love is rendered by hooking both forefingers together. The sign of hatred is conveyed by opposing the backs of the hand, thumbs down, "showing one's back to the husband."[133] The sign of speech emerges in the crossing of two staffs.[134] The presence of the leopard is variously expressed, either by crawling, or trembling, "when the leopard moves through the underbrush, he is shaking, shaking, moving the underbrush before him, stalking his prey, confounding everything before him."[135] The elders of Ngbe mime transformation into leopards by other means, gently "pawing" invisible earth before their bodies, with a graceful gesture of the arms.[136] These latter signs relate to checkered pattern ("leopard cloth")[137] worn by messengers of the society, suggesting in the strong vibration of primary colors, one against the other, the quivering quality of the beast.

The sign of the Janus, fusing heaven and earth, is communicated by touching the region of the eye and pointing to the sky, the other person answering by indicating earth, pointing down.[138] I have seen a single performer combine both gestures, answered by another who similarly brought the two together. Banyang gloss this sign: "God is in heaven, Ngbe on the earth" (Mandem achi efe ne, Nyankpe achi ameke).[139]

The use of the signs is grammatical. They appear in sequence and they are almost always used *responsorially*, in the manner of call-and-response. Thus a Calabar informant: "before you make signs, you draw the attention of the person; you call him."[140] The challenger calls the person by pointing, vigorously, with the right forefinger at his head. This has the force of "you!" and then the caller continues by passing his right forefinger over the eyes, meaning, "have you seen Ngbe?"—*i.e.*, "are you a member?" The person nods, if he is. Then an intellectual inquisition may begin. Each tests the other's knowledge and depth of initiation until one or the other receives a challenge for which he does not know the answer. The challenger may tap his right shoulder with his left hand ("what have you worn?"); the respondent activates both shoulders, alternately, ("I have worn the Ngbe costume"). An elder, seated, may accost a young visitor with the following sign—he mimes washing, with his right hand, his left elbow, then his right elbow with his left hand, saying, cryptically, "before you eat with elders your hands must be clean and pure." This means: "we don't know you, explain yourself."[141]

The member especially learns the form and meaning of masked figures who manifest the spirit of departed leopard-chiefs, and the "leopard voice," the most jealously guarded secret of the society. Every lodge includes at least two masked messengers, *ebongo*, (Color Plate VIII) who dance "very cool" and who are garbed in soft material.[142] Abakpa Ejagham say ebongo represents the

Plate 220
Ejagham woman with Nsibidi tattoo

(1)
the sign of love or marriage:

(2)
the sign of hatred or divorce:

(3)
the curved line of mendacity written over the straight line of truth:

(4)
the sign of speech, sometimes interpreted to mean that an Ngbe command has been uttered.

(5)
the signs of important discussion

(6-7)
the sign of the leopard, the muliplication of his spots:

(8)
the Janus of sky and earth, male and female; the four eyes of clairvoyance.

Figure 2
Nsibidi signs

181

mother of the leopard spirit, hence the relative gentleness of the image.[143] The corresponding image is "hard," the male spirit, *emanyankpe*.[144]

Emanyankpe is a more elaborate mask, associated with fierceness and terror. It dances by itself. Non-members scatter when he appears: "this one will beat widows."[145] He has the right to strike any woman who treated her husband with disrespect while he lived.

Emanyankpe combines a variety of nsibidi. Each unit of the costume is a symbol in itself, not a mere segment of a descriptive whole. The dancer becomes a document.

The conical headdress *(esi)*,[146] not unlike the conical head of the ancient basalt monuments, is an extraordinary abstraction. The mouth is not rendered: "because the leopard spirit does not speak; the moment it speaks it becomes a man."[147] At the back of the head of the dancer, appears another head *(isun)*, in the form of a disk. This disk, made of cloth over a circular cane frame, re-centers us within the notion of Janus. The disk grants the spirit-dancer extra eyes, sometimes boldly rendered as appliqued mirrors.[148] The mirrors guard his back, imparting magic vision.[149] About the neck is wrapped a magnificent coil of raffia *(nki)* which, according to informants, adds, to the power of the leopard, the power of the lion. This ornamental coil is carefully trimmed and shaped, sometimes brilliantly colored with alternating bands of orange, black, and natural raffia.

The dancer is clothed in a tight skin-fitting knitted costume which covers his body entirely, from the conical hood to the ankles and wrists, leaving the feet and hands exposed. An opening in the region of the chest, through which the dancer enters the costume, is concealed by the raffia ruff. The costume is often checkered in brilliant gold, black, and red patterns, in allusion to the vitality and pelt of the leopard. A simpler costume from the village of Akriba, in upper Banyang, purchased at Calabar in 1963, is striped brown, orange and white (Plate 222). The brown of this costume stands for "terror," the orange for "people dancing," and the white for "purity and peace."[150] Terror, pleasure, and purity are commingled as flickering absolutes, within the striped pattern. Finally, like illuminating circles of forest ferocity, raffia fringing decorates the points of flexibility: ankles, wrists, and shoulders. The meaning of the raffia is: "when you meet raffia over a path, in the forest, you know it means a dangerous thing."[151] A heavy bell is attached to the waist by two sashes, one red, the other white. The sashes are said to refer to mourning bands and to allude to the fact that the spirit has come from the dead.

The dancer carries a staff *(esangbe)* and a bundle of leaves *(afungbe)*. The usage is complicated; staff and leaves can be crossed to make signs or manipulated separately. The spirit can punish with his staff or "throw greetings" with the bunch of leaves, as demonstrated by a leopard-spirit in the forest village of Mbeyan (Plate 223),

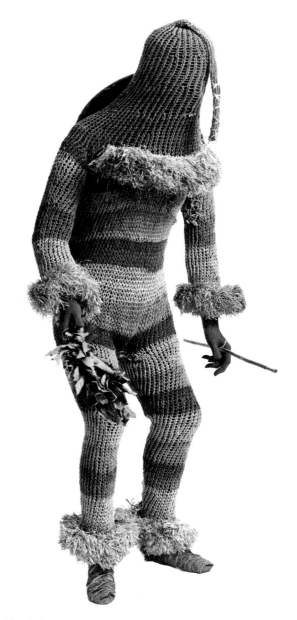

Plate 222
Nigeria, Ejagham, Ngbe costume, 5' 8"

182

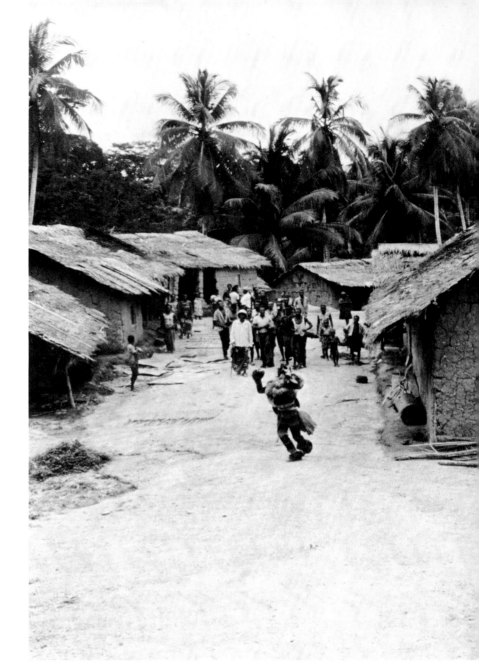

Plate 223
Ngbe dancer hailing the departure of a visitor

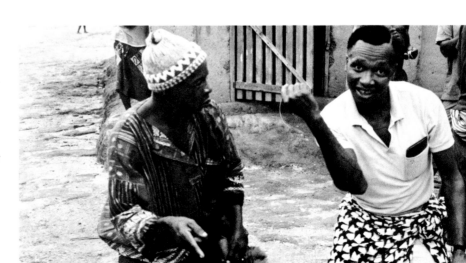

Plate 221
The Nsibidi mime performed by two members of the Ngbe society

hailing the departure of a visitor.

(d) The Privileged Motion of the Leopard

The movements and culminations of the Ngbe ceremony are dramatic. The idea of the leopard and his magic grace, rather than the presentation of his movement *per se*, is illustrated. What follows is a composite description, based on public dancing of a leopard-spirit at Otu in the summer of 1969, together with motions observed in the Banyang village of Akriba in January 1972 and March 1973.

The music of Ngbe is rich. The basic meter is 6/8, at a fast tempo. This concentration on a rolling metrical pattern lends to the performance a sense of urgency.[152] Instrumentation includes the use of a rattle, one in each hand, by the titled member known as *morua*, who sometimes guides the masked messenger by the sound of his percussion. Another titled member, *ekini*, the Ngbe messenger, provides stylized shouts at irregularly timed moments, beating his hand over his lips, making an Ejagham sign of welcome (Plate 224). He adds a tricksterish element of surprise. In fact his crooked stick, said to mirror the moral condition of those he summons to deliver themselves to the moral interrogation of the sound of Ngbe, compares most intriguingly to the hook of the kao gle and the Yoruba trickster.

The Ngbe drum choir provides a juggernaut of sound. There are four wedge-tuned drums, including the *no nko*, two medium drums called *bekpiri*, and a small drum, *mokpen*.[153] A slit-gong adds varied accents. In addition to the drums, women provide a rousing counterpoint, striking sticks together around the periphery of the dancing ring (Plate 225). When they see dancing they particularly admire, say, an improvisation by an onlooker or member, they surround him with their beating sticks and praise him with a circle of percussion.

The blending of strong and soft voices in Ngbe singing is particularly noble. Critics of the song particularly prize the two-part structure *(bakwi ne mbah)* of the singing, a texturally thin but vital form of harmony, reminiscent of the Akan "harmony of moving parts conceived melodically, but performing different roles and spaced at least a third or fourth apart."[154] Two-part Ngbe harmony, soft and strong, in vernacular terms, recalls the division of the masked messengers into categories: cool and hard.

The coming of the leopard-spirit (emanyankpe) to the village square of Otu, a natural platform of laterite high on the slope of a hill, was accompanied by a band of initiates who danced with their hands oscillating gently before their bodies, miming the testing of the earth by the graceful pawing of the leopard. They entered singing proverbs of moral allusion. The spirit danced into view. His patterned garment, interrupted at the shoulders by an enormous ruff of raffia, provided visual music to accom-

Plate 224
Ngbe messenger making the sign of welcome

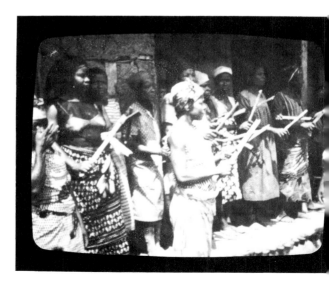

Plate 225
Women accompanying Ngbe drum choir

184

pany stylized trembling and whirling. He whirled several times, revealing the Janus-disk at the back of his head and a diptych on this disk that opened and closed, opened and closed. He made signs of speech by crossing stick and leaves, washed his body with his leaves and returned to trembling, recalling the image of the leopard in the leaves, making the bush tremble, confounding all before him. He moved towards a crowd of watching villagers. Two young men, each bearing a lance-like staff, rushed forward, crossed their staffs, and placed them on the earth. This sign of speech commanded the spirit to stop where the staffs had touched the earth.[155] He obeyed. He remained rooted to the spot until they removed the staffs from the earth and, still trailing them along the surface of the earth in crossed position, urged him to follow. With the cross set in motion, the meaning of the sign changed from "stop" to "follow" and the spirit was drawn closer to the elders.

The enormous dinner-bell tied to the spirit's hip rang on the offbeat between each step, activated by a forward-backward tilting of his pelvis that seemed most strongly sexual, as if one source of vitality were instantly translated into another. Throughout his dancing he continued to weave his pelvis forward and back and kept the dinner-bell in action, creating a startling sound that "rhymed" with his flashing visual presence. The gleam of his "pelt" was answered by the pawing of the human elders.

Then, without warning, the leopard attempted to run away into the forest. Men picked up pieces of wood and held out their arms with the wood extended. Other men grasped the ends of the wood with either hand until a large and impressive corral had been conjured, with the leopard within. The leopard dashed his body against the men, attempting to break free. He tried, again and again. Later an elder in private explained: "they are controlling Ngbe, guiding him to the elders."[156] Inexorably, the brilliant beast within the circle was moved in the direction of the council house. He was allowed to break free. The circle evaporated. Emanyankpe began to make signs: bathing his body with his leaves, crossing his arms before his chest, making his legs tremble, freezing his torso, revolving his head, spinning the tassel on his head in circular patterns.

A young man found himself within the path of the spirit and knelt. He attempted to get up; the spirit danced over him. He knelt more deeply. An elder remarked: "he is kneeling to show proper respect before *ntui* (the chief) and ngbe (the leopard)." Within moments, stimulated by the mounting excitement, a pair of men began to "throw signs," one member pointing at the sky, as if scouting something in the air, and repeating it for emphasis, and the other indicating the earth, "God is in heaven, and Ngbe is on the earth." This statement of Janus powers was, in a sense, mirrored by the double presence hovering over the kneeling man. Suddenly the rumbling of the

spirit of the leopard-leader, within the council hall, was heard

Entering the Ngbe house at Akriba (Plate 226) the viewer hears the vibration from behind the calligraphic cloth, the secret sound behind the richly beautiful curtain. The visitor notes the careful arrangement of a table (underneath is another secret which cannot be revealed). Ruel describes such an interior:

> The house must have two sections; a large main room in which most people sit and most activities occur, and a small inner room, or recess, which is separated from the main room by a curtain.... Within the main room members sit according to three main status-categories: the most senior are the 'leaders' who sit in a position of prominence behind the 'table.' [157]

An initiate enters and takes the metal-tipped *esangbe* staff that rests against the table and greets his brothers with ritual phrases while grasping this staff of speech with his right hand.[158] They answer each of his phrases with thunderously concerted cries. Then he takes, as a senior member, the leopard skin-covered staff, *monyo*, which has a flowing mane and red tassel at top, like the male spirit dancer. In fact the staff seems a standing surrogate of both leopard and chief, and this makes of the emblem a most appropriate means by which the title member salutes and answers Ngbe. The titled member holds monyo in his right hand and calls the voice behind the cloth.[159] Ngbe answers, ominous but concerned. The voice comes from behind the leopard-cloth, dramatically emblazoned with repeat-motifs of power, shaded diamond patterning set at slashing diagonals, like the path of the leopard's claws. [160]

The men were happy. There was meat and there was wine and the mood was merry. The leopard voice roared and grunted in time to the drums, weaving the supernatural into the secular range of contentment. The vibrations from the secret source gradually became one with the cloth, as if the ideographs had come alive in sound. Men "danced" their staffs, causing them to move, up and down, in rhythm to the bell on the hip of the spirit-dancer. Everything suddenly seemed counterpart: voice to cloth to staff to member to messenger to God.

There is no question but that the Ngbe atmosphere of enjoyment and greatness, once experienced, proves irresistible. Ngbe has spread from its Ejagham heartland, to the Igbo in the west and the Grasslands in the east. [161] It has become an international society.

One key to the attraction is the special relationship established within the cult, between the member and the leopard. There seems to be both power and humility built into Ngbe's basic premise, *i.e.*, that diffuse, wild power, symbolized by the leopard's escape, is restored to the elders who represent authority. Power, in the words of Malcolm Ruel, therefore, becomes authority.[162] The

Plate 226
Interior of the Ngbe house at Akriba, Cameroon

186

leopard is brought back to the elders because they cannot manage without him. They need his symbolic and morally intimidating strength. They need the power he brings which emerges in ability to do extraordinary things:

> You cannot compete with a leopard. Athletes who know how to turn into leopards always win first prize [163]

Humility is defined in the recognition that whatever the warrior does remarkably well he owes to his leopard and to his elders. He has harnessed forces which are not quite his. He has to make amends. He has to restore balance broken by his talent:

> When a person has transformed himself into a leopard, and has been victorious, when he comes back to his village he has to make a sacrifice—for if you transform yourself into a leopard you can harm someone. [164]

He must reward his people for the privilege of his greatness. Balance is restored and energy shared, through translation into money, into feasts. But the man of the leopard does not mind. Magic energy has been absorbed within his frame, purifying consciousness. Within the motion of his mind, corresponding to the motion of his body, he becomes a potential instrument of perfect justice; arriving at such confidence, he can allow himself to be generous, to be kind. He may never again take credit for his talent or his luck: "I was in a horrible automobile accident and felt myself being hurled in space. I survived. My leopard had leapt through the glass." [165]

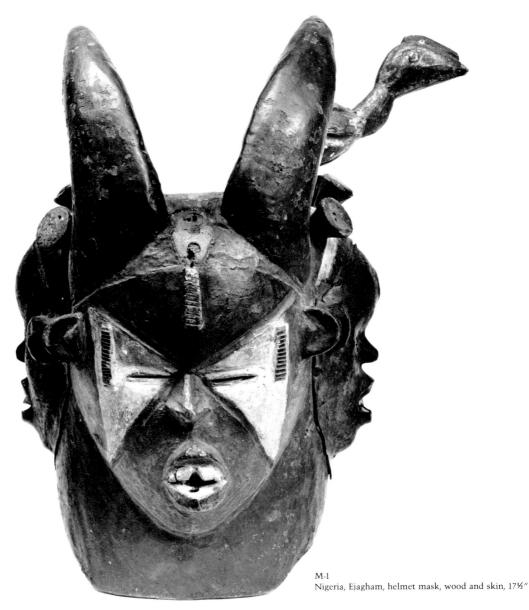

M-1
Nigeria, Ejagham, helmet mask, wood and skin, 17½"

187

M-2
Alternate view of M-1

3. YORUBA MAKERS OF CIVILIZATION

The eleven million Yoruba of western Nigeria and eastern Dahomey, situated in an area that has been urban for a thousand years, are heirs to a classical civilization of extraordinary educative force.[165a] Their ancient holy city, Ile-Ife, where it is believed the world began, was flourishing around the tenth to twelfth centuries A.D., considerably before the discovery of America.[166] The artists of Ife were casting brass heads and shaping figures in terracotta at a time when, according to H.W. Janson, "nothing of comparable quality can be found in Europe."[167]

Ancient Yorubaland was divided into what might be termed city-states: Ife, Oyo, Ijebu, Owu, Ketu, and so on. These were states seen spiritually. The king was second of the gods, dressed on high occasions like a divine inquisitor, concealed by beaded veil and crowned with clusters of birds of magic communicative power.[168] The elders-in-council in many kingdoms derived their power to check the throne from Earth herself.[169] Yoruba civilization was founded on a firm sense of historical destiny and cultural superiority, not unlike the Chinese or Jewish sense of self, and their cities were built in part by hard-working cultivators, market women, priests, priestesses, and kings. Each city was autonomous; thus Roy Sieber: "traditionally each Yoruba city conceived of itself as a self-sufficient entity. Not only were the inhabitants responsible for their own food through agriculture and hunting, but all basic material culture objects were produced locally . . . one looked to one's own city for survival, religion, and prestige."[170]

Yoruba visual tradition is primarily sacred, linked to the worship of some twelve to fourteen major gods. Religious statuary is phrased in the attitudes which we have come to find characteristic in subsaharan art: standing to heed prayer, sitting to sustain authority or to give, riding to protect or govern, kneeling to render homage, and so on. These attitudes, extended by sculpture, suggest necessary oppositions to excess and to lack of discipline.

Yoruba have always absorbed spiritual vitality and moral guidance from the worship of their ancient gods. For example, many of the gods operate within natural forces, such as lightning or a deeply flowing river. These forces are media for moral power:[171] thus the thunder-god cannot abide pathological liars nor adulterers and

fires the roofs of such people with his axe of flame. The origin of water, in one cult, is linked to the idea of salvation, and all the gods and goddesses teach in different ways that, "kind words or actions result in kola coming from the bag, harsh words, or cruelty, an arrow."

Two million Yoruba continue to worship the ancient gods. The demand for traditional icons therefore still remains. Yorubaland conceals pockets of traditional creativity, one town specializing in narrow-loom weaving, another in royal bead embroidery, another in the carving of wooden masks.

Art and motion further the attainment of truth and meaning through spirit possession and/or initiation. Among the Ekiti Yoruba, northeast of the city of Ife, the Epa cult stresses the transformation of young men into stalwart specimens able to bear pain and shoulder heavy weight.

Epa resembles, in many ways, the Bini cult of Ekpo:

Ekpo is essentially a cult which stressed the importance of the young and powerful. It is, in fact, controlled by the *ighele*, the age grade which in olden times constituted the fighting force of the Benin kingdom . . . the *ighele* represent the element of virility and physical strength within the community. The word '*ighele*' itself is a Bini praise name denoting someone who takes swift action or speaks forcefully. Agboghidi, the founder of Ekpo, was 'strong,' that is, had *etin*, the power of accomplishment in both the physical and magical sense.[172]

Elefon dancers in Ekiti, we recall, move using whips aggressively. Only an athlete can dance Epa, hefting fifty pounds or more of heavy wood upon his head. Epa, Ekpo, and Elefon jointly revitalize good government with the stronger power that comes from youth. The leit-motif is muscular endurance. This can apply to Epa-related festivals in Ekiti as well, like the iron god festival at Ire:

On the day of the festival no one stays within his compound; everyone is out, with whips in their hands. The king stays in his palace, because he must not, according to ancient tradition, 'see another king' [i.e., a man possessed by the spirit of the iron god, mythic founding king of Ire]. Men flog each other

with whips. There is dancing around a mound of earth within the forest. Elders dance around this mound. Guns are fired. It is said this 'swells the head' of dancers so much that they strike each other with horrific force[173]

Iron god is the deity of war. Thus youths meaningfully display their nonchalance in the face of pain: "elders say that when young men beat each other they learn who can best bear suffering, who will make a strong and satisfactory warrior." This is a test. Another is dancing while sustaining weight upon the head:

In the afternoon the images are taken out. Youths dance with small images . . . the last are New-Wife-Of-The-Iron-God and Mother-Of-The-Iron-God. The carriers are called *ireru*. Their images are so heavy that when they are finally put down, the carriers rush into a house and fall into a faint[174]

Provisionally, the world of Epa therefore suggests a universal thought: action becomes authority, authority rests on action. No person who has ever carried the weight of an Epa mask can doubt that its carriage strengthens the body and suggests, at the same time, attainment of higher powers of existence.

The Epa image (Plate 141) usually combines a Janus helmet of staring eyes and awesome mouth, balancing or supporting a realistic figural representation mounted on a tray. What the athlete shoulders consequently is superb: life over spirit, present over past. The mask is both a human and a spirit, unified in ritual completeness. The dance, similarly, seems both plausible athletic feat and supernatural marvel.

What follows is an account of Epa masks in action. Detail is based on two observed festivals at a village in northern Ekiti. The description of masks in motion is preceded by a brief section on ritual preparation documented in the region of Ire.

Some fourteen days before the festival, in the eighth month of the year, when there are new yams on the farms, the king will divinate and find the proper time to celebrate the festival.[175] He will tell the chiefs and the people to prepare. Nine days before the festival the king will go before the chiefs to make a special sacrifice. Heavy rains will fall. Five days before the festival members of the Epa cult will ornament the images, washing and repainting them, restoring ephebistic mint condition. Three days before the festival the men will cut whips. One day before the festival no one will journey to their farms. And then the festival arrives . . .

. . . late in the afternoon, an entire village assembles before two planted *odon* trees which mark the entrance to the Epa grove. Within this grove men have sacrificed a cock to the first of the masks to appear, the culture hero, Oloko. They will, or already have effected, further sacrifice and incantation for other masks and their carriers. Elders, outside the grove, are seated at the side of the path leading from the grove, at the point where it meets one of the main plazas of the town. They are seated opposite a mound of laterite, the latter sited some seventy-three feet before them. Mound, elders, grove entrance—these are key points of reference in the structure of the festival.

Percussion fills the air. Two pot-shaped drums are beaten with stick and right hand. Another musician strikes a wooden slit-gong with a wand of wood. This sound rises over the multiple meter like the unfurling of a crimson banner. The slit-gong, called *aikoro* at Osi, where they are beautifully carved (Plate 227), is associated in some villages with age-grades[176] whose members strike such gongs for other festivals. The music of Epa thus is founded, in a sense, on metric accents as strong as fighting age grades.

One of the elders rises from his seat and whirls, a fan of office in his hand. He whirls before the path that leads to the entrance of the grove. Women of the Igbede quarter, where the first of the culture heroes honored in the rite is once believed to have lived, rush forward towards the entrance of the grove along the path. Their heads are bare in honor of the spirit. They move, chanting:

Oloko
Asheru beran'ko
Master-Of-The-Beasts-About-The-Farm
Terror-To-All-Animals-Within-The-Bush.[177]

The verses indentify Oloko as a warrior-spirit, a caution to all enemies surrounding the village, to all beasts about the farms. Three times the women rush from plaza to grove entrance and three times they rush back (Plates 228A and 228B). This motion alerts the town. The festival is underway.

(a) Oloko

The leopard-warrior is the master of the beasts about the farm. The Oloko mask always shows a vigorous leopard leaping on an antelope (Plate 229). The leopard's leap suggests the warrior's bold attack. Oloko images are dressed in striking raffia fibre, from the bottom of the helmet to the waist of the dancer (Plate 230). Sometimes, in a virtuoso touch, a burst of raffia is attached to the leopard's tail. The dancer wears rich and highly valued applique beneath his cloak of raffia. The leap of animal is equal, in a sense, to the flash of wild fibre, "aggression's palm-fronds,"[178] an ancient sign of danger and extremity. The applique equals the ancestral quality of the helmet mask.

The leap of the leopard, in sculptural rendering, directly predicts the leap of the dancer, before the elders

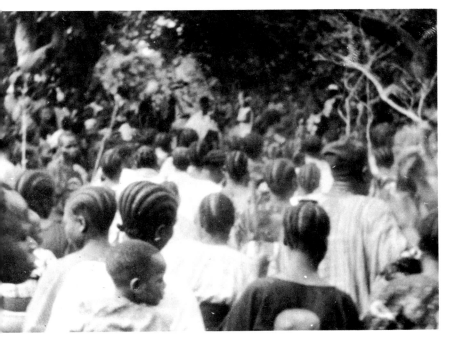

Plate 228 A
Igogo – Ekiti, women rushing in and out to greet Oloko

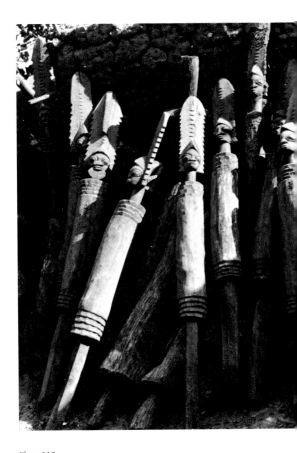

Plate 227
Slit gongs at Osi

Plate 228 B
Igogo – Ekiti, women rushing in and out to greet Oloko

and upon the mound. With a single graceful arc of motion he lands (Plate 231) before the seated elders, raffia flying, "to give them honor." He runs, spins, whirls, dashes, "with a flaming warrior's body," in transition to the second leap. This leap upon the mound (Plate 232) "shows the people that he has the power to rise into the air despite a heavy load." It is also an act of divination. If he stumbles or falls it is considered "woe to the town." He makes a perfect landing and remains upon the mound, waving flywhisks, one in each hand. He descends. He dances before the compound of a prominent chief. The head of the Epa cult rises and dances before the mask, "to show his happiness" and complete the union between the ancient hero and the living elder.

The athlete in the mask is breathing hard. Sweat is pouring down his brow. But this is never seen: "the mask is something like a veil, very special, so that while the body is moving very fast, the head will never seem affected."[179]

The staring almond eyes of the giant helmet, outlined dramatically with white, regard the world with cool ferocity. Similarly, the languid curve of an actual leopard's tail, the flow of his spotted body, the almost human standing of his powerful hind thighs, hold in cool arrest the power of his leap (Plate 233). Oloko runs into the forest, followed by his "dogs," i.e., his messengers. Informal dancing follows. Then a senior woman of the village lifts her fan of office high above her head and, dancing backwards, from the seated elders to the mound, calls, with this gesture, the second group of spirits from the forest.

(b) Ao

The drum choir changes patterning. An edge of coolness, slight but decisive, has been added. There is space between pulsations. This is *ipesi*, the beat of the herbalist-diviner, Ao. Oloko was heralded by women. Ao is preceded by both dancing men and women, channelled between raised whips of wood (Plate 234). The whips recall the vigor and bravery of the warrior associations. Here they are used to establish boundaries, between the masks and the press of the excited crowd.

This mask moves "slower than the leopard, faster than the coming king." We have arrived at the middle point in many senses. The village sings:

> *Ao, Ao, Ao*
> *L'elu igba ojo*
> Herbalist, Herbalist, Herbalist
> Master-Who-Can-Cause-The-Rain.[180]

The chant recalls the magic rain before the festival near Ire. We have moved from the world of the warrior, moving "smartly" with his leopard grace, to a social level where magic compensates for declining force of body.

Plate 231
Igogo–Ekiti, Olóko leaps before the king

Plate 232
Oloko leaps upon the mound

Plate 233
Leopard (Jos Zoo)

Plate 234
The arrival of Ao, Igogo–Ekiti

195

The arrogance of this secret power is communicated, first of all, by the equestrian rendering of the herbalist. He is the doctor on horseback, a follower seated before him (Plate 235). His supernatural gifts are intuited in the tuft which falls from the left side of his scalp. The left is the sinister side, the side he must penetrate in order to conquer sorcery and witchcraft. He masters evil to unlock charms, to release the rains.

The bird atop the herbalist-staff, crowned with spreading wings, sounds another note of supernatural power. The Epa priests in northern Ekiti present a clear and accurate meaning of this bird: "to show the people how powerful the doctor is about his herbs." [181] In other words, the man who charms moisture from the sky, can also magnetize the bird of witchcraft to his staff. He is armed with many powers.

The forest fibres of Oloko mirrored the flash of his feline speed. But the herbalist wears a trade-cloth (Plate 236), with deliberately chosen pattern, a field of circled crosses. The design suggests the crossroads, ancient symbol of trouble and transition. By this logic the man who hears and finds the rain in a dry sky, who freezes witchcraft to his staff, can also practice reconciliation at the crossroads, where truth and falsehood intersect.

Ao's pattern of dancing further suggests knowledge and control of evil in which his healing spirit gains its perfect power: he dances in a zig-zag manner. The dancer moves two paces to the left, two paces to the right, on a course that proceeds, by sharp turns, in alternating directions. The man who dominates fevers and mystic heat from a lordly horse, who cools the earth with rain, can travel in the crooked waywardness of witches to find and neutralize their power. [182] I am reminded of the sign of the doctor-herbalist among the nsibidi-using descendants of the Abakpa Ejagham: a horn of medicine set across a staff over which is set a crooked line. [183] Allusions to the left, to witch-birds, and to a crooked track suggest, as a unit, the world of night, the darkness of the other side where the witches dwell. These points compare with the Bini herbalist mask type known as Obo:

> The Obo mask goes . . . against the people of the night. The mask is painted black to signify that it represents a native doctor. Traditionally these doctors put on dark regalia and painted their faces black when they went to battle or made sacrifices to Osun, the god of medicine. The elaborate superstructure represents magical ingredients which prevent rainfall during the rites. [184]

Blocking the rain would seem a structural inversion of a classic function of the Ao priest.

Ao is seconded by another doctor-herbalist who wields a horn of medicine and dances zig-zag patterns. Ao and his retinue retire. There is more interlude dancing.

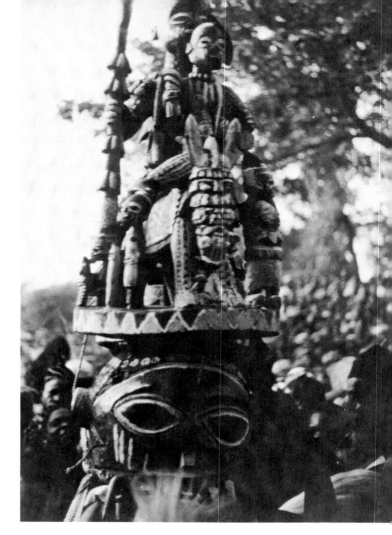

Plate 235
Epa mask representing Ao

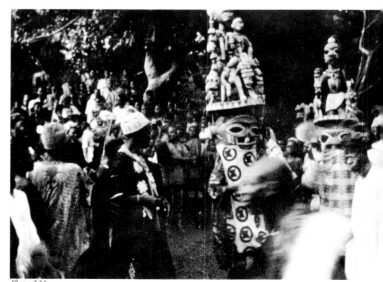

Plate 236
Ao dancing at Igogo – Ekiti

196

(c) Orangun

Suddenly the entire atmosphere changes. People are leaping (Plate 237). Each person hurls his body, three times, matching the first syllable of each word of a three-word song:

> Ofe, ofe, t'ala
> Charm, charm, the white-cloth charm. [185]

This verse is infinitely repeated. Ofe is a charm to make the body light. [186] It is appropriate encouragement for the man within the grove, preparing to dance with the heaviest and most senior of the Epa loads. The act of leaping announces that: "a person of the highest rank is coming; just as a person bows down three times for a spirit from the dead, so the people jump into the air three times for Orangun, the mighty king we are calling from the grove." [187]

Members of the village continue to leap. Men within the grove are wrapping an immense and immaculate white cloth about the image of Orangun. Orangun emerges. He slowly moves between the trees, spectral in his shining garment (Plates 238-241). The white cloth is beautifully tied, framing the face of the ruler and the head of his horse, but hiding the carved detail which richly surrounds him. The king is followed by two images, respectively representing an herbalist and a senior wife. The white cloth about the king, building suspense by momentarily hiding the complements of entourage and social happening carved about his sides, takes the light of the sun most brilliantly.

Elders explain the wearing of the cloth: "we cover him with whiteness to call his name." [188] His name is thus associated with the purity of mind of divine Obatala, "King-Dressed-In-White-Cloth," whose thought resembles the healing flow of "water of the calm," the magic white fluid from the center of the snail, the heart of patience and collectedness of mind. [189] And these qualities reappear in motion translation. Oloko lept. Orangun glides. Priests describe the character of this movement: "he moves with dignity and coolness . . . he does not activate his legs in any violent way; he moves with patience and with calm." He moves in slow and gentle curves, under a raiment of shining purity.

The relation, in scale, of wife and herbalist to their lord is simple and very natural (Plate 241). They form a dancing triangle: the kneeling wife, the standing herbalist, the riding monarch. In some villages their roles can be mixed or recombined and it is the woman who rides upon the horse (Plate 242, Color Plate IX). The theme of the mounted ruler is, in fact, quite frequent. The clash of postures is unified by movement in a pattern of collectivity and response.

Orangun makes circuits of the town, a trail of exultant people always at his side. A prominent carved

Plate 237
Youths brandishing saplings and leaping to honor the coming of Orangun

Plate 238 – 241
The coming of Orangun, Igogo–Ekiti

bird rides the summit of his bonnet, with actual egret feathers, shining white: "these feathers appear so he will be recognized as a mighty king." A band of running men cut a current through the crowd, recalling in their energy the leaping of the opening moments of the dance of Orangun. Their vitality emphasizes by contrast the cool motion of the mask. Orangun is slowly moving towards the elders, where an unveiling will occur: "the white cloth which dignifies the king above all other images will not be removed until it is time for Orangun to depart the dancing center for the forest." [190]

The unveiling is exquisitely rendered. The cloth must be removed just so, not rent, not allowed to touch the earth. And it is done. The dancer turns in one direction, a person pulls in the opposite direction, and from this counter-tension the cloth snaps free (Plate 243). The festival is ending. Orangun makes final circuits of the plaza, excited men and women forming concentric moving circles about his towering form.

The village has achieved a cathedral of artistic motion. Human followers surround the image. Warriors in wood ride the Janus ears (Plate 244). A carved universe of urban life surrounds the mounted king: pressure-drummers, soldiers bearing arms, full-breasted women with fans. Each level of visually elaborated praise, in flesh and in wood, has a logic of spiritual suggestion and vitality. Dance and image illustrate God's presence in good government. The spiralling of people about a central source of ruling grace, not unlike the discharging into heaven of the energies of a cathedral dome, is moving. The dance of Orangun confirms for a final time that understanding sculpture without people is impossible.

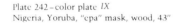

Plate 242 – color plate *IX*
Nigeria, Yoruba, "epa" mask, wood, 43"

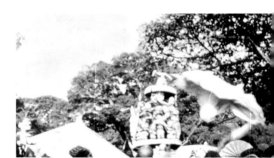

Plate 243
The unveiling and triumph of Orangun

Plate 244
The departure of Orangun

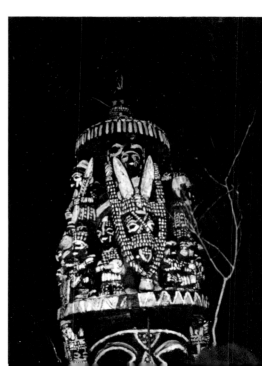

4. YORUBA ASSUAGERS OF THE WITCHES

The great Epa headdresses of the northeast of Yoruba-land honor the makers of civilization: warriors, herbalists, priestesses, kings. In the southwestern portion of Yoruba-land, among Ketu, Shabe, Ohori-Ije, Anago, Ifonyin, Aworri, and Egbado Yoruba, there is another program of sculpture, dance, and dress called Efe and Gelede. The sculpture for this society, numerically one of the largest programs in the history of art, involving thousands upon thousands of masks in wood, is a landmark in the cultural history of Africa. These masks in motion are mediating objects: they honor and cool magically active people of the night, dangerous beings, whose very name is spoken with care:

> The Yoruba word for witch is Aje and would appear to be a contraction of 'Iya je,' meaning 'mother eat.' The word, Aje, is in practice avoided as much as possible or at least spoken in a whisper (for fear of attracting the witch's attention or offending her). The expressions 'agbalagba' (old people), 'awon iya wa' (our mothers), or 'awon eni toni aiye' (those who rule the world) being substituted. A witch's malignancy may be turned upon a man for almost any reason—for some impoliteness, or because he accuses her of being a witch, or because he is getting too high in the world, or often for no reason, 'just because they are evil women.' [191]

Witchcraft springs into being, following this argument, where canons of social interaction have been violated ("impoliteness"), where a person fails to avoid a rude and frontal manner of confrontation ("accuses her of being a witch") or fails to share the fruits of social advancement and prestige ("gets too high"). There is socially pragmatic basis for such belief. Fear of witchcraft projects upon a mystic plane the possible consequences of disrespect for elders or lack of social conscience.

The people of the night come into their own in the world of sleep and dreams:

> One of the commonest fantasies about the powers of the witch is that she can transform her 'heart-soul' (okan) into a bird or animal. This occurs at night and her physical body remains in a deep sleep while her transformed heart-soul moves abroad. A woman who sleeps on her back with mouth open and arms outstretched is probably a witch . . . most witches transform themselves into night birds of some type 'a white bird with a long red beak and red claws' or a 'brown bird like a bush fowl with a long red beak' . . . these creatures are all active at night, for it is believed that witchcraft is a nocturnal thing, the witches being most active between 12 and 3 A.M. in the realm of dream and nightmare. If the witches' activities are brought into the light of day, they lose their potency, e.g., by confession. [192]

The members of the cult of Efe and Gelede hope to persuade the "mothers" with magic, art, and honor to guard humanity, turning their powers of destruction to positive purposes. Otherwise, man sleeps in danger. His blood and his vital essences may be drained from his temples through the penetrating red beak, come to his side in the night.

There are, fortunately, limits set upon these powers, so it is believed. At the beginning of the world, myth says, one of the most powerful of the ministers of God, the divination deity, Orunmila, forced "those who rule the world" to obey signs set up to protect men and women from indiscriminate killing:

> When Eshu [the Trickster] came, you left for a place
> in the sky and it received you not,
> Then you went to Orunmila and when you got there
> you greeted him and he asked you where you
> were going
> Then you said you were going into the world to be
> killing people and to be debarring their progress
> Then Orunmila said that he would not allow
> the gates to be opened to you, unless with a very
> solid agreement
> Then you said he should get the ram's horn,
> tortoise shell, the long spine of the porcupine,
> fowl's feather and soap.
>
> Because nobody will ever eat the tortoise
> with the shell
> Nor the ram with the horn
> Or the porcupine with the spine
> Or the fowl with the feathers. [193]

The grim devourers cannot penetrate shells, nor digest quills or feathers. But even if there were no guards, the power of the witch is not inherently evil. Good and evil can combine in witchcraft. It is told that "those who rule the world" came down in the form of birds on seven trees. On three of these trees they worked for the good, on three they worked for evil, and on the seventh tree they worked for both evil and good.[194] The problem, then, is to discover the positive moral qualities embedded in witchcraft so that the whole of mankind can benefit from such powers.

The goal of Efe and Gelede is to achieve this by aesthetic means, involving magic, percussion, sculpture, dress, and dance. There is authority for this ambition in the literature of divination, according to which the god of divination mastered the "mothers" with sacred leaves and charms and then obeyed their demand that he should dance. He held an *agogo* gong with his hand and struck it while he danced. The sound of the iron gong is associated with persuading the mothers to work for men and women. He finished his dance. The mothers said, "God of Divination! What you have done is beautiful!" Charmed by his magic and his dance, they then unleashed a long and mighty blessing. They began with the wish that any journey he might undertake would end well and they ended with the prediction that he would live to a ripe old age.[195]

The "mothers," consequently, are attracted to the sound of music and the sight of dance. They are also strongly affected by the sight of their own kind of costume. It is told that the god of divination instructed men of Efe and Gelede how to protect themselves from the persons of the night: wearing a mask, head-ties, and iron bangles. This signaled to the mothers that the dancer was one of them. They would not destroy him.[196]

In combining action and words, transmitting praise to the mothers via the audible rhythms of bangles *(eku)* and the visible and striking details of female dress, men of the Efe and Gelede cult contrive to avoid encounter with the annihilating gaze of "those who control the world." Fear of the "mothers" can make a man join the male society called Efe and Gelede: "As I have already got three children there is no reason why I should not die But as I am a member of the Gelede society, the witches will spare me"[197] The fear can be morally educative; it can make a man think about inequities of social level and economic structure and take care in his relations with elderly people, never laughing at their infirmities and helping where he can. Above all, he fears attracting jealousy by making more money than his brothers. He shares what he gets, if he is moral, or tries to conceal his wealth, if he is not. Significantly, one of the classic messengers of the witches, the trickster, Eshu, started, on the day that he was born, to throw stones at the houses of the rich.[198]

Men of Efe and Gelede, aware of the dangers of "getting too high," devote themselves to the expense of placating the mothers with elaborate costuming, athletic displays of choreographed stamina and grace, and exact response to the speech of the drums. Money can be variously expended upon the perfection of the details of this tradition. The tradition thus absorbs funds which might otherwise have created disparity and social friction.

The season of Efe and Gelede is normally at the end of the dry period, roughly March to May, when cultivators scan the skies in anticipation of the first rains. There are out of season dances for the funerals of important members and *ad hoc* occasions of civic calamity or celebration.[199]

The joint celebration of Efe and Gelede is divided into appearances of the night and day. Efe is nocturnal, Gelede diurnal. Efe ceremonies occur at midnight, generally, in the main market of a town. In the Ketu area members of the cult construct a portal lined with palm fronds at one end of the market. This is called the Mouth-Of-The-Power-To-Bring-Things-To-Pass.[200] Through this portal the twin performers of the night, Tetede and Efe, appear. Tetede is female. Efe is male. I saw them dance in Ketu in August 1972 during a ceremony honoring the visit of dignitaries of the Dahomean government from Cotonou.

As the first-born of twins, Tetede "tastes the world" for her senior brother, Efe, to see if the setting is suitably "cool" and fitting for his visit.[201] The male dancer within the costume of Tetede wore an exquisitely carved female mask, covered with shining kaolin. He moved in a larger-than-life manner because of the heavy padding of his costuming. He sang, while alternately waving his arms; this graceful act dissolved as the market crowd picked up the chorus to his song, and was replaced by sinuously phrased S-curves of motion in a small amount of space before the portal. Tetede sang three songs and called three times for "Word of Efe" *(Oro Efe)*. Oro Efe literally means "Word-That-Is-Couched-In-Jocular-Idiom"; the blunt directness of what he has to say violates the norms of Yoruba diplomacy, hence the euphemism.

Oro Efe appeared in the portal. He had been dressed under the direction of the female head of the cult, Alashe, She - Who - Has - Mastered - The - Power - To - Bring - Things-To-Pass.[202] Both her name and the name of the gathering point where Efe was dressed, Ashe (power to command the future), intimate the power of Efe to single out the evil and predict their doom. The effect of the dressing of the Oro Efe figure with rich lappets of highly valued appliqued cloth, not unlike the expensive cloths which dress the Yoruba impersonators of the dead (egungun), impressively enlarged his dimensions, recalling, in a sense, the founding of the world when deities walked the earth as giants. The mask of Oro Efe was highly similar to an Efe mask in the White Collection (Plate 245), *i.e.*, the face was round and composed, the eyes slitted, and the head surmounted by a decorative device including representations of knives and a devouring bird. The

knives, according to Ketu informants, stood for the "fierceness of the male who must boldly sing the truth."[203] The bird attacking the serpent was emblematic of the power of Oro Efe to strike at evil on behalf of the ruling mothers of the night.

In sum, Efe seemed a dignified king, come from another world. The quietude of his motion, a form of stylized pacing, underscoring and adding variety to his words, was perfectly in keeping with his character.

Oro Efe sang songs attacking elements of corruption and petty deception among members of the Ketu community. He sang until dawn, at which point a jackal mask *(koriko)* on stilts appeared to break up the crowd and signal that the rite was done. Although most of his singing had to do with social criticism, the full range of Efe songs, as Henry Drewal shows, can include invocation and self-authorization, curse, prophecy, allusion to sexual conduct and morality, comment on foreign and domestic politics, as well as remarks on religion, hierarchy, history, and funereal commemoration.[204]

I shall never forget the singers of Efe at Lagos in a ceremony lasting from midnight to dawn, on the morning of 5 January 1964.[205] In Lagos, the island capital of the Federal Republic of Nigeria, there are two Efe and Gelede societies, with a third in Ebutte-Metta, across the harbor. In this teeming city of nearly a million, Efe singing is complicated. There is a series of paired male singers, with faces and shoulders covered with raffia fringing, a form of decoration strongly redolent of danger and aggression in the Yoruba imagination. Singing was almost entirely devoted to social criticism, curse, and prophecy. A certain Yoruba official in Lagos, for example, was impugned by a pair of identical masks, called World-Does-Not-Love-A-Slanderer *(Aiyekofegan)*. These masks chanted that the official was, "acting superior to the wishes of the people." They claimed he, "wanted to steal shoreline from the people of Isale-Eko and lease it to foreigners for wharves and deprive the Yoruba fishermen of the quarter of their rightful place of living." There was spirited reaction to this. A man screamed in English, "I want to fish, O!" The entire audience picked up these verses, adding the weight of their agreement to the seriousness of the argument.

The dancing was in a tiny square, Iduntasa, in the traditional quarter of Lagos, about thirty yards in length with three drums at one end and the point of entrance for the masks at the other. Each pair of masks entered and approached the drummers together, paying homage to certain gods before launching into their social commentary. Their motion was negligible. They sang phrases, waving flywhisks. They stamped one bangled foot at the end of each phrase. Their dancing consisted mostly of stamping slowly, swaying from side to side, moving to and from the drums. The nobility of the effect was very much in the manner of Oro Efe of Ketu.

Another pair of Efe masks appeared, this one called

Plate 245 Nigeria, Yoruba, "Gelede" mask, wood, 15"

Passing-Sign-Of-The-Moon. They sang, jingling their bangles with a stamp at the end of each phrase. Their phrasing was elliptical:

Trickster has six beards
Gives one to a man to dry
Who cannot make it dry
Beard should not be lost
Trickster grinds fiery pepper
Applies it to your penis
Now we ask: does it bite hot or not? [206]

There was laughter and much clapping and spontaneous dancing on the edges of the tiny plaza. An allusion had been instantly understood and approved: a powerful politician in Lagos was attempting to "dry the beard" of the people, *i.e.*, ask socially ruinous things of them for his own selfish aims, selling land, alienating traditional property to foreign investors. Oro Efe warned that, in revenge, the people, with magic borrowed from the mothers, would place him in a situation in which he would be soon engulfed in fire and death. The Efe pair continued:

This man—
His lips are like a fan
Spoiling the palace
Awolowo, hero of the Yoruba,
Husband of us all,
Will return
That when Awo returns
All of these people will flee and run to the bush. [207]

The song was lustily applauded. Much to the satisfaction of the singers, within a few months after this ceremony the arrogant politician died in office and in the aftermath of the Nigerian civil war the apostle of Yoruba nationalism, Awolowo, was released from prison and returned to office and to the people.

The singers of Efe are called the "eyes of the mothers" and it is not difficult to comprehend why. Efe is himself a kingly witch, enraged, like the mothers, by human arrogance, by those who "get too high," by those who press on in life with their individualist ambitions, mindless of the impact of their actions upon the livelihood and security of the people. Efe can predict the doom of such people and, it is told, whatever he says will come to pass. This, too, is a power of witches and kings. The mothers, at the peak of their force during the hours before the dawn, support the brave men who confront, in some instances, the most powerful political figures in Nigeria.

After the invocations and criticisms of the night, Gelede is played on the following afternoon. Efe brings into the open exotic moral behavior, including remarks on politicians, thieves, adulteresses, adulterers, prostitutes, pompous fools, idle rich. Gelede concretizes, in some of the themes of the masked dancers of the after-

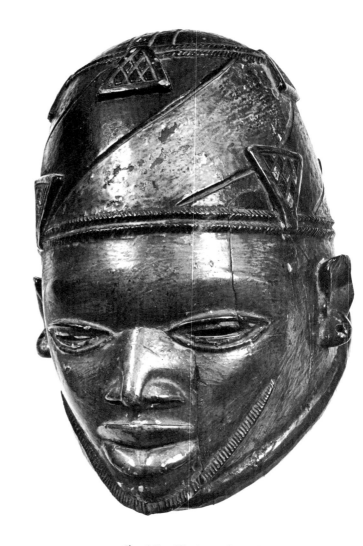

Plate 246 Nigeria, Yoruba, "Gelede" mask, wood, 11 ½"

Plate 247 Two "Ere Gelede" (the fishmonger)

202

noon rite, the making visible of the sources of social disorder. There are images of thieves, adulteresses, figures from foreign worlds of worship, such as the Muslim cleric, repatriated Afro-Brazilians, white missionaries and imperialists—all manner of witchcraft, positive and negative. The dandy in a Muslim fez (fila tajia) is a favorite of the carvers of the style range of the capital of the Aworri Yoruba (Plate 246). In many respects, the attempt is also to honor these witchcraft-related figures so that their power, which is the power of the mothers, can be turned to public advantage, even as the positive witchcraft of Western diagnostic medicine has been turned to spectacular advantage in controlling certain forms of tropical disease.

The pairing of the masks of the night, Tetede and Efe, is, in a sense, extended by the custom of dancing Gelede masks two at a time, in twinned appearances (Plate 247). Within the Gelede rite there is a distinction between *akogi* (male) masks and *abogi* (female) masks, with appropriately phrased choreography. Akogi dance "hard" and "hot." Abogi dance with a "cool" elegance, "in a high-life mood," as one modern-minded informant put it.[208] Henry Drewal, with a wealth of supporting evidence, has shown how this distinction applies even to the overall design of the dancer moving in space.[209] Akogi cut erratic, sharp-edged, speedy lines in space; Abogi phrase their motions with graceful curves which are self-contained.

Efe and Tetede are protected from the wrath of the mothers and have no need to cool them in their dance. They are already proof to their annihilating regard because they themselves have the "eyes of the mothers." They have their eyes in the sense that if someone does evil in the village, Efe and Tetede will see it and bring it to the attention of the multitude.

Gelede is different. Gelede is dance. The rite is named, Egbado informants claim, after the ponderous motion of the enormous queen of the witches, Yemoja.[210] The gist of the dance in Gelede is the choreographing of short bursts of creative brilliance before the senior drum *(iya ilu)*. These brief sequences are called *eka*, possibly punning on the cruelty *(ika)* of the mothers.

Eka represent an intensification of the canon of properly ending the dance. The point of their execution is exact matching of the phrasing of the senior drum, syllable for syllable, beat for beat, the whole rounded off neatly, at the final syllable of the drum phrase, by lifting the right leg in the air, not unlike the Akan dancer who ends his phrase with a special gesture. The syllables of eka are usually meaningful in themselves, based on proverbial expressions. The following is an example:

When the maize is old and very tough
Monkey will not eat it.[211]

This shows the typical Efe and Gelede preoccupation with devouring and restates the belief that, when we become important, enemies will attempt to devour us. But spiritual power and knowledge come from God, and the mothers will protect us. The whole point of appreciation of the dance in Gelede is to realize that the brief bursts of choreographic expression before the drums are danced expressions of proverbial knowledge and moral observation. The sound of the bangles on the feet of the Gelede dancer transmits lore to the ears of the multitude. The critics listen with trained ears for errors or unusually fine accomplishment.

As visual spectacle, Gelede eka are splendid. Two men dancing in unison, parsing moral expressions in syllabic code, cause the sound of their bangles to mirror exactly the heraldic drumming of the master percussionist while also causing their masks to move within amazing sequences of graceful arcs and flowing curves, if the mask is female; hot hopping, stamping, twirling, and aggressive patterns, if the mask is male. I have seen three dances of Gelede at Ketu, a staged performance in the summer of 1965 and two traditionally generated dances in 1972. In each case the drums were placed near the western boundary of the market and the dancers approached the drums from the east, dancing within the crowd-formed ellipse, roughly following the long axis of the ellipse from one end to the drums.

There is an unwritten code which most dancers follow at this point, according to an old and knowledgeable Gelede performer, Adensayan Adegbami:

When the dancers of Gelede enter the ring, they break out the dance as soon as they reach the drums. The onlookers give them fan, give them pleasure. After about five minutes you know they are going to make *eka*. Eka are special drum phrases, a glory to Gelede, to please our mothers *(i.e., the witches)*. Drums tell the dancer what to do; if he dances with the drummer exactly, he is called *aiyejo*, the finest dancer. An *alaiye mojo* is someone who does not know how to obey the drums. The ankle rattles of iron the dancers wear *must* make the same sound as the drum. If he makes a mistake it will be audible.

The dancer has to end the phrase *exactly* when the senior drum ends it. They must balance *(dogba)*. *A thousand dresses, it does not matter, if you compromise the drum speech you are not a good dancer!*[212]

According to another Ketu source, the mothers say explicitly, "say, for my glory, exactly what the drums say and end it well."[213] Gelede duos are therefore the Efe of the day, bringing morality into the open, with phrasing cool and general, applying to humanity instead of focussed fiercely upon a given individual. The cooling moral aphorisms of the danced eka go consistently with greater emphasis upon beautiful dress and with the fact that the dance takes place in the afternoon when the witches are

quiescent.

The exact mirroring of drum speech with the sound of bangles (iku) on the ankles of two men dancing in unison presupposes, ideally, another virtue, comradeship:

> Raufu Akani was my partner in dancing Gelede. Our hour of birth was almost the same. We were delivered on the same day. Our mothers decided that we would be good friends in life and we were. We danced Gelede together in Meko. [214]

Two friends dancing in perfect unison amplify with the sound of their bangles the moral perceptions of the eka, the syllables of which are instantly understood and translated into speech by connoisseurs. This drum speech, to repeat, must be perfectly phrased and ended: "if they make a mistake it will be audible."[215] The wearing of the bangles therefore imposes an awesome ban of metric perfection upon the dancers.

Outsiders observing Gelede dances vaguely sense division into sequences, public twirling, dancing before the drums, and, sometimes, competitive dancing between pairs, but few are aware that the most important action takes place within a brief span of minutes before the drums, and that the beauty of the mask and dress are secondary to the perfection of eka. Gelede might be concisely defined as the combination of sculptural calm over metric activations of iron bangles. There are deep meanings embedded in the later sounds:

> If you have a child, and the mother of that child dies, you put iron bangles on the ankles of that child. This is done so that the dead mother will not come to that child in dreams. The baby makes a sound with the iron bangles, woyo-woyo-woyo, so that the dead mother will not come down and cause it death or fill its mind with dreams. [216]

Plate 248 Young man demonstrating Gelede steps

The protective quality of bangles in eka is illustrated by this lore. The Gelede dancer, "child" before the "mother" in a marvelous sense, transmits directly to the elders of the night the syllabic messages of his bangle-born percussion. This compares with the child who keeps the dead mother from taking him to the spirit world by means of the sound of his jingling bangles. The bangles both protect and assure communication.

Small wonder, then, that significance attaches to their sounding. If Efe is the eyes of the mother, Gelede is pleasure for their ears, hence the importance of ending each eka correctly, kicking out the right leg on the last syllable of a given phrase. Before each eka begins, the junior drums perform ostinato patterns, to which the duos respond with a "holding pattern," reserving their show of strength and improvisatory genius for the cadences of the eka on master drum.

I once saw a small boy perform a flawless series of five eka in Ketu, each perfectly ended with a charming min-

iature kick, whereupon the local master of Efe and Gelede, Lasisi Ogundipe, rushed into the dancing ring, took the lad, and lifted his small body, bangles and all, into the air, while the crowd reacted approvingly.[217] In pleasing the master, the lad had also proved that he had pleased the mothers and this could only redound to the favor of Ketu itself.

There is a relation between mask and choreography in Gelede. Masks emblazoned with bold and manly themes are accompanied by angular tracks in space and hot stamping, hopping, and twirling patterning. For example, in the male eka known at Ketu as "Baba Shukute," when the senior drum repeats the following syllables—

Baba Shukute
lehin t'ara nje
a fa sere gbe jo
ntara nje, Shukute,
lehin t'ara nje [218]

—the dancer, breaking his motion into segments exactly congruent with the syllables and the phrasing, pausing before and after the second mention of the word, "Shukute," stamps in place with arms spread out from the sides of his body. This action recalls the image of the sleeping witch. He danced the eka one-gesture-to-a-syllable, one-step-to-a-syllable.

One remarkable eka is executed by a duo wearing masks representing the wild wart hog *(Phacocoerus Africanus Afer),* called, in Yoruba, *Imado.* Imado masks are spectacular. I have seen them in a variety of Egbado, Aworri, and Ketu towns. At Ketu in August 1972 a talented Gelede dancer, Jean Adegbite, danced Imado to the syllables of an eka which described this animal rooting about, snout upon the earth, devouring and digging. His motion was a perfect complement to the animality cited in the verse to which he danced. He fell to the earth, used his hands as forward paws, alternately kicking up either leg, then kicking up his legs together, then resting on one palm while spinning in a circle. The speed of these figures was of the essence of praising the mothers with the image of one of the animals in which they sometimes travel.

One of the finest dancers of Imado that I have seen is the young blacksmith, Abiodun Ogunyomi of Ilusa compound, Pobe, at the southern end of Ohori-Ije in Dahomey. This muscular young man demonstrated some of the steps of Imado. He begins the eka standing, with peppery asymmetric thrusts of his elbows (Plate 248). Then, hopping four steps in one direction, four steps in another direction, he suddenly "gets down," continuing the phrasing of the dance, in terms of sequences of four pulsations, with perfect transition. He pawed the earth; he activated his elbows. He sank to his knees and continued to complicate the silhouette of his body with angular dispositions of his arms (Plate 249). These sharp accents matched

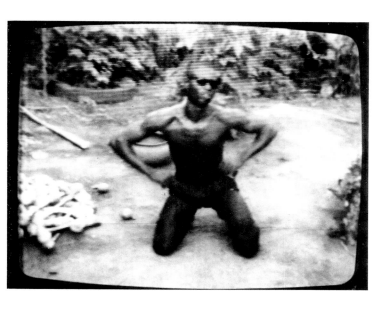

Plate 249 Young man demonstrating Gelede steps

205

Plate 250 Gelede mask

Plate 251 Gelede mask

the horizontal thrust of the Imado mask (Plate 250).

He also demonstrated, without dress, eka for the harte-beest, Gelede *Ira* (Plate 251). For all the animal energy and horizontality of the motion, there was a princely air of nonchalance. This was accentuated by the conceit of the dancer's dark glasses, breaking the norms of visibility in a coolly assertive way. The composure of his face (Plates 248 and 249) and the polish of his phrasing contrasted vividly with the supposed animality of his representation. Of course the calm of his face would not be visible when masked, but the nobility of its effect could be sensed in royal details of decoration added to the animal masks. Thus the hartebeest was surmounted by the image of the leopard, classic motif of the king, as necessary killer, punning on the propensity of the mothers. The jaws of the wart hog were screened by an exquisitely carved device covered with royal interlace patterning *(igbo),* of the type frequently found in the repertory of royal bead-embroidered themes. In the masks of hartebeests, bush pigs, and other animal familiars of Gelede, a missing dimension of horned or horizontal imagery, running like a leitmotif through most of the witch-detection cults of Africa, such as the Do masks of the Ligbe, reemerges. Horizontality and witchcraft are of the essence in comprehending the Basinjom headdress of the Banyang of Cameroon which we shall examine next.

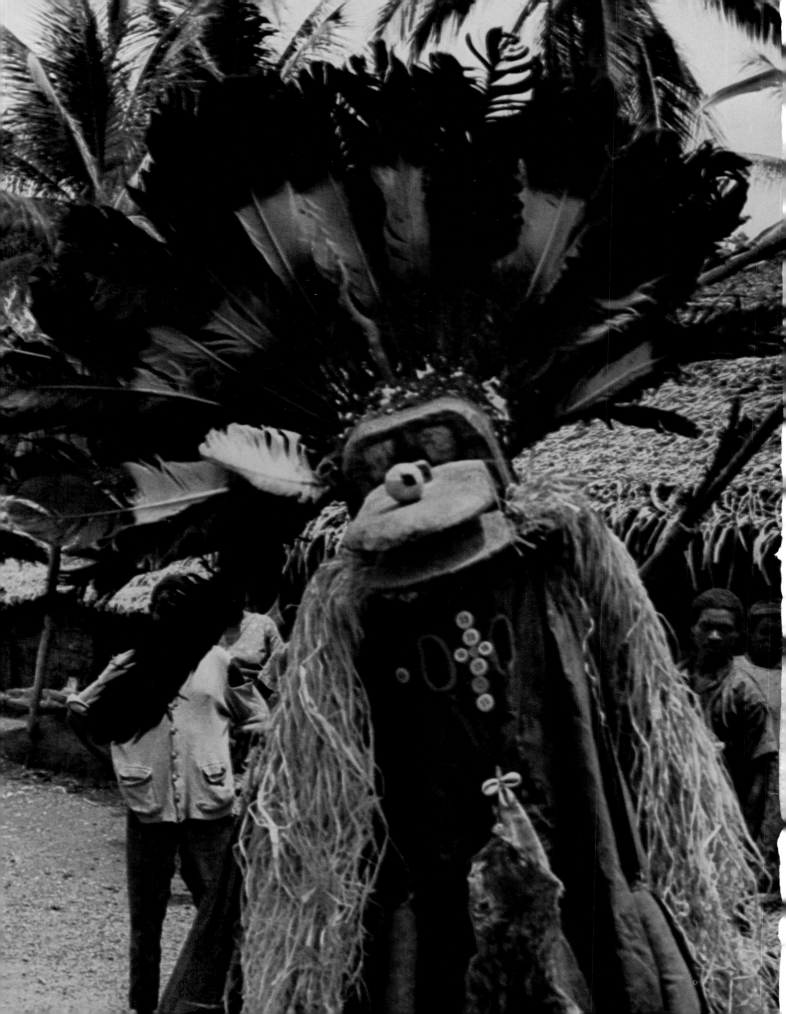

5. THE CHOREOGRAPHING OF BANYANG VILLAGE HARMONY

The Banyang live in the central area of the basin of the Cross River in the western portion of the United Republic of Cameroon. They number over eighteen thousand people. Their territory is called Kenyang. They divide themselves into two portions: Upper Banyang, in the hills leading towards the Grasslands, and Lower Banyang, in the region of Mamfe where the western Banyang meet and mingle with the eastern Ejagham. The language and cultural forms of Lower Banyang have prestige, as a function of their proximity to the fabled ritual expertise of the Ejagham.[219]

Banyang are settled people, devoted to agriculture. Their hilly country is often beautiful, and their forests are rich with a variety of wild animals. As in most of tropical Africa, kinship ties are strongly developed: it is through kin that a man is made into a person, i.e., fully brought into society. The necessity of village solidarity and the importance of kinship have a bearing on elaborate beliefs in witchcraft.

Witchcraft, in Kenyang, is a metaphor for selfish individualism and anti-social irresponsibility. The witch runs counter to the norms of cooperation, sharing, and generosity. From the excellent researches of Malcolm Ruel we learn that Banyang define witchcraft as the possession, by a person of the community, of a double indentity.[220] That is to say, he is human, but he also commands an animal familiar within the forest. The witch has the power to move within the body of an animal counterpart while his real body lies inert in sleep.

The understanding of this power exerts a subtle fascination. Each animal familiar symbolizes a particular kind of human accomplishment; the community rises against a person of such metaphoric power when he or she uses it in defiance of propriety.

There are some animal familiars which are morally neutral; these take their social significance from the particular way they are used, i.e., either for or against the people. Others, such as the male owl, the python, and the bush pig, are characterized as intrinsically dangerous; these three may be said to symbolize acts of persons who aim to destroy humanity. These animals transgress the central virtues. Their devouring habits limn the nature of irresponsibility on a monstrous heroic scale.

Other animal familiars can be used for positive purposes of individual accomplishment. We have seen, many times, how the leopard magically amplifies a man in athletic or martial prowess. Ruel sums up the situation: the problem to people in Kenyang is not the possession of animal familiars per se, which is accepted, but rather the definition of their use for the common good.[221]

A person may use the strength of a leopard or a bush cow or a crocodile, but not to the extent that such power begins to diminish the life or health of others. The security of an extraordinarily gifted man ought not to be built on the insecurity of others. He should, to extend the example, have the initiative associated with the lightning strike, but he cannot become reckless with this power and penalize or destroy the village unity with mindless thrusts of his ambitious power.

In sum, individuality, with all its potential for witchcraft, must be mediated, i.e., become attentive to the response of others and the nature and meaning of this response. The good person works his powers aware of others; he shares his prowess to the best of his ability. He does not work alone. Banyang say, "a community will not burn with people living in it."[222] With witchcraft of the worst sort, the community bursts into disorder because of the heat of a single ambitious mind.

Belief in witchcraft in Banyang territory is light-years removed from a nightmare vision of absolute evil so easily conjured in racist visions of traditional African belief. There are, of course, unspeakably evil people here and there, as in all cultures; but, in the aggregate, the impact of belief in witchcraft strengthens the notion of sharing, strengthens being hospitable, being kind, being cool—lest one be taken for a witch.

There are some people, not unlike corrupt politicians in high places in certain Western civilizations, who believe themselves above the law and who are mindless of God and his commandments. These are the witches who cause the most damage with their powers. They must be combated by gifted persons of second sight. People with special vision can "see the place"[223] where the animal familiars of the worst kind meet to wreak their havoc on the social order.

Recovery from the fevers and other disorders which the witches bring from their secret "place" is only possible after the person owning the wicked animal familiar has

confessed, either as an open statement before the people as witness, in daylight, or by confession plus ritual purification by a cultic society, such as Basinjom.

(a) Basinjom and the Witches

The Basinjom cult is one of the two most important traditional societies of the upper Cross River. The origin of the cult is Ejagham. "Basinjom" in Ejagham literally means "the future brought by God,"[224] an allusion to the divinatory powers of the spirit and the belief that the goodness of his power, to heal and protect the people, stems ultimately from God. The Basinjom cult seems to have emerged in what is now southeastern Nigeria in the Oban region about 1909. It was then called *Akpambe;*[225] there were cognate societies with similar masks in existence in that area at the time.[226] Thereafter it spread, to the northeast, so that by 1930 the cult was present among the Ekwe Ejagham near the present Nigerian border, in Cameroon.

The main purpose of the Basinjom cult is the detection and exposure of witchcraft. The success of the society in kenyang—the first lodge in upper Kenyang in the Mbang clan area was at Defang in 1932[227]—relates to the prohibition of older methods of exposing witchcraft.

The essential power of Basinjom lies within his eyes: "to see pictures of the place of witchcraft—that is the force of the Basinjom image."[228] The importance of mystic vision controls as an operating metaphor, both the initiation and masked dancing within the cult. Thus when a man is initiated, in a ceremony called The-Pouring-Of-The-Medicine-Within-The-Eyes *(bajewobabe),* the initiating priest and an assistant (Plate 252), prepare a mixture of material taken from the African Tulip Tree and palm wine. They place the fluid in the specially prepared, folded, conical leaf which serves as eye-dropper. They allow the mixture to marinate in palm wine[229] (Plate 253). The medicine is dropped in the eyes of the initiate, through the aperture at the point of the cone of the folded leaf container. The medicine stuns the initiate. It is believed to, "wash his eyes magically, so that he can see the place of witchcraft." The medicine also aids him to gain the possession state without which he cannot wear the gown. There are four grades within the society; I am concentrating on the second, that which entitles a man to wear the gown and learn its meaning.[230]

Upon initiation into the second grade, eyedrops are administered to the postulant. He stands on two stones, has the drops put into both eyes by the priest, stares at the light of the sun for a second, and is given his own cutlass and told to wipe the droplets from his eyes with the sharp edge of this instrument. He does this. He then immediately extends his right hand, holding the matchet, and cries, *Kwa! Ko Haiyo!* His fellow initiates answer, *njom!*

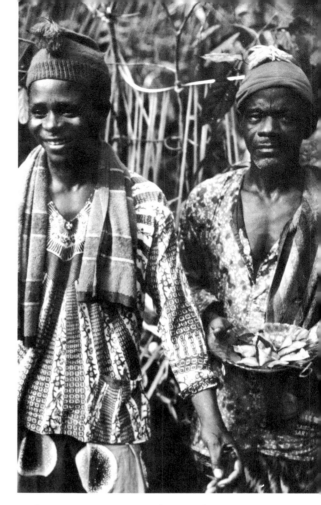

Plate 252 Initiating priest and assistant for Basinjom cult

Plate 253 Medicine for initiation ceremony

Following cash payments, ritual scarification of his ankles, wrists, forehead, and back, "to make the person lighter, so that when he carries the gown if he should meet any charms set within the road their force will be kicked back to their makers," he is given a fascinating array of protective pieces of bark (from several species of trees) which space does not allow me to discuss.

He is taken to the Basinjom grove for further instruction. In the grove he is given the lore of the cult. He is fed several feasts of boiled bush pig, pepper, and rice. He is given further dosages of the African Tulip Tree medicine in his eyes. In an initiation, videotaped in a Basinjom grove in upper Banyang in March 1973, then copied, photographically, from the videotapes, in Los Angeles, we see an initiate receiving eyedrops in the bajewobabe portion of the ceremony (Plate 254), the initial stunned reaction, as the full effect of the stinging drops is felt (Plate 255), the ritual cleansing of the eyes with the sharp edge of a cutlass (Plate 256), and the return to laughter of another initiate, who has successfully mastered these tests (Plate 257). Later the initiate will be shown how to mime in Ejagham action writing the details of this ceremony, including a mime of administering the eyedrops (Plate 258) in which he will play the roles of both initiator and initiate.

The brief staring at the heat of the sun, the hot sting of the drops in the eyes, and the ability, while in a stunned state, to calmly lift a sharp instrument (itself born in the heat of the forge) to the eyes, are orchestrated demonstrations of manful "cool" and discipline. These tests prove the member will know what to do and how to conduct himself when confronted later with the horrific heat of the vision of the place of witchcraft.

Iconographically, the essential moment of the initiation to the second grade follows after another dosage of eye medicine. The senior priest leads the postulant to an opening in the Basinjom grove where he discovers the Basinjom mask and gown displayed next to an image of the *ekponen* owl (Plate 259). The initiate has, according to instruction, picked up a pebble, moistened it with his mouth, and placed it within the vessel supported by the abstract image of the owl. This act combines his spirit with that of his brothers, all of whom have deposited similar pebbles from their mouths within the water in the vessel. The priest begins a lengthy exegesis:

Here is the *ekponen* owl, representing all the medicines of the forest, the whole study of them. It is a bird which will see demons for you. In the night, when you sleep, you will hear it, *kwa! kwa!*, the sound of that owl late at night.

As that pot stands, so you will stand, in truth, with your brothers. If you lie to a member, the owl will paralyze your hand and leg and you will never walk again.

211

Plate 254 Basinjom initiate receiving "eyedrops"

Plate 255 Basinjom initiate responding to effects of "eyedrops"

Plate 256 Basinjom initiate ritually cleansing his eyes

Plate 257 Completion of "eyedrop" sequence

Plate 258 "Eyedrop" administration mime

The egg [inserted in the staff which supports the vessel] is a watchman, guarding the bird, protecting the *ekponen* owl.

The chains [of braided vegetal matter] are the legs of the bird. These legs move in the night and the bird looks around.

The water in the vessel is a power. If a person comes to this place to work evil against us, the whole area becomes as a sea.

The raffia fronds are a sign of danger, that you should know this is a forbidden thing of the forest.

As that pot stands, all the medicines of Basinjom stand. This bird is the source of your vision and your power. All the medicines that compose the Basinjom are put within that vessel. The medicine we have placed in your eyes purifies your sight so you can *see*. As you go deep into our society you will learn to enter the body of that bird to spy on the place of witchcraft, to see 'the place.' [231]

The words of the initiator reveal Basinjom and the owl as an essential Janus, a polarity in act and vision which cannot be guessed at in the context of the dance in public. The priest turns to the Basinjom gown. The explanation of its elements is given:

You see the knife, resting on the gown. This is the knife called *isome.* It is for strong members [initiates to the second grade]. With this knife one sees many things. You see the place of the witches. You see fully what is happening there. The other instrument [made of wicker] you place with your left hand to your ear, to hear, the *sound* that evil makes.

The blue feathers [of the touraco] mean: 'war bird.' You know this spirit goes to war against the witches. These are feathers of a very strong bird. One that cannot be easily shot by a gun. It moves around with the brothers in Basinjom. It is a very strong kind of bird.

The three red feathers stand for the same danger that the blue feathers stand for—anything that comes from a bad, hot thing is symbolized by these feathers which are red.

The porcupine quills [inserted among the feathers] stand for prevention against the whole of the work of thunder and lightning; they are very strong medicine.

The roots [inserted within the feathered headdress] symbolize members entitled to wear this gown. You will be given a root. If there are five members who can wear this gown in our lodge, there will be five roots standing on the head. If you are going to dance in the gown, I will remove the root, chew on alligator pepper, take the root, and blow on it, repeating your name, and crying *apa toi! apa toi! toi!* mention your

name and finish with the word *aba!* This will awaken the spirit and make you become possessed by Basinjom.

The eyes of Basinjom are mirrors. Mirrors are a sign of seeing into other worlds, to the place of witchcraft. The mirror eyes move in the night to see and predict. The mirrors are also examples of the work of the medicine we have put in your eyes. It stands for the work of the medicine, that you can now see anything.

The long snout is the mouth of the crocodile. It is for controversial things, to speak far for the people. We break eggs in their shells over this snout to feed Basinjom [the snout has a deeper meaning which is not revealed until the fourth stage, *i.e.*, that a person in the last grade becomes as a member or brother to crocodiles in the river who become intimate with him and love him. The bones and shells found inside the Dwarf Forest Crocodile *[Osteolamus tetraspis]* are sewn to the outside of the gown of the wearer, as a sign of embodied and controlled evil]. [232] The shells 'come from a bad thing, fighting bad things, using parts of the body of bad animals.'

In the mouth of Basinjom is a piece of the King Stick, the most powerful tree in the forest. No witch can fly over the tree from which the King Stick comes. We use it for our bodies, to protect against the witch-sent illness and against lightning barrages.

The back of the head of the crocodile is made of many herbs, collected and pounded together and mixed with liquid medicines and applied to the back of the head to protect the mask from thunder and poisoned magic. At the back of the head is a small mirror, meaning Basinjom 'sees behind' and a small upright peg, 'something like a small bodyguard, with an amulet attached to his tiny neck, both protecting Basinjom against thunder or any danger coming from the rear.'

The gown is dark, deep black; someone who will do evil will wear a dark gown. It is, as we say, something which will 'not hold death.' That is, when you are in darkness, no one can see you, no witch can perceive you.

The raffia hair and hem are taken from the forest and they mean: danger, something men who are not strong should avoid.

The skin of the genet cat is a demon who catches fowls from our farms. We use it to invoke the spirit of that animal-familiar so as to have protection against them. [233]

The preceding exegesis—actually a composite from explanations given by initiators from Kendem, Mamfe, and Defang—does not, for all its detail, exhaust the iconic

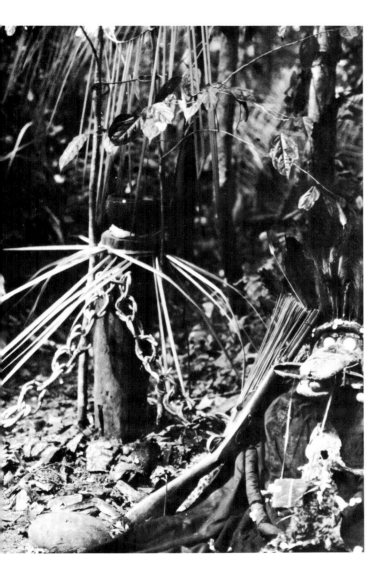

Plate 259 Basinjom mask and gown displayed next to an image of the "Ekponen" owl

complexity of the Basinjom image. Like a witch moving with familiar animals, Basinjom mixes in a marvelous way parts of one dangerous animal with another and garnishes the combination with further additions of natural power from the animal and mineral realm. He is owl, crocodile, war bird, tree, lightning, darkness, and cat—all at once, all at the same time.

Standing beside him in his forest grove is the image of his other pair of eyes, the eyes of the owl. They form, I repeat, the essential Janus, reminiscent of the whole world of Janus allusions which so strongly colors the visual tradition of the Ejagham people who first imagined this extraordinary weapon. The ekponen owl kills with water; Basinjom kills within water as a crocodile. The feathered owl of magic vision is transformed into the blue-feathered bird of war. The owl is guarded by an egg; Basinjom is guarded by the tiny image set within his occiput. Both take the dress of danger, raffia fronds. Both are conceived in terms of magic ambulation, the owl of the forest walking on strange, long legs, Basinjom, as we shall very shortly see, moving about, like a mystic hovercraft.

The explanation of the meaning of these forms within the grove is a necessarily didactic moment, in which the initiate is given a body of traditional notations, about the powers of the owl and the powers of the Basinjom image, from which he takes his justification. But in the dance, the owl and image run together in a single form. All the elements of necessary danger fuse, with a self-sufficiency and fullness reminiscent of the force of music. Basinjom, in the dance, speaks of the conquest of all evil, with an ascending tone, a pure poetic act which fuses his gown and motion in single symphonic structure. We turn now to viewing that structure in the dance.

(b) The Dance of Basinjom

In spring, 1973, members of the Mbang clan (the villages of Defang, Fotabe, and Ntenmbang in upper Kenyang) were distressed by the sudden emergence of dry rot in their crops. Supernatural action was suspected. A trial of two women suspected of witchcraft was called in the name of Basinjom. The trial coincided with the initiation of three men into the mask-carrying grade, but the latter played no vital role. Events demanded a seasoned dancer. [234]

At noon the gown and mask were displayed in front of the house of the chief of Defang. This was a sign: imminent divination by Basinjom of suspected witchcraft.

A priest suddenly walked before the ranking mask-carrier and blew, from his mouth, a mist of African Tulip Tree resin mixed with palm wine. This mist struck the eyes of the mask-carrier. Instantly the spirit of Basinjom possessed him. His body stiffened. He stood in place. His arms hung heavy at the sides of his body. He stared blindly into space. In a high, piercing register he called

213

out, from time to time, a single syllable, *Wo!* Eerie, truncated, this note contrasted in its plaintive aliveness with the rigor of his body, as if a note of music intermittently was heard in wood. *Wo!* A person said, "he is now within a different spirit."

Initiates removed his clothing. They left him standing in a pair of shorts. The priest placed a red wool cap upon his head, sign of his right to carry the Basinjom mask and gown. Basinjom's orchestra began to play. The music was pure percussion: a double-rattle *(nchak),* two small wedge-tuned drums *(bekpiri),* a long cylindrical drum *(no nko),* and a superb slit-gong *(enok),* long enough to accommodate three players. These men were seated hierarchically, in social perspective, with junior musicians flanking the master performer. Each struck the slit-gong with two sticks. The junior players performed, in unison, a rapid-fire ostinato pattern: *ku, dun-dun dun-dun, ku, dun-dun dun-dun.* This was a variant of a standard gong or clap pattern in tropical African music. [235] The rattle-player doubled this. The master gong player made intellectually challenging statements, virtuosic commentary which departed from, delayed, caught up with, leapt over, or passed beyond the foundation pattern struck to his left and right.

As a unit, percussion flowed smoothly and continuously, reminiscent of forms of Yoruba music described by Robert Plant Armstrong:

the sounds are as dense as matter, and to the unaided ear the individual atoms of sound are too fine to discern . . . the musical time, so densely filled with rapid, interlocking beats . . . is less an analysis of time—though analysis it is—than the presentation of time itself. [236]

"When they strike that instrument in that hard way," an informant said of the slit-gong, "they are moving you to the gown." The initiate, in fact, now stands before the costume. He takes the raffia hem in his hands. He faces the mask. He vigorously shakes the garment side to side three times, and leaps inside. This action "balances the gown," for, "if you don't do this the mask will strike you down." Shaking the gown before entering charges the total image with stability. To fall, while within, would bring, without immediate costly sacrifice, almost certain death to the dancer.

Inside the gown, the wearer finds himself in a hot, dense, blueish world, lit by penetration of light through the indigo-dyed garment. He struggles to reverse his body. He tries to find the eye-holes, under the mask. Two mask-carriers leap into the gown, to help. They guide his face to the eye-holes, his arms to the sleeves, and after making final adjustments in the siting of the mask upon his head, exit from the back. The carrier, now properly gowned, is handed his special knife of vision, the iron instrument with a carved wooden handle. The blade is perforated

with a special pair of mystic eyes: "it is power for seeing." He takes the knife in his right hand. Then the wicker-made instrument, not unlike a telephone receiver in gross structural outline, is placed in his left hand: "power for hearing."

He is now fully armed. He has a knife to spy the place of witchcraft and a hearing instrument with which to listen to the other world. Basinjom utters, in a parched voice, the ritual greeting of the mask-carriers: *Kwa! Ko Haiyo!* He shakes his head, listening for witches. He stands at attention and calls: *Atunjom monshe!* This summons a man with bag and cutlass. The latter replies: *Tai! Tai!* Basinjom calls again: *A! Aburinjom ego!* Two riflemen step forward. Basinjom calls a third time: *Esayenjom!* This produces his spear-carrier. He cries, *Hoi!* with satisfaction. Then he calls for his horn-player: *Ebangjom!* The latter brings a "cooling horn" *(ebang),* a bamboo tube covered with raffia, to be used whenever Basinjom talks too much, "to cool his voice." [237a]

The army of Basinjom is complete: cutlass-bearer, riflemen, spear-carrier, blower of the horn of silence. Basinjom prays over the clan: may the towns remain cool, may there be no sudden deaths, may small children grow up in harmony and peace. The spear-carrier duly translates this into standard Kenyang.

All this time percussion continues, stoking the fires of enthusiasm. Expression of the possibility of purification and reconciliation has attracted an ever-growing crowd, as well as the spectacular drumming and the "flash" of the costume and the mask. The entire clan is waiting for Basinjom to impose aesthetic authority and truth upon a ruined landscape. The chant begins:

Bwanjoronjo, nkundack!
Bwanjoronjo, nkundack!

Bird! You should hear!
Bird! You should hear! [237b]

They are calling on Basinjom to enter the body of the owl, the bird that gives him messages, to find, as from the sky, the place of witchcraft, the source of social heat. Basinjom obeys. He pulls up his gown. He makes a neat, straight line with cloth between his hands, like a wing-span of indigo, bristling with finials of upraised magic vision held in either hand (Plate 260). Taking the gown in this manner is a secret signal to his followers: move! He glides forward, they follow instantly.

The dance begins. The feet of the dancer in the mask are completely hidden. The dancer moves very rapidly, taking short steps. The swooping, gliding character of the motion of the mask stems from unseen means of locomotion. Basinjom circles through dust he himself has raised by force and speed of wheeling. He moves in fleeting circles with a speed so fluent the weight and density of his mask and gown seem to dissolve in gyring patterns.

He wheels and wheels, taking on qualities of bird-like grace and suspended balance.

Basinjom lets fall his gown, and the motion stops (Plate 261). Then he begins to wheel again, lifting his gown, activating his magic warriors. At the sight of the two rifles, one chief said, "See those followers. You see guns. You know: there is danger here!" The men keep their rifles pointed at the sky, where the witches keep destructive magic in the form of lightning. Basinjom shakes his head, contratempo to the rhythm of his flow. This is a sign of listening to unseen disturbances: "he is moving and listening." Basinjom now fulfills the meaning of the song, "bird, you should hear."

He loomed over the two women accused of witchcraft. The darkness of his gown, the thrust of his crocodilian jaw, and the striking silhouette of his chest-plate made of the skin of a genet cat, all acquired momentum from his motion. These signs seem to pass beyond his motion, confronting evil with autonomous, detached force.

He put down the gown. The followers stopped. He knelt, bending slowly down. The followers knelt simultaneously, in perfect unison with their lord, lowering their weapons. A person explained, "he is bending down to read, to read with his knife; he wants to see things, the *bad things.*" He turned his back upon the two women, lifted his gown, croaked, flew through the village common once again and came back quickly, his followers running fast, one bending down to adjust a wrinkle in Basinjom's gown.

There followed more gliding and listening, more circling and seeing, more wheeling and scrutiny, with a counterpoint of head-shaking miming supernatural listening (Plate 262) (Color Plate X). This created gradually but, finally, overpoweringly, an image of complex detection of all evil steps, from the vantage point of a circling owl, moving over the surface of the earth.

Basinjom lifted his knife of vision above the level of his head. This silenced percussion. He began to speak, facing the two women and the crowd behind them. He related intimate things, divinatory insights, thoughts, dreams. He specified certain selfish acts, breaches of cooperative contract, lapses of generosity, unkind words, and then he said: ". . . and with this evil familiar did you go out, when the planting was under way, and sow your filth into the earth. You planted it. You! and You! You are the ones responsible. All our crops have been affected. You went to your 'place' and all our plants have been attracted there ruined by your power."

He called their names. He asked, "have you done this?" They answered, "Yes." He asked again, "were you at a certain place?" Again they answered, "Yes." They apologized and said that they did not know that their powers had been so destructive. They begged forgiveness. They offered material amends and these were accepted. They were purified by Basinjom, who said, "from today I do

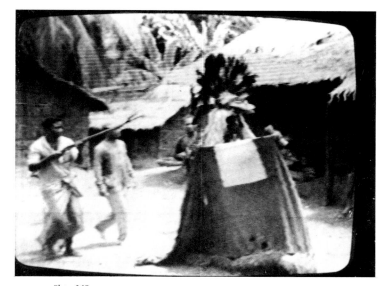

Plate 260
Basinjom raises his gown, commanding his anti-witchcraft warriors to move

215

not want to see any further trouble from your house." A goat was sacrificed. The women swore not to do such evil a second time. They were purified by Basinjom and forgiven. The case was closed.

In other cases, it was necessary for the riflemen of Basinjom to fire into trees, where witches gathered, into latrines, where they also gather in the filth, and into the sky at the point where they gather death in lightning.

In reviewing the evidence, it is difficult to say whether hard feelings had anticipated the accusation or, in fact, had been created by it. It was certain, however, Basinjom had spectacularly satisfied the village. He had humiliated a source of evil, specifying, under the metaphor of the "place of witchcraft," sources of anxiety and discontent. Informants recalled the time when Defang was bombarded by an incredible seven days of unremitting volleys of lightning that had terrified women and children, and Basinjom's men had protected Defang with the King Stick.[238]

The accused women were conscious actresses in a public drama meant to inculcate deep decorum, meant to warn the world of the dangers of polluting social landscapes by dark and hidden thoughts. The ritual humiliation was, in a sense, more performance than trauma, an artistically phrased combat between real or imaginary sources of evil (the witches) and metaphoric opposition to this action (Basinjom). The trial was an artistically perceived act, a generic mimesis of complicated phenomena, according to the canons of the cool: it was a model of confronted evil, with basis in fact and basis in myth, not so real as to leave the women socially destroyed, and not so abstract as to have no binding force.

The women were rewarded with reconciliation. All had participated in a moral drama that was meant to show the consequences of resentment and bad thinking.

The point of this impassioned happening was precisely its embodiment within the assuaging genius of art and motion. There was drumming. There was dance. There was sculpture. There was dress. Art and motion were sectioned by metaphors of the means of rediscovered order within destruction. The way the mask and costume said "clairvoyance" with mirror eyes, "circling owl" with movement and with song, "midnight evil" with dark-hued gown, "crocodile familiar" with length of jaw, "forest dancers" with hem and hair of raffia, and "thunder" with inserted quills, gave sight and time, things wild and things dangerous, their precisely comprehended weight and density, as if, having surmounted media of earth and sky, a talent for metaphor, running forward in the dance, achieved absorption of all other powers under God.

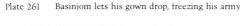

Plate 261 Basinjom lets his gown drop, freezing his army

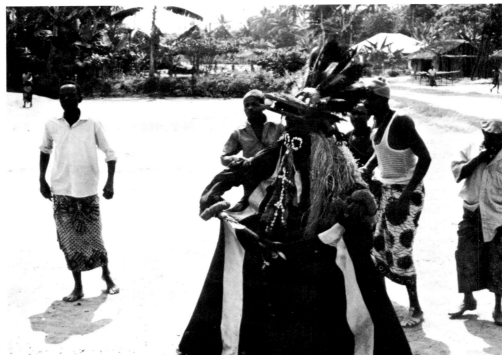

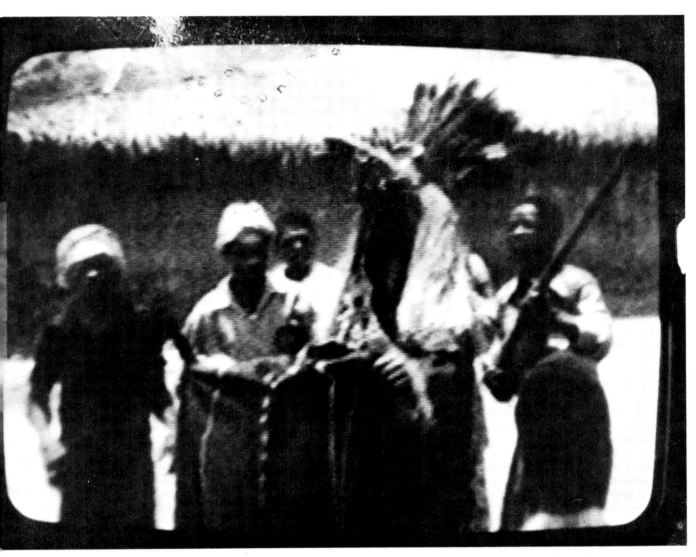

Plate 262 Basinjom sighting witches in the sky

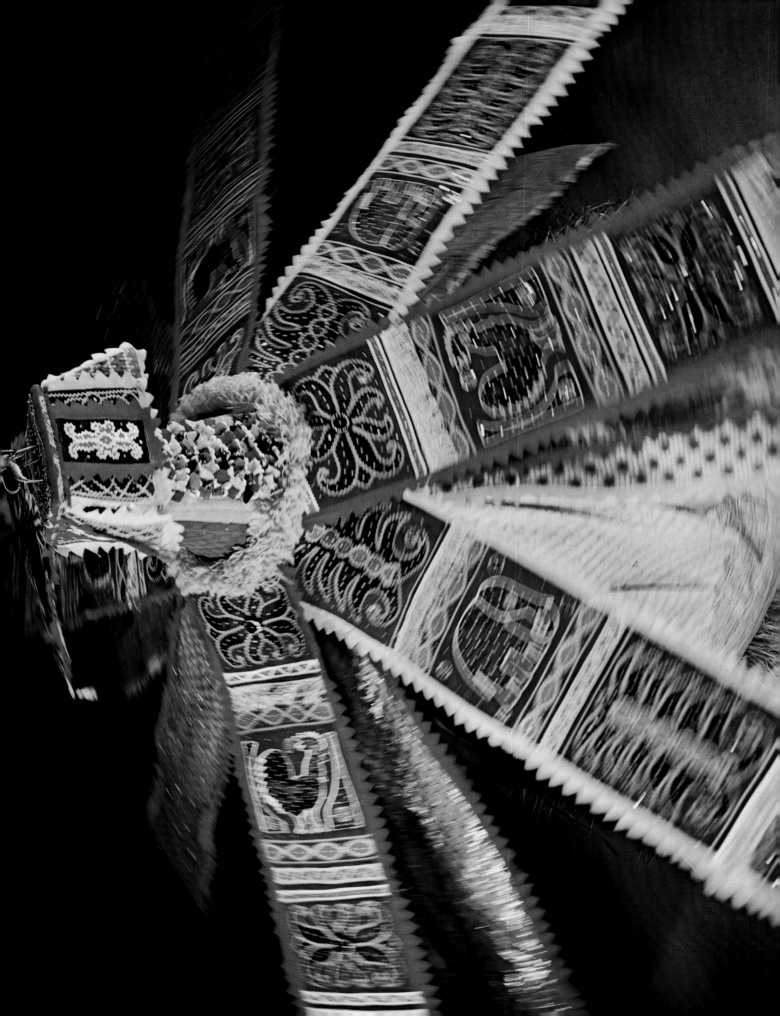

6. THE WHIRLING RETURN
OF THE ETERNAL KINGS OF YORUBALAND

Magnificent spirits represent the departed kings, founders, and leaders of Yorubaland. These spirits, covered with voluminous and highly valued cloths, are called Egungun (Plates 263 and 264). They incarnate the spirit of the dead. Some come to judge the world. Some are purely entertainers. Others extend the authority of the elders to infinity. They represent a wisdom beyond all human understanding. Their shapes are otherworldly and very strange. They are creatures of two worlds.

An introduction to the richness of the tradition appropriately begins with the words of village connoisseurs:

> The senior bata drum sounds the phrase, *titiketike*, which the junior drum repeats, and suddenly the Egungun image is whirling with all his might, the cloths about his body blowing like the wind.
>
> The other Egungun uses all his power in performance. As soon as the drums start, he begins to dance, all his cloths swirling like a violent breeze.[239]

This cuts through detail to essential elements: cloth, wind, and power. Myth gives a rationale for the importance of the cloths. The cult of the goddess of the whirlwind, Oya, explains the emblematic usage of air in violent motion. Other sources gloss other functions. Let us consider the evidence.

(a) Eku and Igbala: Cloths of Salvation, Cloths of Resurrection

The origin of Egungun textiles is explained in myths. Here is one:

> Once there was an epidemic. We are not certain what it was, we only know what the god of divination says it was—a dread illness that killed thousands, leaving deadly little spots broken out on people's bodies [smallpox?]. Diviners told us to carry three red cloths, called [as a unit] *eku*, to a certain spot and sacrifice there, to save the city. At this place the carriers of the cloth met the spirits of disease. The latter fled at the sight of the three red cloths.[240]

And another:

> There was once an important man who had become ill, before the celebrated journey of the men with the crimson cloths to the place of sacrifice. He was dead when they returned. But when they placed these triple crimson cloths upon his body, he lifted up his head. He had come back from the dead. He took the name *Onigbori*, He-Lifts-Up-His-Head.[241]

And still a third:

> The original three cloths of Egungun were of the color red. They terrorized the witches. They terrorized the forces of pestilence. Afterwards, whenever important elders died, these powerful cloths were added to their corpse and the body rose up as Egungun.[242]

Even the powerful thundergod, mythic fourth king of the imperial city of Oyo-Ile, was saved:

> The thundergod, Shango, fell gravely ill. It was an epidemic. His followers used a part of the Egungun dress, the panels with sawtooth border known as *igbala*. The word, *igbala*, means: 'something that saves a person.' It was a sign of Egungun to add to Shango's clothing. At the sight of this sign, the spirits of disease fled in terror. That is why today we find serrated crimson cloth attached to the bottom of the wallet *(laba shango)* of the thundergod and to the hem of his dancing skirt. These sawtooth borders *(igbala)* are brilliant red because that is the Nupe color, and Oya, the wife of Shango, is a daughter of Nupe. She brought to her husband the love of the color red.[243]

These verbal fragments help enrich our understanding of Egungun. Meaning and magic are conveyed by cloth alone. Red cloth is apotropaic. Panels with sawtooth borders suggest salvation. The cloths have the power *in themselves*, when the different panels are combined, to resurrect the dead, to build back morale in time of pestilence. An art historian, faced with the formalized insistence of sawtooth borders in the art of Egungun textile design might suspect iconic content. Myth suggests how to interpret them. Sculpture, where added to the composition, is not the central object of emphasis unless explicitly so interpreted by a village. The cloths make and bring back the spirit. The cloths attack witchcraft and disease. Egungun, therefore, forms a history of iconic cloth.

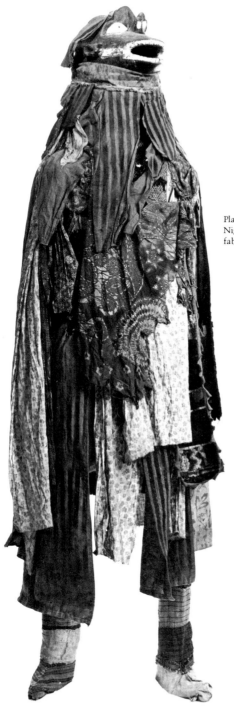

Plate 263
Nigeria, Yoruba, "Egungun" costume,
fabric, etc., 68"

Plate 264
Nigeria, Yoruba, "Egungun" costume,
fabric, etc., 76"

220

(b) Egungun as Divine Wind

Red is the color of the goddess Oya. She comes from Nupe where red remains the color of triumphant wealth. She is the patroness of all Egungun because Egungun was the ninth son she bore:

[Oya] was the wife of Ogun and could not have children. She consulted a [diviner] who revealed that she could have sons with a man who possessed her violently... Shango took her. Oya had nine sons by him. The first eight were born dumb. Again ... Oya consulted the [diviner] who told her to make sacrifices. The result was the birth of Egungun or Egun, who was not dumb, but could only speak with a voice which was not human. [244]

I have seen the head Egungun of the city of Oyo, in nuclear Oyo Yoruba territory, dancing in the name of Oya. This is the dread spirit, I-Devour-In-The-Forest *(Jenju)*. [245] Devour-In-The-Forest is a killer of witches. He appeared within a towering funnel of brilliant crimson, capped at the summit with a swelling dome of indigo-dyed substance. He postured and whirled. A priest made exactly mirroring gestures. The living and dead danced together. Their movements were unpredictable. They stopped, twirled, burst into motion, and stopped. Suddenly the body of the spirit elongated in height and soared twelve feet into the air, rising like a crimson cyclone. Then it shrank to a mere four feet. Then it soared again.

In the land of Oya there is a cognate Nupe tradition called *ndako gboya*. These spirits mirror rather exactly identifying characteristics of Egungun I-Devour-In-The-Forest: witch-killing, dramatic shifts in height in the course of a performance, parallel dancing by an attendant. In Nupe eyes ndako gboya are a most powerful weapon. The story of their origin is illuminating:

A 'certain king of Nupe' was troubled by his mother who constantly meddled in his affairs At last he consulted a diviner and asked for his help. The diviner instructed the king to procure ten lengths of cloth. The diviner then sewed the pieces together in the form of a tall, hollow tube, and used a 'secret' on it. The cloth rose up, flew through the air, and dropped upon the king's mother, covering her. It carried her up into the sky, and she was never seen again. [246]

Abstraction of a person in circling, swirling cloth conjures the image of the whirlwind, an image often remarked by commentators in Yoruba villages when talking about Egungun dancing. This is precisely the image of the mother of the cult:

Oya, whose husband is red
Wind of death
The strong gale that razes the tree at the gate
 of the in-laws

Rumor hurling thunder from above
Oya, the whirlwind that sucks up leaves
And makes them dance in pairs. [247]

The spinning about of contrasted cloths around an unseen inner core is comparable to the pairing of the leaves in the rise of the whirlwind. As we shall see, when the drums incite and inspire the performer, he transcends all sense of human limitation precisely when he begins his whirl.

(c) Egungun in Motion

There have been a number of excellent studies of the social function of Egungun. For instance, senior Egungun come as ancestors to hear disputes, enforce tradition, and uphold moral standards. To defy their will or decision was formerly punishable by death. Even today an elder may kneel before one of these visitors from another world (Plate 265). I shall concentrate on how such images operate as art in motion, giving first an abbreviated account of the annual Egungun festival at Ilaro, capital of the Egbado Yoruba, in order to build some sense of total context for the masks. Then I will identify, again very briefly, the different main mask types and their functions. Finally, I will consider Egungun in motion in two remote forest villages, virtual Yoruba enclaves, in southern Dahomey.

The following summarizes the main points of the Ilaro festival:

The senior figure, called *Agan*, comes in the night to herald the coming of Egungun. The belief is that anyone who dares to look at *Agan* will be turned to stone. When *Agan* calls, the followers will answer, blocks and blocks away.

Next comes *Baba Parikoko*, a day or so later. This type has a long flowing robe, trailing fifty yards behind the dancer. After the elder Egungun, *Agan* and *Baba Parikoko*, have appeared, junior and less important figures follow.

These are: miracle-workers *(onidan)*, displayers-of-cloth *(alabala)*, and tumblers *(olokiti)*. *Onidan* can conjure up a big stream of water on dry land and call other Egungun to fish in it. They are so wonderful. *Alabala* have hands concealed in folds of cloth within the costume and they can hold whips in their hands and run and chase after people. They are the somersaulters, the ones who tumble and look smart. The central entertainers are the *onidan* but the elder egungun are above them all. [248]

The order of presentation neatly inverts the normal proprieties of Yoruba social discourse. The last word is usually reserved for the king. Here, as in the Efe and Gelede sequence we saw in a preceding section, the most important matters happen first. The voice that must be

Plate 265 Elder kneeling before Egungun dancer

answered blocks and blocks away is balanced by the train of cloth that trails yards and yards behind. These mannerisms, of distortion and exaggeration, are of the essence of the Egungun cult. A sense of distortion, suggesting origin from another world, runs through all the categories: (1) *elder egungun*, most powerful and most feared, wear an amorphous mass of clay upon the head, into which skulls, horns, medicines, and charms are embedded; such images (Plate 266) are often witch-executioners, "presumably because they were too dangerous to be apprehended"; (2) *children of egungun*, the most numerous category, conceal and distort their bodies within a lavish carapace of sawtooth-bordered panels of gleaming cloth or leather applique (Plate 267); (3) *egungun alago* appear in long trailing gowns likened to bags, said to represent shrouds. A cultist appears in this garment at the annual festival, moving in amazing mimesis of a particular deceased person's habit-of-walking; (4) *trickster egungun*,[249] deliberately astonish people with their rapid-fire transformations, from human into snake (Plate 268) for instance, or from beast to man, man to woman, woman to baboon, in a frenetic and hilarious demonstration of the African taste for role-switching; they also lampoon foreigners and contrive spectacularly sudden disappearances; they form an irreverent foil to the beauty or the seriousness of the senior masks.

In sum, then, Egungun visual tradition encompasses a rich variety, from costumes which clearly outline the body of the wearer (Plate 269) to abstract textile compositions which strike the eye as autonomous sculptures. The latter sometimes resemble moving columns of sparkling color in the sun (Plate 270). We begin with simple robes, mittens, and leggings and we progress upwards to a near-papal glory of swirling applique.

The *children of the egungun* masks of the coast of Dahomey are among the more beautiful of the entire tradition. In this complex corridor of cultural cross-influence the great applique arts of the Fon have enriched an already complicated Yoruba form. The following are excerpts from two separate village ceremonies witnessed in August 1972.

The first village, near Ouidah, was visited quite by accident. The author had turned into a side-path and ran full tilt into an Egungun festival, well underway. The entire village was seated at one end of a cleared market plaza. Before them sat four drummers, three playing pegged barrel drums, different from the double-membraned bata drums often played for Egungun in nuclear Oyo country, and a fourth playing a pair of smaller drums between his legs. The latter drums were of high and penetrating pitch. The empty plaza, normally crowded and noisy, was an eerie index to the importance of the visitation.

A pair of masked departed kings appeared, talking in the disguised guttural voice that Egungun use for commu-

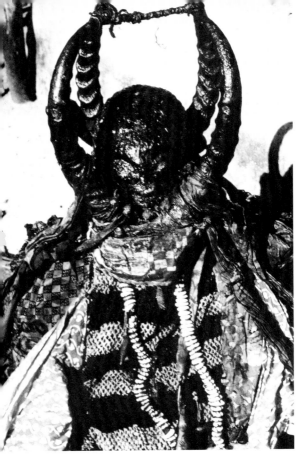

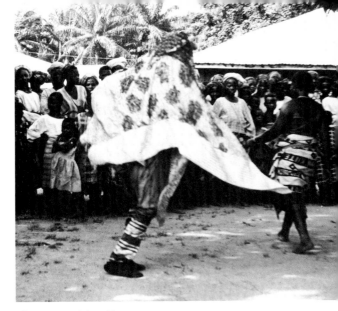

Plate 269 Trickster Egungun

ate 266 Elder Egungun

Plate 267 Child of Egungun

Plate 268 Trickster Egungun

Plate 270 Child of Egungun

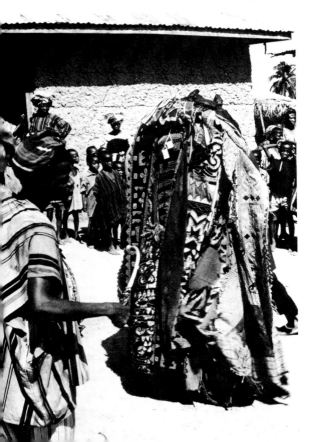

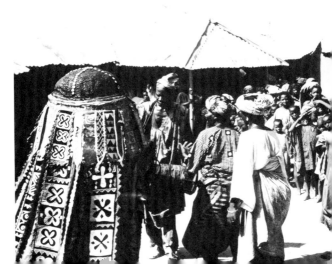

223

Plate 271 Egungun dancer

Plate 272 The children of Egungun

nication with the living. They danced in elegant slippers, with reserved dignity appropriate to kings, and sat down together with absolutely twinned unity.

Out of nowhere streaked another "children of egungun" mask, robes trailing like substance streaming from a comet (Plate 271). He raced from one end of the plaza to the other, accompanied by an athletic acolyte bearing the sacred *ishan* staff, "a staff which has been ritually prepared and is the only means by which an Egun can be controlled and kept at a distance."[250]

Triggered by a riffing pattern, at high register, on the master drum—*titiketike, titiketike, titiketike, titiketike, ti-KEN-ken, ti-KEN-ken*—the spirit raced across the square, directly aimed at a person. He stopped his motion, as the acolyte thrust his staff between them, within a fraction of a second of mowing the person down. He stopped precisely on the strong accent of the drummer's phrase, KEN, and reared back on the following KEN, and reared back again. An African commented, "he runs like a bird and then he stops suddenly, like an automobile, in order to avoid creating a serious disturbance."[251] The braking was aptly compared to the hair-trigger control of one aspect of modern technology. This spirit, called Crowned Ancestor (Egungun Alade), surged into another line of people, stopping barely before their bodies, rearing back, at the slap of the drum, causing the cloths about his frame to explode in every direction, like a puff of smoke about a pistol.

Then, in a virtuoso display of balance and control, he spun across the plaza many times, came out of his last spiral, and sat abruptly down.

The second festival was in a larger southern Dahomean village, rather prosperous, with urbanized members contributing segments of their salaries to the local cult of ancestors. The tradition is lavishly maintained (Plate 272). These presiding spirits stare through special gleaming veils of cowrie shells. The most impressive was Crowned-Fish-Within-The-Deep (Ejalonibu Alade), draped in visual praise names, recollecting his links to the goddess of coolness and creativity, Odua (symbolized by the motif upon his fan), or a sense of secret power derived from royalty beneath the sea (communicated by the theme of the crocodile on three front panels). An informant added, "it is the crocodile who rules the deep." These images wear projecting canopies, imparting a marvelously distinctive hooded quality.

Standing at a place of honor, immediately right of Crowned-Fish-Within-The-Deep, was Brilliant-As-The-Sun-Upon-The-World (Apiri-Bi-O-D'Aiye). This Egungun was singled out by bold and brilliant use of leopard, cock, and tree motifs. A miniature image of a leopard in brass crowned the summit of its canopy. The White Collection includes a modern copy (Plate 136 and Color Plate 4), made in the city of Cotonou in the fall of 1972. The son of the maker, Alade, has glossed the meaning.

Brilliant-As-The-Sun-Upon-The-World was a rich and powerful magician-king who lived "several generations ago" among the Yoruba of southern Dahomey. He was, in his time, a chief of noble parentage, with many wives and children. He was extremely rich. He spent his money on his children. When he died his children returned the affection by the creation of this ornate costume. Alade gives the meaning of the more important iconic units:

Apiri, when he lived, was incredibly well-built and strong. When he died one sees his force alive in the shining form of the leopard at the top.

The sign of the elephant [beautifully rendered in sequined green on a purple velvet background] honors the chief's physical prowess and compares him to the lordly fame of the elephant in the forest. The sign shown above the elephant is the sign of motion or good fortune [a whorl or sunburst pattern].

The panel showing the elephant standing by a tree refers to the tree we praise as Superb Leaf (iwe dada) and which is more ordinarily known as Iroko. It is the Iroko, standing straight with fullest power, that honors the elephant and the chief. We have a saying: that where the mighty Iroko stands, there you also find the elephant, breathing with confidence.

The brilliant panel [in checked gold lame] has been added as a special kind of praise, saying that the spirit when he lived was as valuable as a piece of gold, that he was very, very rich.

Apiri was a warrior, always arising three hours before the dawn, always more alert than any enemy, always compared to the early-rising cock. The image of the cock also recalls his battle cry, like the powerful cry of the cock at dawn. When he called his warriors together everyone was afraid, saying, 'it is a man calling there.'

The [pinwheel-like] designs below the leopard on the canopy and at the top of many panels represent the good fortune of the leader; they represent a positive force, provoking him to do good things, inciting the elephant, inciting the rooster, giving motion to his greatness. [252]

Apiri was as muscular as a leopard, famous as an elephant, stalwart as a tree, brilliant as gold, and possessed of manly voice. These qualities all acquire, under the sign of motion, redoubled vitality and fullness. The motif of the whirlwind predicts their being set in motion. They, in return, add resonance to the whirling cone that purifies the ground. The mask stands revealed, not as an image of a man as he lived on earth, but as the redistilled shaping of his finest powers.

When Apiri danced, he whirled alone within the middle of the village common (Plate 273). Two small calabash-vials (ado), filled with magic medicines, attached to his head by chains of brass, suddenly went into orbit. They whirled about his body. They represented a deadly extended radius of his power to kill the wicked and the corrupt. If a person were so impertinent as to intersect with their orbit, therefore being hit, it is believed that person might fall ill and die. "These are powers; no one can ignore them."

Apiri's acceptance of many motion roles—running, stopping, spinning, rearing-back, lunging, starting, trembling in place—matched, for diversity, the segments of his brilliant dress. Most impressive was a sequence of honorific lungings at the chief of the village, speaking the parched croak of the dead, pressing against the eyes of the seated onlookers, vibrating the clearly visible motifs of his greatness (Plate 274). He used his whirls at this point with a different selectivity; they were not as full nor prolonged as the whirls in the middle of the plaza, but rather a series of reserved, fleeting billowings-in and billowings-out, snapped-out very suddenly and finished just as quickly, suspending the beat of a phrase. His body dilated to the sweet aliveness of the senior drum, recalling the verse about the elephant, standing beside the tree, breathing with confidence.

In a sense, Apiri projected to infinity the canons of the arts of subsaharan Africa. His dancing was strong: "he turns round, round, round, round, to show he has power." The culmination of his whirls, "killing" the phrase, accented in stillness, the notes of equal strength in the telling, with texture and with color, of the beauty of his ruling mind. Overlapping the choir of drums and singing, in phase exactly with the senior drum, he challenged and accepted human call-and-response. His heroism, his rising three hours before the dawn, his generosity mirrored in the lavishness of his descendants' response, were phrased in terms that any man or woman could comprehend and hope to emulate. He was a glittering example of aesthetic smartness, the privilege of those who purely lead the world towards aesthetically imposed order which makes all turning back from greatness seem impossible. The point of his beauty was his generosity, attractive to the gods, who long ago gave the crimson sawtooth border to the Yoruba as an emblem of salvation.

As he whirled for the last time, his costume opened. The panels rose into the air (Color Plate IV). The dancer's feet momentarily were exposed. At the moment of his exaltation, when all his moral colors were released, the body of a man, standing at the center of this beauty, aiding its expression, was apparent. The equilibrium struck, never static but constantly reachieved, transformed the lessons of the past into an intensely visualized glowing present. He had mastered the secrets of beauty, which are also truth and goodness, and realized their end is never reached. Communion with the gods depends on man passionately exceeding himself. He spun a score

of times, without a loss of equilibrium, and disappeared. The purifying wind of coolness, the wind of God, had balanced briefly upon the head of man.

Plate 273 Apiri-Bi-O-D'Aiye dancing

T-1
Nigeria, Yoruba, "Egungun" mask,
wood, 10"

Plate 274 Apiri-Bi-O-D'Aiye lunging at the chief

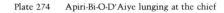

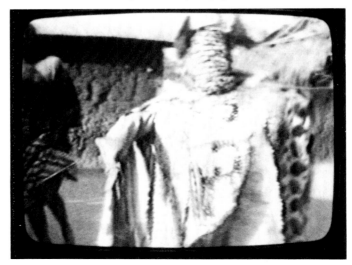

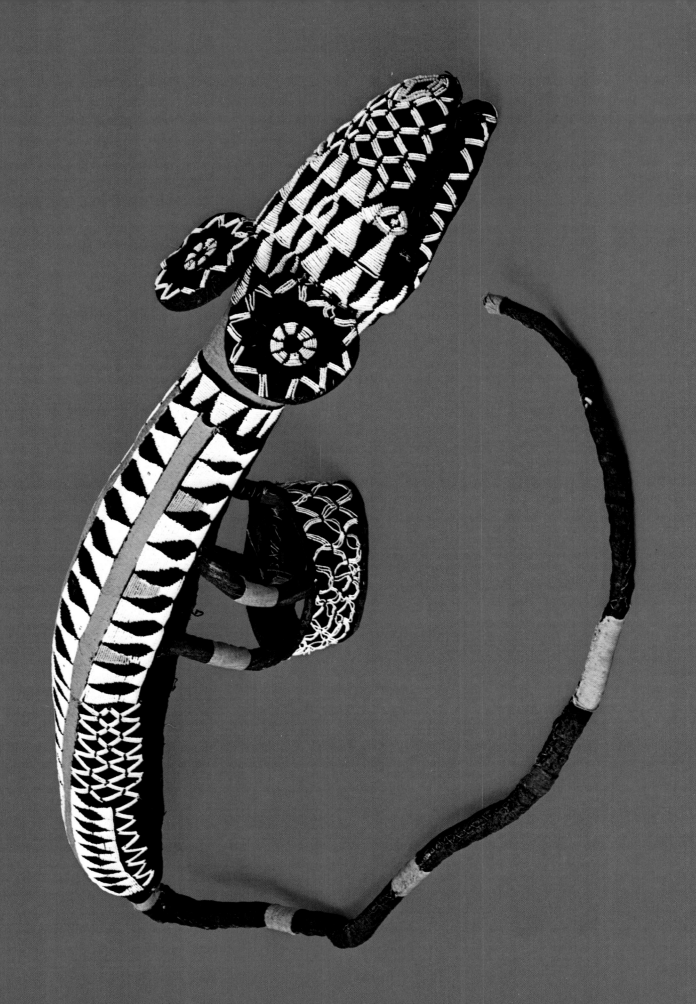

FOOTNOTES: CHAPTER I

1. For example, see Richard N. Henderson, *The King In Every Man* (New Haven: Yale University Press, 1972) p. 266: "purification of self transforms one's general identity to bring a man close to the divine order of things."

2. *Cf.* Frank Willett, *African Sculpture* (New York: Praeger, 1971) pp. 208–222, for a good survey of available data on African aesthetics.

3. Robert Schmitz, *Les Baholoholo* (Brussels: A. Dewit, Collection de Monographies Ethnographiques, 1912) p. 410.

4. Jomo Kenyatta, *Facing Mt. Kenya* (New York: Vintage Books, 1962) p. 100–1.

5. Jean Rouch, "La Danse," *Le Monde Noir,* Numero Special 8–9, *Presence Africaine,* 1950, p. 223–4.

6. Margaret Read, *Children of their Fathers* (New Haven: Yale University Press, 1960) p. 147. *Cf.* also Alvin Wolfe, *In The Ngombe Tradition* (Evanston: Northwestern University Press, 1961) p. 16.

7. Kwabena Nketia, *Drumming in Akan Communities* (London: Thomas Nelson, 1963) p. 169.

8. Personal communication to the author, 1 February 1966.

9. Appendix, Informant 1.

10. *Ibid.*

11. *Ibid.*

12. *Ibid.*

13. R. C. Abraham, *A Dictionary of Modern Yoruba* (London: University of London Press, 1958) p. 424, *mon* "know" and p. 199, *ewa* "beauty." See also T. J. Bowen, *Grammar and Dictionary of the Yoruba Language* (Washington: Smithsonian Contributions to Knowledge, 1858): "*amewa:* a judge of beauty." For Efik evidence, see Hugh Goldie, *Dictionary of the Efik Language* (Ridgewood: The Gregg Press, 1964) reprint, p. 66; Kikongo, K. E. Laman, *Dictionnaire Kikongo-Francaise* (Hants: The Gregg Press, 1964) reprint, p. 683.

14. Butuo, Nimba Country, Liberia, 30 March 1967.

15. S. A. Babalola, *The Content and Form of Yoruba Ijala* (Oxford: Oxford University Press, 1966) p. 51.

16. I am indebted to John Neuhart of the UCLA Department of Art for these insights, Los Angeles, 19 November 1972.

17. *The American Heritage Dictionary,* William Morris, ed. (Boston and New York: American Heritage Publishing Co. and Houghton Mifflin Company, 1969) p. 439.

18. Shown a photograph of this object, one of the "linguists" to the Agogohene of Agogo remarked, "This one is most beautiful to me. If you look at the neck it is befitting to him. The Ashanti have a saying, 'a handsome person is a person who has respectability'" (*eno na eye me fe esiane se nanim fere. Wohwe ne kon a efata no paa. Asante foo ka see obi ho ye fe a na owo animnonyam*). Agogo, Northern Ashanti, 2 January 1971. The Agogohene was pleased by the implication of youth in the firm curve of the jaw and the smoothness of the skin.

19. Daniel Crowley, "An African Aesthetic" in: *Art and Aesthetics In Primitive Societies,* ed. Carol Jopling (New York: Dutton, 1971) p. 323. "Hence old and worn masks are thrown away or allowed to be eaten by termites. Similarly bright colors are preferred to dull. . . ." The Mende and Baoule cases come from unpublished field work shared by Frank Dubinskas and Susan Vogel. The Fang evidence, collected by James Fernandez, also appears in the Jopling anthology on p. 366: "the statue presents both an infantile and an ancestral aspect." Note that Fang seem to bracket infancy and old age within shining muscularity.

20. Crowley, *ibid.*

21. Andre Gide, *Travels in the Congo* (Berkeley and Los Angeles: University of California Press, 1962) p. 80.

22. See Appendix, Informant 60.

23. Gunther Schuller, *Early Jazz* (New York: Oxford University Press, 1968) pp. 7–9.

24. *Ibid.,* p. 8.

25. A. M. Jones, "African Rhythm," *Africa,* Vol. XXIV, No. 1 (January 1954) p. 28.

26. Informant: "James," from Eket District, Ibibio country, Nigeria, at the central market, Bida, 18 July 1965. He did not like the designs of Nupe cloths either, and criticized their off-beat phrasing: "it's scattered; not properly aligned."

27. Appendix, Informants 40, 36, 59.

28. Appendix, Informants 43, 47, 68.

29. Susan Vogel, "Yoruba and Baoule Art Criticism," unpublished research paper, March 1971. Appendix, p. 19.

30. Robert Goldwater, *Primitivism In Modern Art,* Revised Edition (New York: Vintage Books, 1967) p. 230.

31. Appendix, Informant 87.

32. I am indebted to Professor Wyatt MacGaffey of Haverford College for this information. Personal communication, 3 May 1972.

33. Peggy Harper, "Dance in Nigeria," *Ethnomusicology,* Vol. XIII (May 1969) pp. 288–9.

34. Source: Katherine Coryton White archive.

35. *The Philosophy of Hegel,* ed. Carl J. Friedrich (New York: Modern Library, 1953) p. 28.

36. For information on the "knot of wisdom" motif, see Kofi Antubam, *Ghana's Heritage of Culture* (Leipzig: Koehler & Amelang, 1963) p. 176. However, Antubam's interpretations of Akan motifs should not be taken as universally applicable. The reef-knot motif he interprets, for example, as "the detection of the secret motive underlying a diplomatic move" whereas at Agogo I was told that the motif refers to "unusual kingly knowledge," "ability to unlock that which common men cannot." Brigitte Menzel, *Goldgewichte Aus Ghana* (Berlin: Museum fur Volkerkunde, 1968) p. 68. At p. 69 Menzel reports her own informants' interpretation of the wisdom knot motif: "only a wise man would be able to tie or loosen that kind of knot."

37. Roy Sieber, *African Textiles and Decorative Arts* (New York: The Museum of Modern Art, 1972) p. 190.

38. Richard Alan Waterman, "African Influence on the Music of the Americas," *Mother Wit from the Laughing Barrel,* ed. Alan Dundes (Englewood: Prentice-Hall, 1973) p. 88.

39. A. M. Jones, *Studies in African Music,* Vol. I (London: Oxford University Press, 1959) pp. 149, 274.

40. A. M. Jones, *African Music In Northern Rhodesia And Some Other Places* (Livingstone: The Rhodes-Livingstone Museum, 1958) p. 11.

41. Melville J. Herskovits and Frances S. Herskovits, *Suriname Folklore* (New York: AMS Press, 1969). Reprint of the 1936 edition, p. 518.

42. Appendix, Informant 34.

43. Henry Stanley, *In Darkest Africa* (New York: Scribners, 1890) pp. 436–8.

44. Appendix, Informants 22, 27, 37, 50, 87.

45. S. Kobla Ladzekpo and Hewitt Pantaleoni, "Takada Drumming," *African Music,* Vol. 4, No. 4 (1970) p. 12.

46. Personal communication, 15 August 1973.

47. Robert Farris Thompson, *Black Gods and Kings* (Los Angeles: Museum and Laboratories of Ethnic Arts and Technology, 1971) p. 13/5.

48. Clara Odugbesan, "Femininity in Yoruba Religious Art," *Man in*

Opposite: Color Plate VI Cameroon, Bamileke, Python headdress

Africa, ed. Mary Douglas and Phyllis M. Kaberry (London: Tavistock, 1969) p. 202.

49. Personal communication, 10 September 1973.

50. Charles Keil, *Tiv Song,* 21 May 1973, mimeographed, p. 39.

51. Quoted in Alan P. Merriam, "African Music," *Continuity and Change in African Cultures,* ed. William Bascom and Melville J. Herskovits (Chicago: University of Chicago, 1959) p. 58.

52. Philip Gbeho, "The Indigenous Gold Coast Music," *Journal of the African Music Society,* I, (5) 1952, p. 31.

53. Waterman, "Hot Rhythm in Negro Music," *Journal of the American Musicological Society,* Vol. I, No. 1 (Spring 1948) p. 26.

54. Laura Bohannan, (pseud. Eleanor Bowen Smith), *Return to Laughter* (Garden City: Doubleday and Co., 1964) p. 123.

55. Keil, *op. cit.,* p. 22: "*a vine a tsorogh* might be translated she is dancing polymetrically."

56. Harper, *op. cit.,* p. 290. In addition, I mention a letter from Joann Wheeler Kealiinohomoku, dated 1 October 1966, in which she points out the necessity of distinguishing between polymetric and polyrhythmic, something that is not always done in writings on African music and dance: "when, for example, a ballet dancer moves rapidly across the stage in *bouree* while performing an *adagio port de bras* she is using polyrhythms. Using 3/4 against 12/8 *is* polymetric . . . dancing with the right hand moving in a 5/4 meter and the feet performing a strong 3/4 beat is also polymetric. In other cases, where there is really only one meter, as in Western music, the dancer feels that pervading meter, and the different body parts select different portions of the overall organization for expression."

57. Personal communication, 21 August 1973.

58. *The Republic and Other Works,* translated by B. Jowett (New York: Doubleday & Co., 1960) p. 372.

59. Appendix, Informants 22, 53, 56, 58, 64.

60. Informant: Adisa Fagbemi, Ajilete, southern Egbado, Yorubaland.

61. Commentary collected at Ilaro, capital of the Egbado Yoruba, June 1963.

62. Appendix, Informant 1.

63. A. M. Jones, 1959, Vol. I, p. 94.

64. Appendix, Informant 5.

65. Appendix, Informant 44.

66. Appendix, Informant 66.

67. R. C. Abraham, p. 522, 399.

68. *Ibid.,* p. 399.

69. Goldie, p. 237, *nwet* "pattern;" p. 268, *siak,* "to divide."

70. Charles Keil, Abstract, *Tiv Song,* mimeographed, 21 May 1973, p. 2.

71. Appendix, Informant 5.

72. See Roger Abrahams, "Patterns of Performance In The British West Indies," *Afro-American Anthropology,* ed. Norman E. Whitten and John F. Szwed (New York: The Free Press, 1970) p. 164.

73. J. David Sapir, "Diola–Fogny Funeral Songs and the Native Critic," *African Language Review* (1969) p. 178.

74. Appendix, Informant 1, criterion vii.

75. Appendix, Informant 37.

76. Kwabena Nketia, "The Role of the Drummer in Akan Society," *African Music,* Vol. I, No. 1 (1954) p. 42. I have inserted Nketia's footnote 3 after the phrase, "timed to the end beats" and before the next paragraph of the citation.

77. See M. D. McLeod, "Goldweights of Asante," *African Arts,* Vol. V, No. 1 (Autumn 1971). The description of this piece appears beside the masthead of the magazine, p. 4.

78. Appendix, Informant 36.

79. *Ibid.,* Informant 45.

80. *Ibid.,* Informant 87.

81. Kevin Carroll, *Yoruba Religious Carving* (New York: Praeger, 1967) pp. 96–97.

82. Interviewed at Agogo, 2 January 1971.

83. Brigitte Menzel, *Textilien Aus Westafrika* (Berlin: Museum fur Volkerkunde, 1972) Fig. 982.

84. Nana Ntiamoah Mensah, interview, Agogo, Ghana, 2 January 1971.

85. Bessie Jones and Bess Lomax Hawes, *Step It Down* (New York: Harper and Row, 1972) p. 44. They add: "a clear mental picture of the difference in basic foot position might be gained if Bill Robinson's and Fred Astaire's tap dancing styles could be visualized."

86. See Irwin Panofsky, *Meaning In The Visual Arts* (Garden City: Doubleday Anchor Books, 1955) p. 128. Panofsky shows that: "This ascent from the material to the immaterial world is what the Pseudo-Areopagite and John the Scot describe—in contrast to the customary theological use of this term—as the 'anagogical approach' (*anagogicus mos,* literally translated: 'the upward-leading method'); and this is what Suger professed as a theologian, proclaimed as a poet, and practiced as a patron of the arts."

87. Appendix, Informant 33.

88. *Ibid.,* Informant 41.

89. Amos Tutuola, *Feather Woman Of The Jungle* (London: Faber and Faber, 1962) p. 49.

90. Harris Memel-Fote, "The Perception of Beauty in Negro-African Culture" *Colloquium on Negro Art* (Paris: Presence Africaine, 1968) pp. 51–2.

91. Karl Laman, *The Kongo, I* (Upsala: Studia Ethnographica Upsaliensia, 1953) pp. 41–2.

92. R. C. Abraham, p. 671. See *won,* as in the phrase, *o mun oti niiwon* "He drank liquor in moderation."

93. Robin Horton, *Kalabari Sculpture* (Lagos: Department of Antiquities, 1965) p. 22.

94. Mario Meneghini, "The Bassa Mask," *African Arts,* Vol. VI, No. 1 (Autumn, 1972) p. 47.

95. Capt. R. S. Rattray, *Religion and Art in Ashanti* (Oxford: Clarendon Press, 1927) p. 110.

96. Appendix, Informant 37.

97. Appendix, Informant 87.

98. E. E. Evans-Pritchard, "The Dance," *Africa I,* 4 (October 1928) p. 450.

99. Waterman, *op. cit.,* p. 90.

100. *Ibid.*

101. See Robert Farris Thompson, "An Aesthetic of the Cool: West African Dance," *African Forum,* Vol. 2, No. 2, Fall 1966.

102. A phenomenon I have observed at Sebikotan, Senegal; Butuo, Liberia; throughout Yorubaland; in West Cameroon; and in Zaire.

103. Ulli Beier and Bakari Gbadamosi, *Yoruba Poetry* (Lagos: Black Orpheus, 1959) p. 62.

104. For an excellent study, see Esther Pasztory, "Hieratic Composition in African Art," *Art Bulletin,* Vol. LII, No. 3 (September 1970) pp. 299–304.

105. E. E. Evans-Pritchard, *op. cit.,* pp. 455–6.

106. K. Marx, *The 18th Brumaire of Louis Bonaparte* (New York: International Publishers, 1963) p. 19.

107. See R. F. Thompson, *Black Gods and Kings,* p. 20/3.

108. John S. Mbiti, *African Religions and Philosophy* (Garden City: Anchor Books, 1970) p. 141.

109. Appendix, Informant 89.

110. Appendix, Informant 14.

111. Mbiti, *op. cit.*, p. 277.

112. *The Historian in Tropical Africa*, ed. Jan Vansina, Raymond Mauny, and L. V. Thomas (London: Oxford University Press, 1964) pp. 372–3.

113. *Ibid.*, p. 373.

114. *Cf.* Gertrude Prokosch Kurath, "Panorama of Dance Ethnology," *Current Anthropology*, Vol. 1, No. 3 (May 1960) p. 247: "Still photography, monochrome or color, can have some value for the analysis of posture, costume, and so on, especially if the pictures are taken in series. Such pictures are also more practicable for publication than are frames from films, and have been used to excellent effect in many books They cannot convey the kinetic element, however, and thus can only supplement notes and films."

115. Ibn Batuta, *Voyages: Texte Arabe Accompagne d'une Traduction*, ed. and trans. C. Defremery and B. R. Sanguinetti (Paris: 1949) pp. 413–14.

116. Rene Bravmann, "Masking Tradition and Figurative Art Among the Islamized Mande," mimeographed, paper read at Boston University, 1970, pp. 6–7.

117. Vasco da Gama, *The Journal of the First Voyage of Vasco da Gama*, ed. and trans. by E. G. Ravenstein (London: Hakluyt Society, 1898) p. 11. "Bay of Sao Braz [Mossel Bay] December 2, 1497: "On Saturday [Dec. 2] about two hundred negroes came, both young and old They forthwith began to play on four or five flutes, some producing high notes and others low ones, thus making a pretty harmony . . . and they danced in the style of negroes." Eugenia Herbert brought this reference to my attention.

118. In: *Europeans In West Africa*, ed. John William Blake, Vol. II (London: Hakluyt Society, 1942), "William Towerson's First Voyage to Guinea 1555–6," p. 360. Towerson himself appears to be the narrator of the voyage. The area he describes appears to be between Monrovia and Cape Palmas.

119. *Ibid.*, p. 368. The women were simultaneously dancing and hand-clapping.

120. Nketia, *Drumming in Akan Communities of Ghana*, pp. 32–5. I have observed similar use of drum syllables among other Kwa language speakers, notably Fon and Yoruba.

121. *Ibid.*, p. 34.

122. Fernando Ortiz, *Los Bailes y el Teatro de los Negros en el Folklore de Cuba* (Havana: Ediciones Cardenas y Cia, 1951) p. 253. I have documented the same phrase with the same structure among Remo Yoruba at Ilishan in October 1963. In both instances the last syllable is nasalized. I have transcribed Ortiz' materials to bring them in closer consonance with standard Yoruba orthography, hence the substitution of *yan* for *ya*. But the melodic and syllabic structure remains identical.

123. I am indebted to Professor Antonio Regalado of New York University for this information.

124. Horacio Jorge Becco, *El Tema del Negro en Cantos, Bailes, y Villancicos de los siglos XVI y XVII* (Buenos Aires: Ollantay, 1951) pp. 31–2.

125. For a brief study of this particular province of the world of African-influenced music and dance in the Americas, see my "New Voice from the Barrios," *Saturday Review* Vol. L, No. 43 (October 28, 1967) pp. 53–5, 68.

126. Pieter de Marees, *Description et Recit Historial du Royaume D'Or de Guinea* (Amsterdam: 1604) p. 71.

127. *Ibid.*, p. 68.

128. See Walter Hirschberg, "Early Historical Illustrations of West and Central African Music," *African Music*, Vol. 4, No. 3 (1969) p. 6.

129. See I. Schapera, *The Early Cape Hottentots* (Capetown: Van Riebeeck Society, 1933) p. 139.

130. Lorna Marshall, "Kung Bushman Religious Beliefs," *Africa*, Vol. 2 (1962) p. 249.

131. Sylvia Boone, unpublished seminar report, "Sources for the History of Black Dance: Egypt and the Middle East," November 1972. Yale University.

132. Richard Jobson, *The Golden Trade* (Teighmouth: E. E. Speight and R. H. Walpole, 1904) p. 136.

133. Nicholas Villault, *Relation Des Coste D'Afrique Appellees Guinee* (Paris: Denys Thierry, 1669) p. 315. Translation mine.

134. *Ibid.*, 394.

135. Awnsham Churchill, *Collection of Voyages and Travels*, Vol. VI, *Captain Thomas Phillips Journal of his voyage from England to Cape Mounseradoe in Africa and thence along the Coast of Guiney to Whidaw* (London: 1752) p. 193.

135a. Quoted in: Freda Wolfson, *Pageant of Ghana* (London: Oxford University Press, 1958) p. 61.

136. Churchill, *op. cit.*, p. 201. He adds, "they began the dance moderately, but as they continued it, they by degrees quickened their motion so that at the latter end they appeared perfectly furious and distracted." This is an interesting detail on variation in tempo. Later, at Ouidah, on the coast of modern Dahomey, he saw more dancing (p. 223): "they dance as untowardly, the whole being only an antick continued jumping, one at a time, with odd gestures of head, arms, and body."

137. Jean-Baptiste Labat, *Nouvelle Relation de L'Afrique Occidentale* (Paris: Guillaume Cavellier, 1728) p. 280–2. Note that the illustrator has placed the spear in the right hand, not left, as indicated in the text.

138. Michel Leiris, *L'Afrique Fantome* (Paris: Gallimard, 1934) see photograph opposite p. 33.

139. John Atkins, *A Voyage to Guinea, Brasil, and the West Indies*. Second Edition. (London: Ward and Chardler, 1737) p. 53: "dancing is the diversion of their evenings: men and women make a ring in an open part of the town, and one at a time shows his skill in antick motions and gesticulations yet with a great deal of agility, the company making the music by clapping their hands together during the time, helped by the louder noise of two or three drums made of a hollowed piece of tree and covered with kid-skin. Sometimes they are all round in a circle laughing, and . . . blame or praise somebody in the company." Francis Moore, *Travels Into The Inland Parts of Africa* (London: E. Cave, 1738) p. 110.

140. See A. M. Jones, "Drums Down The Centuries," *African Music*, Vol. I, No. 4 (1957) p. 5.

141. Philip Curtin, *The Image of Africa* (Madison: University of Wisconsin Press, 1964) p. 16.

142. Michel Adanson, *A Voyage to Senegal, the Isle of Goree, and the River Gambia* (translated from the French) (London: J. Nourse, 1759) p. 111.

143. *Ibid*

144. Sir James Alexander, *Narrative of a Voyage of Observation among the Colonies of Western Africa in the flagship Thalia; and of a Campaign in Kaffir-land*, Vol. I (London: Henry Colburn, 1837) p. 171. Alexander apparently saw the same dance, down-coast, at Accra (p. 192): ". . . girls were practicing that extraordinary clap, jump, and heel dance of *osarah* formerly described."

145. See Vincent Akwete Kofi, *Sculpture In Ghana* (Accra: Ghana Information Services, 1964) pl. 23. See also Louise E. Jefferson, *The Decorative Arts of Africa* (New York: The Viking Press, 1973) pl. 208.

146. Alan Lomax, *Folk Song Style and Culture* (Washington, D.C.: American Association for the Advancement of Science, 1968) p. 256.

147. George Schweinfurth, *The Heart of Africa*, Vol. I, trans. Ellen E. Frewer (New York: Harper and Bros. 1874) p. 75. During this decade and the preceding ten years the quality of reporting improved somewhat. Explorers evaluate African dancing, sometimes with admiration. Thus Richard Burton, in his *The Lake Regions of Central Africa* Vol. I (London: Longman, Green, Longman & Roberts, 1860) p. 360 praised one form of Central African dancing: "The dancers plumbing and tramping to the measure with alternate feet, simultaneously perform a treadmill exercise with a heavier stamp at the end of every period: they are such timists, that a hundred pair of heels sound like one." The quality of timing which he admired also appears in the "Bandussuma" dance in Henry Stanley's *In Darkest Africa, infra.*

148. Wilhelm Junker, *Travels in Africa*, Vol. II (London: Chapman and Hall, Ltd., 1891) pp. 238–9.

149. *Cf.* a standing female figure, Mangbetu, in the Tervuren Museum (55.128.1). Illustrated in: A. Maesen, *Umbangu* (Brussels: "Cultura," 1960) pl. 46.

150. Alan Merriam, "African Music," *Continuity and Change in African Cultures*, ed. William Bascom and Melville J. Herskovits (Chicago: University of Chicago Press, 1959) p. 58.

151. Henry M. Stanley, *In Darkest Africa* (New York: Charles Scribners, 1890) p. 438.

152. L. G. Binger, *Du Niger Au Golfe de Guinee* (Paris: Hachette, 1892) p. 222–3: "... some hours before gun shots announce the burial, the balafon players go to the village gate, everyone assembles clothed in clean linen, the warriors in their war dress with hats decorated with feathers. At the moment when the body passes, tied on a matting and carried on the heads of two vigorous men, all noise ceases and everyone stands out of the way of its passage. The body is always preceded by women singing the virtues of the defunct person and carrying in their right hands cowtails which they shake a little in the air."

153. Robert Goldwater, *Senufo Sculpture from West Africa* (New York: Museum of Primitive Art, 1964) pl. 67.

154. Roy Sieber suggests the Senufo rider in the White Collection was once part of a helmet. See Katherine White archive.

155. D. Denham and H. Clapperton and Dr. Oudney, *Narrative of Travels and Discoveries in Northern and Central Africa* (London: J. Murray, 1826) p. 212. Binger, *op. cit.*, saw a similar dance in Dagomba country and thought it original enough to merit documentation: (p. 71) "At the sound of two . . . tam-tams, a circle is formed from which two dancers break off at two points diametrically opposed. They turn two or three times on themselves in such a way as to give themselves a good spring and to meet in the center, striking their posteriors together as violently as possible." Eugenia Herbert brought this reference to my attention.

156. Capt. Guy Burrows, *The Land of the Pygmies* (London: C. A. Pearson, 1898) p. 93.

157. *Ibid.*, p. 213.

158. An Ashanti proverb documented at Agogo, Ghana, 2 January 1972.

159. Marcel Griaule, *Folk Art of Black Africa* (New York: Tudor, 1950) p. 58.

160. H. Cory, *African Figurines* (London: Faber and Faber, 1956) p. 153.

161. R. F. Thompson, "Aesthetic of the Cool," *African Arts*, Vol. VII, No. 1 (Autumn 1973) pp. 41–3, 64–67, 89–91.

162. *Ibid.*, pp. 90–91, Table.

163. I have in mind here a parallel with the use of the verb, "signifying" in Black and Standard English: "What is unique in Black English usage is the way in which signifying is extended to cover a range of meanings and events which are not covered in its Standard English usage." For details, see Claudia Mitchell-Kernan, "Signifying" in: *Mother Wit from the Laughing Barrel*, ed. Alan Dundes (Englewood Cliffs: Prentice-Hall, 1973) p. 313.

164. *E.g., Black Gods and Kings* (1971)

165. Appendix, Informant 15, 66. See also, Robin Horton, for the last reference, which is Ijaw, "The Kalabari Ekine Society: A Borderland of Religion and Art," *Africa*, Vol. XXXIII, No. 2 (April 1962) p. 103: "by people, i.e. who are in many ways the antithesis of the aggressive, thrusting politician. The same is often true of the core of dancing enthusiasts who give the society its real vitality." Cool people, Horton says, are able to stand back from life and portray it in the masquerade; his data coincide closely with the idea of detachment and humor (refusal to suffer) embedded in the cool of many forms of African philosophy.

166. Keil, *op. cit.*

167. Appendix, Informant 35.

168. Appendix, Informant 81.

169. David Sapir, *op. cit.*, p. 183.

170. Quoted in Karl Riesman, "Remarks on Sama Vocabulary," paper read at Northeastern Anthropological Association Annual Meeting, April 27, 1973, p. 13.

171. For details, see Crowley's contribution to the forthcoming *The Traditional Artist in African Society*, ed. Warren d'Azevedo (Bloomington: Indiana University Press, 1973).

172. Personal communication, 3 April 1973. I am indebted to Professor Charles S. Bird for sharing his rich knowledge of Manding culture.

173. Abraham, p. 80.

174. Victor Turner, *The Forest of Symbols* (Ithaca: Cornell University Press, 1967) p. 76.

175. Charles Keil, personal communication, March 1966.

176. Appendix, Informant 38. He says this by indirection—"the style of some people will not shine well."

177. Melville J. Herskovits, *The New World Negro* (Bloomington: Indiana University Press, 1966) p. 187.

178. Crowley, *op. cit.*, p. 323.

179. Henderson, *op. cit.*, p. 263.

180. Sapir, *op. cit.*, p. 183.

181. S. A. Babalola, *The Content and Form of Yoruba Ijala* (Oxford: Oxford University Press, 1966) p. 75.

182. Appendix, Informant 1.

183. Henderson, *op. cit.*, p. 14.

184. Quoted in Kenneth M. Stampp, *The Peculiar Institution* (New York: Vintage Books, 1956) p. 366.

185. Gerald D. Suttles, *The Social Order of the Slums: Ethnicity and Territory in the Inner City* (Chicago: University of Chicago Press, 1968) pp. 62, 66. I thank Roger Abrahams for this reference.

186. A. M. Jones, *Studies in African Music*, Vol. I, p. 264.

187. Jean Rouch, *La Religion et la Magie Songhai* (Paris: Presses Universitaires de France, 1960) p. 223.

FOOTNOTES: CHAPTER II

1. Source: Araba Eko, Isale-Eko, Lagos, Nigeria. January 1972. It is believed the gods established the correct manner of formal self-presentation in standing, sitting, and other activities. *Cf.* G. Gosselin, "Pour une Anthropologie du Travail Rural en Afrique Noire," CEA, 12, (1963) p. 521: proper decorum in work gestures are sanctioned in West Africa frequently by reference to tradition and to the world of the sacred—"one thinks specially of the repetition of archetypal gestures mentioned in origin myths."

2. See note 5, below.

3. *The American Heritage Dictionary*, pp. 1256, 85, 554.

4. Griaule, *Folk Art of Black Africa*, p. 100.

5. Alade Banhoufewe, Cotonou, 4 June 1973; Ako Nsemayu, Mamfe, 8 June 1973; Piluka Ladi, Kinshasa, 13 June 1973.

6. Alan Lomax, *Folk Song Style and Culture* (Washington, D.C.: American Association for the Advance of Science, 1968) p. 256.

7. Ralph Coe, *The Imagination of Primitive Man* (Kansas City: The Nelson Gallery and Atkins Museum Bulletin, 1962) pp. 25–6. William Fagg refines this attribution: "may well be an early work by Osei Bonsu," *African Tribal Images* (Cleveland: Cleveland Museum of Art, 1968) pl. 99.

8. E. Minkowski, Preface, F.J.J. Buytendijk, *Attitudes et Mouvements* (Bruges: Desclee de Brouwer, 1957) p. 16.

9. *Ibid.*, p. 125.

10. Kofi Antubam, *Ghana's Heritage of Culture*, p. 71.

11. Katherine Coryton White archive.

12. Harris Memel-Fote, "The Perception of Beauty in Negro-African Culture," *Colloquium on Negro Art*, p. 58.

13. D.T. Niane, *Sundiata: An Epic of Old Mali* (London: Longmans, 1965) p. 21.

14. Informant: Araba Eko, Lagos, January 1972.

15. *Ibid.*

16. Buytendijk, *op. cit.*, p. 125.

17. Henri Frankfort, *The Art and Architecture of the Ancient Orient.* Paperback edition. (Baltimore: Penguin Books, 1970) p. 46.

18. Araba Eko, Lagos, January 1972.

19. Appendix, Informant 1.

20. Buytendijk, *loc. cit.*

21. I am grateful to the Agogohene for many informal seminars on the traditional arts of northern Ashanti.

22. Interviewed at Accra, 31 December 1971.

23. See Rene Bravmann, *West African Sculpture* (Seattle: University of Washington Press, 1970) pl. 142, p. 66.

24. Personal communication, Paul Gebauer. Recorded in Katherine Coryton White archive.

25. Tamara Northern, *Royal Art of Cameroon* (Dartmouth: Hopkins Center Art Galleries, 1973) p. 11.

26. Jan Vansina, *The Tio Kingdom of the Middle Congo* (London: Oxford University Press, 1973) p. 232.

27. See Northern, *op. cit.*, p. 21–2.

28. Araba Eko, January 1972; April 1966.

29. Informant: George Tabmen, Monrovia, March 1967.

30. Personal communication, September 1973.

31. I am indebted to John Janzen for this information.

32. See, for example, Paul Gebauer, *A Guide To Cameroon Art From The Collection Of Paul And Clara Gebauer* (Portland: Portland Art Museum, 1968) p. 15 (pagination supplied).

33. Hans Himmelheber, "Wunkirle, die gastliche Frau: eine Wundentragerin bei den Dan und Guere (Liberia und Elfenbeinkuste)," *Festschrift Alfred Buhler*, ed. Karl Schmitz and Robert Wildhaber (Basel: Pharos-Verlag, 1965) pp. 171–181.

34. Katherine Coryton White archive. See also Himmelheber, *ibid.*, p. 177.

35. Himmelheber says that spoons ending with a face are always a "portrait of the wunkirle" *i.e.*, a generalized feminine countenance which can come to be associated with the face of the actual owner. Legs are meant to suggest wunkirle, also, according to Himmelheber.

36. Albert Maesen, "Congo Art and Society," *Art of the Congo* (Minneapolis: Walker Art Center, 1967) p. 60.

37. H. Burssens, "La Fonction de la Sculpture Traditionelle chez les Ngbaka," *Brousse*, 2 (1958) p. 21: "si les NGBAKA ajoutent des jambes a la harpe, c'est, disent-ils, pour pouvoir la mettre sur terre."

38. Kwasi Myles of Accra has supplied the reference to the adekum calabash.

39. Warren d'Azevedo, "Standard Elements of Design Employed by Woodcarvers," mimeographed, 1968, p. 2.

40. Frank A. Dubinskas, *The Beauty of the Sowo: Spirit of the Mende Women's Secret Society.* 1972. Unpublished manuscript, p. 54.

41. *Cf.* d'Azevedo, 1968, p. 2.

42. Thompson, *Black Gods and Kings*, 11/3. For a Yoruba wrought-iron staff surmounted with the actual head of a bird see the exhibition collection of the Musee des Missions Africaines de Lyon. (No. 344.)

43. *Cf.* Plate 85.

44. Araba Eko, Isale-Eko, Nigeria, January 1972.

45. Informant: Alaperu Iperu, October 1962, Iperu-Remo, Nigeria. The identical phrase came to Cuba, with the same meaning, via Yoruba slaves. See Fernando Ortiz, *Los Instrumentos de la Musica Afrocubana*, I. (Havana: Ministerio de Educacion, 1952) p. 182: "the osun must be always standing erect; it cannot be allowed to lean or to recline. If it falls it is of such evil augury that a prayer [of reconciliation] must be immediately made, according to what the gods demand." Ortiz' Yoruba text is corrupt. It should read: *duro gangan ni aba osun.* He shows: *duru nganga labosi.* The second word is Ki-Kongo and the third would appear to represent a misunderstood elision.

46. Robert Goldwater, *Senufo Sculpture from West Africa* (New York: The Museum of Primitive Art, 1964) p. 26.

47. Sources: Professor Wyatt MacGaffey, Haverford College, September 1973; Karl Laman, *The Kongo*, I. (Upsala: Studia Ethnographic Upsaliensia, 1953) pp. 42–3.

48. MacGaffey, personal communication, October 1973.

49. *Ibid.*

50. Marie-Louise Bastin, *Art Decoratif Tshokwe* (Lisbon: Companhia de Diamantes de Angola, 1961) p. 155, fig. 51.

51. In a letter to Jacqueline Delange, dated "beginning of December 1968," cited in: Philip Fry, "Essai sur la Statuaire Mumuye," *Objects et Mondes* (1970) p. 28.

52. Fry, *ibid.*, p. 15: "Cette spiralisation est un trait d'homologie morphologique applicable a l'ensemble de l'echantillon selon des degres d'accentuation variables."

53. Arnold Gary Rubin, *The Arts of the Jukun-Speaking Peoples of Northern Nigeria* (Ann Arbor: University Microfilms, 1970) pp. 78ff. For reference to rain in connection with such statuary see especially p. 83. Rubin reports (p. 82) that the "connection of the figures with chief and chieftainship is very close; not only do the figures represent

54. Fry, *op. cit.*, p. 24.

55. Fry, fig. 4, "Montol statue in wood. Brown mat patina. M.H. 69.135.1." Roy Sieber, *Sculpture of Northern Nigeria* (New York: Museum of Primitive Art, 1961) fig. 32, Montol, Komtin Society diviner's figure. The facetting of the surfaces of the legs of the latter figure shows one aspect of stylistic affinity with Mumuye statuary. Komtin is an herbalists' society kept secret from women and uninitiated men, according to Sieber.

56. Quoted in Katherine Coryton White archive.

57. T. Northern, *op. cit.*, pl. 17.

58. Quoted in a lecture on the implications of the act of standing in Greek sculpture, Sheldon Nodelman, Yale University, February 1973.

59. Abraham, *Dictionary of Modern Yoruba*, p. 350.

60. Goldie, *Dictionary of the Efik Language*, p. 290.

61. Daniel Biebuyck, *Lega Culture* (Berkeley and Los Angeles: University of California Press, 1973) p. 186.

62. Interviewed at Mamfe, 9 June 1973. The informant was a member of the family of Ako Nsemayu of Kendem.

63. See Kofi Antubam, *Ghana's Heritage of Culture*, p. 114, *Atenase:* The Manner of Sitting.

64. *Ibid.*, see also p. 69.

65. Informant: Thomas Akyea, Accra, Ghana, January 1972.

66. Susan Vogel, "Yoruba and Baoule Art Criticism," unpublished paper, 1971, p. 5. Vogel cites Pierre Etienne, "Les Baoule et le Temps," *Cahiers Orstom ser. Sciences Humaines* (Abidjan) 5, 3 (1968) pp. 17–37. Etienne finds that Baoule expend unusual time, labor, and money on bathing and rank this pleasure high among the good things of life.

67. *Ibid.*, pp. 2–3: "One figure shown to Baoule critics, however, was represented as wearing a heavy ivory bracelet and critics often remarked it with pleasure. 'It is called *nze*,' they told me, 'and it is the type of bracelet worn by men in the old days.'"

68. Eva L. R. Meyerowitz, *The Akan of Ghana* (London: Faber and Faber, 1958) p. 28.

69. *Ibid.*, p. 31. In addition, Thomas Akyea, on behalf of the Agogohene, added the following information about the role of the Queen Mother during the process of field work at Agogo, Ghana on 19 May 1969: "The Queen Mother is either the sister, niece, or even mother of the king. She is a member of the court panel and without her presence the court is not full. Any pronouncement or judgment given without her confirmation will not be binding. In her absence no authority can enstool a chief." The throne upon which she sits thus refers, in a sense, to further dimensions of her prestige.

70. Kevin Carroll, *Yoruba Religious Carving* (New York: Praeger, 1967) p. 32.

71. Source, Onayemi Oginnin, Ilesha, Nigeria, 5 August 1965.

72. Laman, *The Kongo*, Vol. I, pp. 44–5.

73. *Ibid.*, p. 45.

74. Clifford Geertz, *The Religion of Java* (New York: The Free Press, 1964) Paperback edition. p. 12.

75. But see Joseph Cornet, *Art of Africa: Treasures from the Congo* (London: Phaidon, 1971) p. 28: "Unfortunately, none of the catalogues issued periodically by the Kircher Museum ever acknowledged these accessions from Central Africa." In addition, Professor Vinigi Grottanelli, of the Pigorini Museum, in a letter dated 10 June 1968, shared the following information: "of our four *mintadi*, only two date back to the 17th century. There are no documents of any sort to go with them, but merely the mention in our post-1870 catalogue that the two figurines belonged to the Museum Kircherianum. The remaining two were collected and entered the Museum late in the late 19th century." Then, in another letter, dated 23 July 1968, Grottanelli adds: "It appears that the first nucleus of what was to become the 'Kircherianum' (and then the 'Pigorini') derived from a legacy or gift by a certain Alfonso Dorino in 1651. A 'curiosity cabinet' was then formed, in the Collegio Romano, and a first catalogue was made by one Giorgio de Sepi in 1678 . . . I do not know where Verley [whose article on *mintadi*, in the journal, *Zaire* (1955), is the source of the misinformation] got the 1690 date but it is a fact that the ntadi seen by you in the old Pigorini Museum is one of the two possessed by the Kircherianum." There the matter rests. I have gone into detail about the alleged "four mintadi" (there are only two), and their possible dating, because what they show in terms of posture will obviously become crucial in African gestural history—if they can be substantiated chronologically. It may be possible to date the antiquity of Kongo formal sitting posture, by other kinds of evidence. Thus firm dates for the introduction of slaves from lower Zaire to Trinidad might provide one such source, for J. D. Elder, in a personal communication dated 18 October 1970, has told me that in the 1940's and 1950's there was still one old man of lower Zaire descent in Trinidad who "shaved his head and sat cross-legged."

76. Laman, Vol. I, pp. 43–4.

77. Placide Tempels, *Bantu Philosophy* (Paris: Presence Africaine, 1959) p. 122.

78. H. Cory, *African Figurines* (London: Faber and Faber, 1956) p. 91.

79. Wyatt MacGaffey, personal communication, May 1972.

80. Marie-Louise Bastin, *L'Art Decoratif Tschokwe*, Vol. II, p. 326, pl. 135.

81. Bertil Soderberg, "Antelope Horn Whistles with Sculptures from the Lower Congo," *Ethnos* 1–4 (1966) p. 24.

82. *Cf.* Thompson, *Black Gods and Kings*, p. 2/2 for a Yoruba paradigm: "To be generous in a beautiful way seems the essence of morality and the assurance of continuity." Compare Richard Price, *Saramaka Social Structure*. Xeroxed manuscript. 1970. pp. 28–9: "the quintessence of morality is generosity. In the abstract, the greatest value is placed on 'living well', conceived of almost exclusively in terms of material fulfillment of kinship (and other) normative obligations. In trying to project a favorable self-image, Saramakas stress not their cleverness, wealth, or renown, but rather their generosity with goods and services; ostensibly, then, they compete by 'giving' rather than 'having'. . . ." Saramaka culture was formed of runaway slaves who stemmed from Ghanian, Dahomean, Nigerian, and Zaire-Angola areas, plus West African territories yet to be determined.

83. Ako Nsemayu, Mamfe, 8 June 1973.

84. Quoted in Babatunde Lawal, *Yoruba Sango Sculpture In Historical Retrospect* (Ann Arbor: University Microfilms, 1971) p. 113.

85. *Ibid.*, p. 114. See also Humphrey J. Fischer's useful study, "'He Swalloweth The Ground With Fierceness And Rage': The Horse In The Central Sudan," *Journal of African History* XIII, 3 (1972) pp. 367–88 and (part II) *Journal of African History* XIV, 3 (1973) pp. 355–379.

86. There are mentions of riding in the legend of Sundiata, *e.g.*, D. T. Niane, *Sundiata: An Epic of Old Mali*, p. 80: "The women of Mali tried to create a sensation and they did not fail. At the entrance to each village they had carpeted the road with their multi-colored pagnes so that Sundiata's horse would not so much as dirty its feet on entering their village."

87. Jack Goody, *Technology, Tradition and the State in Africa* (London: Oxford University Press, 1971) p. 71.

88. Kohler, "Das Pferd in den Gur-sprachen," *Afrika und Ubersee* xxxviii (1953–4). Quoted in Goody, *op. cit.*, p. 69.

89. Goody, *op. cit.*, p. 66.

90. Alade Banhoufewe, Cotonou, 4 June 1973.

91. Goody, *op. cit.*, pp. 66–7: "Association with the horse took on ritual significance . . . the image is . . . explicit in certain speech forms used to refer only to the paramount chief of Gonja. At times he is spoken of as *bange* (horse) The founding ancestor of the Mossi kingdom of Wagadugu was . . . known as 'the red stallion'. . . ."

234

92. Goldwater, *Senufo Sculpture from West Africa*, p. 25, pl. 119.

93. Bertil Soderberg, "Antelope Horn Whistles," p. 7: "functionally, sculpture-adorned whistles are associated with the *nkisi*-cult, especially when connected with hunting, and they were possibly also used as signal whistles during hunting, as wooden whistles are used. Only men initiated in the nkisi-cult were allowed to possess and use the sculpture-adorned whistles, that is socially prominent people such as the medicine men and possibly the village chiefs. They were not carried by ordinary people" At p. 32: "The religious function of the sculptures with antelope horns has not earlier been dealt with in a scientific manner. They are all members of 'children' of different *minkisi*, and each functions according to the requirement of its *nkisi*. They can therefore be used when sorcerers (bandoki) are exposed or sick persons healed, and they can be used as hunting charms."

94. Marcel Griaule and Germaine Dieterlen, *Le Renard Pale* (Paris: Institut D'Ethnologie, 1965) pp. 455–6: "A rider, symbol of Amma, is sometimes placed to the side or on the horse, symbol of Nommo The horse is called *amba suru* 'power of Amma,' for [this] form, taken by the Nommo, connotes its force, the running of the animal, the reach of its power on the Earth." See also p. 457. *Cf.* Jean Laude, *African Art of the Dogon* (New York: Brooklyn Museum in association with The Viking Press, 1973) p. 49: "Horsemen: This group . . . numerically important, can be subdivided according to the position of the rider on his mount, his posture, and his gestures. 1. The rider, thrown back kneels on a quadruped . . . 2. The rider, with differentiated breasts, kneels on a quadruped and leans forward. 3. A horseman with differentiated breasts rides bareback and grips his mount with bent knees. He leans back and raises his hands towards the heavens 4. The horseman is riding a saddled and bridled mount, holding the reins in one hand . . . One arm is bent. The right fist holds what appears to be a weapon."

95. *Ibid.*

96. Thurstan Shaw, *Igbo-Ukwu*, Vol. I (London: Faber and Faber, 1970) p. 262. "the portrayal of a horse . . . needs to be taken into account in the consideration of the date, but unfortunately little enough is known for certain about the date of the introduction of horses into the area. It has been generally assumed that they were not common in northern Nigeria until about A.D. 1000." Recently Babatunde Lawal challenges the "around 9th century" date for Igbo-Ukwu, arguing that the presence of European-type manilla and beads, and the preservation of highly perishable materials, textiles, thread, and wood fragments, suggest a fifteenth century date. "Dating Problems at Igbo-Ukwu," *Journal of African History*, XIV, I (1973) pp. 1–8.

97. Robert Smith, "Yoruba Armament," *Journal of African History*, VIII, I (1967) p. 88, note 8.

98. J. F. Ade Ajayi and Robert Smith, *Yoruba Warfare In The 19th Century* (Cambridge: Cambridge University Press, 1964) caption to illustration, facing p. 2. The object is not a ritual stool, as given, but a divination bowl.

99. Photographed 14 July 1965. The Onibara said that this divination bowl was "over a hundred years old, it belonged to my great grandfather," *i.e.*, carved, allegedly, before or during the time of the American Civil War.

100. O. M. Dalton, "On Carved Doorposts from the West Coast of Africa," *Man* I, (1909) p. 69.

101. Thompson, *Black Gods and Kings*, p. 14/6.

102. T. J. Bowen, *Grammar and Dictionary of the Yoruba Language* (Washington: Smithsonian Contributions to Knowledge, (98), 1858): "*ajae*-cord with which a prisoner's hand is bound to his neck."

103. Smith, pp. 100–103. Men working in copper, lead, silver and brass often made these accoutrements. See Bolanwe Awe, "Militarism and Economic Development In Nineteenth Century Yoruba Country: The Ibadan Example," *Journal of African History*, XIV (1973) p. 70.

104. Celine Baduel-Mathon, "Le Langage Gestuel En Afrique Occidentale: Recherches Bibliographiques," *Journal de la Societe des Africanistes*, XLI, 2, (1971) pp. 207, 209, 212, 213, 217, 218.

105. Human Relations Area File: Dieterlen—118 E-5 (1946–49) 1951 FA8 Bambara; Dieterlen—101 E-5 (1946–49) 1951.

106. Eugene Mangin, *Les Mossi: Essai sur les Usages et Coutoumes du Peuple Mossi au Soudan Occidental* (Paris: Augustin Challamel, 1921) p. 52.

107. Elliot P. Skinner, "Trade and Market Among the Mossi People," Paul Bohannan and George Dalton, eds. *Markets In Africa* (Evanston: Northwestern University Press, 1962) pp. 739, 753.

108. Louis Tauxier, *Le Noir du Yatenga* (Paris: Emile Larose, 1917) p. 36. For bending down as a form of salute among Mossi, see A. A. Delobsom, *L'Empire du Mogho-Naba* (Paris: Les Editions Domat-Montchrestien, 1932) pp. 40–1.

109. Celine Baduel-Mathon, *op. cit.*, p. 206.

110. Marion Kilson, *Kpele Lala* (Cambridge: Harvard University Press, 1971) p. 85.

111. Informant, the late Abatan Odefunke Ayinke Ija, summer 1964, Oke-Odan Nigeria.

112. E. A. Ajisafe Moore, *The Laws and Customs of the Yoruba People* (Abeokuta: Fola Bookshops, n.d.) p. 7.

113. Samuel Johnson, *The History of the Yorubas* (Lagos: C. M. S. Bookshops, 1921) p. 11.

114. R. C. Abraham, *Dictionary of Modern Yoruba*, p. 150.

115. Laman, *The Kongo*, Vol. I, p. 47.

116. Jack Flam, "The Symbolic Structure of Baluba Caryatid Stools," *African Arts*, Vol. IV, No. 2 (Winter 1971) p. 59.

117. Griaule and Dieterlen, *Le Renard Pale*, pp. 35–36.

118. Katherine Coryton White archive.

119. I am enormously indebted to Anita Glaze of the University of Illinois at Champaign, History of Art Department, for generously sharing aspects of her fieldwork among Senufo artists and performers without which the Senufo dimension to the White Collection would have been considerably diminished.

120. Informants: Ako Nsemayu of Mamfe, and Chief Defang, Cameroon; and Piluka Ladi of Kinshasa, June 1973.

121. Personal communication, 30 September 1973.

122. *Cf.* Harper, "Dance in Nigeria," *Ethnomusicology* (May 1969).

123. Kwabena Nketia, "Yoruba Musicians in Accra," *Odu*, No. 6 (June 1958) p. 40. I have retranslated the song from the original Yoruba text.

124. Daniel Biebuyck, "The Kindi Aristocrats and their Art among the Lega," *African Art & Leadership*, ed. Douglas Fraser and Herbert Cole (Madison: University of Wisconsin Press, 1972) p. 20.

125. Informant, Onayemi Oginnin, Ilesha, 3 August 1965.

126. A brief survey of the holdings of Amherst College in African art, on 10 December 1969, elicited the information that a graduate of the Amherst College class of 1845, one Josiah Taylor, evidently travelled in Africa and collected Zulu sculptures, now at Amherst, including the three head-rests.

127. Peter Mark, unpublished research paper, May 1972.

128. Elsy Leuzinger, *African Sculpture* (Zurich: Atlantis Verlag, 1963) p. 104. See also A. A. Y. Kyerematen, *Panoply of Ghana* (New York: Praeger, 1964) p. 10, and William Bascom, *African Arts* (Berkeley: Robert H. Lowie Museum of Anthropology, 1967) p. 76.

129. Malcolm Ruel, "Witchcraft, Morality and Doubt," *Odu*, Vol. 2, No. 1 (July 1965) p. 12.

130. Peter Sarpong, *The Sacred Stools of the Akan* (Accra: Ghana Publishing Corporation, 1971) pp. 23–4.

131. Agogo, 19 May 1969.

132. Katherine Coryton White archive. See also James Y. Tong, *African Art In The Mambila Collection of Gilbert D. Schneider* (Athens: Tong, 1967) p. 8 and Plates 26–7.

133. Paul Gebauer, *Spider Divination in the Cameroons* (Milwaukee: Milwaukee Public Museum, 1964) p. 69: *kumso bubo.*

134. Daniel J. Crowley, "Chokwe: Political Art in a Plebian Society," *African Art & Leadership,* ed. Fraser and Cole, p. 33.

135. Robert C. Smith, *The Art of Portugal* (New York: Meredith Press, 1969) p. 288.

136. David Crownover, "Take The Chair," *Expedition,* Vol. 4, No. 4 (Summer 1962) p. 23.

137. Crowley, *op. cit.,* p. 32.

138. Marie-Louise Bastin, *L'Art Decoratif Tshokwe,* II, pp. 376, 371–2.

139. Frans M. Olbrechts, *Les Arts Plastiques du Congo Belge* (Brussels: Editions Erasme, 1959) p. 78, pl. XXXIV, 162; XXXV, 171.

140. Placide Tempels, p. 74: "The eye, speech, movement, symbolic acts, trances, inspiration, possession are criteria from which the Bantu [*i.e.,* Baluba] deduce the existence of certain vital and given forces...."

141. Dominique Zahan, "Significance and Function of Art in Bambara Community Life," *Colloquium on Negro Art* (Paris: Presence Africaine, 1968) p. 41.

142. *Ibid.*

143. Kofi Antubam, *Ghana's Heritage of Culture,* p. 179, *cf.* a porter bearing a head load equals a retort against the ostentation of an inferior; a stool bearer equals a retort against the pomposity of an inferior towards a superior person.

144. See Memel-Fote, *supra* for Akan examples.

145. Cornet, *Art of Africa,* p. 192.

146. Jack Flam, *African Arts,* (Winter 1971) p. 56.

147. *Ibid.,* p. 57.

148. *Ibid.*

149. Charles Beart, *Jeux et Jouets de L'Ouest Africain* (Dakar: IFAN, 1955) Tome I, p. 264, "Equilibres Avec Object Sur La Tete."

150. Zahan, p. 42.

151. Professor Daniel McCall kindly shared this information with me.

152. R. S. Rattray, *Ashanti* (Oxford: Clarendon Press, 1923) p. 148.

153. Pierre Verger, *Notes Sur Les Orisa* (Dakar: IFAN, 1957) p. 305.

154. Adetoye of Efon-Alaiye, August 1964.

155. The senior wife of the Alaiye was the source of this information, 2 December 1963.

156. See Clara Odugbesan, "Femininity in Yoruba Religious Art," *Man in Africa,* ed. Mary Douglas and Phyllis M. Kaberry, (London: Tavistock, 1969) p. 202, 209.

157. Philip Allison, unpublished field notes, Nigerian Museum Lagos, typewritten, 1960.

158. Personal communication, 15 October 1973.

159. Ajilete, Nigeria, 5 December 1962.

160. Source: the senior wife of the Alaiye of Efon, 2 December 1963.

161. Iloro, 21 December 1963.

162. Goldwater, *Senufo Sculpture,* pp. 20–21.

163. Personal communication, 30 September 1973.

164. Griaule and Dieterlen, p. 437, fig. 160 "figures representing the descent of the ark." A. Schweeger-Hefel mentions this motif, in her excellent monograph, "Die Kunst der Kurumba," *Archiv fur Volkerkunde,* Band XVII/VIII, 1962/1963.

165. *The Collected Poems of W. B. Yeats* (New York: Macmillan, 1952) p. 168.

FOOTNOTES: CHAPTER III

1. Irmgard Bartenieff and Forrestine Paulay, "Choreometric Profiles" in: Alan Lomax, *Folk Song Style and Culture* (Washington: American Association for the Advancement of Science, 1968) p. 256.

2. *Ibid.* pp. 257–8. In a world of multi-metric dancing, marvels of self-presentation are possible. See, for example, Michel Leiris, *L'Afrique Fantome* (Paris: Gallimard, 1934) p. 33: "15 June [1931], [Maka, Senegal] . . . when most of the women had danced, the singer with the goatee executed the following sequence: he continued to play his drum with his left hand, activating the rattles on his left wrist [as he did so], while tracing, with the index finger of his right hand, designs within the sand. These were in the form of squares and Islamic magic figurations. When he completed making these patterns, he hurled down the small stick which he had been using to beat his drum from time to time. The staff fell in one of the figures and the singer indicated the place of its fall with his finger. It was an astonishing mime of divination, combining music, drawing, dance, and magic"

3. For recent research on mbiras, see Paul Berliner, *The Meaning of the Mbira, Nyunga-Nyunga,* mimeographed M. A. Thesis, Wesleyan University, 1970. See also the liner annotations to Berliner's *The Soul of Mbira* (Nonesuch LP H-72054). The latter source includes excellent field photographs.

4. Karl Laman, *The Kongo,* IV, (Upsala: Studia Ethnographica Upsaliensia, XVI, 1968) p. 77.

5. See illustrations accompanying Berliner Nonesuch LP.

6. See Marie-Louise Bastin, *L'Art Decoratif Tshokwe,* Vol. II, Plates 206, 207, 211. See also Carlos Cabrita, *Em Terras de Luenas* (Lisbon: Agencia Geral do Ultramar, 1954), Plate facing p. 165.

7. John Blacking, "Patterns of Nsenga Kalimba Music," *African Music,* Vol. 2, No. 4 (1961) p. 29.

8. *Ibid.* For another kind of artistic complementarity, arising when the striking of the keys of an mbira is played against continuous buzz created by special added materials, see A.M. Jones, *African Music In Northern Rhodesia And Some Other Places* (Livingstone: The Rhodes-Livingstone Museum, 1958), p. 32: "when the instrument is played, this membrane produces a 'sizzing' sound, rather like that produced by singing through a comb covered with tissue paper. The purpose of the sizzing is to produce a continuous legato sound and also to amplify it. If there were no membrane the Bantu would say that the sound stops short between each note; they want the sound to run continuously." This would appear to corroborate Robert Plant Armstrong's principle of "intensive continuity" developed in a remarkable book on African aesthetics, *The Affecting Presence* (Urbana: University of Illinois Press, 1971) p. 136.

9. See especially Biebuyck's excellent *Lega Culture* (Berkeley and Los Angeles: University of California Press, 1973).

10. *Ibid.,* p. 131.

11. *Ibid.,* Plate 103.

12. Quoted in William Fagg, *African Tribal Images* (Cleveland: The Cleveland Museum of Art, 1968) Plates 271–2.

13. Biebuyck, *op. cit.,* p. 57.

14. Biebuyck, Plate 31, caption.

15. Susan Vogel, *Yoruba And Baule Art Criticism: A Comparison,* p. 14.

16. Informant: Saliu Oyadina, Oke-Odan, Nigeria, 16 January 1972.

17. Informant: E. O. Fominyen, Mamfe, West Cameroon, 9 January 1972.

18. Informant: Ekong Imuna, Big Qua Town, Calabar, Nigeria, 14 January 1972.

19. Placide Tempels, *Bantu Philosophy* (Paris: Presence Africaine, 1959) p. 67.

20. Marcel Griaule, *Folk Arts of Black Africa* (New York: Tudor, 1950) p. 53.

21. Tempels, *op. cit.,* p. 68.

22. Barbara Blackmun and Matthew Schoffeleers, "Masks of Malawi," in *African Arts* Vol. V, No. 4 (Summer 1972) p. 39. Information on function also found in Katherine Coryton White archive.

23. Blackmun and Schoffeleers, *op. cit.,* p. 39.

24. *Ibid.*

25. Frank A. Dubinskas, *The Beauty of the Sowo: Spirit of the Mende Women's Secret Society* (Berkeley: April 1972) unpublished typewritten manuscript. See p. 53: "visual balance between young girl beauty attributes and serious spirit attributes." Dubinskas collected vernacular criticism of Bundu masks, including fragments on the representation of spirit seriousness by means of closed, pursed lips (p. 70): "this woman is neither angry nor laughing, but serious about what she is doing" *(ngi yaumbu ye ngoi sai numui a ye na i yema ta o i lile ni).* Her lips strike a balance between laughter and anger.

26. *Ibid.,* p. 39: "Several informants told me that sowo are seen coming out of the water; this is the way the spirit appears to human beings. The neck rings are an extension of the concentric waves which are formed on still water by the sowo head breaking the surface. It is these rings in the water which the neck rings represent: 'they are due to the resemblance to the spirit coming from the water.'" For the vernacular source, see p. 70: *(e nja hun hanii loma mu a lo).* The Mende interpretation of the eyes and forehead of the Bundu appears on p. 61 of his text.

27. P. Gervis, *Sierra Leone Story* (London: Cassell, 1952) p. 156. Quoted in Sylvia Ardyn Boone, *The Sande Society Mask: Bundu,* M.A. Thesis, Yale University, September 1973, p. 88.

28. John Beattie, *Spirit Mediumship and Society in Africa* (London: Routledge, Kegan Paul, 1969) p. 18.

29. Informants: the elders of the court of the Agogohene, Northern Ashanti, 2 January 1972. Their phrasing was: *Eti a ehwe fam keyere awerehoro na eti a ehwe soro kyere amigyae ne Onyame mu ahotosoo,* lit. "head seen down shows sorrow and head looks up shows joy and trust in God."

30. Informant: W. Yaw Sarpong, Bantama, 5 January 1972. According to Sarpong, the phrase is a proverb and is appropriately cited at the funeral, to offer stylized condolences. As to the relation of Akan terracotta heads to possession priests, see Kwabena Ameyaw, "Funerary Effigies from Kwahu" in *Ghana Notes and Queries,* No. 8, 1966, p. 12.

31. J. H. Kwabena Nketia, *Funeral Dirges of the Akan People* (Achimota: University College of the Gold Coast, 1955) p. 50. The literal phrase is: "tree that gives shade and coolness has been hewn down." This concentrates, as Nketia shows, on the impact of the loss upon the living.

32. Informant: Araba Eko, Isale-Eko, Lagos, 13 January 1972.

33. For an excellent study of the Efe rite, see Henry Drewal, "Efe: Voiced Power and Pageantry," forthcoming in *African Arts.*

34. William Fagg and Margaret Plass illustrate a similar omo in their *African Sculpture* (New York: Dutton, 1964) p. 122.

35. W. Fagg, *African Tribal Images,* captions, Plates 49 and 52.

36. Richard Henderson, *The King In Every Man* (New Haven: Yale University Press, 1972) pp. 276–7.

37. Thurston Shaw, *Igbo-Ukwu,* Vol. I (London: Faber and Faber, 1970) pp. 74, 120, 141, 185, and 281.

38. Th. Monod, A. Teixeira da Mota, and R. Mauny, eds. *Description de la Cote Occidental d'Afrique* (Bissau: Centro de Estudos da Guine Portuguesa, 1951) p. 83.

39. Dominique Zahan, *Societes d'Initiation Bambara* (Paris: Mouton & Co., 1960) p. 150.

40. *Ibid.*

41. *Ibid.*, p. 152.

42. For another possible source of inland artistic influence in this area see Leon Siroto, Book Review, *American Anthropologist* Vol. 72, No. 1 (February 1970) p. 129: "Certain masks and headdresses from the Bissagos Islands are completely new to the field and suggest—perhaps with good reason—a maritime version of the art of the Upper Voltaic culture province." Possibly the Manding mediated this secondary influence, while strengthening the theme of the horned personage of power, however, the situation is extremely complex and cannot be fully rendered in these pages. Professor Peter Weil, who has done considerable fieldwork among Manding groups, informs me that the circumcision mask "in the Gambia region" illustrated by Froger in 1698 is to be attributed, probably, to the Dyola, a West Atlantic group. In addition, some Dyola soft-material masks possibly predate the coming of Manding masking influence. In other words, though Manding influence in horning is a fair supposition, Weil reminds us of the possibility of a prior Dyola sub-stratum in the art history of Senegambia. See also Weil's, "The Masked Figure and Social Control: The Mandinka Case" in *Africa* (October, 1971).

43. Fernando Galhano, *Esculturas e Objectos Decorados da Guine Portuguesa* (Lisbon: Junta de Investigacoes do Ultramar, 1971). The wearing position of this mask is modelled at page 42.

44. D. T. Niane, *Sundiata: An Epic of Old Mali* (London: Longmans, 1965) p. 62.

45. Rene Bravmann, *Islam and Tribal Art in West Africa: A Re-evaluation* (Ann Arbor: University Microfilms, 1971) pp. 195, 199.

46. *Ibid.*, p. 187.

47. *Ibid.*, p. 199.

48. Personal communication, 27 September 1973. I thank Professor Bravmann for sharing aspects of his recent fieldwork in Upper Volta.

49. Bravmann, personal communication, 3 October 1973.

50. Frans M. Olbrechts, *Les Arts Plastiques du Congo Belge* (Brussels: Editions Erasme, 1959). Second Edition. Plate 223, p. 150.

51. I have profited by conversation with Professor Daniel Biebuyck on the subject of kifwebe masks. See also J. Maes, *Aniota-Kifwebe: Les Masques des Populations du Congo Belge et le Materiel des Rites de Circoncision* (Anvers: Editions "De Sikkel," 1924) p. 36. I thank George Ellis for xeroxing a copy of this volume for me.

52. Marie-Louise Bastin, *Art Decoratif Tshokwe*, Vol. II, Plate 233. See also pp. 371–2.

53. For the field context, see Paul Gebauer, *A Guide to Cameroon Art from the Collection of Paul and Clara Gebauer* (Portland: Portland Art Museum, 1968), *i.e.*, an illustration showing, "gathering of masks at the funerary rites for the late Fon Nsi"

54. Katherine Coryton White archive.

55. Malcolm Ruel, "Witchcraft, Morality, and Doubt," in *Odu*, Vol. 2, No. 1 (July 1965) pp. 11–2.

56. Jan Vansina, *The Tio Kingdom of the Middle Congo: 1880–1892* (London: Oxford University Press, 1973). In 1963 Teke smiths were still characterized as "masters of fire" and their craft was related to royalty because of the king's eternal fire, the anvils in his kitchen, and for other reasons (p. 142). Tio chiefs of the Pool held in their right hand the ceremonial adze, with a flywhisk in the left, and a brass collar about their neck. In a sense, the adze, whose blade issued from the mouth of a human figure, represented the embodied speech of the ruler in a political sense (p. 335): "Lords had many retainers. Their messengers would go when ordered bearing the lord's adze . . . to bring his orders to squires and village leaders."

57. Igor Kopytoff, "The Suku of Southwestern Congo," in *Peoples of Africa*, ed. James L. Gibbs, Jr. (New York: Holt, Rinehart and Winston, 1965) p. 469.

58. *Ibid.*

59. *Ibid.*

60. Quoted in Bravmann, *Islam and Tribal Art in West Africa*, p. 158.

61. See R.F. Thompson, *Black Gods and Kings*, pp. 9/3–4.

62. Douglas Fraser, "The Legendary Ancestor Tradition" in *Colloquium on Negro Art*, Vol. II (Paris: Society of African Culture with the collaboration of UNESCO, 1971) pp. 152–177.

63. *Ibid.*, p. 153.

64. Denise Paulme, *African Sculpture* (London: Elek Books, 1962) p. 67–8.

65. Niane, *Sundiata*, p. 8: "your heart is generous and it is you who will be the buffalo's vanquisher . . . I am the buffalo you are looking for" and p. 26 where the witches say to the hero, "you confound us with your bounty." It is promised that they will flock on his roof as a sign that they will protect, not destroy, Sundiata's royal line. *Cf.* the theme of the bird on the roof of the palace of Benin. This may well be one of the ancient motifs of royal power in African art.

66. Okot p'Bitek, *Song of Lawino: An African Lament* (New York: Meridian Books, 1969) p. 40. I am most grateful to Sylvia Boone for bringing this poem to my attention.

67. Informants: The Agogohene of Agogo and Thomas Akyea, Agogo, Northern Ashanti, 1 January 1972.

68. Tom Davin, "Conversation with James P. Johnson" in *Jazz Panorama*, ed. Martin Williams (New York: Collier Books, 1964) p. 56.

69. *Ibid.*, p. 60.

70. *Ibid.*, pp. 58–9.

71. R.F. Thompson, "Dance and Culture" (Andover: Warner Modular Publications, 1973) p. R367–9.

72. Daniel Crowley, "Aesthetic Value and Professionalism in African Art: Three Cases from the Katanga Chokwe" in *The Traditional Artist in African Societies*, ed. Warren L. d'Azevedo (Bloomington: Indiana University Press, 1973) p. 247.

73. Leon Siroto, "The Face of the Bwiti" in *African Arts*, Vol. I, No. 3 (Spring 1968) p. 89.

74. *Ibid.*, p. 88.

75. R.F. Thompson, "Abatan: A Master Potter of the Egbado Yoruba" in *Tradition and Creativity in Tribal Art*, ed. Daniel Biebuyck (Berkeley and Los Angeles: University of California Press, 1969) pp. 179–80.

76. Informants: senior members of Akin Aina compound, Iletu, Iyessi, 13 July 1963.

77. Hugo Zemp, *Musique Dan* (Paris: Mouton, 1971) p. 97.

78. Hugo Zemp, commentary, *The Music of the Dan* (Barenreiter Musicaphon LP BM 30 L 2301) p. 1.

79. *Ibid.*

80. *Cf.* Rose Brandel, *The Music of Central Africa* (The Hague: Martinus Nihhoff, 1961) p. 32. For recorded Dan hocketing see Packard L. Okie, *Folk Music of Liberia* (Ethnic Folkways LP FE 4465) Side II, Band 1, "Gio Song."

81. Informant: George Tabmen, Monrovia, Liberia, 22 March 1967.

82. Hans Himmelheber, *Negerkunst und Negerkunstler* (Braunschweig: Klinkhardt & Biermann, 1960) p. 141.

83. *Ibid.*, p. 138.

84. George W. Harley, *Masks as Agents of Social Control in Northeast Liberia* (Cambridge: Peabody Museum, 1950).

85. *Ibid.*, pp. 30–1.

86. George Tabmen, Monrovia, 24 March 1967. Harley, *op. cit.* p. 9. Mario Meneghini, "The Bassa Mask" in *African Arts*, Vol. VI, No. 1 (Autumn 1972), p. 48; B. Holas, *Les Masques Kono* (Paris: Paul Geuthner, 1952) pp. 121–9. There are further instances, according to Harley, mentioned in his "Notes on the Poro in Liberia," *Papers of the Peabody Museum of Harvard University*, Vol. XIX, 1941, p. 12, wherein *maa go* are appropriately used. For example, a priest *(zo)*

might cool his anger and restore himself to poised rationality by washing his *maa go.* An initiated boy who had suffered bad dreams could wash his *maa go* and free himself of their disturbing influence.

87. Hans Himmelheber, "Die Geister und ihre irdischen Verkörperungen als Grundvorstellung in der Religion der Dan" in *Baessler-Archiv* NF, XII, p. 77–8.

88. Hans Himmelheber, "Sculptors and Sculptures of the Dan," *Proceedings of the First International Congress of Africanists*, ed. L. Brown and M. Crowder (London: 1964) pp. 243–55. Cited by Frank Willett in his *African Art* (London: Thames and Hudson, 1971) pp. 184–8.

89. Tabmen, Monrovia, 22 March 1967.

90. *Ibid.*

91. *Ibid.*

92. Informant: Laame of Boelay. Interviewed at Butuo, Western Dan, 29 March 1967.

93. Informant: the *zo* of Gaa Wree-Wre, interviewed near Butuo, 29 March 1967.

94. The original text is as follows:

> *Do zie gbee?*
> *A po Krua boo*
> *A po gbon gy zyy zy boo*
> *bia boo*
> *Tono boo!*
> *Me nu me do boo*
> *Yoo o yi!*
> *bia boo*
> *Tono boo!*
> *Gle bii boo yi*
> *Heeeeeeeeeeee! Heeeeeeeeeeeeeey!*
> *Ee gle boo*
> *Do zie gbee?*
> *Do zie?*

95. Harley, *Masks*, p. 41; Himmelheber, "Die Geister . . . ," p. 80; Himmelheber, *Negerkunst . . .* , p. 153.

96. *Cf.* Harley, *Masks*, p. 41: "he carried a whip or stick with two iron prongs, threw things around and beat people."

97. Himmelheber, *Negerkunst . . .* (p. 153) distinguishes three types of kao gle: (1) the "cubistic" Dan mode (2) the red-snout Kran mask called *Tradgo*, with deep-set eyes; (3) the Kran mask *Gbonkila*, having the head of a rhinoceros bird.

98. Informant: Chief Tomah of Butuo, 1 April 1967.

99. Informant: George Tabmen, Butuo, 1 April 1967.

100. Informant: Chief Tomah of Butuo, 1 April 1967.

101. *Ibid.*

102. Himmelheber, *Negerkunst . . .* , p. 153.

103. I am indebted to the elders of the Miame Clan, Butuo, for these terms.

104. At a screening of a film of Dan masks in action by Hans Himmelheber, at the University of California, Berkeley, on 6 May 1967, I was struck by the appearance of an identical up-down looming gesture used by a mask and its followers. The mask did not seem to be of the *kao gle* category, at least in terms of facial structure. Possibly aspects of one mask's dance can be recombined with aspects of another, even as facial traits are sometimes recombined in the making of Dan masks.

105. Compare a Kran procedure within the kao gle category: "*Badekomo* [a "hook spirit"] fell into a rage every few minutes and hurled stones, clods of earth, pieces of wood . . . at his singers, who gracefully caught the objects in their shields, never pausing in their singing and moving backwards and forwards in rhythm." For a superb illustration see Himmelheber, *Negerkunst . . .* , Plate VI, and p. 145.

106. *Cf.* Gregory Bateson, *Steps To An Ecology Of Mind* (New York: Ballantine Books, 1972) p. 498: "The healthy system, dreamed of above, may be compared to an acrobat on a high wire. To maintain the

ongoing truth of his basic premise ('I am on the wire'), he must be free to move from one position of instability to another If his arms are fixed or paralyzed (isolated from communication), he must fall." These notions apply even more appropriately to the understanding of Dan stilt-dancing.

107. *I.e.*, during the 1860's. Most sources agree on the Kono origin of Dan stilt-dancing. Holas, *Les Masques Kono*, pp. 110–114; Himmelheber, *Die Dan* (Stuttgart: W. Kohlhammer, 1958) p. 20, 88–89; Etta Donner, *Hinterland Liberia* (London and Glasgow: Blackie & Son, 1939) p. 138.

108. Hugo Zemp, 'Eine esoterische Uberlieferung uber den Ursprung der maskierten Stelzentanzer bei den Dan (Elfenbeinkuste)" in *Festschrift Alfred Buhler*, ed. Carl A. Schmitz and Robert Wildhaber (Basel: Pharos-Verlag, 1965) p. 456.

109. Zemp, *ibid.*, pp. 452–3; Holas, pp. 112–3. Holas claims the long tress which hangs from the middle of the face represents the nose.

110. Zemp, p. 453.

111. Peter Mark, unpublished research report on films of Dan masks in motion, Yale University, Spring 1973.

112. Jacques Bernolles' *Permanence de la Parure et du Masque Africains* (Paris: G. –P. Maisonneuve et Larose, 1966) pp. 168–70, surveys African stilt-dancing. Herbert Cole's *African Arts of Transformation* (Santa Barbara: The Art Galleries of the University of California, Santa Barbara, 1970) p. 50 reminds us of the basic fact that human dimensions are dramatically transcended by lengthening the limbs in stilt-dancing.

 Worth examination is the meaning of the frequent resting of Dan stilt-dancers on the roofs of habitations. It is just possible that by this act they clear the roofs from traces of witchcraft, left by night people come to roost in bird-like form.

113. There are many terms for Ejagham. Efik call them "Ekoi." Efik also designate as "Qua" the Abakpa Ejagham of Calabar. Up river, the Banyang of the Mamfe area call their Ejagham neighbors "Keaka."

114. Rosemary Harris, *The Political Organization of the Mbembe* (London: Her Majesty's Stationery Office, 1965) p. 135, note 1.

115. Daryll Forde, *Yako Studies* (London: Oxford University Press, 1964) p. 159.

116. P. Amaury Talbot, *In the Shadow of the Bush* (London: William Heinemann, 1912) p. 287.

117. *Ibid.*

118. Philip Allison, *African Stone Sculpture* (New York: Praeger, 1968) p. 27. As to the importance of hunting among Ejagham men, see Talbot, p. 142.

119. Talbot, *op. cit.*

120. Philip Allison, *Cross River Monoliths* (Lagos: Department of Antiquities, 1968). The figure, two hundred sixteen, does not refer to the entire corpus of known monoliths, which nearly numbers three hundred, but to a select group of basalt akwanshi among the Nta, Nnam and Nselle Ejagham. As Allison says (p. 31): "Of these, the Nta Akwanshi show the greatest variety of styles and the traditions surrounding them are better preserved than elsewhere, which suggests that it may be from these that all the Akwanshi derive."

121. Talbot, *op. cit.*, p. 39.

122. Marcilene Wittmer, "Distribution Of Cross River Skin-Covered Heads," unpublished research paper, Indiana University, 1970, p. 7. I am grateful to Mrs. Wittmer for a copy of this paper.

123. Keith Nicklin, "Nigerian Skin-Covered Masks" in *African Arts* (in press).

124. *Ibid.*

125. I am immensely grateful to the Chief of Otu, Emanuel Nyok, for courtesies extended on each of my research trips to Otu, especially in June 1973.

126. The tentative portrayal of this style range is based on documented examples in the collections of the Nigerian Museum Lagos; Museum fur Volkerkunde, Vienna; and the Linden Museum, Stuttgart.

239

127. Harris, *op. cit.*, pp. 202–3.

128. Marcilene Wittmer, *Images of Authority: From Benin to Gabon* (Miami: Lowe Art Museum, 1973) p. 22. See also *A Guide to Cameroon Art from the Collection of Paul and Clara Gebauer*, "Dancers in the Mameta marketplace," Widekum area; *cf.*, Basel Museum 1143, helmet mask from Mameta, bought in Bali in 1938. Finally, *cf.* Paul Gebauer, "Art of Cameroon" in *African Arts*, Vol. IV, No. 2 (Winter 1971) Fig. 4.

129. Allison, *Cross River Monoliths* p. 34–5, *re.* the antiquity of the akwanshi: "Although the evidence . . . is conflicting and far from complete, it suggests that the monoliths of the Nta were carved during a period extending from the beginning of the sixteenth century to the beginning of the present century."

130. The best survey of traditional black writing in Africa is David Dalby's "The Indigenous Scripts of West Africa and Surinam: Their Inspiration and Design," *African Language Studies*, IX, 1968, pp. 156–197. The signs given in this volume derive primarily from Talbot, plus other early twentieth century sources given in Dalby's article. I have added to this the important Afro-Cuban study, Lydia Cabrera, *La Sociedad Secreta Abakua* (Havana: Ediciones CR, 1959), useful for the study of Ejagham sacred scripts in Caribbean continuation. According to Cabrera's Ejagham-descended or Ejagham-influenced informants, the sign of the Janus is most important (p. 185): "the circle (*arakasuaka*) divided by crossed lines, with the small circles . . . the *biane*, four small circles which symbolize the eyes of Tanze and Sikan." Tanze is the divine leopard-fish, associated with the sky; Sikan, a female spirit associated with the earth.

131. Malcolm Ruel's *Leopards and Leaders* (London: Tavistock, 1969) provides an excellent overview on Ngbe as a social system, pp. 216–258. I have relied heavily upon these pages.

132. *Ibid.*, pp. 231–2.

133. Informant: Ekong Imuna, Big Qua Town, Calabar, 14 January 1972. Efik gloss the sign in the following manner: *mkpa edem nwut ebe—* lit. "show back to the husband."

134. Informant: Patrick O. Ekuri, Middle Cross River area, interviewed at Besongabang, Cameroon, 2 June 1969.

135. Informant: Chief Defang Tarhmben, Defang, Cameroon, 12 June 1973.

136. *Ibid.*

137. Patrick Ekuri, as from Middle Cross River area.

138. Informant: Chief Ayuk Ngie, Customary Court, Tinto, Manyu, Cameroon, 7 January 1972.

139. *Ibid.*

140. Ekong Imuna, Big Qua Town.

141. Imuna gives original Abakpa: *Oso abo obat uye njom ja ninkoe—* "if you wash hands clean, you'll eat food with elders."

142. Ruel, *op. cit.*, p. 233.

143. Informant: The Ndidem of Big Qua Town, Nigeria, 14 January 1972.

144. Ruel, p. 233.

145. *Ibid.* Spoken in my presence by the Chief of Akriba, Upper Banyang, during an Ngbe funeral ceremony, March 1973.

146. Informant: Ndidem of Big Qua Town.

147. *Ibid.*

148. See description of the Ngbe costume at Otu, Cameroon, *infra.*

149. Informant: Ekuri of Besongabang.

150. Chief of Akriba, March 1973.

151. Told the author by various Ngbe members from Kendem area, at Mamfe, Cameroon, June 1973.

152. For a document of such music see Harold Courlander's *Cult Music of Cuba* LP, recorded on the Ethnic Folkways label, Havana, 1940. The Ejagham quality of this music is relatively pure; the meter is 6/8.

153. Ruel, *op. cit.*, p. 231.

154. *Cf.* J. H. Kwabena Nketia, *African Music in Ghana* (Evanston: Northwestern University Press, 1963) p. 61.

155. The Abakua (Afro-Cuban Ejagham) equivalent is: placing two crossed plantains on the earth. This has the identical effect of "stopping" the masked Ngbe dancer. I am grateful to Argeliers Leon for bringing this detail to my attention during a *plante* (Ngbe ceremony) witnessed in Marianao, Cuba, April 1960.

156. Independently, the chief of Otu, Cameroon, and the Ndidem of Big Qua Town.

157. Ruel, *op. cit.*, p. 224.

158. For an early notice of the *monyo* staff, see M. D. W. Jeffreys, "Some Notes on the Ekoi," *Journal of the Royal Anthropological Institute*, 69, (1939) p. 102.

159. This "voice" has been described in context. Harold Courlander, "Abakua Meeting in Guanabacoa" in *The Journal of Negro History*, ed. Carter G. Woodson, Vol. XXIX (October 4, 1944) p. 467 and p. 468–9. The classic source is Fernando Ortiz, *Los Instrumentos de la Musica Afrocubana*, V, (Havana: Cardenas and Co., 1955) pp. 203–61.

160. Informant: Ekuri of Besongabang.

161. It is present in Cuba, as copiously documented by Ortiz and Cabrera, and it has reached the Cameroon Grasslands, among the Bangwa. For details of the latter diffusion, see Robert Brain and Adam Pollock, *Bangwa Funerary Sculpture* (Toronto and Buffalo: University of Toronto Press, 1971) pp. 107–8.

162. Ruel, *Leopards and Leaders*, p. 248, note 1.

163. Chief Defang, in a conversation documented at Mamfe, June 1973.

164. *Ibid.*

165. Told to me by an Ngbe member at Mamfe, 9 June 1973. On that evening Chief Defang added, "if I am in danger at night or if I am in danger in an automobile—I have to turn into a leopard."

165a. R. F. Thompson, *Black Gods and Kings*, Chapter 1.

166. Frank Willett, *African Art*, p. 269–70, note 68.

167. H. W. Janson, *History of Art* (Englewood Cliffs: Prentice-Hall, 1964) p. 29.

168. R. F. Thompson, "The Sign of the Divine King" in *African Arts*, Vol. III, No. 3 (Spring 1970) pp. 8–17, 74–80.

169. Peter Morton-Williams, "The Yoruba Ogboni Cult in Oyo" in *Africa*, XXX, pp. 362–74.

170. Roy Sieber, "Ede: Crafts and Surveys" in *African Arts*, Vol. VI, No. 4, p. 46.

171. *Black Gods and Kings*, Chapter 12.

172. Paula Ben-Amos and Osarenren Omoregie, "Ekpo Ritual in Avbiama Village" in *African Arts*, Vol. II, No. 4 (Summer 1969) p. 10.

173. I am immensely grateful to Father Kevin Carroll for sharing his unpublished field documentation, written in Yoruba, with me. The citation is from his notes on Ekiti art and the translation from the Yoruba is mine. I received these materials in 1962.

174. *Ibid.*

175. *Ibid.*

176. John Picton, interview at the British Museum, 26 August 1970.

177. Informant: the Elepa of Igogo-Ekiti, 18 August 1965.

178. S. A. Babalola, *The Content and Form of Yoruba Ijala* (Oxford: Oxford University Press, 1966) p. 7, note 1.

179. Elepa of Igogo, 18 August 1965.

180. *Ibid.*

181. Informant: Cosmas Ogidi, Igogo-Ekiti, 18 August 1965.

182. This is my own interpretation.

183. Cabrera, *Sociedad Secreta*, p. 163, illustration; Ortiz, Vol. V, 1955, Fig. 458.

184. Ben-Amos and Omoregie, p. 13.

185. Informants: The Chief of Igogo and the Elepa, 21 August 1964.

186. *Ibid.*

187. Cosmas Ogidi, 18 August 1965. *Cf.* a similar statement by the Chief of Igogo, Appendix, Informant 33.

188. Elepa of Igogo, 18 August 1965.

189. *Black Gods and Kings*, p. 16/1.

190. Chief of Igogo, 21 August 1964.

191. Raymond Prince, "The Yoruba Image of the Witch" in *The Journal of Mental Science* [British Journal of Psychiatry] 107, No. 449, p. 797. It is impossible to overstress the importance of this article for the study of Yoruba artistic philosophy.

192. *Ibid.*

193. *Ibid.*, p. 796.

194. Pierre Verger, "Grandeur et decadence du culte d'iyami osoronga (ma mere la sorciere) chez les Yoruba" in *Journal de la Societe des Africanistes*, 35, No. 1 (1965) p. 147.

195. For a fragment of this myth, see Verger, 1965, p. 189.

196. *Black Gods and Kings*, p. 14/4.

197. Ulli Beier, "Gelede Masks" in *Odu*, No. 6 (June 1968) p. 5.

198. Told by the Araba of Lagos, January 1972.

199. Henry Drewal, "Efe: Voiced Power and Pageantry" in *African Arts*, forthcoming.

200. Peggy Harper, "The Role of Dance in the Gelede Ceremonies of the Village of Ijio" in *Odu*, New Series, No. 4 (October 1970) p. 76. The term, in Yoruba, is: *enu ashe*.

201. Henry Drewal, personal communication, October 1973.

202. Drewal, "Efe: Voiced Power . . ."

203. Informant: Lasisi Ogunipe, Ketu, Dahomey, 10 September 1972.

204. Drewal, "Efe: Voiced Power . . ."

205. I am indebted to Bola Ajasha, of the Ketu Gelede house of Isale-Eko, who both transcribed and translated the songs of Efe on 5 January 1964, of which excerpts are given in this sub-section.

206. Translation: Bola Ajasha.

207. *Ibid.*

208. Adisa Fagbemi, Ajilete, Nigeria, December 1962.

209. Henry Drewal, *Efe/Gelede: The Educative Role of the Arts in Traditional Yoruba Culture*. Unpublished Ph.D. dissertation, Columbia University, 1973.

210. *I.e.*, informants at Ajilete, among the Egbado of Ibara quarter, Abeokuta, and at Lagos.

211. Source: Adesanyan, Ketu, 9 September 1972.

212. Appendix, Informant 13.

213. Informant: Fagboun, Aide Olifagi, Ilogbo, Ketu, 10 September 1972.

214. Adesanyan Adegbami of Ketu, 9 September 1972.

215. Appendix, Informant 13.

216. Adesanyan Adegbami.

217. I was able to videotape for UCLA the ritual dressing of this young performer at the house of Ogundipe, Ketu.

218. Informant: Jean Adegbite, Takon, Dahomey, 8 September 1972. Adegbite was an admirable dancer-informant, causing a sensation wherever he performed in Ketu and Anago territory in Dahomey in the late summer of 1972.

219. For a short bibliography on the Banyang, relatively unknown to the literature of African art history, see Ruel, *Leopards and Leaders*, pp. 335–338.

220. Ruel, "Witchcraft, Morality, and Doubt."

221. *Ibid.*, p. 26.

222. Malcolm Ruel, "The Modern Adaptation of Associations among the Banyang of the West Cameroon" in *Southwestern Journal of Anthropology*, Vol. 20, No. 1 (Spring 1964) p. 3.

223. Ruel, "Witchcraft . . . ," p. 21. The vernacular term in Kenyang for "see the place" is *degomban*.

224. Informant: Peter Eno, Mamfe, June 1969.

225. Talbot, 1912, p. 198.

226. *E.g.*, Talbot, p. 45: "The most interesting figure in the last New Year's dance, however wore nothing rich or attractive. This was the Ekuri Ibok It is a very old Ekoi Juju, but was renamed a few years ago when the axe was placed between its jaws in addition to the other insignia. The image was robed in a long gown of dark blue cloth, daubed with mud from the river bed. Over the robes of the image dark-spotted juju leaves were fastened here and there. On its head it bore a crocodile mask, carved in wood It was attended by two hunters armed with flint-lock guns, a third bore a fishing net, and a fourth a curious earthen trumpet covered with leopard skin." The relationship to the style of the Basinjom mask and retinue is systematic. This reference implies that the roots of the Basinjom tradition, despite the apparent "emergence" of the form, at Oban at the turn of the century, may well be ancient.

227. Informant: Chief Defang, Upper Banyang, June 1973.

228. *Ibid.*

229. I am grateful to the elders of the Defang Basinjom society for the privilege of documenting initiatory details within their grove on the outskirts of Defang in March 1973.

230. For the sociological background of the Basinjom cult among the people of Kenyang see Ruel, *Leopards and Leaders*, pp. 210–3.

231. Solomon Ekong, priest of Basinjom, spoke; his words were translated by Chief Defang and later glossed both by Defang and Ako Nsemayu, independently, the latter reviewing my materials with great care at Mamfe, both in March and June of 1973. At Mamfe, Moses Akpa added details missing from the original documentation. The account is therefore a synthesis.

232. There are examples of the Basinjom head and gown in the collections of the Museum fur Volkerkunde, Basel, in the Dublin Museum, and the Nigerian Museum, Lagos. As to the Basel specimen, Katherine Coryton White reported, in the winter of 1972–73, that shells were sewn to the gown "like occasional sequins, looking truly magical." Personal communication. I am grateful to George Ellis, for bringing the Dublin specimen to my attention.

233. Ekong, Defang, Nsemayu and Akpa, March and June 1973. The merits of this account belong entirely to these men.

234. The account is, again, a composite of events both viewed and explained.

235. This is also the "clave beat," the basic artery of Afro-Cuban music.

236. Robert Plant Armstrong, *The Affecting Presence* (Urbana: University of Illinois Press, 1971) p. 132.

237a. The clearest rendering of this portion of the ceremony was given by Ako Nsemayu.

237b. Transliteration and English translation by Rudolph Fongang and Chief Defang.

238. Source: Chief Defang, June 1973.

239. Informants: Ajao and others, Ipapo, western Oyo, July 1965.

240. Source: Araba Eko, August 1964.

241. *Ibid.*

242. *Ibid.*

243. *Ibid.*

244. Juana Elbein dos Santos and Deoscoredes M. dos Santos, "Ancestor Worship in Bahia: The Egun-Cult" in *Journal de la Societe des Americanistes*, Vol. LVIII (1969) p. 88. For earlier sources, see index entry, "Egungun," H. Cole and R.F. Thompson, *Yoruba Sculpture Bibliography* (New York: Museum of Primitive Art, 1964).

245. R.C. Abraham, *Dictionary of Modern Yoruba* (London: University of London Press, 1958) p. 345.

246. S.F. Nadel, *Nupe Religion* (New York: Schocken Books, 1954) Second Edition, p. 172.

247. Pierre Verger, *Notes sur le Culte des Orisa et Vodun* (Dakar: I.F.A.N., 1957). I have combined praises from Ketu, Aja Were, 416–7, and Baningbe, 418, pp. 415, 416–7, 418.

248. Informant and helper: Akindele Latifu, summer 1963.

249. William Bascom, *The Yoruba of Southwestern Nigeria* (New York: Holt, Rinehart and Winston, 1969) pp. 93–4.

250. dos Santos, p. 95.

251. Appendix, Informant 29.

252. Interviewed at Cotonou, June 1973.

NOTES TO PREFACE

1. Charles Keil, *Tiv Dance: A First Assessment* (1966), generously shared with the writer in a personal communication from northern Nigeria in 1966.

2. See the first section of Chapter III.

3. Here I have been partially inspired by Dan Rose's interesting paper, "Continuities of Sensibility Within Circum-Atlantic Populations," delivered at the XIIIth Annual Meeting of the Northeastern Anthropological Association in Burlington, Vermont, April 27, 1973. Rose talked about United States blacks conceptualizing, at the traditional level, the parts of the body as having a life of their own and that from this bodily mosaic energy for the creation of autonomy is liberated. His point is subtle and I think it applies, as well, to the brilliant vibration of the parts of the musculature in some forms of traditional subsaharan dancing. It also applies, perhaps, at another level of conceptualization, to the detachment of the force of the self and its addition to works of art in the dance to complete the object's meaning and communicative force.

4. *Cf.* Jacques Maritain, *Creative Intuition in Art and Poetry* (New York: Pantheon, 1953) p. 3: "By Poetry I mean, not the particular art which consists in writing verses, but a process both more general and more primary: that intercommunication between the inner being of things and the inner being of the human Self which is a kind of divination (as was realized in ancient times; the Latin *vates* was both a poet and a diviner). Poetry, in this sense, is the secret life of each and all of the arts." The inclusiveness of all the arts is a happy solution, in the Maritain definition of poetry, and has the added force of honoring the exquisitely multi-vocal expressions of African art in motion and musical settings. Those traditional Africans, one Yoruba, the other Banyang, who have initiated me into their religious societies took pains to emphasize the secret life of objects as symbols of higher powers and purer levels of being. When Maritain directs our attention to the importance of metaphor and spiritual interpenetration in art and poetry it is almost as if he were speaking as a colleague of the traditional priests and artists in Africa, for whom these qualities loom as well-nigh imperative.

5. I briefly sketched the notion of danced art in Africa in my "Sons of Thunder: Twin Images Among the Oyo and Other Yoruba Groups," *African Arts*, Vol. IV, No. 3 (Spring 1971) p. 79, n. 31. But the present volume is the first occasion I have had to really explore this important aspect.

6. Noted during the initiation of three young men into the second grade of the Basinjom cult, in the Basinjom Grove, near Defang, Cameroon, 17 March 1973. I am enormously grateful to Neil Allen for assisting in the field work of that day.

7. Informants: Chief Defang Tarhmben and Solomon Ekong, of Defang and Sumbe villages, west Cameroon, 17 March 1973.

8. It is interesting that among a group of intelligent observers of the arts in Africa, it was a black poet who came closest to the truth in Ghana, closer than a straightforward student of traditional music. By the "truth" I mean, of course, the fact of the fusion of the arts of sound and space in African festival and ritual life. Thus, while Philip Gbeho, in his "The Indigenous Gold Coast Music," *Journal of the African Music Society*, Vol. 1, No. 5 (1952) says, at page 31, "May I make it clear that when I talk about music I am referring to drumming, dancing, and singing? They are all the same thing and must not be separated," his compatriot, Francis Ernest Kobina Parkes, in a poem, "African Heaven," restores to this unity a missing visual dimension:

> Let the calabash
> Entwined with beads
> With blue Aggrey beads
> Resound . . .
> Mingle with these sounds
> The clang of wood on tin:
> *Kentensekenken*
> *Ken-tse ken ken ken*

He saw the flash of brilliant beads as well as the dancing bodies. This poem was published in *New World Writing No. 15* (New York: Mentor, 1959) pp. 230–232.

Similarly, a Western musicologist, the Rev. A.M. Jones, in his *Studies in African Music*, Vol. I (London: Oxford University Press, 1959), says, at page 51: "The norm of African music is the full ensemble of the dance; all other forms of music are secondary This consists of the instruments of the orchestra, the hand-clapping, the song, and the dance." It remained for Joel Adedeji, a student of the drama, to set the record straight by reference to costume, cosmetics, coiffure, and other visual arts which complete important aesthetic happening in traditional Africa. Adedeji's remarks, albeit written in terms of Yoruba traditional drama in Nigeria, nonetheless apply to many civilizations of West and Central Africa: "the aesthetics of the Yoruba theatre are the total integration . . . of all the art forms in one performance . . ." Quoted in Herbert M. Cole, *African Arts of Transformation* (Santa Barbara: The Art Galleries of the University of California, Santa Barbara, 1970) p. 56. In sum, traditional African creativity can unite music, handclapping, singing, dancing, and various forms of visual address, especially the use of beads and coiffure. But we must not forget exceptions, such as a single man serenading himself with an *mbira* (the so-called "thumb piano") while walking down a lonely path, or dirges without rhythmic pulsation, and so forth.

BIBLIOGRAPHY

Abraham, Roy C.
1958 *A Dictionary of Modern Yoruba,*
 London, University of London Press.

Abrahams, Roger
1970 "Patterns of Performance in the British West Indies,"
 Afro-American Anthropology, ed. Norman E. Whitten and John F. Szwed, New York, The Free Press.

Adanson, Michel
1759 *A Voyage to Senegal, the Isle of Goree, and the River Gambia,*
 London, J. Nourse.

Ajayi, J. F. Ade and Robert Smith
1964 *Yoruba Warfare in the Nineteenth Century,*
 Cambridge, Cambridge University Press.

Alexander, James
1837 *Narrative of a Voyage of Observation among the Colonies of Western Africa in the Flagship Thalia; and of a Campaign in Kaffir-Land,* maps and plates,
 C. C. Mitchell, London, Henry Colburn.

Allison, Philip
1960 Unpublished field notes (typewritten),
 Nigerian Museum, Lagos.
1968a *African Stone Sculpture,* New York, Praeger.
1968b *Cross River Monoliths,*
 Lagos, Department of Antiquities.

Ameyaw, Kwabena
1966 "Funerary Effigies from Kwahu,"
 Ghana Notes and Queries, 8.

Antubam, Kofi
1963 *Ghana's Heritage of Culture,*
 Leipzig, Koehler & Amelang.

Armstrong, Robert Plant
1971 *The Affecting Presence,*
 Urbana, University of Illinois Press.

Atkins, John
1737 *A Voyage to Guinea, Brasil, and the West Indies*
 (Second Edition), London, Ward & Chandler.

Awe, Bolanwe
1973 "Militarism and Economic Development in Nineteenth Century Yoruba Country: The Ibadan Example," *Journal of African History,* XIV.

d'Azevedo, Warren
1968 "Standard Elements of Design Employed by Woodcarvers" (mimeographed).

Babalola, S. A.
1966 *The Content and Form of Yoruba Ijala,*
 Oxford, Oxford University Press.

Baduel-Mathon, Celine
1971 "Le Langage Gestuel en Afrique Occidentale:
 Recherches Bibliographiques,"
 Journal de la Societe des Africainistes, XLI, 2.

Bartenieff, Irmgard and Forrestine Paulay
1968 "Choreometric Profiles," *Folk Song Style and Culture,*
 ed. Alan Lomax, Washington, D.C., American Association for the Advancement of Science.

Bascom, William
1967 *African Arts,* Berkeley, Robert H. Lowie Museum of Anthropology.
1969 *The Yoruba of Southwestern Nigeria,*
 New York, Holt, Rinehart & Winston.

Bastin, Marie-Louise
1961 *Art Decoratif Tshokwe,*
 Lisbon, Campanhia de Diamantes de Angola.

Bateson, Gregory
1972 *Steps To An Ecology Of Mind,*
 New York, Ballantine Books.

Beart, Charles
1955 *Jeux et Jouets de l'Ouest Africain,*
 Dakar, I.F.A.N.

Beattie, John
1969 *Spirit Mediumship and Society in Africa,*
 London, Routledge, Kegan Paul.

Becco, Horacio Jorge
1951 *El Tema del Negro en Cantos, Bailes, y Villancicos de los Siglos XVI y XVII,*
 Buenos Aires, Ollantay.

Beier, Ulli
1968 "Gelede Masks," *Odu,* 6 (June).

Beier, Ulli and Bakari Gbadamosi
1959 *Yoruba Poetry,* Lagos, Black Orpheus.

Ben-Amos, Paula and Osarenren Omoregie
1969 "Ekpo Ritual in Avbiama Village,"
 African Arts, II, 4 (Summer).

Berliner, Paul
1970 *The Meaning of the Mbira, Nyunga-Nyunga*
 (mimeographed), M.A. Thesis, Wesleyan University.
1972? *The Soul of Mbira* (LP H-72054), linear annotation,
 New York, Nonesuch Records.

Bernolles, Jacques
 1966 *Permanence de la Parure et de Masque Africains,*
 Paris, G.-P. Maisonneuve et Larose.

Biebuyck, Daniel
 1972 "The Kindi Aristocrats and their Art among the Lega,"
 African Art and Leadership, ed. Douglas Fraser and
 Herbert M. Cole,
 Madison, University of Wisconsin Press.
 1973 *Lega Culture,* Berkeley and Los Angeles,
 University of California Press.

Binger, Louis Gustave
 1892 *Du Niger au Golfe de Guinee,* woodcuts after
 drawings by Riou, Paris, Hachette.

Bird, Charles S.
 1973 Personal communication, 3 April.

Blacking, John
 1961 "Patterns of Nsenga Kalimba Music,"
 African Music, 2, 4.

Blackmun, Barbara and Matthew Schoffeleers
 1972 "Masks of Malawi," *African Arts,* V, 4 (Summer).

Blake, John William, ed.
 1942 *Europeans in West Africa,* London, Hakluyt Society.

Bohannan, Laura (pseud. Eleanor Bowen Smith)
 1964 *Return to Laughter,* Garden City, Doubleday.

Boone, Sylvia Ardyn
 1972 "Sources for the History of Black Dance: Egypt and
 the Middle East," unpublished seminar report,
 Yale University.
 1973 *The Sande Society Mask: Bundu,*
 M.A. Thesis, Yale University.

Bowen, T. J.
 1858 *Grammar and Dictionary of the Yoruba Language,*
 Washington, D.C., Smithsonian Contributions
 to Knowledge.

Brain, Robert and Adam Pollock
 1971 *Bangwa Funerary Sculpture,*
 Toronto and Buffalo, University of Toronto Press.

Brandel, Rose
 1961 *The Music of Central Africa,*
 The Hague, Martinus Nihhoff.

Bravmann, Rene
 1970a *West African Sculpture,*
 Seattle, University of Washington Press.
 1970b "Masking Tradition and Figurative Art Among
 The Islamized Mande" (mimeographed),
 paper read at Boston University.
 1971 *Islam and Tribal Art in West Africa: A Re-evaluation,*
 Ann Arbor, University Microfilms.
 1973 Personal communications, 27 September
 and 3 October.

Burrows, Guy
 1898 *The Land of the Pygmies,* London, C.A. Pearson.

Burssens, H.
 1958 "La Fonction de la Sculpture Traditionelle
 chez les Ngbaka," *Brousse,* 2.

Burton, Richard
 1860 *The Lake Regions of Central Africa,*
 London, Longman, Green, Longman & Roberts.

Buytendijk, F. J. J.
 1957 *Attitudes et Mouvements,*
 Bruges, Desclee de Brouwer.

Cabrera, Lydia
 1959 *La Sociedad Secreta Abakua,* Havana, Ediciones CR.

Cabrita, Carlos
 1954 *Em Terras de Luenas,*
 Lisbon, Agencia Geral do Ultramar.

Carroll, Kevin
 1962 Field notes.
 1967 *Yoruba Religious Carving,* New York, Praeger.

Churchill, Awnsham
 1752 *Collection of Voyages and Travels,* Vol. VI, *Captain
 Thomas Phillips Journal of his voyage from England
 to Cape Mounseradoe in Africa and thence along the
 Coast of Guiney to Whidaw,* London.

Coe, Ralph
 1962 *The Imagination of Primitive Man,* Kansas City, The
 Nelson Gallery and Atkins Museum Bulletin, 1962.

Cole, Herbert M.
 1970 *African Arts of Transformation,*
 Santa Barbara, The Art Galleries
 of the University of California, Santa Barbara.

Cole, Herbert M. and Robert Farris Thompson
 1964 *Yoruba Sculpture Bibliography,*
 New York, Museum of Primitive Art.

Cornet, Joseph
 1971 *Art of Africa: Treasures from the Congo,*
 London, Phaidon.

Cory, H.
 1956 *African Figurines,* London, Faber & Faber.

Courlander, Harold
 1940 *Cult Music of Cuba* (LP), Havana, Ethnic Folkways.
 1944 "Abakua Meeting in Guanabacoa,"
 The Journal of Negro History, XXIX (October).

Crowley, Daniel J.
 1971 "An African Aesthetic," *Art and Aesthetics in Primitive
 Societies,* ed. Carol Jopling, New York, Dutton.
 1972 "Chokwe: Political Art in a Plebian Society," *African
 Art and Leadership,* ed. Douglas Fraser and Herbert
 M. Cole, Madison, University of Wisconsin Press.
 1973 "Aesthetic Value and Professionalism in African Art:
 Three Cases from the Katanga Chokwe,"
 The Traditional Artist in African Societies,
 ed. Warren d'Azevedo,
 Bloomington, Indiana University Press.

Crownover, David
 1962 "Take the Chair," *Expedition,* 4, 4 (Summer).

Curtin, Philip
 1964 *The Image of Africa,*
 Madison, University of Wisconsin Press.

Dalby, David
1968 "The Indigenous Scripts of West Africa
and Surinam: Their Inspiration and Design,"
African Language Studies, IX.

Dalton, O. M.
1901 "On Carved Doorposts from the West Coast
of Africa," *Man*, I.

Davin, Tom
1964 "Conversation with James P. Johnson," *Jazz Panorama*,
ed. Martin Williams, New York, Collier Books.

Delobsom, A. A.
1932 *L'Empire du Mogho-Naba*,
Paris, Editions Domat Montchrestien.

Denham, D., H. Clapperton and Dr. Oudney
1826 *Narrative of Travels and Discoveries in Northern
and Central Africa*, London, J. Murray.

Donner, Etta
1939 *Hinterland Liberia*,
London and Glasgow, Blackie & Son.

Drewal, Henry
1973a Personal communication, October.
1973b *Efe/Gelede: The Educative Role of the Arts
in Traditional Yoruba Culture*, unpublished
Ph.D. dissertation, Columbia University.
n.d. "Efe: Voiced Power and Pageantry,"
African Arts, forthcoming.

Dubinskas, Frank
1972 *The Beauty of the Sowo: Spirit of the Mende
Women's Secret Society*, unpublished MS, Berkeley.

Ellison, Ralph
1952 *Invisible Man*, New York, Random House.

Etienne, Pierre
1968 "Les Baoule et le Temps,"
Cahiers Ostrom ser. Sciences Humaines, 5, 3.

Evans-Pritchard, E. E.
1928 "The Dance," *Africa*, I, 4 (October).

Fagg, William B.
1968 *African Tribal Images*,
Cleveland, Cleveland Museum of Art.

Fagg, William B. and Margaret Plass
1964 *African Sculpture*, New York, Dutton.

Fernandez, James
1971 "Principles of Opposition and Vitality in Fang
Aesthetics," *Art and Aesthetics in Primitive Societies*,
ed. Carol Jopling, New York, Dutton.

Fischer, Humphrey J.
1972– "He Swalloweth the Ground with Fierceness
1973 and Rage: The Horse in the Central Sudan,"
Journal of African History, XIII, 3; XIV, 3.

Flam, Jack
1971 "The Symbolic Structure of Baluba Caryatid Stools,"
African Arts, IV, 2 (Winter).

Forde, Daryll
1964 *Yako Studies*, London, Oxford University Press.

Frankfort, Henry
1970 *The Art and Architecture of the Ancient Orient*
(Paperback edition), Baltimore, Penguin Books.

Fraser, Douglas
1971 "The Legendary Ancestor Tradition," *Colloquium
on Negro Art*, Paris, Society of African Culture with
the collaboration of UNESCO.

Friedrich, Carl J., ed.
1953 *The Philosophy of Hegel*, New York, Modern Library.

Fry, Philip
1970 "Essai sur la statuaire Mumuye," *Objets et Mondes*.

Galhano, Fernando
1971 *Esculturas e Objectos Decorados da Guine
Portuguesa*, Lisbon, Junta de Investigacoes do Ultramar.

da Gama, Vasco
1898 *The Journal of the First Voyage of Vasco da Gama*,
ed. and trans. E. G. Ravenstein,
London, Hakluyt Society.

Gbeho, Philip
1952 "The Indigenous Gold Coast Music,"
Journal of the African Music Society, I, 5.

Gebauer, Paul
1964 *Spider Divination in the Cameroons*,
Milwaukee, Milwaukee Public Museum.
1968 *A Guide to Cameroon Art from
the Collection of Paul and Clara Gebauer*,
Portland, Portland Art Museum.
1971 "Art of Cameroon," *African Arts*, IV, 2 (Winter).

Geertz, Clifford
1964 *The Religion of Java* (Paperback edition),
New York, The Free Press.

Gervais, P.
1952 *Sierra Leone Story*, London, Cassell.

Gide, Andre
1962 *Travels in the Congo*, Berkeley and Los Angeles,
University of California Press.

Glaze, Anita
1973 Personal communication, 23 October.

Goldie, Hugh
1964 *Dictionary of the Efik Language*
(Reprint), Ridgewood, The Gregg Press.

Goldwater, Robert
1964 *Senufo Sculpture from West Africa*,
New York, Museum of Primitive Art.
1967 *Primitivism in Modern Art* (Revised edition),
New York, Vintage Books.

Goody, Jack
1971 *Technology, Tradition and the State in Africa*,
London, Oxford University Press.

Gosselin, G.
1963 "Pour une Anthropologie du Travail Rural
en Afrique Noire," *C.E.A.*, 12.

Griaule, Marcel
1950 *Folk Art of Black Africa*, New York, Tudor.

Griaule, Marcel and Germaine Dieterlen
 1965 *Le Renard Pale,* Paris, Institut d'Ethnologie.

Grotanelli, Vinigi
 1968 Letter from the Pigorini Museum, 10 June.

Harley, George W.
 1941 "Notes on the Poro in Liberia," *Papers of the
 Peabody Museum of Harvard University,* XIX.
 1950 *Masks as Agents of Social Control in Northeast Liberia,*
 Cambridge, Peabody Museum.

Harper, Peggy
 1969 "Dance in Nigeria," *Ethnomusicology,* XIII (May).
 1970 "The Role of Dance in the Gelede Ceremonies of the
 Village of Ijio," *Odu* (new series), 4 (October).

Harris, Rosemary
 1965 *The Political Organization of the Mbembe,*
 London, Her Majesty's Stationery Office.

Henderson, Richard N.
 1972 *The King In Every Man,*
 New Haven, Yale University Press.

Herskovits, Melville J.
 1966 *The New World Negro,*
 Bloomington, Indiana University Press.

Herskovits, Melville J. and Frances S.
 1947 *Trinidad Village,* New York, A. A. Knopf.
 1969 *Suriname Folklore* (Reprint of the 1936 edition),
 New York, AMS Press.

Himmelheber, Hans
 1958 *Die Dan,* Stuttgart, W. Kohlhammer.
 1960 *Negerkunst und Negerkunstler,*
 Braunschweig, Klinkhardt & Biermann.
 1964 "Sculptors and Sculptures of the Dan," *Proceedings of
 the First International Congress of Africanists,*
 ed. L. Brown and M. Crowder, London.
 1965 "Wunkirle, die gastliche Frau, eine Wundentragerin
 bei den Dan und Guere (Liberia und Elfenbeinkuste),"
 Festschrift Alfred Buhler, ed. Karl Schmitz
 and Robert Wildhaber, Basel, Pharos-Verlag.
 n.d. "Die Geister und ihre irdischen Verkorperungen
 als Grundvorstellung in der Religion der Dan,"
 Baessler-Archiv NF, XII.

Hirschberg, Walter
 1969 "Early Historical Illustrations of West and
 Central African Music," *African Music,* 4, 3.

Holas, B.
 1952 *Les Masques Kono,* Paris, Paul Geuthner.

Horton, Robin
 1962 "The Kalabari Ekine Society: A Borderland
 of Religion and Art," *Africa,* XXXIII, 2 (April).
 1965 *Kalabari Sculpture,* Lagos, Department of Antiquities.

Human Relations Area File

Ibn Batuta
 1958 *Voyages: Texte Arabe Accompagne d'une Traduction,*
 ed. and trans. C. Defremery and B. R. Sanguinetti,
 trans. H. A. R. Gibb, Cambridge, Hakluyt Society,
 University Press.

Janson, H. W.
 1964 *History of Art* (Fifth printing),
 Englewood Cliffs, Prentice-Hall.

Janzen, John
 n.d. Personal communication.

Jefferson, Louise E.
 1973 *The Decorative Arts of Africa,*
 New York, Viking Press.

Jeffreys, M.D.W.
 1939 "Some Notes on the Ekoi,"
 Journal of the Royal Anthropological Institute, 69.

Jobson, Richard
 1904 *The Golden Trade,*
 Teighmouth, E. E. Speight & R. H. Walpole.

Johnson, Samuel
 1921 *The History of the Yorubas,* Lagos, C.M.S. Bookshops.

Jones, A. M.
 1954 "African Rhythm," *Africa,* XXIV, 1 (January).
 1957 "Drums Down the Centuries," *African Music,* 1, 4.
 1958 *African Music in Northern Rhodesia and
 Some Other Places,*
 Livingstone, The Rhodes-Livingstone Museum.
 1959 *Studies in African Music,*
 London, Oxford University Press.

Jones, Bessie and Bess Lomax Hawes
 1972 *Step It Down,* New York, Harper & Row.

Junker, Wilhelm
 1891 *Travels in Africa During the Years 1879–1883,*
 trans. A. H. Keane, London, Chapman & Hall.

Keil, Charles
 1966a *Tiv Dance: A First Assessment,* unpublished MS.
 1966b Personal communication, March.
 1973 *Tiv Song* (mimeographed), 21 May.

Kenyatta, Jomo
 1962 *Facing Mt. Kenya,* New York, Vintage Books.

Kilson, Marion
 1971 *Kpele Lala,* Cambridge, Harvard University Press.

Kofi, Vincent Akwete
 1964 *Sculpture in Ghana,*
 Accra, Ghana Information Services.

Kopytoff, Igor
 1965 "The Suku of Southwestern Congo," *Peoples of Africa,*
 ed. James L. Gibbs, Jr.,
 New York, Holt, Rinehart & Winston.

Kurath, Gertrude Prokosch
 1960 "Panorama of Dance Ethnology,"
 Current Anthropology, I, 3 (May).

Kyerematen, A. A. Y.
 1964 *Panoply of Ghana,* New York, Praeger.

Labat, Jean-Baptiste
 1728 *Nouvelle Relations de l'Afrique Occidentale,*
 Paris, Guillaume Cavellier.

Ladzekpo, S. Kobla and Hewitt Pantaleoni
 1970 "Takada Drumming," *African Music,* 4, 4.

Laman, Karl
 1953– *The Kongo,* Upsala, Studia Ethnographica
 1968 Upsaliensia
 1964 *Dictionnaire Kikongo-Francais* (Reprint),
 Hants., The Gregg Press.

Laude, Jean
 1973 *African Art of the Dogon,* New York, Brooklyn
 Museum in association with the Viking Press.

Lawal, Babatunde
 1971 *Yoruba Sango Sculpture in Historical Retrospect,*
 Ann Arbor, University Microfilms.
 1973 "Dating Problems at Igbo-Ukwu,"
 Journal of African History, XIV, 1.

Leiris, Michel
 1934 *L'Afrique Fantome,* Paris, Gallimard.

Leon, Argeliers
 1960 Personal communication, Marianao, Cuba, April.

Leuzinger, Elsy
 1963 *African Sculpture,* Zurich, Atlantis Verlag.

Lomax, Alan, ed.
 1968 *Folk Song Style and Culture,*
 Washington, D.C., American Association
 for the Advancement of Science.

MacGaffey, Wyatt
 1970 *Custom and Government in the Lower Congo,*
 Berkeley and Los Angeles,
 University of California Press.
 1972 Personal communication, 3 May.
 1973a Personal communication, September.
 1973b Personal communication, October.

Mangin, Eugene
 1921 *Les Mossi: Essai sur les Usages et Coutumes*
 du Peuple Mossi au Soudan Occidental,
 Paris, Augustin Challamel.

de Marees, Pieter
 1604 *Description et Recit Historical du Royaume*
 d'Or de Guinee, Amsterdam.

Maritain, Jacques
 1953 *Creative Intuition in Art and Poetry,*
 New York, Pantheon.

Mark, Peter
 1973 Unpublished research report on Dan masks
 in motion, Yale University.

Marshall, Lorna
 1962 "!Kung Bushman Religious Beliefs,"
 Africa, XXXII, 3 (July).

Maes, J.
 1924 *Aniota-Kifwebe: Les Masques des Populations du*
 Congo Belge et le Materiel des Rites de Circoncision,
 Anvers, Editions "De Sikkel."

Maesen, Albert
 1960 *Umbangu,* Brussels, "Cultura."
 1967 "Congo Art and Society," *Art of the Congo,*
 Minneapolis, Walker Art Center.

Mbiti, John S.
 1970 *African Religions and Philosophy,*
 Garden City, Doubleday Anchor Books.

McCall, Daniel
 n.d. Personal communication.

McLeod, M.D.
 1971 "Goldweights of Asante," *African Arts,* V, 1 (Autumn).

Memel-Fote, Harris
 1968 "The Perception of Beauty in Negro-African Culture,"
 Colloquium on Negro Art, Paris, Presence Africaine.

Meneghini, Mario
 1972 "The Bassa Mask," *African Arts,* VI, 1 (Autumn).

Menzel, Brigitte
 1968 *Goldewichte aus Ghana,*
 Berlin, Museum fur Volkerkunde.
 1972 *Textilien aus Westafrika,*
 Berlin, Museum fur Volkerkunde.

Merriam, Alan P.
 1959 "African Music," *Continuity and Change in African*
 Cultures, ed. William Bascom and Melville J.
 Herskovits, Chicago, University of Chicago Press.

Meyerowitz, Eva L. R.
 1958 *The Akan of Ghana,* London, Faber & Faber.

Mitchell-Kernan, Claudia
 1973 "Signifying," *Mother Wit from the Laughing Barrel,*
 ed. Alan Dundes, Englewood Cliffs, Prentice-Hall.

Monod, Theodore, A Teixeira da Mota, and R. Mauny, eds.
 1951 *Description de la Cote Occidental d'Afrique,*
 Bissau, Centro de Estudos da Guine Portuguesa.

Moore, E. A. Ajisafe
 n.d. *The Laws and Customs of the Yoruba People,*
 Abeokuta, Fola Bookshops.

Moore, Francis
 1738 *Travels into the Inland Parts of Africa,*
 London, E. Cave.

Morris, William, ed.
 1969 *The American Heritage Dictionary,*
 Boston and New York, American Heritage
 Publishing Co. and Houghton Mifflin.

Morton-Williams, Peter
 1960 "The Yoruba Ogboni Cult in Oyo," *Africa,* XXX.

Nadel, S. F.
 1954 *Nupe Religion,* New York, Schocken Books.

Neuhart, John
 1972 Personal communication, 19 November.

Niane, D. T.
 1965 *Sundiata: An Epic of Old Mali,* London, Longmans.

Nicklin, Keith
 n.d. "Nigerian Skin-Covered Masks,"
 African Arts (in press).

Nketia, J. H. Kwabena
 1954 "The Role of the Drummer in Akan Society,"
 African Music, I, 1.

1955 *Funeral Dirges of the Akan People*,
 Achimota, University College of the Gold Coast.
1958 "Yoruba Musicians in Accra," *Odu*, 6 (June).
1963a *African Music in Ghana*,
 Evanston, Northwestern University Press.
1963b *Drumming in Akan Communities of Ghana*,
 London, Thomas Nelson.

Nodelman, Sheldon
 1973 Lecture on the implications of the act of standing in
 Greek sculpture, Yale University, February.

Northern, Tamara
 1973 *Royal Art of Cameroon*,
 Dartmouth, Hopkins Center Art Galleries.

Odugbesan, Clara
 1969 "Femininity in Yoruba Religious Art,"
 Man in Africa, ed. Mary Douglas
 and Phyllis M. Kaberry, London, Tavistock.

Okie, Patrick
 n.d. *Folk Music of Liberia* (LP FE 4465), Ethnic Folkways.

Olbrechts, Frans M.
 1959 *Les Arts Plastiques du Congo Belge*
 (Second edition), Brussels, Editions Erasme.

Ortiz, Fernando
 1951 *Los Bailes y el Teatro de los Negros
 en el Folklore de Cuba*,
 Havana, Ediciones Cardenas y Cia.
 1952 *Los Instrumentos de la Musica Afrocubana*,
 Havana, Ministerio de Educacion.
 1955 *Los Instrumentos de la Musica Afrocubana*,
 Havana, Cardenas.

Panofsky, Irwin
 1955 *Meaning In The Visual Arts*,
 Garden City, Doubleday Anchor.

Pasztory, Esther
 1970 "Hieratic Composition in African Art,"
 Art Bulletin, LII, 3 (September).

Paulme, Denise
 1962 *African Sculpture*, London, Elek Books.

p'Bitek, Okot
 1969 *Song of Lawino: An African Lament*,
 New York, Meridian Books.

Picton, John
 1962 Field notes.
 1970 Personal communication, 26 August.

Price, Richard
 1970 *Saramaka Social Structure* (Xeroxed).

Prince, Raymond
 1961 "The Yoruba Image of the Witch,"
 The Journal of Mental Science, 107, 449.

Rattray, R. S.
 1923 *Ashanti*, Oxford, Clarendon Press.
 1927 *Religion and Art in Ashanti*, Oxford, Clarendon Press.

Read, Margaret
 1960 *Children of their Fathers*,
 New Haven, Yale University Press.

Regalado, Antonio
 n.d. Personal communication.

Riesman, Karl
 1973 "Remarks on Sama Vocabulary," paper read at the
 Northeastern Anthropological Association
 Annual Meeting, April 27.

Rose, Dan
 1973 "Continuities of Sensibility within Circum-Atlantic
 Populations," paper read at the annual meeting of the
 Northeastern Anthropological Association, April 27.

Rouch, Jean
 1950 "La Danse," *Le Monde Noir*," Numero Special 8–9,
 Presence Africaine.
 1960 *La Religion et la Magie Songhai*,
 Paris, Presses Universitaires de France.

Rubin, Arnold Gary
 1970 *The Arts of the Jukun-Speaking Peoples
 of Northern Nigeria*,
 Ann Arbor, University Microfilms.

Ruel, Malcolm
 1964 "The Modern Adaptation of Associations among
 the Banyang of the West Cameroons,"
 Southwestern Journal of Anthropology, 20, 1 (Spring).
 1965 "Witchcraft, Morality, and Doubt," *Odu*, 2, 1 (July).
 1969 *Leopards and Leaders: Constitutional Politics
 Among A Cross River People*, London, Tavistock.

dos Santos, Juana Elbein and Deoscoredes M. dos Santos
 1969 "Ancestor Worship in Bahia: The Egun Cult,"
 Journal de la Societe des Africainistes, LVIII.

Sapir, J. David
 1969 "Diola-Fogny Funeral Songs and the Native Critic,"
 African Language Review.

Sarpong, Peter
 1971 *The Sacred Stools of the Akan*,
 Accra, Ghana Publishing Corporation.

Schapera, I.
 1933 *The Early Cape Hottentots*,
 Capetown, Van Riebeeck Society.

Schmitz, Robert
 1912 *Les Baholoholo*, Brussels, A. Dewit,
 Collection de Monographies Ethnographiques.

Schuller, Gunther
 1968 *Early Jazz*, New York, Oxford University Press.

Schweeger-Hefel, A.
 1962– "Die Kunst der Kurumba,"
 63 *Archiv fur Volkerkunde*, XVII; XVIII.

Schweinfurth, George
 1874 *The Heart of Africa*, trans. Ellen E. Frewer,
 New York, Harper.

Shaw, Thurston
 1970 *Igbo-Ukwu*, London, Faber & Faber.

Sieber, Roy
 1961 *Sculpture of Northern Nigeria*,
 New York, Museum of Primitive Art.

1972 *African Textiles and Decorative Arts,*
New York, Museum of Modern Art.
1973 "Ede, Crafts and Surveys," *African Arts,* VI, 4 (Summer).

Siroto, Leon
1968 "The Face of the Bwiti," *African Arts,* I, 3 (Spring).
1970 Book Review, *American Anthropologist,*
72, 1 (February).

Skinner, Elliot P.
1962 "Trade and Market Among the Mossi People,"
Markets in Africa, ed. Paul Bohannan and George
Dalton, Evanston, Northwestern University Press.

Smith, Robert
1967 "Yoruba Armament," *Journal of African History,* VIII, 1.

Smith, Robert C.
1969 *The Art of Portugal,* New York, Meredith Press.

Soderberg, Bertil
1966 "Antelope Horn Whistles with Sculptures
from the Lower Congo," *Ethnos,* 1, 4.

Stampp, Kenneth M.
1956 *The Peculiar Institution,* New York, Vintage Books.

Stanley, Henry
1890 *In Darkest Africa,* New York, Scribners.

Suttles, Gerald D.
1968 *The Social Order of the Slums:
Ethnicity and Territory in the Inner City,*
Chicago, University of Chicago Press.

Talbot, P. Amaury
1912 *In the Shadow of the Bush,*
London, William Heinemann.

Tauxier, Louis
1917 *Le Noir du Yatenga,* Paris, Emile Larose.

Tempels, Placide
1959 *Bantu Philosophy,* Paris, Presence Africaine.

Thompson, Robert Farris
1957 "New Voice from the Barrios,"
Saturday Review, L, 43 (October).
1966 "An Aesthetic of the Cool: West African Dance,"
African Forum, 2, 2 (Fall).
1969 "Abatan: A Master Potter of the Egbado Yoruba,"
Tradition and Creativity in Tribal Art,
ed. Daniel Biebuyck, Berkeley and Los Angeles,
University of California Press.
1970 "The Sign of the Divine King," *African Arts,*
III, 3 (Spring).
1971a *Black Gods and Kings,* Los Angeles, Museum
and Laboratories of Ethnic Arts and Technology.
1971b "Sons of Thunder: Twin Images among the Oyo and
other Yoruba Groups," *African Arts,* IV, 3 (Spring).
1973a "Dance and Culture" (Reprint),
Andover, Warner Modular Publications.
1973b "Aesthetic of the Cool," *African Arts,* VII, 1 (Autumn).

Tong, James Y.
1967 *African Art in the Mambila Collection
of Gilbert D. Schneider,* Athens, Tong.

Turner, Victor
1967 *The Forest of Symbols,* Ithaca, Cornell University Press.

Tutuola, Amos
1962 *Feather Woman of the Jungle,* London, Faber & Faber.

Vansina, Jan
1973 *The Tio Kingdom of the Middle Congo: 1880–1892,*
London, Oxford University Press.

Vansina, Jan, Raymond Mauny, and L.V. Thomas, eds.
1964 *The Historian in Tropical Africa,*
London, Oxford University Press.

Verger, Pierre
1957 *Notes sur les Orisa,* Dakar, I.F.A.N.
1957 *Notes sur le Culte des Orisa et Vodun,* Dakar, I.F.A.N.
1965 "Grandeur et Decadence du Culte d'Iyami
Osoronga (Ma Mere la Sorciere) chez les Yoruba,"
Journal de la Societe des Africainistes, 35, 1.

Villault, Nicholas
1669 *Relations des Costes d'Afrique Appellees Guinee,*
Paris, Denys Thierry.

Vogel, Susan
1971 "Yoruba and Baoule Art Criticism: A Comparison,"
unpublished research paper.

Waterman, Richard Alan
1948 "Hot Rhythm in Negro Music," *Journal of the
American Musicological Society,* I, 1 (Spring).
1973 "African Influence on the Music of the Americas,"
Mother Wit from the Laughing Barrel,
ed. Alan Dundes, Englewood Cliffs, Prentice-Hall.

Weil, Peter
1971 "The Masked Figure and Social Control: the
Mandinka Case," *Africa,* XLI, 4 (October).

Weman, Henry
1961 *African Music and the Church in Africa,*
Upsala, Ab Lundequistka Bokhandeln.

White, Katherine Coryton
n.d. Archive.

Willett, Frank
1971a *African Art,* London, Thames & Hudson.
1971b *African Sculpture,* New York, Praeger.

Wittmer, Marcilene
1970 "Distribution of Cross River Skin-Covered Heads,"
unpublished research paper, Indiana University.
1973 *Images of Authority: From Benin to Gabon,*
Miami, Lowe Art Museum.

Wolfe, Alvin
1961 *In the Ngombe Tradition,*
Evanston, Northwestern University Press.

Wolfson, Freda
1958 *Pageant of Ghana,* London, Oxford University Press.

Zahan, Dominique
1960 *Societes d'Initiation Bambara,* Paris, Mouton.
1968 "Significance and Function of Art in Bambara
Community Life," *Colloquium on Negro Art,*
Paris, Presence Africaine.

Zemp, Hugo
1965 "Eine esoterische Uberlieferung uber den Ursprung
der maskierten Stelzentanzer bei den Dan
(Elfenbeinkuste)," *Festschrift Alfred Buhler,*
ed. Carl A. Schmitz and Robert Wildhaber,
Basel, Pharos-Verlag.
1971 *Musique Dan,* Paris, Mouton.
n.d. *The Music of the Dan* (LP BM 30 L 2301),
commentary, Barenreiter Musicaphon.

APPENDIX:
Texts Of Artistic Criticism
Of The Dance In Tropical Africa, 1964–1973

*Tones and special phonetic signs have been eliminated
in the following vernacular texts.*

LIBERIA

Dan Aesthetics: Sculpture

Monrovia

25 March 1967
1. George Tabmen
 Dan (Liberia)
 30ish
 Professional informant
 Christian; Dan traditionalist

1. Whenever you see a Dan mask which has a very nice appearance with slumberous face, a sleepy eye (slitted) . . . when a woman looks at this face, which looks like a woman, she is not afraid. Beauty in Dan art has to do with slitted eyes.

2. *The Ideal Dan Countenance* (female): slitted eyes, big eyebrows, big hair, clean teeth with openings in the middle, long neck with creases (a person who has creases in his neck is a person who attracts you without your even knowing why), big buttocks, big calves.

3. *Dian* or *Godaglo* mask types entertain the public or make peace between people. The *Bodaglo* have a society for teaching the traditions, legends, and folklore of the Dan. In this respect, women are affiliated. And since women are restricted from participation in the masks, they are therefore afraid of masks. Yet in their school, without the help of women, men will not succeed. So the initiation masks must be carved with *beautiful* appearance in order to be able to transact business between the school and the women; also, beautiful masks keep children from fright, because it is through the masks that they will learn tradition.

 Now the Dan woman is easily emotionally aroused by the appearance of beauty. The only way the women got hold of us in this connection is that the boys (initiates) who are in the initiation group need to be fed with good food. Cooking is not the work of Dan men. It is the duty of these masks to encourage mothers to cook for their children. So, for this reason you find masks of this nature carved in the likeness of a woman's face. You even find fine masks with double scarification lines on the forehead, which is indeed a wonder of beauty for a Dan woman.

4. In carving an image of the person, every part of the body must be equivalent to another part, not to have a big head, small body. This is not beauty.

5. A person with slitted eyes—oh! it's *fine*!

6. Deliberately separated incisors ('fish teeth') are considered beautiful in one part of Dan country. If I want to make my teeth look like this a blacksmith will file my teeth, either the upper teeth or the lower. There is another way, practiced in the Bahn and Tapita areas of Dan-speaking country—the middle tooth is extracted from either the upper or lower row of teeth.

7. Dan women hold both breasts to make a vow and this is beautiful. But to curse, she spills milk from one breast and slaps her right thigh. [RFT: this breaks the balance.]

Dan Aesthetics: Dance, Performance, and Bodily Motion
1. Are there critics of the dance among the Dan? Very much. Who are they? The young and the old, most especially the dancers themselves. We have critics for music, we have critics of sculpture. Carvers are the critics of sculpture.

2. Dan can even criticize a handsome person by the way he walks and the way he acts even though this person is otherwise completely beautiful. We can say:

 He is fine, but he bends his head when walking
 (E sa ka a gagban tay gu).

 There is no mistaking a completely beautiful person who walks and talks and acts and looks beautifully. We teach the composing of the face, the right way of walking, the right proportion of standing, and the right way of acting with the body when making conversation.

3. We say:

 It is not good for a beautiful person to be stiff in the body when standing *(Me sa ba dakpei do sy ka sa).* Stiffness is bad in standing, in bodily beauty.

4. *Proper procedure when dancing (as a stranger) in the ring:* first you salute the drum to get you motion, to settle your rhythm. Then you begin a simple toe-dragging sequence, kept simple because the drummer is studying your motion. Slowly the dance develops. You must keep the drummer active. *When the applause mounts, the smile dies down and you pay more attention to the footwork.* Hot applause occasions an immediate change of style.

5. The music of a guitarist at the cow feast of my father was criticized. The music was not touching, it did not get their nerves. But there were two songs that they highly praised him for. Our critics make comment for and against the player. *Audience Reactions:* this legend shows how the inhabitants of the village of Blimiple [a Liberian village near the River Cess close to the Ivory Coast border] deal with criticism of music and the dance:

 If a band of performers come to the town of Blimiple and attempt to perform in the town square but have no talent whatsoever, the town chief or the quarter chief will tell them to go to the house of Mr. *Woya* (Mr. Bad Singer's House) and the town will have been informed [in local code] to ignore these men because of their lack of musical quality.

 If there is a play and they discover that the performers are repeating and repeating, singing and dancing the same phrases over and over again, then a citizen of the town will stop the music, thank the minstrels, and say, 'let's go

before one of our elder's houses,' his name is *Pindou* (Mr. Repetition). Singers whose voices are not smooth will be invited to visit the house of *Zoogbaye* (Mr. Harsh Singing).

If the singers begin to sense that their efforts are not appreciated and become belligerent, they are led to *Nyazii* (Mr. Excessive-Reaction-to-Criticism, lit. Mr. Unfair Advantage). A better translation would be *Nyazii* = Mr. Frankness, for *Nyazii* will stop the music, tell them frankly it is terrible, and to pack their things and move on.

The spectators can criticize a dance without saying a word. With their lips closed they can say, '*m!*' (bad) and, with their arms folded, walk away, looking to the right, as if they smelled something bad.

A good dancer is known by the applause of the spectator, but Dan don't clap. They shout '*yaa titi*,' with arms outstretched, palms up and parallel as if to embrace the dancer, you want to embrace him as a sign of deep respect. The cry, '*yaa titi*,' is reserved for something exciting, for the pleasure of the people. Bad dancing is hooted with the cry, '*hooooo*,' with the arms out stiff, palms down. The gesture means 'shame on you.'

Criteria of Excellence in Dancing
 i. A good Dan dancer must dance with the rhythm of the musical accompaniment.

 ii. He should *stop* when the sound of the musical instrument stops, *at the same time*.

 iii. Every movement of the body should correspond to the sound of the music.

 iv. A dancer must dance with flexibility *(de ka wree-wree, lit. self-make-flexible-easy)*.

 v. A dancer should apply the motion of dignity to his performance. He should dance with *nyaa ka* (with flair). This is a quality which must be added to all his actions. With *nyaa ka* I have added something to my dance or walking, to show my beauty to attract the attention of all those around me even if they should be thinking of something else.

 vi. The best dancer is a dancer who dances with different styles of movement *(ta ge gbegbe ka, lit. he is a song with many steps)*. There is not a definite word for dance in Dan. For dance, we say *ta ka*, 'feet of song,' because the movement of the foot is done to the sound of singing or musical instrument. We dance to onomatopoeia, but this depends upon the musical instrument: *kiri kiri ken* is the sound of a CocaCola bottle struck with a nail; *pele pele pe* is the sound of a drum. As the instrumentation changes you change the onomatopoeia and adjust the bodily style.

 vii. A good dancer is the dancer who *yia* ('ends') his dance with the rhythm of the instrument, *i.e.*, in our tribal dancing, you can be a good dancer with all the requirements I have mentioned displayed in your performance, but if you are dancing and do not *yia*, end things properly, you are not a good dancer.

 viii. There must be a *flourish* at the end, or at certain intervals, during the performance.

 ix. Good dance is song-making. When you dance it means you are making the song, putting the song into use.

 x. You must be *happy* and *free* in your body.

 xi. A dancer ought to be a good musician, dancing and singing at the same time. That is one of the factors that makes a good dancer.

 xii. A good dancer must seem to be smiling, but not as a duty. He must dance with pleasure.

 xiii. A good dancer must display for, and satisfy, the whole ring, not just the drummers.

 xiv. He must balance his dancing.

 xv. A good dancer uses all parts of his body *(ge sa me e ta ko dae a de pla taka, lit. foot beautiful person when song-making, makes the song with all his position)*.

 xvi. He dances smoothly, *tiotio*, like a top spinning, because no part of a top will wait; the whole is going.

 xvii. When he dances every part of his body trembles *(E ta ko dae e wa de pla zuu tete)*.

 xviii. The good dancer is the dancer who dances like a body without bones *(E ta ko ne me e ga ka gye do, lit. he dances as though he has no bones)*.

 xix. Shyness in Dan dance is bad; shyness in dancing spoils the effect of the art; a good dancer must be bold—this is very important for a Dan dancer.

Butuo
30 March 1967
 2–4 Three Elders of Butuo Village
 Dan (Liberia)
 Two aged 50–60; one, 70–75
 Cultivators
 Christian and Dan traditional religion

[Re performance of Maa Po dance by adolescent girls. Author asked the group which dancer among the girls was the best. Choral response:]

 We know which children are best, but they are our children! You have to decide!

[The question was then more broadly phrased, "what parts of the dance of *all the girls* do you find beautiful?" Response:]

1. This dance an aged person would not be able to execute because they bend [so fluently] when dancing *(ta e bee me zii yaa moa nyee ka, bii ya koe wo koo wo beido)*.

2. Because they do not fall in spite of the bending *(do wo woo sea waa pyo be)*.

3. Their costumes match the dance *(wo buan po be waa ta be wo ye koa)*.

4. It is an old dance *(kwe zy ta my)*.

5. The rattles and the beads shake beautifully and make the spectator's heart sweet *(ze nwaa nyoy byo wo zuu sa ka wo de ga me zuo hee he)*.

31 March 1967
 5. Unidentified Critic
 Dan
 50ish
 Said to be a cultivator
 Religion not given

[Re a second performance of Maa Po. He considered the dancing quite beautiful on the score of eight qualities.]

1. The rattles are beautiful *(ze be sa)*.

2. A good dancer, making several stampings with the feet while dancing *(me e de de kua a ka be sa)*.

3. The line dancing with relatively straight and upright bodies is also impressive [i.e., before bending they dance in a line with the body relaxed but virtually standing] *(a byo wea wo boa ka waa do sea kun be e sa)*.

4. The extending–out of their legs is beautiful *(wo ge wo saada be e sa)*; it is a special art, which can only be performed by a good dancer because it is not easy to extend out the legs [i.e., testing both flexibility and balance and youthful vigor] *(slade de my bii ge saasie de gbee ta kay gy)*.

5. The vital jumping patterns make the dance beautiful *(oa wo wo da wo son gy wo do da be)*.

6. The vibration of the back and chest while dancing is beautiful *(yia wo wo da wo bei be)*; this shows a certain flair *(e taanyia pa)*; they know how to cut *(yia)*; it is like a pattern, it looks fine on a person *(e kee bua pa do, e me ma ku)* [i.e., the vibrations of the back and of the chest decorate the body like sumptuously patterned cloth].

7. Dancing two persons together [in a mirrored movement] is beautiful *(da wo wo da pleple be)*.

8. Change of songs makes the dance more beautiful *(ta wo kan da yoo do be)*.

DAHOMEY
Whevie, near Porto Novo
30 August 1972

6–8. Three Mothers of Twins
(names not recorded)
Popo
20ish, 30ish, 40ish
Priestesses of various deities
Popo traditional religion

[Informants were asked what their dancing for twin spirits meant to them. Response:]

1. If we dance this dance, it pleases the ancestors *(nu eya mi do bayi eno vivi nami u we mi no ja wa meja)*.

9. Segodo
Popo, male
c. 46 years old
Cultivator
Devotee of the traditional gods

1. Anyone coming to see us finds pleasure in our dance; pleasure is the reason people adore our dancing *(elo nu kpe ton ton gbe ton eno vivi nami)*.

2. You 'dance the shoulders' to make it beautiful *(nami to we me ko kplo bo e ko ma mi)* and,

3. to move our shoulders in the style of our dancing brings pleasure.

Ajibame
31 August 1972

10. Wife of the Chief of Ajibame
Yoruba
40ish

Priestess
Traditional Yoruba religion

[Author begins to follow steps of master drum during Egungun festival; wife rushes up and brings Yoruba robe:] You cannot dance our dance properly without our clothes on . . .

11. Chief of Ajibame
Yoruba
50ish
Cultivator; priest
Traditional Yoruba religion

[He was asked what a devotee should do to make an Egungun masquerader beautiful. Answer:]

1. One dances this so that when the ancestral spirit arrives, he sees the rich cloth of the ancestor (and he is pleased), that it is done just so; thus our father will create (on our behalf) the power-to-bring-things-to-pass *(o njo wipe ti egungun ba ja de o wo aso baba e. Nigbati t'o se bee nka ti baba wa se da l'ase)*.

2. The one who is inside the costume 'works his arms' and 'works his whirls' because he is content.

3. He whirls his cloths about in the dance because he takes pleasure in whirling about [the priestly opulence] of the robes of the thundergod priest *(l'o fi jo ti l'o fi yeri ke)*.

4. The cloths upon his body [he whirls them about] to make [their glittering panels] visible *(aso ti mbe ni ara e, lo fi hon)*.

Katagon
2 September 1972

12. Antonet Tosun Atogba
Bi-lingual, Fon/Yoruba
40ish
Cultivator
Catholic; Sato dancer

[The Chief of Katagon sat next to Antonet during the following discussion and by movements of his head and brief comments encouraged and lent official support to the on-going testimony.

Essentially, Antonet Tosun Atogba found that a highly marked degree of stylistic variability, or constant motif-switching, marked the beauty of the dancing of young girls accompanying several stilt-dancers in a performance called Aguele Yeye. These were the motifs he admired, but they by no means exhaust the inventiveness of the recombinations. He spoke in Yoruba for our convenience, although Fongbe is really his maternal language.]

1. When they begin to drum, they place their two hands on their back and, with the legs spread apart, the dancers go back and forward *(ti won ba bere ilu, owo mejeji ni baji wa ketan mejeji li wa fo soke ati ni waju)*.

2. When they start again, they shut their eyes, oscillating their shoulders and elbows (lit. their 'sides' [while sliding forward on the ball of the foot] *ni gbanan wa tun bere wa boju, wa tun fi egbe fijo)*.

3. Start the play, while kicking up . . . alternate legs in front *(wa bere dire, wa kakpako dire nigbana wa ma jo ese re ni 'one-by-one' ni iwaju)*.

4. They lunge against each other at the same time that they cross their hands over their chests *(wa ya itan re ni igbanna wa ka owo re mejeji si ni aya)*.

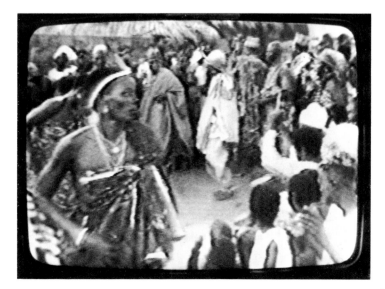

5. They place their hands on their hips, twist in and out, while dancing in a pleasurable manner (lit. with pleasure) *(wa ka owo re si ni ibaji. Wa katan nigba won ma jo pelu ilara)*.

6. They feign kicking at each other while enlacing arms, placing their hands upon each other's shoulders *(won ma se apere ese sira won nigbanna won fi owo won si ni ejika enikeji won)*.

7. They begin the play [*i.e.*, they start another "riff"-motif or respond to another riff] with hands on hips; now they shift their body from side to side [while throwing the shoulders back and forth] *(wa bere dire; won ma wa nisinsinyi ni egbe ara won)*.

Ketu
9 September 1972

> 13. Adesanyan
> Ketu Yoruba; born Meko
> 50ish
> Former schoolteacher, now lives in
> palace of the Alaketu
> Christian; member of Gelede

1. When the dancers of Gelede enter the ring, they break out the dance as soon as they reach the drums. The onlookers give them fan, give them pleasure. After about five minutes you know they are going to make *eka. Eka* are special drum phrases, a glory to Gelede, to please our mothers (*i.e.*, the witches). Drums tell the dancer what to do; if he dances with the drummer exactly, he is called *aiyejo*, the finest dancer. An *alaiye mojo* someone who does not know how to obey the drums. The ankle rattles of iron the dancers wear *must* make the same sound as the drum. If he makes a mistake it will be audible.

2. The dancer has to end the phrase *exactly* when the senior drum ends it. They must balance *(dogba). A thousand dresses, it does not matter, if you compromise the drum speech you are not a good dancer!* [said with great seriousness and emphasis.

 Later the author essays a turn at dancing an *eka* in the Ketu market, guided by Lasisi, an old and powerful leader of the local Gelede cult world. Lasisi, with much prompting and friendly nudging, taught the writer to end the *eka* simultaneous with the ending of the drum phrase, and to round off the completion of the phrase by lifting the right leg to mirror the last note. It is entirely to the credit of Lasisi's power as a dance master that the foreigner was able to do this at all. Some of the bystanders were visibly awed, one remarking with astonishment, as if he had just seen a talking dog, *O ti dogba!* (he balanced it!).]

3 June 1973

> 14. Saliyu Ayide
> Yoruba; born Ajashe, Dahomey (Porto Novo)
> 32 years old
> Worker
> Muslim

[Shown videotape of Sakpatassi dancing, Ouidah.]

1. I love this dance because it shows our region; each region has its own characteristic and this is clear, here.

2. We like this [he indicates the region of his belly with his right hand] because it restores the mind to pleasure (lit. sweetens the belly, *a fe nitori inu mi ti dun*).

3. It is our blood that is dancing this *(eje wa o n jo)*.

15. Mama
 Bariba, from Djougou, northern Dahomey
 38 years old
 Gendarme premier, Cotonou
 Muslim

[Tri-lingual, he speaks in Yoruba for the convenience of the writer. Re: Sakpatassi.]

1. This pleases me because it is our grandparents who created [dances like] that *(o wu mi nitori awon baba wa ti se eleyi)*.

2. The entire body *(gbogbo ara)* dances, arms, torso, back

3. It cools the town when you dance like that *(nigbati a n jo, aiye na, o maa n fun ilu maa tutu)*.

4. When you finish (a ritual dance like this) and sit down you are restored to repose (coolness), and reconciliation with your family *(nigbati o tan ati ijoko pelu ibile ki no tutu ma wa)*

[Interrupted at this point.]

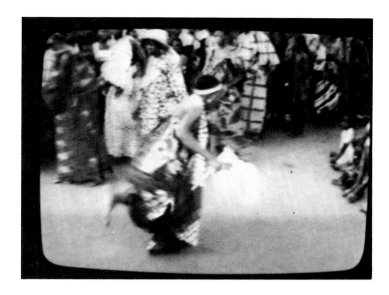

Takon
3 June 1973

16. Fagbemi Olaifa
 Anago Yoruba, native of Takon, Dahomey
 50 years old
 Cultivator
 Roman Catholic; member of Gelede cult

[Re: Sakpatassi.]

1. This dance pleases me most because it is a traditional dance of our land *(ijo naa o wu mi ju o si je ijo ibile ilu wa)*.

2. I love this dance, just so, because it is a dance that embodies difficult motions *(mo ni ife ijo na bee nitori o je tulasi*, lit. because it is difficulty).

17. Ojuade Arebiyi
 Anago Yoruba. Takon, Dahomey
 35 years old
 Cultivator
 Methodist; member of Gelede cult

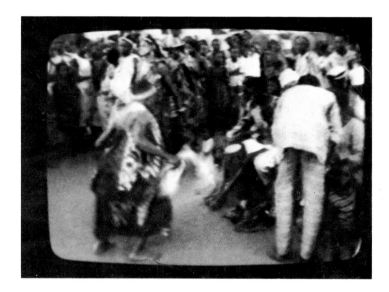

1. The ones who danced after that woman had danced [at pt. 326 on videotape] interested me the most *(awon ti o to seyin irawon lo wu mi niñu ijoye)*

2. because they brought so much pleasure *(nitoripe o ni faji pipo)*. [Applause from bystanders broke out at this point. Critic also praised the dancing pointing out:]

3. there was a pleasurable quality to the gestures that could not be performed by someone whose body was not cool and whole *(ajijona pelu ilara bee nitori idaraya bi osi bee arawa etutu)*.

[For variety, the writer imitated some of the Sakpatassi steps and invited criticism from:]

18. Omini Adekanbi
 Anago Yoruba. Takon, Dahomey
 60 years old
 Cultivator
 Member of the Igese cult; member of Gelede

1. Your body lacked the beauty of flexibility *(ere re o le dada)*, i.e., you failed to bring your body low to the earth.

2. You failed to properly incline your back *(o le eyin diye ni*, lit. did not make flexible the back).

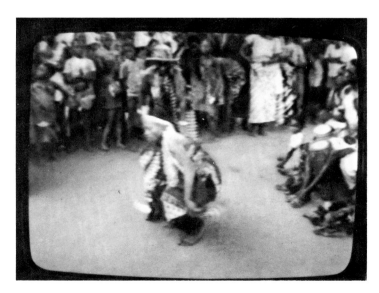

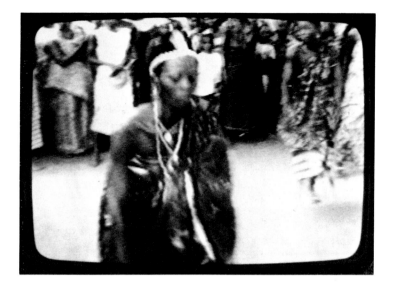

19. Fakoirede Kosade
 Anago Yoruba. Takon, Dahomey
 40–30ish
 Cultivator
 Roman Catholic; Gelede member

1. Feet were harmonized with thighs (*ese pelu iton won se ise kanna ninu ijo*, lit. the feet with the thighs did the same work in the dance).

2. Legs were harmonized with shoulders, also (*ihun ese on se ni ijike papa o n se*) [Informant then began an aside on the proper freezing of the face in dancing, adding:]

3. The face of someone who is dancing (properly) is different from someone who is not dancing (*oju oni ti jo o yato si eni ti ko jo*)

4. because that particular face is concentrated [as if taken away to another world] (*nitori oju na akati*, lit. rolled up and put away).

20. Adeyeri Oluponna
 Anago Yoruba. Takon, Dahomey
 40ish
 Cultivator
 Roman Catholic; member of Gelede

1. The quickness of the rhythmic activation (lit. pounding) of the body (*o we fun ere yiya*).

2. It pleases me because she dances with her thighs straight and parallel (*nitori o wu . . . l'o mu'ton duro*).

[Why?]

3. Without the trunk the thighs cannot stand (*bi inon ko ba si iton ko le mura duro*).

4. The work of the trunk (in the dance) is a traditional style that our fathers taught (*ise ino wa o je ise ibile ti baba wa ti ko ni*).

[The next informant demonstrated the steps of the Gelede *eka* (dance pattern) called "Sukute" and tore up the earth with his bare feet in a whirlwind of energy.]

21. Olulade Fadele
 Anago Yoruba
 50 years old
 Cultivator
 Methodist

1. Dancing 'tough' is a total pleasure (*jejo yiyi o je ilara ododo*).

2. The feet say what the drum says (*ihun yelu so ohun le si ese re*).

22. Eriyomi Agbolumi
 Anago Yoruba
 Cultivator-diviner (*babalawo*)
 Traditional Yoruba religion

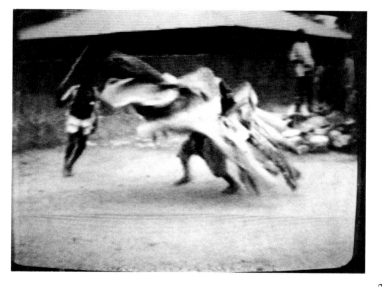

1. The termination [of the step?] was fitting because finished at a level superbly low [close to the earth] (*kase kike o je eye nitori abere dada*).

2. Very beautiful (*o da pupo*)

3. because while the shoulders were activated the feet were stamping the ground (*nitori bi a nse ejika ese nkile*).

Katagon
3 June 1973

256

23–6. The Chief of Katagon and Three Elders

[Aguele YeYe dance:]

1. [As soon as] one raises one's arms on high and then brings the hands down suddenly—that is power *(lese-kese eni k'apa s'oke, ka si f'owo sile, agbara ni).*

2. We have learned (power) in this dance; now we go out on stilts and stop [at the termination of the drummer's] phrases where it is appropriate *(a won ko nkanna nisinsinyi a tun lo igbo igi pelu re lati fi da ijo na bi o ti ye).*

3. [We cut the phrase] when we hear the [finish of the] drum phrase (on the master drum) as we are supposed to *(a wo feti bale ko ao fun gbo idalu na bi o ti ye).*

Cotonou
4 June 1973

 27. Eugene Akogbeto
 Anago Yoruba
 80 years old
 Former cook
 Catholic

1. If the drum strikes strong, you bend down in the dance.

 28. Omolade Kogbakin
 Anago Yoruba
 50 years old
 Dock-worker
 Egun-worshipper

[Views Egun dancing on monitor.]

1. This pleases me. That particular drum brought pleasure to that spirit, it began to whirl *(o wu mi . . . ilu na gbadun orisa na . . . oma yipo).*

2. When the Egungun spins, it releases its color; the spins are beautiful because they allow the colors to fly out.

 29. Andrew Agbaje
 Anago Yoruba
 20 years old
 Student
 Christian

[Views Egungun on video monitor, remarks:]

1. I like it *(o wu mi).*

2. Why do I like it? *(nitoripe mo feran ijo na).*

3. It is a dance of our country *(o je ijo ilu wa).*

4. It was a certain dance that brings coolness to the generations *(o ti je ijo kan to maa m fa tutu wa inu iran).*

5. That person that danced it, spun himself around and around, spun like a top (then) subsided *(eyi to ma njo, to ma nyi ara re, to ma nloyi, to ma lole).*

6. His manner of turning is different from smallpox dancers turning *(ijo egun o lilo o yi e o yatosi t'olisakpatasi).*

7. He goes out, spinning like a whirlwind *(o ma nlo yi gidi)* to such an extent that one might say that he was going to fall—but he does not fall *(to je n pe o ti fe ma subu, sugbon ki subu).*

8. He runs like a bird *(o sure bi eiye).*

9. And then he stops suddenly, like an automobile, in order to avoid creating a disturbance among the spectactors *(o si maa n duro l'ojiji (bimoto) ko ba maa le janpata awon to wo iran).*

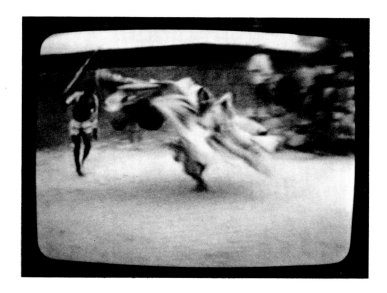

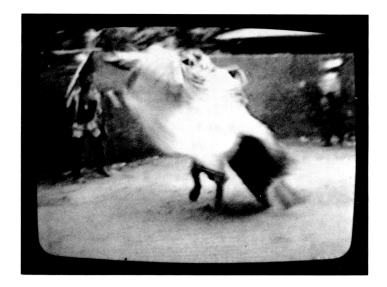

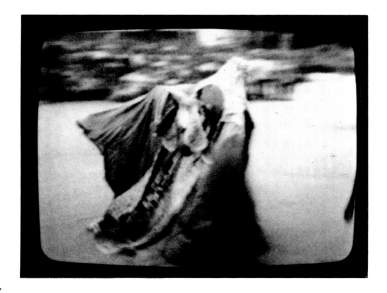

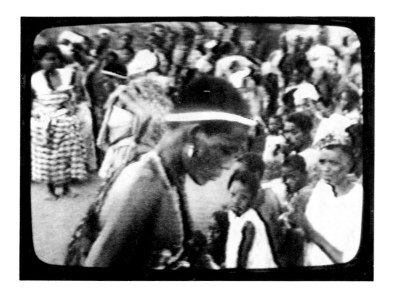

NIGERIA

Itele
16 August 1964

> 30. Chief of Itele
> Ijebu Yoruba
> 50ish
> Cultivator and chief
> Christian

[Speaks English]

1. You can tell how beautiful the dancing of a person is by the distance he is called from for our festivals. We hire the best dancers for the Agbo (waterspirits) ceremony; they come from Oke-Igbu, near a farm, several miles north of our town.

Madogun, Ohori
August, 1964

> 31. Unidentified Elder in Market
> Ohori Ije Yoruba
> 50ish
> Cultivator
> Traditional religion

1. A person dances Gelede to make the entire town cool.

Meko

> 32. Priestess of Babaligbo
> Ketu Yoruba
> Age not determined; probably over 50
> Priestess
> Traditional religion

1. Dancers for Babaligbo (smallpox) must cast their eyes upon the ground when they dance; they must continue to stare at the earth while dancing. There is usually a person, elderly or a mother, to aid each dancer to straighten her cloth, wipe the sweat from her brow, and so on. There must be a watching guard or mistress of the novitiates to keep a close watch on their faces, that they are performing correctly, and with proper control and dignity.

Igogo-Ekiti
21 August 1964

> 33. The Chief of Igogo
> Ekiti Yoruba
> 30ish
> Traditional chief
> Christian

1. The mark of a good Epa dancer is keeping the image straight. It's very dangerous carrying those heavy images and they must be kept straight. We watch the footwork (*ese ti won gbe*, lit. the legs that they carry). Those who carry Orangun must use the right foot more than the left, because Orangun is a man. Ordinary bystanders must jump in the air three times for Orangun, to honor his high rank, just as one bows down three times for the Alagba of the Egungun. There is a special time within the ceremony for the king of the town to dance. At that time a special song is sung:

> Good fortune to our king
> Good fortune to our king,
> We are your right hand,
> Don't let it spoil.

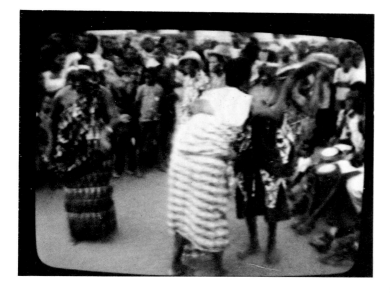

All must dance their full power to show that they are happy, can dance regardless of their troubles, and are healthy.

34. Chief of Itele's Son
 Ijebu Yoruba
 30ish
 Cultivator
 Religion not given

1. We identify good Agbo dancers in this manner; we watch to see if:

 a. when the drummers are drumming, if the person will have to watch the drums carefully, or whether he will miss the beat;

 b. whether he follows the drums with his hands, his head, and his body;

 c. whether he dances immediately according to the changing of the rhythms;

 d. whether he knows various patterns (orisirisi ona);

 e. whether he knows that when the drums go up high in pitch that he is supposed to dance up high (almost on tip-toe).

Ajilete
10 July 1965

35. Ogunlade
 Egbado Yoruba
 20ish
 Cultivator
 Religion not given

[Views dance of Agbeke, master dancer of the area. Says her dancing is beautiful because:]

1. of her ear training (eti igbolu, lit. informed listening to the voices of the drums),

2. the 'calculation of her feet' (kika ese),

3. her stepping and stopping at the correct place (dida ese kjo si ibi to ye),

4. correct freezing of her glance when dancing (oju ifi ri ibi ti o ye lati jo gba, lit. staring at a correct place when dancing),

5. using the arms to make visible the [direction of the] dance she is dancing (apa lati fi hon ijo ti o njo, lit. arms make visible the dance she is dancing),

6. correct following of the changing drum patterns (iyi jo pada pelu ese) with the feet,

7. changing the motions to fit the particular style, such as Kokan Loko (yiya pada si kokan loko ati bi njo).

Imasai, northern Egbado
14 July 1965

36. Unidentified Male Critic
 Egbado Yoruba
 30ish
 Cultivator
 Religion not given

1. This dance brings vitality to the body (ijo yi ninu ara lokun).

2. This dance intensifies the honor and memory of our lord, the God of Iron (ijo yi nfi kun iyin ati iranti olorun Ogun).

3. It reminds us how our forefathers worshipped their lords in olden days (ijo yi nran ni leti bi awon baba wa ti nse nsin awon olorun won nigba lailai).

4. It (performance of this dance) transforms one into a notable person among the people of the world (ijo yi ninu enia di gbajumo laarin enia).

5. This dance demands careful instruction from people; moreover, the master drummer must study the lore of Ogun very thoroughly (ijo yi ko nko awon enia; papa, onilu Ogun l'eko pupo).

6. This dance gradually makes visible the distinction between our art and the art of our fathers (ijo yi nfi iyato diedie to wa l'ona esin awon baba wa han).

7. If a person wishes to dance this dance for the Iron God in a beautiful manner, he must get himself prepared for the particular drum-phrases sounded by the drum, the pleasure and praise that exist within this dance [tradition]. This is most essential. One dances with the hands, with the legs, and by twisting the buttocks side to side (bi eniaba fe jo ijo Ogun ki o dara, oni lati mura lati ba didun ilu mu Eyi gan ni adun tabi iyin to wa ninu ijo yi. Oto ni fifi owo jo, oto ni fifi ese jo, ati ki enia ma redi. Lehin, eniti njo yio wa fi gbogbo arajo). In conclusion, the dancer will dance with all his body.

Ipokia
27 July 1965

37. Adejumon
 Anago Yoruba
 50ish
 Cultivator
 Christian; member of Gelede

1. When you dance you must bend down to complete the dance (nigbati a ma jo, k'o bere) [RFT: the verb, bere, simultaneously means "to bend down; to commence" which suggests, to me, that starting position and elevation close to the earth are possibly correlated in the Yoruba mind.

 Later in Ago ShaSha, a village famed for its Gelede dancers, Adejumon met the writer by chance on 29 July 1965 and observed the writer enter the dance ring during an Egbe Arobajo dance; a battle of dance speedily broke out, the writer versus the local master of the dance, with predictable results. Adejumon felt that the writer had committed an aesthetic atrocity and wasted no time in enumerating reasons.]

2. The carrying of the legs and of the entire body was balanced (in the dancing of the local master) (ese to ngbe ati gbogbo ara dogba).

3. The creating of [phrases to match the] drumming was fitting in the case of that particular local boy, [far] exceeding the foreigner's [talents] (dida ilu omo na bamu, ju ti oyinbo lo).

4. Various styles of dancing were called for by the drumming and the local member danced them as they were sounded (orisirisi ijo ni omo na njo ti o ba ilu mu) . . . the foreigner not (oibo ko)

5. The foreigner does not understand the import of the drums (oibo ko mo ilu na da).

[Another critic broke in at this point and elaborated: "you don't know how to *stop* correctly when the master drummer signals 'stop.' The drum said 'PAM!' and you missed this calculation completely, whereas our lad perfectly obeyed."]

6. The foreigner did not bend down where appropriate (oibo ko mo kunle nibiti o ye).

[Again another critic intervenes and adds: "when they beat the drums in the lower voice you were to follow it going down and you shake your hips according to the illustration of the drums."]

7. All parts of the male body are moving at the same time (ara okunrin na sepo yika),

8. which the foreigner utterly failed to do (ti oibo ko se bee).

9. He doesn't grasp the on-going creative flow of phrases from the drum (how to convert them into bodily imagery) at all (ko mo ilu ida rara).

[Bystander again: "you don't raise the leg until the master drummer has finished his accent—PAM!—and then you raise the leg."]

10. The foreigner does not know the preparation for beginning the dance; that particular child of our group *does*,—he organizes his patterning with feet in relation to his body (oibo ko mo imura ibere ijo; omo na mo se; papa onlo ese pelu ara).

[Two women begin to dance.]

11. The women of our country know the optimum tempo ("not too fast and not too slow") in whatever step they are executing (awon obinrin ilu wa mo olele ijo na, nipa isise, lit. according to the step).

12. Of the two women, the short one knows how to dance better than the older one because she is not pregnant and can bend down well in their dancing (ninu awon obinrin mejeji, eyi kukuru mojo, ju agba lo, nipa pe enikeji ko ti loyun nipa bibere ninu ijo won).

13. But they stop the dance [when the drum says to do so] equally well; the same applies to their opening phrases (sugbon nwon nda ijo dogbdogba, won si ribere bakanna).

14. The two are equal in terms of the moderate tempo of the dance (awon mejeji nipa olele ijo dogba).

[Now, two men intervene and compete.]

15. The two men are of equal talent in terms of dancing to the 'hard' (hot) dancing of the society (okunrin mejeji dogba nipa jijo ako ijo egbe).

16. This particular dance is very pleasing (lit. is sweet too much) because of its fast, hard beat (ijo na dun pupo nipa ako ijo ti won njo, lit. according to the maleness of the phrasing).

17. That is the most difficult of the dances within the society of Arobajo (eleyi ni ijo ti o le ju ninu ijo egbe arobajo).

[Another critic interrupts and adds, "you must be long-winded, you must have stamina." RFT: The particular step was amazing: the dancers were dancing on the *sides* of their feet, from the toes to the heel, defying gravity, departing from the security of feet-flat-on-the-ground norms of dancing.]

Ago ShaSha
27 July 1965
 38. Kosoko of Ago ShaSha
 Anago Yoruba
 40–50ish
 Cultivator
 Deeply involved in local Gelede cult

Five things identify the good dancer.

1. Someone who understands the beat of the drum better than someone else (ekini nipe elomi ma gbo ilu ju elomiran lo).

2. Someone who is more patient or 'cool' than someone else (ekeji nipe elomiran ti ara bale ju elomiran lo).

3. A person who dances but does not know the appropriate time [to halt the legwork when dancing] is not good (eketa elomiran ajo ijo ko ni mo asiko ti o ye),

4. (therefore) a deaf person cannot dance (ekerin nipe aditi ko gbodo jo),

5. (and) the style of some people will not shine well (eda elomiran ko ni ba mo).

Oke Odan
30 July 1965
 39. Bale Shango
 Egbado Yoruba
 70ish
 Cultivator and priest
 Traditional Yoruba religion

1. When the priest of Shango sees that the town is cool, that there are no disturbances in the town, then he will play with the thundergod axe and dance beautifully with it (nigbati o ri pe ilu tutu, ti ko si nkankan ni ilu, ni ose nse ere daradara).

16 April 1966
 40. S. O. Adeleye
 Egbado Yoruba, Oke-Odan
 32 years old
 Teacher
 Christian (however, shows intimate knowledge of traditional religion)

[Witnessed with an extremely careful eye, the dancing of Agbeke, one of the master dancers of the Yewa valley and, after she had finished dancing a cycle of dances for the water or riverain gods and goddesses of the Oshun/Erinle cycle, remarked quickly:]

1. Agbeke is a person who dances more beautifully than anyone else. She comprehends the drum, she dances with her entire body (Agbeke je eni ti o jo daradara ju enikeji lo. O gbo ilu, o si fin gbogbo ara jo).

2. She does not smile at all when she is dancing; she loves to look upon the earth upon which she is dancing (ko rerin rara nigbati o njo. O si feran lati ma wo ile ti o ba njo).

3. She is someone who has a great deal of power, more than anyone else. In addition, she knows how to interpret (in her dancing) the proverbs that the master drummer directs to her (o je eniti o ni agbara pupo ju enikeji lo. Papa, o mo wu owe ti onilulnpa).

4. She isn't too quick for the drum; she (keeps things) balanced. She knows how to move her legs together with the drum (lit. upon the face of the drum); she uses her hands to dance with (ko yara ju ilu lo. O dogba. O mo ese gbe si oju ilu. O si nfi owo jo pelu).

5. For five minutes, until she stopped her dance, she did not speak nor did she reply to any question (fun iseju marun, ti o ba pari ijo, ko ni le soro tabi ki o dahun ibere kan), because she uses her entire being with which to dance (nitoripe o ti fi gbogbo agbara re jo).

21 April 1966
 41. Ajibola Adebowale Alabi
 Egbado Yoruba ?
 40ish
 Priest and itinerant dancer for Eshu
 Traditional Yoruba religion

[Remarks on trickster (Eshu) dancing by a practicing priest of the cult.]

1. Eshu dancing is exceedingly beautiful to dance, for, if a person who dances it is troubled, after (lit. when) he dances it he will regain his health *(ijo esu dara pupo ni jijo, ti enia ba njo ti o si yo ni enu, nigbati o ba njo o ni lati ni alafia.)*

2. When they dance in a town, that town will be peaceful *(ti won ba njo ni ilu kan, ilu na ni lati ni alafia).*

3. When someone knows how to dance Eshu, and he understands the drums when the drums please him, he can use part of his body as an expression of the dance, or he can use both arms or legs. And he can display styles *(ara) (ti enia ba mo jo, ti o si gbo ilu nkan ti o ba wun ni ole se pelu eya ara re fun gegebi ohun ti o wun lati se. o le fi gbogbo apa mejeji jo tabi gbogbo ese mejeji jo ki o si fi da ara).*

4. It is Eshu Alabada who likes to dance on one leg—that means he wants to fight somewhere at the time he dances on one leg. Wherever he dances in this manner a fight breaks out. But he stops the fight the moment he puts the leg down *(Esu Alabada ni, ti o ba wun ole fi ese kan jo, ti o ba fe lo soro ni o ma fi ese kan jo. Ti o ba fi ese kan jo, ni ibi jo gbe feja yen o ti nja ni akoko ti o fi ese kan jo. Ti o ba ja ija yen fan lo man fi ese kan toku kan ile).*

Oyo, Koso quarter
23 July 1966
 42. Alaka
 40ish
 Oyo Yoruba
 Master bata drummer
 Yoruba traditional religion

1. When the drum is beautifully strong, the dance must be strong, and the dancer must dance with all his might *(ti ilu ba nle daradara, ijo yio le, eniti o ba njo yio si jo pelu agbara)*

2. . . . while he will create various styles, according to what the drum tells him *(nigbana yio da ara orisirisi pelu ohun ti ilu ba nso).*

3. The dancer who is dancing will apply his ear to careful drum listening, so as to know when he should lift his leg in the dance he wishes to dance *(eni to njo yio fi eti sile lati gbo ilu, ko o ba le mo bi yio ti gbe ese ijo ti o fe jo).*

4. When the drum beats hard, Sango will be greatly encouraged to dance hard; he will surrender himself to dance a dance that is beautiful. The thundergod will then be greeting the dancing members, 'I thank you! I thank you!' *(nigbati ilu ba le ori sango yio ya daradara; yio si jo ijo ti o dara. Sango yio si ma ki awon onijo pe, 'o seun, o seun').*

Ipokia
17 July 1966
 43. S. A. Adeosun
 Anago Yoruba
 42 years old
 Cultivator; head of Egbe Arobajo society
 Muslim

[Watched two women dancing Egbe Arobajo dance.]

1. The dance that the two women are dancing is beautiful *(ijo ti awon obinrin meji jo dara).*

2. They used their entire might to dance that particular dance *(won fi gbogbo agbara jo ijo na).*

3. They were re-creating tradition in the dance they were dancing *(won da asa inu ijo ti won jo).*

4. They twisted their shoulders together (lit. they made their shoulders) *(won se ejika).*

5. They shook their bodies beautifully (from head to thighs, in a twist) *(won ti ni ara won daradara).*

6. They then danced going close to the surface of the ground *(won si tun jo lo si ile).*

7. When the drums stop the dance, they stop the motion of their legs at the same time *(igbati oni ilu da ijo, won da ese, duro ni ese kanna).*

8. Their understanding of the drumming is beautiful (lit. they hear the drum beautifully, *won si gbo ilu daradara).*

9. If a person wants to dance this dance, he should listen carefully with his ear and heart because if he does not apply carefully ear with heart to the matter, he will not be able to manage to dance this dance at all *(ti enia ba fe ma jo ijo yi, o ni lati fi eti bale pelu okan nitoripe ti ko ba fi eti sile pelu okan ko ni le jo ijo rara o)*

[Interrupted by a young Yoruba, Adisa Fagbemi, who adds (in English), "you should *dance the whole cloth*" (involve your garments fully in the dance).]

CAMEROON

Kumba
As from: Fontem
14 March 1973
 44. S. Acha
 Bangwa hunter (Western Bangwa)
 c. 28 years old
 Nominal Christian; involved in tradition

1. The finest Bangwa dancers move like the palm bird, very smart, with a very wonderful shaking *(yeye)* [RFT: analogy is made between the shaking of the leg-rattles of Bangwa dancers and the fluttering in mid-air of the Pin-Tailed Whydah, vibrating his feathers up and down during the mating season to display his plumage to full effect].

2. Such a dancer, whether sitting or standing, he will be shaking all his body; you will see him making terrible (i.e., magnificent) dances.

3. The drum will know you; will call you; you will answer, shaking your chest; when you hear the drumming and think 'very wonderful, very wonderful' hold a fist aloft, fingers tight together—this means: you know how to play!

March 1973
 45. Chief Fochap of Fontem
 Western Bangwa
 60ish
 Sub-chief
 Christian; member of Ngbe

1. There is merriment in dancing,

2. but there is [also] much competition. People are judged by the way they enter correctly on a drum phrase or not; by the way they shake their body, beautifully or without feeling, and by the different sides (*i.e.*, directions) they use. A man may dance only one side *(abahamoho)* where a good dancer will dance both sides *(abimba biya)* and will move both up and down.

3. Bad dancers are *obombo nset*—could not even shake their foot.

4. Drums play specially for the finest dancer Now every chief has a leopard. And when they see that a chief is dancing superbly they say: 'Oho, he takes out his leopard to dance' *(abima afunji,* lit. dance resembles leopard) . . . anyone reaches this level, people will be talking all over the country. A leopard is the most smart animal in the forest; men who take their leopards out to dance are strong men, who can jump without touching the ground.

Bakebe
15 March 1973

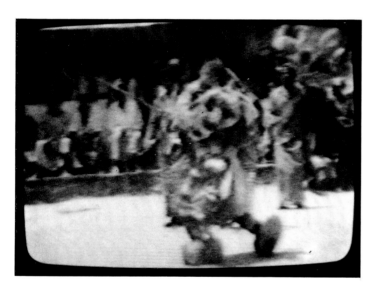

 46. Ayuk Enow
 Banyang
 50ish
 Sculptor (traditional)
 Christian; member of Ngbe

1. The melody of the drum makes one dance well.

2. Raffia fringes in Ngbe make the movement fine, like a style. You dance the cloth.

3. When women are dancing, shaking small beads, you see it vibrating, you enjoy it.

 47. Eta Egbe
 Banyang
 30ish
 Storekeeper in Bakebe
 Christian; member of a traditional society

1. *[Learning]*
 I was taught dancing by my father. He said: 'watch me doing, stand to the side of your father.' He said for me to be the mirror of his dancing, 'take the same measure of the father. See how I am using the legs.' I studied how he plays the toes, waist, hands, head.

2. *[Alleged inherent Banyang style]*
 The hands give power to the body to dance. All the power comes from the hands; keep the hands free, the body enjoy 'em . . . we don't have any 'hard' (*i.e.*, harsh, aggressive) dancing; our dances are all normal *(ekwaii)*.

Defang
16 March 1973

 48. Chief Defang Tarhmben
 Banyang
 40ish
 Traditional chief; cultivator
 Christian (Bahai); member of Basinjom society.

1. There are so many things that lead a man to choose the best dancer. Fine dancers are those who always can *see* intelligently and *clearly*; it is a gift, just like school children; in the long run some advance further than others.

2. The dancer must listen to the drum. When he is *really* listening he creates within himself an echo of the drum *(eyong bako,* lit. drum-echo)—then he has started really to dance.

3. Once he is seeing the echo, he is dancing with pride. When you are shy you cannot dance properly. You dance with pride *(paka)*.

Akriba
22 March 1973

 49. Chief of Akriba
 Banyang
 80ish
 Cultivator
 Christian; member of Ngbe

[Criticism of author's trial attempt to dance within knitted Emanyankpe costume.]

1. You stood in one place (you are supposed to travel, with many styles) *(de te devied amod!)*.

2. The shaking of your waist was incorrect *(de nekesi ebo)* [I moved from side to side, instead of with the forward tilt that causes an enormous bell strapped to the waist to ring strongly and properly].

3. Don't pass (follow) on the line of dancers *(o kefued du ndong)*.

4. It is good to show signs of Ekpe *(E chi erere du ne tong ngbe)*.

5. One can never be perfect in learning something in a day! Dance and be looking at members who are participating with you in the dancing *(mu aporenge ening nob re mod, oben o inge noko mu ne achi ambe ane mu ako)*.

6. (You were unaware that) after dancing the chief will sit down and take up the staff and signal the seven signals *(mpoko ne ba ben mfor ngbe a choko amek ansie ngbe ne esang)* [i.e., you kept on dancing after the call to silence and arrest of all movement had been made].

Douala
6 June 1973

 50. Justin Jokunde
 Mbam, from Yasem
 30ish
 Steward
 Roman Catholic

[Re videotape of Dahomean Sakpatassi]

1. They dance very seriously.

2. There is no brutality *(abiiya)* to their motion.

3. Very beautiful, how she turns, lifts her feet, and how they reward her with money.

4. They dance close to the earth, similar to our choreography—our *ganga* dance.

[Re Egungun dancer whirling]

1. He lifts himself up, he lifts himself up, he lifts himself up!

2. He chases people; [but] the others are still there

3. He turns, turns, turns!

Konye
Kumba-Nguti road
6 June 1973

 51. Charles Kome
 Kossi, native of Nyandong village
 16 years old

 Schoolboy
 Christian

[Views same Egungun sequence. "Beautiful!" because:]

1. of the attire the person has on *(bime be mode a nne a yole)*,

2. of the way the man obeyed the conductor,

3. to see how the people organized the masquerader,

4. the way they greet the chief,

5. the music: it is African music,

6. the *opening-up* of the garment when he is turning.

7. The man turns around without falling *(mode a wedi a homine a de e hone a seh)* one can turn around so, then stand and fall—but *that* one did *not*.

Otu
7 June 1973

 52. Ben Ndifon
 Ekwe Ejagham
 c. 40 years old
 Cultivator
 Roman Catholic; Ngbe

[Video of Sakpatassi]

1. *Fine!* That one . . . because the woman danced shaking all the body *(abona ashoroshoroa shen-shen biji)*.

2. The drums—I like the manner of handling the drums, the accord of sound with manner of striking [the earth with the feet].

3. I like the woman; she moved according to tradition . . . she knows how to dance *(a ma negeban)*.

 53. David Tabi
 Ekwe Ejagham
 c. 35 years old
 Cultivator
 Roman Catholic; Ngbe

[Points to a dancer whom the author himself finds most aesthetic and remarks:]

1. This one I like best! *(n je koron!)*

2. because goes around while shaking the body they are dancing *(a ki boni afara ofari)*.

3. I liked that woman who wore the cloth on one side and who tied the feather in her hair—this showed a very good tradition *(a tone epini nji ane emini,* lit. showing the fashion of ancient men).

4. I like the beating—and that man who is handling that big drum he knows how to play. . . .

 54. Chief Emanuel Nyok
 Ekwe Ejagham
 c. 45 years old
 Traditional chief; cultivator; priest of Ngbe
 Roman Catholic

[As videotape plays, smiles, exclaims, "bo!" (lovely!), laughs at the point where the passage of the Egungun is blocked by the young man with the *ishan* staff; follows much of the action with dry, brimming laughter, then composes his face and remarks

very seriously, his eyes still sparkling from obvious pleasure in the motion:]

1. I like the mask in the form of the dead chief [Chief Nyok had asked to be told about the function of Egungun dancing and listened, very attentive, to a thumb-nail sketch].

2. I liked the way the man came, danced, and tumbled himself (*a kpuga okpegi*, lit. he tumbled himself).

3. He came as a wonderful story, when someone dies and comes back [sequence with two crowned dead kings moving in unison].

4. I like their dancing together, shaking and jumping up—it's a wonderful thing, like the Second Christ!

[Author then switched reels and played for the first time a few minutes of Minganji dancing by Pende in Kinshasa. This caused a minor sensation and small children shouted *Ngbe!* by analogy with the striped decoration of the costumes, the raffia fringing at points of bodily articulation and the Ngbe-like close-fitting quality of the knitted costume. A critic then stepped up and confirmed in formal analysis what the reaction of the children had implied.]

55. Patrick Eji
 Ekwe Ejagham
 29 years old
 Cultivator
 Roman Catholic

1. First of all, I like the things they wear. Looks like my country, just like a leopard skin *(kongbe)* because of the white and black all over and because of the raffia *(ibom)* which they wear at the wrists and at the ankles.

2. Their dance looked very attractive because they looked smart and danced well.

[Author then asked, "what makes them look smart?" Answer:]

3. They jump and turn themselves *(e fa bun koso . . . e kpikun biji)*.

4. Their caps are so fanciful *(ita m naring*, lit. cap with colors).

5. I liked that they had that tradition of circumcision.

[Minganji tape replayed.]

56. James Otang
 Ekwe Ejagham
 c. 43 years old
 Cultivator
 Roman Catholic

1. I liked that second dancer because of the feather headdress; he was covered with feathers.

2. Also: the dancers all break at the same time *(eyon tambiyen*, lit. break, one-time).

3. The way they dance and shake themselves. They dance shaking themselves and breaking at the same moment *(a bona anyana biji*, lit. dance twisting of torso with arms; *eyon tambiyen*, break at the same moment).

[Basinjom sequence at Bakebe then played; criticized by an *Ewunjom*, a man who carried the Basinjom head himself, for the Otu area.]

57. John Etok
 Ekwe Ejagham
 c. 50 years old
 Cultivator
 Roman Catholic; Ewunjom

[In general, he liked the Banyang version of the original Ejagham play and said:]

1. I like the way he carried the gown; he began to turn to the left and turn to the right.

2. He was dancing together with all the other Basinjom people [interrupted at this point; noise of children and other curious onlookers becoming oppressive; someone shouts *ejo pa*, then repeats *EJO PAAA! i.e.*, shut up! Critic resumes commentary:]

3. It is fine if you turn 'em so, turn 'em so, turn 'em so *(e kpiginga, e kpiginga, e kpiginga).*

4. But: the drum is better in Otu. The people do not know how to play the Basinjom drums.

[Why?]

Because they are *lacking songs.*

[At this point the chief, Emanuel Nyok, intervenes and remarks, "we have the original Basinjom and the songs are in our language; somebody not talking the talk of the songs cannot do the same thing as the person for whom the talk is native."]

[Basinjom tape replayed.]

58. Henry Ekpo
 Ẹkwe Ejagham
 c. 38 years old
 Cultivator
 Roman Catholic

1. I like the drumming, because of the *striking*, especially the *ejuk* (slit-gong)—when somebody is lost in the forest you play this gong.

2. I like the dance of Obasinjom because Obasinjom has its own god and he doesn't tell lies.

3. I like the way he moves because he is always listening to something *(a djino ayukwa nshot).*

4. [Critic repeats for emphasis:] Obasinjom dance is beautiful; *to move and be listening to something*—this is Obasinjom.

59. Unidentified informant
 Ejagham
 Cultivator
 Baptist

[Re Pobe Gelede dancer practicing.]

1. He dances about native affairs.

2. The way he dances is very, very enjoyable.

[In what way?]

3. By the way he danced following the beats of the drums in the steps of the music. I like it very much. He takes the correct steps *(eyumon nkokwet)* it encourages more people to join the group.

4. He turns round, round, round to show that he has power in dancing.

60. Aritani
 Ejagham
 Born in 1914
 Ex-soldier, cultivator
 Christain

[Speaks in English]

1. I like him because he uses the conversation with his body.

2. Even an old man can dance conversation using the whole body; that old man why he so dance? to show still get power!

[The author then ran full-tilt into an Ngbe funeral ceremony in

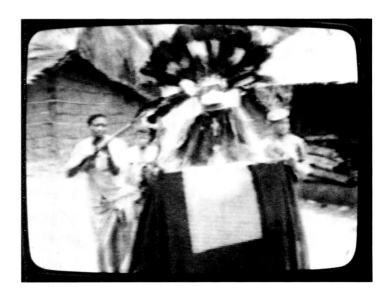

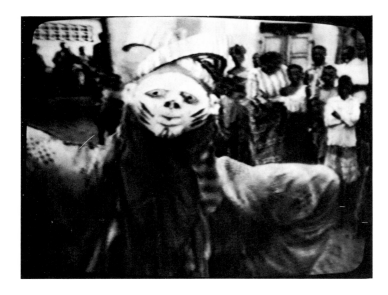

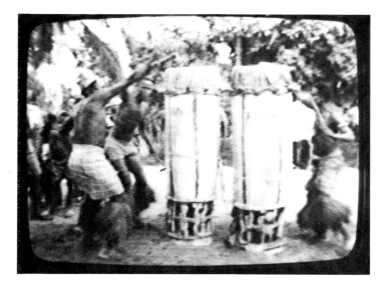

the village quarter of Mfoni-Tanyi Enow and was invited into a special mourning shed made of cool screens of leaves, creating the effect of a densely shaded forest glen conjured in the middle of a farming village; in this cool spot several of the society volunteered to criticize aspects of the videotape.]

 61. Otto Enok
 Ejagham
 c. 29 years old
 Cultivator
 Baptist; Ngbe member

[Viewed the Gelede dancer from Pobe and said:]

1. This is one that is not good for me.

[Why so?]

2. I have never seen it, nor where it was played.

[Then shown video of Ngbe in Cameroon.]

3. I like it; because it is native to us; the dress is all correct.

Mamfe
8 June 1973
 62. Ako Nsemayu
 Banyang, native of Kendem
 41 years old
 Steward
 Christian; member of Basinjom society

[Remarks on videotape of Basinjom dancing.]

1. The beauty depends on how you handle the gown, how and what it looks like in the dance. The breeze carries the gown, got in the gown; it not resemble anything but there must be breeze

2. The kneeling (*i.e.,* where Basinjom with his troupe all squat low simultaneously) part is fine; he wants to see things, *the bad things,* he is stopping and bending down to read with his knife.

Mfoni
8 June 1973
 63. Eno Ashu
 Ejagham
 34 years old
 Cultivator
 Presbyterian; Ngbe member

[Shown video of Ngbe drum dancing, Eyoumojok.]

1. I like the Emanyankpe because he dances and salutes the chief and it is usually the chief or a very important personality.

2. The dance is very very nice *(enok tamchan).*

3. It's *fine* because of the clothes, because of the raffia.

4. I like it because it is an African traditional dance.

5. He wears the *enkanika* bell so that people will come to see him; it is a tradition of our forefathers.

 64. Chief Mfoni
 Ejagham
 80ish
 Cultivator
 Christian; Ngbe

[Shown Sato drum dancing from Dahomey:]

1. I am interested in the *hitting* of those very high drums and the dancing around them; they are dancing to impress the vistors.

2. They are bending down and hitting *(a komen kan si kasuma nka).*

266

65. Agbo Ashu
 Ejagham
 26 years old
 Christian; Ngbe

1. It attracts me very much—the movement, the ringing of the bell; he calls each to order, attracting every individual to the group.

66. Aaron Akem Ndip
 Ejagham
 32 years old
 Cultivator
 Baptist; Ngbe

[Viewed a certain section of the Eyoumojok Ngbe sequence, where the chiefs dance before the Ngbe house where a cloth *(okarangbe)* with *nsibidi* signs had been briefly unfurled]

1. The chiefs of Eyoumojok—they dance quite well and according to the song.
2. I like it because it is the traditional dance and because of the organization.
3. They keep peace when they are dancing *(kem maka ejok e bu a ke mene ben).*
4. [Repeats for emphasis] they keep *themselves* peaceful when they are dancing—this is reassuring to the townsmen.
5. They show how they belong to Ngbe according to the rules and signs.
6. When they are swinging their arms, they show *sign* [italization of the last word indicates that the critic's voice rose to a falsetto at this point to underscore the importance of the symbolization . . . later the writer learned that the loose, forward patting of the arms and hands in the air symbolized the pawing of the earth by a leopard].

[Zaire sequence of Minganji shown.]

7. I like the color, the dress, the style; they show the sign of the music as they dance.
8. Very smart with the hands, legs, torso—correct.

67. T.N. Enowabong
 Ejagham
 35 years old
 Cultivator
 Baptist; Ngbe

[Re Minganji:]

[Before the criticism and commentary formally began the informant was already exclaiming *a re be! a re be!* (very good! very good!)]

1. How they move!
2. They all move together; some are very good, they come in, follow, follow, their dancing goes very straight
3. They are smart—the way they go with their singing; the song go correct with the dancing—smart, because they move from pattern to pattern.
4. The first batch, second batch, they check, all come in, all their movement together.

68. Tabe Enow
 Ejagham
 60 years old
 Cultivator
 Baptist; Ngbe

[Immediately demonstrated the steps of an accomplished Ngbe

messenger dancer, then remarked about Eyoumojok Ngbe dancing:]

1. I like it; because they *dance!* All dancing with the things where they make 'em [demonstrates what he means by "make 'em," *i.e.*, vibrations of torso, ending right at the hips; hips up and down pulsation, torso laterally vibrating in a kind of restrained twist.]

[Obasinjom sequence: critic immediately became sober and switched to talk about function:]

2. The dress of Obasinjom is good in the dance because he save people who are sick; witch people who are doing bad, he kills.

Defang Village
9 June 1973

 69. Ako Defang
 Banyang
 50ish
 Cultivator
 Traditional Banyang religion

[Video of Bakebe Basinjom.]

1. I like the man wielding the Basinjom broom *(nkong esanganjom)* . . . the interpreter.

2. I like the handling of the broom *(nkong dekem kethinge).*

3. The way he can interpret the message of Basinjom *(eyu ne ebasinjom a ngati ndack ye a ndem).*

 70. Moses Akpa
 Banyang
 28 years old
 Cultivator; native herbalist
 Traditional Banyang religion

[Views Bakebe Basinjom and patriotically proclaims Defang village Basinjom better . . . gives reasons:]

1. I like the Basinjom dancer of Defang *(nkong ebasinjom ene defang)*

2. because our ancestors left it to us *(eyu na bo tayese ke baro yo),*

3. because the power is not comparable *(eyu na betang ebi be beke ebong njenji).*

4. [The other] is just like a learner *(aji ji mo njoh).*

5. He's weak *(aji nneob).*

6. He carries the gown too high *(ajong ngock te afai), i.e.,* 'the gown must be carried just above the tips of your toes.'

 71. Rudolph Fongang
 Banyang
 50–55
 Cultivator
 Traditional Banyang religion

[Critic first enthused over the Basinjom singing and although he did not remark further or give reasons, he translated the refrain:]

 Bwaanjoronjo
 Nkundack
 Bird, you should hear!
 (*i.e.,* because it is the bird that gives messages to Ebasinjom).

[Then shown Ngbe sequence, Eyoumojok.]

268

1. I like the singing *(dekwai ke me nkongho)*.

2. Is sung in parts *(bakwai ne mbah)* (i.e., one part in strong voice, the second with the softer voice).

3. But: the bell is not going in harmony with the beat of the drum *(nkaranka a perong ne eyong bako)*.

4. The gown of that cloth is nice *(eseke ema ereh)*.

5. He dances like our ancestors *(a emen ngbo botah)*.

6. A chief of Ngbe knows how to dance *(bafow ngweg baringe ebenǀ*

72. Lawrence Enoh
 Banyang
 c. 34 years old
 Cultivator
 Traditional Banyang religion

[Tape replayed, small children see Ngbe masquerader, gasp, and cry out: *Emanyankpe!* Critic smiles at this, then says:]

1. It is the gown I like *(nku eyi ke mme nkong)*,

2. the way it is sewn *(eyuk ne bajem yo)*—the colors according to the cloth of our ancient ancestors.

73. George Ayuk Tambe
 Banyang
 34 years old
 Cultivator
 Bahai; Ewunjom

[Shown Sato from Dahomey; immediately smile died and he stared at the monitor with a hard eye, remarking *a! a!* (surprise, in this case, not favorable).]

1. I do not like this dance because we don't have it here *(nbeke ekong deben eno eyu depu bese fai)*.

2. They dance like devils *(ba eben ngbo bagube enem)*.

3. No interest *(ye esong epu)*.

74. Joseph Bayle
 Banyang
 34 years old
 Cultivator
 Bahai

[Video: athletic dancer of Gelede, Pobe, Dahomey.]

1. It is a powerful dancer *(ji deben betang)*,

2. that's why he is sweating *(nsong nti efu ye ameoag)*.

3. The way he sat, like a gorilla *(nkong eyune ye achoko nbo nsong nya)*.

[All of this said with a joyous smile.]

75. Edimo Ayuk
 Banyang
 28 years old
 Cultivator
 Bahai

[Shown sequence of Adegbite "Jean" of Ketu demonstrating with vocal drumming some of the steps of famous *eka* (Gelede sequences).]

1. I like him dancing with power *(nkong ye eyu ye aben ne betang)*.

2. He is like a small child playing *(deji nbo bokati ba eki ntock)*.

3. He dances like a crazy person *(a eben nbo mu ebogeri)*.

4. He puts down his head and lifts up his legs *(ateb nti ameg anjong betag afai)*.

Sumbe village
9 June 1973

76. Solomon Ekong
 Banyang
 60ish
 Cultivator
 Head of the Basinjom cult

[Shown Adegbite Jean of Ketu. Laughter. *A! A!* (exclamation of surprise), steady smiling gaze; laughed with Jean precisely at the moment the videotape shows the dancer himself "cracks up" with merriment over the pleasure of reliving steps he had not danced "for years" though the dexterity belied this]

1. The first step he danced was beautiful *(mu mbembe aben ajayi)*.

2. He danced with honor *(aben ne kenoko)*.

3. The second man dances like a crazy person *(mu nsem aben nbo mu bekem)*.

4. Tall, smart, and slender *(asab, awakari, ne achi negeneng)*.

77. Samuel Tambi
 Banyang
 55 years old
 Cultivator
 Bahai

[Same video.]

1. He dances like a scholar *(aben ngbo bokati)*.

2. The other is tall *(anefu wu asab)*,

3. and he dances differently *(aben eni deben nyangh)*.

4. He jumps *(a doketi)*.

5. Like the dance of a scholar *(chi deben bokati)*.

78. Joseph Tiko
 Banyang
 40 years old
 Cultivator
 Bahai; Ngbe

[Basinjom sequence]

1. I like the dance *(nkong deben eni)*.

2. He dances with joy *(aben ne banyak)*.

3. Dances in the style of other Basinjom *(aben ngbo bateh bewunjom)*.

4. But: he raise the gown too much *(ajong ngog afai tonto)*.

Sumbe No. 2
9 June 1973

79. Mfo Ayuk
 Banyang
 61 years old

Traditional chief; cultivator
Christian

[Remarks on Bakebe Basinjom.]

1. They dance properly *(ba eben erara).*

2. There is no difference *(be wesi bepu)* [from the accepted standard].

3. They dance like other Basinjom *(ba eben nbo bebasinjom ebengfu).*

4. They keep the rhythm of the drum *(a kungo eyong bakoh).*

Defang village
 80. Jacob Tataw
 Banyang
 55 years old
 Cultivator
 Baptist

[Video of Ngbe dancing, Eyoumojok.]

1. They dance properly *(ba ringe eben).*

2. The Ngbe style is correct *(emanyankpe echi erere),*

3. just like the ones from Calabar *(ngbe aya achi ngo ane Calabar).*

Grasslands
11 June 1973
 81. Tuwad Tinyi
 Bamenda
 50ish
 Hotelier
 Christian

[Shown Sonde dancing, Zaire]

1. I enjoy the dresses.
2. I enjoy the dancing styles.

3. The demonstration: how they display is good.

 82. Joseph Gosche
 Bamenda
 40ish
 Cook
 Christian

1. From the way they dance the steps you know they understand each other.

2. If they want to change the style, they do it together.

3. Another style goes fine, another goes fine, [they] keep changing it

Santa, Grasslands
11 June 1973
 83. Paul Chebo
 Penyin; from a village "near Santa"
 58 years old
 Correspondent-clerk in Santa Council
 Presbyterian

[Shown Tu-Chokwe stilt dancing; tundanji. His eyes wide open, laughs, remarks, "Fine! Very good indeed!"]

1 I like the dance—the way they show the style.

2. That style of dancing shows that the people know plenty steps, plenty music—I would also like to dance exactly like them.

3. [Repeats] the style shows plenty knowledge. We say fine *(a pon ne)*.

4. The style of dancing is fine *(akue pene apon)*.

Bafunda, Grasslands
11 June 1973

84–85. Daniel Dasi and Father
Bamileke
Son c. 20; Father 80ish
Cultivators
Christian

[Tu-Chokwe dancing. Chief and young man delighted—Daniel comments:]

1. The dancing is good; well-studied.

2. The mask, fibre, and gestures are all beautiful.

3. The movement of the body is excellent, particularly the trembling of the shoulders and the hips, the trembling pattern resembles our own style of dancing, when we go *san, kakakaka-ka* in dancing. There are stiff people who cannot dance this

Nkongsamba
11 June 1973

86. Claude Amougou
Bulu (speaks Bulu, French, German)
40ish
Fonctionnaire (civil servant)
Protestant

[Tu-Chokwe Muyinda]

1. I like it because it is African,

2. and the manner of turning *(afoo mekan)*,

3. and the display of balance *(a wua mo)*,

4. and the impressive masks.

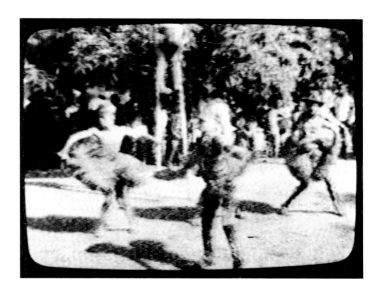

ZAIRE

Kinshasa
24 March 1973

87. Ilunga
Luba, born in Luebo
c. 24 years old
Waiter in Kinshasa restaurant
Roman Catholic

1. Luba say: one must move one's hips in as supple a manner as possible.

2. In fact, one must, in general, dance in a supple manner *(kuja muteketa)*.

3. You should not align the limbs in too straight a manner.

4. You should determine the position of your body *before* dancing.

5. Dance with the knees bent, the arms symmetrically bent at the elbow [Ilunga demonstrates this posture].

6. You should dance *(uja)* bending deep *(ku puekelela,* lit. descending).

7. Dance gently *(maja bitekeja)*, but there is one moment where it is necessary to dance very fast, very strongly, for balance.

8. Keep your elbows and hips close-in to the body; you must move your entire body, vibrate the whole, but you must keep the movement self-contained, not to go too far out with gestures and thrusts of the arms and legs *(kui kula to)*.

25 March 1973

> 88. Kutesa Waditela
> Sonde
> 20ish
> Urban worker; professional dancer of
> traditional Basonde dances
> Roman Catholic

[Author attempts to imitate some of the Sonde steps. Waditela comments.]

1. Your feet are heavy *(yendu idi ya lemu)*.

2. Your head is immobile *(mutshu udi wakola)*,

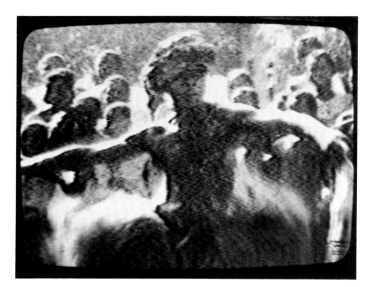

3. but you were sufficiently supple *(kuswaswabana)* to follow *parts* of our dance.

4. You followed the drum patterns with full intelligence *(wenda walaba makinu pimbu ni nzingi jibima)*.

26 March 1973

> 89. Zomoko Kasi
> Kongo
> 30ish
> Taxi driver
> Roman Catholic

[Re traditional Kongo dances.]

1. Our ancestors gave us these dances; we cannot forget them.

2. The good dancer is one who speaks, as it were, with his body.

3. What I like I must say in my own language—*(muntu tomeno zaya kina ndwoyo zeyi toma nikune muluketo ze toma zebula ye toma nikune nitu)*. A person who well knows how to dance, moves his buttocks and shakes his body.

> 90. Kapambu Sefu
> Pende
> 30ish
> Teacher and professional dancer of Pende
> traditional dances
> Protestant

[Praised Minganji dancers with the following two phrases:]

1. They obeyed the drums.

2. Began on the left foot.

12 June 1973

> 91. Paul Mawika
> Tu-Chokwe
> 40ish
> Watchman and professional drummer
> Roman Catholic

[Saw videotape of his own troupe and apropos of a particularly beautiful passage of tundanji dancing, where the hands oscillate beautifully from extended arms, said:]

1. Good dancing, lifting up the hands and extending them out (lit. proffering them) *(kosamoko mwilu)*.

2. We dance as our ancestors *(wino bakoko)*,

3. with pride or haughtiness *(mboma nzombo)*.

4. We shake our whole body to the *machakata* rhythm.

> 92. Mwabumba Shamakondo
> Tu-Chokwe; native of Kahemba area
> 40
> Ex-soldier
> Protestant

[Remarks of his own tundanji:]

1. We love the raffia skirt *(nzombo)* of the circumcised boys *(tundanji)*.

2. We love to produce marked movement, and to move our hands *(misese)*.

3. When you are dancing tundanji you have, first of all, to heat the drums with the fire and tune them; when the drums begin to resound properly and are accurately tuned, then the gesturing and the singing can begin. Afterwards, one begins to give form to the body. The form comes from the heart *(ku waha)* and it gives you deep pleasure *(kubema)*. Our most beautiful motions have to be learned over a two-year period; the best dancers do not emerge without at least this much training.

4. Our ancestors were the ones who began to dance with all their bodies. We dance with all our bodies *(nisese)*, too . . . our stilt-dancers *(muyinda)* come when there is a spell of bad luck, a sign that something important has been left undone with our ancestors; we bring them out to appease our ancestors.

5. Tu-Chokwe men do not dance, normally, with the feet flat on the ground. We dance with the feet trembling rapidly over the face of the earth...with trembling feet *(ni moolo kanahangana)*.

6. One of our most beautiful dances is *kiyanda,* where you dance with elegant extensions of the arms.

7. Most important: you should dance all the rhythms in your body. This quality of dancing to several rhythms at once we call *chingenoyaso.* You take one morsel from one rhythm, a morsel from another rhythm, and you play with all of these patterns in your body. You combine all the fragmentary drum patterns *(ngoma se pinji)*.

8. When you make the gestures of the kiyanda dance you feel, very deeply, pleasure *(wahachingi)*.

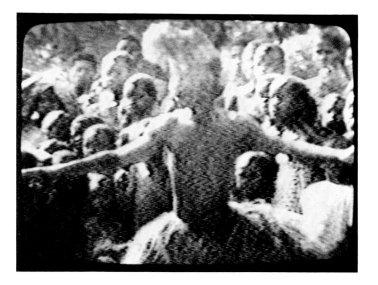

13 June 1973

> 93. Kabimba Kindanda
> Mbala from Kingawu village, Bandundu
> 32 years old
> Hotel worker
> Catholic

[Re Tu-Chokwe dancing:]

1. Of course I love that dance; above all because of the gesturing *(mbandu)* and the way they dance the masks, the gestures and the colors.

2. I love the dance motions *(kukina)*,

3. the manner of moving *(bwendu)*,

4. the special gestures *(kukina)* or activations of the body *(kukina)*,

5. the manner of presentation *(kudilesa)*, aligned and organized,

273

6. the dancing on two staffs (stilt-dancing) *(mutondo)*.

7. I like the swinging to the rhythm of the raffia skirt best of all; reminded me of modern rumbas in Kinshasa

94. Makwansa Amusiele
Yanzi
20 years old
Hotel worker
Catholic

[Video of Tu-Chokwe sequence:]

1. I like the movement of the entire body, the moving of the body with sentiment and feeling.

2. I applaud the supple quality *(ntin)* of the dancing, especially in the moving of the hips.

3. They give you the impression that they have no bones *(mi nkamana mikwo mi a ti)*.

[The author then invited Makwansa Amusiele to recall the normal settings of dance criticism in his childhood, growing up in Yanzi country. After a few thoughtful moments, he recalled:]
 My grandparents watched me beginning to dance in the village square. They watched and then told me:

4. you don't have enough gestures *(ko tam koyepete te seno)*,

5. your feet are heavy *(mboli bur)*,

6. make your arms supple *(ntin)*,

7. keep your feet rapid *(mbiol ntina)*.

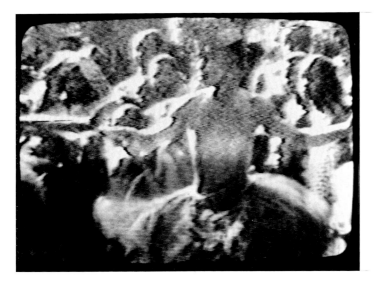

95. Piluka Ladi
Suku, born Kisaku village
25 years old
Worker
Roman Catholic

[Video of Tu-Chokwe:]

1. They dance with beautiful movement; the stirring of the body is not repetitive; one appreciates changes in moving [or changes in gestures] *(matindu)*.

2. They move, they walk, they turn.

3. In the old days our ancestors danced like that.

4. To be able to move in an excellent way, like this, you must know how to speak the vernacular language of whatever region of Zaire you are visiting; you cannot dance our dances without speaking one of our vernacular tongues fluently.

[Piluka Ladi was then asked to recall childhood instruction from Suku elders in his natal village of Kisaku.]

5. I was taught to dance slowly *(malembi,* moderately) [*cf.* Kikongo, Lama, p. 487: *malembe,* "moderately, in a fitting and exact manner"],

6. do not move too fast, do not exaggerate your gesture *(onikan-yiku bwini)*,

7. activating my entire body (lit. "whole statement," *mbandu)*— legs, hips, back, arms,

8. without raising or keeping a sweat *(o kadiku yebiosa)*, raising a sweat means that you are dancing too fast, that a person is dancing bad.

274

9. You dance according to the rhythm of the song [or intonation] *(wuhkina mopila mokonga)*.

10. You dance together with your brothers.

> 96. Sukari Kahanga
> 32 years old
> Pende; interviewed as from Kitobo
> Worker in auto repair shop
> Roman Catholic

The rules for Pende dance *(mianda)* of the circumcision school are very strict; during the time you are learning the tundanji dancing you cannot drink beer, you cannot overindulge yourself in eating, and you have to abstain from having sexual relations with a woman. If you prove this self-control and concenₜₐte on the dancing you will go on to become a dancer, a man of great Pende culture. This will protect you; for you will dance in such a manner that people will say 'you are well-taught' 'you have important kinsmen.' In the bush school, when I was circumcised, I remember the preceptors taught us carefully the rudiments of tundanji dancing. They drilled us every day:

1. Keep your hands in sympathy with your head; if the hands go to the right *(mago gomaja)* or if the hands go to the left *(mago gomajidi)*, the head will follow the hands *(motue a hate mago)* the head tilts to the side if the hands tilt to the side, moreover,

2. hands move with the chest *(nisen mago ni tulo)*. Move your hands with your chest;

3. legs move with the belly *(nisen malo)*;

4. if the legs move to the right, then you must end the phrase on the left: you have to dance both to the left and to the right *(kulu wayandinga bu maja wasuga komajigi)*.

5. The entire body dances by the ear to the drum(s) *(mwila udi mukina matwi gudi ngoma)*.

6. When the drum gives the signal, you bend down low and then you rise up *(shugeno, zugeno, lit. you go down, you come up)*.

7. When singing the dancer dances slowly *(wula tomoyimba itenyi ikine habibila)*.

8. When the dancer stops singing he gives himself up entirely to the dance to show the full range of the motions *(wula ta bemba uyimba kenyi idehanen diago mokena)*.

9. The dancer shows the exact Pende steps; those motions that show that we are Pende *(ilenze kukina wa bapende)*.

10. If one is singing, one does not beat the drum too strongly, so that the spectators can hear the song *(gula tomoyinba mbunji gushiya ngoma mage-mage)*.

11. People listen to the songs we sing *(ndaka ato aze mwanda to mo yiinba)*.

12. We make a special circulatory flashing of the raffia about our hands so that people will not be able to say that there is a man out there *(idimuzela lawi gamba nigi senu mago ndaga mutu ganyiziago munganji mutu)*.

13. Change your style of walking so that when you are in the knitted costume no friend will recognize you from your gait *(swega guwenda ye gwaye ndaga mafuta aye gawiziago gùla udi momonganji)*.

14. Remember: each drum has its rhythm *(ngoma nugushiga kwenji)*.

15. If the drum does not sing out well, the minganji dancer will approach the drum and demand that he play more strongly *(ngoma ishi movya ga nganji womoza momwila momuleza ashiye mongololo)*.

[Later, in more casual conversation, Sakari Kahanga remarks, "When you have sculpture, masks, and so on, you must *dance* with the sculpture, not decorate with it."]

PHOTO CREDITS

All Photos Other Than Those Listed Below Are
by
LARRY DUPONT

Thompson, Robert Farris
2, 4, 8, 9, 15, 18, 105, 130, 197, 198, 199, 201, 202, 203, 204, 205, 206, 207, 208,
209, 210, 211, 220, 221, 223, 224, 225, 226, 227, 228, 230, 231, 232, 233, 234,
235, 236, 237, 238, 239, 240, 241, 243, 244, 247, 248, 249, 250, 251, 252, 253,
254, 255, 256, 257, 258, 259, 260, 261, 262, 266, 267, 268, 270, 271, 272, 273,
274; all appendix plates; color plates VIII and X.

14 Museum of Modern Art, New York

23–26 Carroll, Kevin, *Yoruba Religious Carving.* Praeger: 1967.
 Geoffrey Chapman Publishers, London.

33–34 de, Marees, Pieter, *Descriptions et Recit Historical du Royaume
 d'Or de Guinea.* Amsterdam: 1604.

35 Bassing, Carolyn

36 Barbot—undated engraving

41 Labat, Jean-Baptiste, *Nouvelle Relation de l'Afrique Occidentale,*
 Vol. II. Paris: Guillaume Cavellier, 1728.

42 Alexander, James, *Narrative of a Voyage of Observation Among
 the Colonies of Western Africa in the Flagship Thalia; and of a
 Campaign in Kaffir-Land.* Vol. I. London: Henry Colburn, 1837.

43 Schweinfurth, Georg, *The Heart of Africa,* trans. Ellen E. Frewer,
 Vol. II. New York: Harper & Bros., Publishers, 1874.

44 Stanley, H. M., *In Darkest Africa.* Vol. I.
 New York: C. Scribner's Sons, 1890.

45, 47 Binger, Louis G., *Du Niger au Golfe de Guinée par le pays de Kong
 et le Mossi.* Paris; Librairie Hachette, 1892.

48, 49 Burrows, Guy, *The Land of the Pygmies.* London: C. Arthur Pearson, 1898.

54 Verger, Pierre, *Dieux d'Afrique.* Paris: Paul Hartmann, editeur, 1954.

147 Glaze, Anita

148 MacGaffey, Wyatt, *Custom and Government in the Lower Congo.*
 Berkeley, Los Angeles, London: University of California
 Press, 1970.

EDITOR: Susan Jurmain
COORDINATOR: George Ellis
PROOF READERS: Pat Altman
 Beverly Freiburger
 Nancy Talbert
 Pat Tuttle
DUPLICATION & REFERENCE: Andree Slaughter, Corrine Kantor
DESIGN: Jack Carter
PHOTOGRAPHY: Larry Dupont
MAP: Julie Laity
VIDEO PHOTOGRAPHY: John Neuhart
CONSERVATION/RESTORATION of COLLECTION: Sally O'Connor

PRINTER: George Rice & Sons
TYPOGRAPHY: JFDO Phototypographers